American Cultural Rebels

American Cultural Rebels

*Avant-Garde and Bohemian Artists,
Writers and Musicians from the
1850s through the 1960s*

Roy Kotynek *and* John Cohassey

McFarland & Company, Inc., Publishers
Jefferson, North Carolina, and London

Acknowledgments: Over the years of writing this book, several people have offered vital support and advice. The authors give thanks to their preliminary editor, Virginia Clark, novelists Ken Kesey and Ed McClanahan, and Professor Emeritus of History James Graham, and to Kirk O'Green and Ira Lax for their promotional efforts.

LIBRARY OF CONGRESS CATALOGUING-IN-PUBLICATION DATA

Kotynek, Roy, 1939–
 American cultural rebels : avant-garde and bohemian artists, writers and musicians from the 1850s through the 1960s / Roy Kotynek and John Cohassey.
 p. cm.
 Includes bibliographical references and index.

 ISBN 978-0-7864-3709-2 ∞
 softcover : 50# alkaline paper

 1. United States—Intellectual life—19th century. 2. United States—Intellectual life—20th century. 3. Avant-garde (Aesthetics)—United States—History. 4. Arts—Experimental methods—History. 5. Bohemianism—United States—History. 6. Dissenters—United States—History. 7. Artists—United States—Biography. 8. Authors, American—Biography. 9. Musicians—United States—Biography. 10. Popular culture—United States—History. I. Cohassey, John, 1961– II. Title.
 E169.1.K665 2008
 306.0973—dc22 2008000310

British Library cataloguing data are available

Front cover by TG Design

Manufactured in the United States of America

McFarland & Company, Inc., Publishers
 Box 611, Jefferson, North Carolina 28640
 www.mcfarlandpub.com

Contents

Preface

"Every generation laughs at the old fashions, but follows religiously the new."

— Henry David Thoreau

The hero as rebel, armed with art, wars with convention. At the far edge of society they have thrived, some forever defiant, others ultimately seeking acceptance. For over a century artistic avant-gardists plotted new aesthetic movements, printed magazines, held controversial art shows, and staged experimental theatrical and music performances. "America's Cultural Rebels" introduces readers to these high moderns and bohemian rebels whose influence still resonates in the culture at large.

William Burroughs stated in *Junkie* that "The hip sensibility mutates,"[1] and so do our perceptions of art and lifestyles; what seems new and cutting edge at the moment may have its roots in decades past. Looking at the inter-relationships of artistic avant-gardes — an aesthetic state of mind and creative stance — and countercultures — alternative lifestyles rooted in the appreciation of art — patterns of reciprocal influence emerge revealing how both, in their hip sensibility and ability to shock, have mutated over time. Amorphous phenomena, the artistic avant-gardes and countercultures did not, and do not, travel in history in neatly demarcated points of time. Many studies given to decades (e.g., the 1920s, the 1950s, the 1960s) compartmentalize artistic and cultural trends that develop or mutate over time. In its historical scope spanning the nineteenth and twentieth centuries, "America's Cultural Rebels" reveals the pervasiveness of vanguard ideas and individuals and their attempts to challenge conventions in art and life.

A branch of the avant-garde, bohemia constitutes a community of highly talented and lesser artists living in voluntary poverty, united in their rejection of the middle class and in their openness, regardless of gender or class, experimenting artistically and sexually. A vanguard creator may have little or nothing to do with the lifestyle of bohemia. The emergence of an artistic avant-garde,

1

once at home in upper-class salons and philanthropically supported private venues and publications, did not depend upon bohemia for its creative lifeblood. Conversely, there is no genre known as countercultural bohemian art. Yet the artistic avant-garde and bohemia have maintained at various times tenuous dependencies. Bastion of experimental aesthetic ideas and symbols, the avant-garde often supplies bohemia with model heroes, venerated and copied in dress and behavior, while bohemia is often the nurturer of artistic avant-gardes.

Originally a French military term meaning "advance guard," the term "avant-garde" came to be associated with political revolt, until the 1820s, at the height of romanticism, when it was applied to both social and artistic thought, and then entered the French vernacular in the mid–1840s as defining an icon-oclastic aestheticism.* Adherents of the artistic avant-garde caught in a per-petual cycle of revolt can quickly become victims of new aesthetic innovations, as they engage in what Renato Poggioli termed "activism": acting for acting's sake, the liberating power of self-expression that in its status-quo defiance would lead to the experience of inner revelation. Along with activism, the avant-garde engages in "antagonism," the subversive need to jeer at, shock, and tear down the conventional.[2]

Two diverse strains have run through the artistic avant-garde — that of aesthetic experiments that challenge or transform a genre (its methods, con-cepts, and form) — and another that seeks to challenge or radically transform society through art. While the former initially challenged classical aesthetic conceptions and defied the academy by painting and composing according to individual innovations, other more politically minded avant-gardists have used art to awaken the public from a perceived spiritual lethargy or social decay. These revolutionary vanguardists, who were attempting to transform a nation, or Western society itself, placed upon art the burden of messianic purpose.

This study traces various countercultures influenced by artistic avant-gardes that arose between the 1850s and the 1960s. Common to all the move-ments examined in this work is a reverence for art, and a differentiation is made between various bohemians, lone avant-gardists, and high moderns — individ-uals of wealth and education. Lacking formal settings, bohemian circles typi-cally gather in tawdry cafes and apartments, galleries, and publishing offices, headed by a charismatic leader or formed around independent publications. Conversely, in plush high-modern salons, avant-gardists performed their works sometimes in trial runs that garnered wealthy patronage or attracted other vital interest.

Countercultures and avant-garde salons and popular bohemian dives are

*Quoted in The Challenge of the Avant-Garde, ed. Paul Woods, the 1825 social utopian thinker Henri Saint-Simon equated art as serving the avant-garde and having a central role in the creation of a new society. In The Theory of the Avant-Garde, trans. Gerald Fitzgerald, Renato Poggioli cites the first use of the term in connection with art in Gabriel-Désiré Laver-dant's 1845 essay "De la mission de l'art et du rôle des artistes."

often "discovered," or invaded (to use Ernest Hemingway's term), by "pilot fish"—critics, upper-class voyeurs, thrill seekers, would-be creators, and hangers-on. In urban counterculture enclaves, "pretenders" or "slummers" are drawn to alternative scenes for a brief time before returning to the comforts of their middle-class lifestyle. Most responsible for these alternative scenes' transformation, the media piques the public's interest in commentary and illustrations, making for invasions or numerous copyists intent on re-creating these unique gatherings in their own particular venue or setting.

Since the early nineteenth-century, steam presses have produced inexpensive magazines and newspapers (including little magazines), exposing Americans to the latest cultural trends, including various artistic and bohemian activities. Once captured in stories or novels, or caricatured and parodied, countercultural types have surfaced as new social prototypes. In this pattern the 1910s liberated bohemian woman, who became the model for the 1920s flapper, and similarly, the fashionable African-American bebop jazzmen were the model for the 1950s beatnik.

Culturally predatory, the market often consumes avant-garde elements for new lifestyle and fashion trends. Rapid technological development intensifies the market's quick reception of new concepts, and their commercialized manifestations lead meteorically short lives with little time for maturation and development. All experiments are not successful or, as in the case of art, palatable or of interest to another generation. On occasion, American cultural iconoclasts have attained international cult status and have brought about an aesthetic consciousness influential to larger cultural and social movements. But art once shocking, lifestyles once scandalous often appear as yesterday's conventions, and though some avant-gardists' careers last into middle age, their work, like their physical appearance, can be mocked and scorned, or dismissed by the uneasy, disruptive force of youth.

In a cultural landscape that changes as fast as consumer products and automobile design innovations, youths, caught up in the cult of the new, demand new modes of self-expression, symbols, and sounds. The market can support true artistic innovation, but more often than not it sells pop forms little resembling their bolder, unique experimental sources, and while it can bring attention to an obscure form it can also hasten an avant-garde's death knell—familiarity.

By tracing the artistic avant-garde's historical relationship with countercultures, this study intends to connect the reader with past cultural vanguards. While exploring certain aesthetic innovations, it focuses on illuminating how various American vanguardists, shaped by European modernism, impacted upon, and at times transformed, the culture of a modern industrial nation. Because there has yet to appear a comprehensive study that deals with the interrelationship of the American avant-garde and counterculture a need has arisen for a synthesis that investigates the relationship of these cultural forces that have profoundly shaped modern America.

Because the avant-garde infiltrated the American arts at different periods, the importance of its impact on literature, visual art, music, and theater is emphasized according to the historical significance of each. As the first avant-garde import, bohemia centered on literature, an influence that remained dominant until its encounter with visual art during the 1910s. One of 1910s Greenwich Village's most creative contributions, experimental theater, would also become an innovative force during the 1920s and 1930s. Meanwhile, both white and African-American literary avant-gardists and bohemians interacted in circles where they listened and danced to jazz, their recreational music that underwent tremendous change as it produced, during the early 1940s, its first avant-garde genre, bebop. Modern jazz subsequently impacted on the beat generation's literary imagination and lifestyles. By the 1950s and 1960s jazz moved toward increasing abstraction, often attaining a dada-like level of experimentation bordering on the chaotic (e.g., free jazz) and producing a consciousness of antagonism and conflict. In the 1960s rock music absorbed elements of modernism, performance art, modern jazz, and non–Western music that emphasized tonal abstraction, freer rhythmic explorations, and extended improvisation — attributes that would eventually surface in the many forms of rock music as it departed from its early blues, gospel, and country music roots.

In this course of cultural history, not all avant-gardists have warred against the market. As Adele Heller and Lois Rudnick have observed, "American culture has an almost infinite capacity to absorb — some say co-opt — the radical edge of any new social, political, or cultural movement that comes our way."[3] But to view all modern artists in the role of the "lonely misunderstood genius" content to live in poverty does not accurately describe all American avant-gardists, whose rebellion against staid artistic forms has not always coincided with anti-capitalist consciousness. Thus, the relationship between artist and market will not be presented as necessarily antagonistic. From Whitman to Warhol, artistic experimenters have found means to promote themselves and their work. Because experimental and unique art often places the artist in a position of alienation and poverty, creative individuals have looked to means of economic support that allowed them creative freedom, and innovators like Ernest Hemingway and Miles Davis approached the market on their own terms.

Though many scholars have proclaimed the avant-garde's decline or death, such assertions seem dubious. If our current postmodern epoch may appear, for many, as being in a creative lull, it is out of just such a mood that iconoclasts, bored with the commonplace, arise and deliver their rebellious message. As Roger Shattuck wrote, "Modernism wrote into its scripture a major text, which demands, at least in retrospect, our gratitude: the avant-garde we have with us always."[4]

I

Fatal Destinies

Restless Youth: The Roots of
Nineteenth-Century Countercultures

Embracing the mysteries of man and the cosmos, romanticists worshipped at self-expression's altar. Like other successive avant-garde imports to America, romanticism handed down to generations the task of fusing life and art. Increasingly influential after 1815 when numerous "isms" swept Europe, romanticism stirred America's antebellum artists' imaginations. Edgar Allan Poe found a hero in English romantic poet Lord Byron, an early bohemian icon, whose work and early death befitted his own moody and melancholic temperament; Thomas Cole, under Percy Bysshe Shelley's poetic spell, painted landscapes of breath-taking beauty.

In the French Revolution's aftermath and Napoleon's defeat, youths embraced romanticism's cause as a response to industrialization, urbanization, nationalism, and the promise of individual freedoms. Though romanticism inherited the Enlightenment's notion of the individual as sovereign and of man's inherent fundamental goodness, it rebelled against rationalism, empiricism, and neo-classical ideals of beauty and perfection. It held sacred self-expression in a world rife with mystery, conflict, and abnormal circumstances, forces understood only through intuition and the unchanneled imagination. Turning their back on the academy and national salon, romanticist painters divested themselves from the ornamenting and decorating of churches and palaces—traditional patronage sources they considered as aesthetic enslavement.

With all of romanticism's newly declared freedom it had its sufferers, and what nineteenth-century mainstream society deemed "a misfortune," the romantics made a cult. Middle-class artists and writers, experiencing familial antagonisms and a capricious public, saw themselves as the victims of "misunderstood genius." Whether a romanticist trait or a perceived state of mind, alienation became an exalted condition.

Born at romanticism's height, bohemia was a symptom and response to

the bourgeoisie's ascendance in post–1789 revolutionary France — a new social-cultural lifestyle shaped as much by novels and newspaper images as by a rebellious group of art-minded Parisian youths. With its name taken from the kingdom of Bohemia, once thought to be the homeland of the gypsies, bohemia described early nineteenth-century Parisian outcasts who, as Jerrold Seigel outlined in *Bohemian Paris*, identified with "youth, art, and criminality." Inclined to vice and enamored with art, bohemians defied middle-class expectations that required sons to enter business, the professions, or government, and daughters to become wives and mothers. Refusing such roles or to "sell out" commercially, Parisian bohemians lived in voluntary poverty, renting drafty, damp mansard attics.[1]

Increasingly conspicuous during Louis-Philippe's reign (1830–1848), bohemians lived a life romanticized in popular literature. Derided as the "bourgeois king," Louis-Philippe ruled at a time when the prevailing middle class lost its revolutionary fervor; when emboldened artists asserted new social roles, as Beethoven, flaunting his musical genius, claimed superiority to the aristocracy, and painters stressed the distinction between the artisan and the independent artist.

A new literature defying their instructors' aesthetic strictures—like that of A. M. L. de Lamartine, Alfred de Musset, Théophile Gautier, and Charles Augustin Sainte-Beuve, as well as the English poets Byron and Shelley — intoxicated French students, filling them with wondrous visions, that were also stirred by the cult of "Orientalism" as captured in Delacroix's paintings of Moors and Berbers. In this cultural whirlwind, bohemian students longed to explore exotic lands or, like Lord Byron, fight in foreign wars of liberation; imitating Sir Walter Scott's knights, they wore capes and velvet caps, kept swords in their garrets, and fenced.

Adventurous 1830s youth who were unable to go abroad intermingled with underworld criminals— Parisian "apaches"— and gravitated to the Latin Quarter's cafes, and its dimly lit, foul-smelling lanes. Common to this renowned neighborhood of a rowdy student element were grisettes, young rural-born females reputedly named for their homespun, gray-cloth apparel. Mythologized in popular writings and literature as easy-going and worldly, grisettes of the Latin Quarter did not, for the most part, take artists as lovers, and eventually returned to the countryside to marry respectable husbands.

Grisettes frequented Parisian working-class cafes— haunts of bohemians, criminals, and political subversives, which invited without discrimination and established reputations out of their members' uniqueness. Nerve centers of political subversion and artistic rebellion, Parisian cafes, birthplaces of modern leisure likened to part club and public resort, numbered 3,000 on the eve of the French Revolution and increased to 4,500 by 1845. In cafes artists escaped their cramped apartments, ate and drank cheaply, and for hours on end garrulously engaged in bohemia's pastime of conversation.[2]

Cafes of note set a perennial countercultural pattern by drawing out-siders—slummers, so-called "amateur bohemians" or "poseurs," and econom-ically privileged bon vivants, practicing the art of unrestrained merriment while searching out creative offbeat company. Unlike bohemians from wealthier fam-ilies who had the option of returning to more comfortable circumstances, less fortunate full-time bohemians typically experienced down-and-outer fates. Artistically untalented or fated to obscurity, "unknown bohemians" or the "bohemian ignorée" were prone to substance abuse, ill health, and early death.

Bohemians made good journalistic copy and subjects for novels that, over the next century, gave them a discernible, albeit a fictionalized, urban identity. The bohemian first reached the public's awareness in a series of essays by Félix Pyat in 1834 and later was the subject of George Sand's novel *La dernière Aldini* (*The Last Aldini*). Honoré de Balzac brought further attention to bohemia with his story *Un Prince de la Bohème* (*A Prince of Bohemia*). First serialized in a newspaper in the 1830s, *A Prince of Bohemia* characterized the bohemian as being "between twenty and thirty years of age," gifted in his trade, a perpet-ual drinker and an artful lover. "Deep in debt, the bohemian community lives for the moment," and "has nothing and lives upon what it has. Hope is its reli-gion; and faith (in oneself) its creed." But Balzac's bohemian protagonist sought bourgeois success as did many bohemians, and his fictional artistic-minded sybarites escaped death by disease, alcoholism, or opium and hashish use, pop-ular in 1830s Paris.[3]

Such literary sources and popular print media shaped the larger culture's conception of bohemian behavior and codes of dress, in a "conformity of unconformity" yielding far fewer gifted artists than it attracted. But for a tal-ented minority, whether poor or privileged, bohemia was an individualistic rite of passage to serious and lucrative careers.

* * *

Growing unrest with Louis-Philippe's regime exacerbated radical politi-cal tendencies leading to the 1848 revolution. This event, like the 1830 Revo-lution sparked in Paris, intensified the uneasy relationship between radical politics' disciplined leadership and those within its ranks who clung to creative individualism. To Karl Marx and other radical political thinkers, bohemians were unruly wastrels useless to any serious causes, sometimes art as well. Though some bohemians were socialists or anarchists, Parisian bohemia played a limited role in these events, and some associated with bohemia like Charles Baudelaire briefly joined in the revolution only to distance themselves from pol-itics.

A year following the 1848 Revolution and Louis-Philippe's overthrow, Parisians crowded outside the Varieties Theatre to attend Henry Murger's* play,

**Born Henri Murger in 1822, the writer eventually Anglicized his given name.*

La Bohème. First published in the "petite press" publication *Corsaire–Satan* as a series of sketches (1845–1856) the play won favor with the city's leading theater critic, and enjoyed success "as an attractive escape from nearly two years of revolution, agitation, and uncertainty." In others it touched a nerve of lingering radical sentiment. In 1851 Murger published his novel *Scènes de la Vie de Bohème* (*Scenes from a Bohemian Life*), recalling his early brush with this Parisian-born lifestyle. The son of a tailor and concierge, Murger, never having obtained the baccalaureate, France's symbol of the respectable middle class, had limited career options and, unsuccessful at painting, turned to writing mediocre verse. Between 1841 and 1842 he joined a group of dedicated artists and writers, the "The Water Drinkers." Unlike their fictional portrayal in Murger's play and subsequent novel, the Water Drinkers warred with the seemingly money-hungry and corrupt bourgeois. They attained their sobriquet, not, as some sources suggest, from the impecunious position of not being able to afford alcohol, but out of puritan-like abstinence. As the bourgeois' moral superiors, the Water Drinkers resisted doing work they deemed below their artistic standards.

In *Scenes from a Bohemian Life*, the Water Drinkers were portrayed nostalgically, though sometimes derisively, while some of its characters were based upon Murger's more recent companions.* Among his new extended circle were the soon-to-be-famous writers Champfleury (Jules Fleury-Husson), poet and critic Charles Baudelaire, and photographer Nadar (Gaspard Félix Tournachon), and loosely associated was writer Gérard de Nerval, an eccentric par excellence who once walked a leashed lobster in a Parisian park. By 1844 Murger was meeting Champfleury, Baudelaire, and Nerval regularly at the Café Momus, where, in a reserved upper-floor room, they formed their own private club and a system of controversial credit, blackballing any customer whom they did not consider suitable.

Of Murger's companions, Baudelaire had a lasting countercultural influence, notably his defining the English dandy's French counterpart, the boulevard-strolling flaneur.† Baudelaire believed "Dandyism" to be a symptom within countries that were making a transition from aristocratic rule to democracy. Early in his life, Baudelaire saw art and life as intertwined and interdependent, and, though a periodic smoker of opium and hashish, he extolled the idea that great art was the product of steadfast commitment and hard work. While admiring aspects of the dandy, he labeled bohemia the "cult of multi-

**Though it attracted a steady reading public in France until the turn of the century (and was the basis for Giacomo Puccini's opera* La Bohème*), Murger's book did not see an English translation in America until 1899, when it was published as* Life in Bohemia.

†*First appearing as an English term around 1813, and epitomized by Bryan "Beau" Brummel (1778–1840), the dandy phenomenon invaded France in 1827. Baudelaire produced a famous 1863 essay, "The Painter of Modern Life," which clarified the dandy as personality type and became a role model for the modern artist.*

plied sensation," a way of life in which he was often forced to take refuge whenever impecunious circumstance dictated.

But Baudelaire's genius had little in common with Murger's bohemians— clever extractors of money who exerted as much effort escaping creditors and landlords as in producing art. Murger's bohemian quartet shared clothes and squandered the money made from their art in enjoying "the most ruinous fancies, loving the prettiest, drinking the oldest and best, and never finding sufficient windows to throw their money out of." They spoke a "special language"— an intelligent slang immersed in editor room and studio conversation, and existed as "the hell of rhetoric and the paradise of neologism." In his characters Murger differentiated between the artistically gifted and deluded artist manqués—"obstinate dreamers" and "whining poets whose muse has always red eyes and ill-combed locks, and all the mediocrities of impotence."[4]

Thomas Mann once wrote: "Only the incorrigible bohemian smiles or scoffs when a man of transcendent gifts outgrows his carefree prentice stage, recognizes his own worth and forces the world to recognize it too and pay it homage." Few made this journey through bohemia's side door into respectability and success. Bohemia's incorrigible others experienced its traps and vagaries and "occupational diseases"—consumption, syphilis, and pneumonia. In his own life, despite periods of economic success, Murger never entirely escaped bohemia. In his novel he had warned of the dangers of bohemian life — that it could lead one to "the Academy, the Hotel Dieu, or the Morgue." The most talented of Murger's bohemians, Jacques D., a promising young sculptor, smoker of laudanum-laced tobacco, met an early death, soon followed by that of his consumptive lover, and was buried in an unmarked pauper's grave.[5]

Though they valued art over amorous affairs, the novel's sentimentally attached bohemian quartet, notably Rodolphe and Mimì, were immortalized in Giacomo Puccini's 1896 opera *La Bohème*. Despite its retrospective look at a passé pre–1848 bohemia and published nearly ten years after the Water Drinkers' original activities, *Scènes de la Vie de Bohème* became the guidebook for a few young American cultural rebels who ventured to Paris in search of Murger's Latin Quarter life.

Visions of Utopia

In the decades preceding the Civil War, America established art societies and academies in Philadelphia, Boston, and New York City.* Visiting America in 1831, Alexis de Tocqueville was dismayed by the painted wooden columns of wealthy New England homes and parlors displaying simple family portraits and concluded that Americans were obsessed newspaper readers with little time for or interest in high art.

*New York City produced the American Academy of Fine Arts in 1801, the National Academy of Design in 1826, and the National Art Union in 1839.

Tocqueville's visit coincided with the country's rapid transformation into a democratic market society, emphasizing individualism, competition and freedom from governmental restraint — an ethos that linked financial success with character and required industriousness and a sober work ethic for economic advancement. But for some, obsessive material gain threatened the founders' vision of a republic of virtuous, self-sacrificing citizens, presaging moral decay.

Reformers reacted in diverse ways to western expansion, technological innovations, party politics, and religious revivalism. Out of the Second Great Awakening's religious revivalism, antebellum reformers made their causes into new full-time careers, championing women's rights and combating the evils of drink and slavery. To guide morally the nation's citizenry, reformers founded local and national societies to promote their causes, and by the 1830s those who claimed to represent the country's true moral foundations were challenging every aspect of American life.

For the more righteous crusaders piecemeal reform efforts were hardly enough. Among this minority were communitarian societies that founded religious countercultures, mostly German sects of skilled farmers accustomed to manual labor. German pietists established communities at Ephrata and Harmony, Pennsylvania; Zoar, Ohio; and Amana, Iowa, that practiced rural collectivism and cooperation, and worshipped God according to the tenets of their faith.

Unlike European religious communitarians, America's native-born utopians sheltered those in moral need and longing for a simpler life through worship and hard work. Apart from early socialist enterprises like Robert Owen's New Harmony in Indiana (1825–1828), the majority of the more successful alternative communities were religiously inspired and led by charismatic leaders possessing prophet-like qualities. Inheritor of the antinomian spirit, John Humphrey Noyes in 1848 founded a successful rural New York community, Oneida, built upon the belief in perfectionism — that man, born essentially good, could, with God's grace, attain a state freeing himself from sin.

Like Noyes and other antebellum communitarians, New England transcendentalists opposed the market economy and manifestations of what they saw as flaws in the democratic experiment: African-Americans' enslavement and the subordination of women. Ralph Waldo Emerson warned, "Things are in the saddle and ride mankind," while, in *Walden* (1854), Henry David Thoreau urged that one embrace "Simplicity, simplicity, simplicity!" by engaging in "voluntary poverty" and rejoicing in the wonders afforded by nature.[6]

Despite Tocqueville's prediction that America's creation of high art would remain largely unrealized, five years after his 1831 visit Emerson published *Nature*, and Boston's Transcendental Club was formed — events that contributed to a literary flowering and a new philosophical and artistic consciousness. Though never a unified set of principles, transcendentalism held that intuition was the fount of spiritual truth. It stressed democratic self-reliance

and envisaged a society redeemed and the rise of a new humanity. Transcendentalists, immersed in European romanticism and Eastern thought and opposing Unitarian rationalism, believed that a transcendent spirit joined every individual with nature. As Van Wyck Brooks explained, Emerson "felt the blood of thousands in his body, and his heart seemed to pump through his veins the sap of all this forest vegetation."[7]

Foremost in spreading transcendentalism's gospel, Emerson warned in "Self-Reliance" (1841) that "imitation is suicide," a call that resonated with generations of Americans. In his essay Emerson questioned the "blind-man's bluff ... game of conformity" and penned his oft-quoted maxim, "A foolish consistency is the hobgoblin of little minds." He urged that to understand an ever-changing world man must meet it with new perspectives, that he look at nature (the divine) through spiritual wonder which would inspire new art.[8]

Coinciding with the publication of "Self-Reliance," in 1841 the transcendentalist Reverend George Ripley founded Brook Farm in West Roxbury, Massachusetts, eight miles from Boston. Brook Farm bound its members in a "natural union" that opposed the dominant forces of economic competition, the acquisition of wealth, the institution of slavery, and the oppression of women and fostered the spirit of honest work and intellectual endeavors. By 1843 Brook Farm occupied 208 acres of lush meadows and pine groves, where its members labored and learned in Ripley's vision of a perfect democracy, one, as George Hochfield observed, "where washerwomen may walk with philosophers—indeed, where washerwomen may be philosophers, and philosophers do the laundry."[9]

Brook Farm's relaxed atmosphere, like the 1960s communes, allowed "for fads, for odd attire, for unfashionably bearded and longhaired men." It produced a newspaper, *The Harbinger*, and a reputable six-year college preparatory school that included instruction in various foreign languages, philosophy, visual art, and instrumental music. Though these fruits were Brook Farm's "best crops," there existed in the community the persistent problem of making its members into effective laborers.[10]

Emerson's early enthusiasm for the communal experiment quickly waned, and, like Thoreau, he could never bring himself to surrender his individualism. While Emerson never left home and family, Thoreau lived in semi-seclusion in his "community-of-one" at Walden Pond (1845–1847). After their visits to Brook Farm, Emerson and Thoreau made, in their private writings, critical observations of Ripley's West Roxbury experiment. In May 1843 Emerson commented in his journal, "Brook Farm will show a few noble victims who act and suffer with temper and proportion, but the larger part will be slight adventurers and will shirk work."[11]

On a snowy April day Nathaniel Hawthorne arrived at Brook Farm, finding it idyllic and his transformation into a farmer regenerative. When he first dined at Brook Farm, he speculated that not since the early Christians had there existed

such a spirit. However, daily fieldwork soon took precedence over creating literature; two months after arriving, Hawthorne informed his wife, "It is my opinion, dearest, that a man's soul may be buried and perish under a dung heap or in a furrow of a field, just as well as under a pile of money." In his novel *The Blithedale Romance* (1853), Hawthorne offered a thinly veiled criticism of this unrealistic utopian experiment in its main character, Coverdale. A New England liberal reformer, Coverdale proclaimed:

> We had left behind the rusty iron frame-work of society behind us; we had broken through many hindrances that are powerful enough to keep most people on the weary tread-mill of the established system.... It was our purpose — a generous one ... to give up whatever we had heretofore attained, for the sake of showing mankind the example of a life governed by other than false and cruel principles on which society has all along been based.[12]

Hawthorne's disillusioned Brook Farm departure was indicative of the movement's failure to make successful farmers and artisans out of intellectuals and reformers. Through the influence of the wealthy New Yorker and socialist reformer Albert Brisbane, Brook Farm had become by 1844 a utopian community modeled upon the Phalanx system of French social thinker Charles Fourier (1772–1837). In 1845 Brook Farm, officially chartered, took the name Brook Farm Phalanx. To honor Fourier an imported plaster statue of the French social theorist was placed in the newly erected phalanstery, or main building. In 1847 a fire destroyed the uninsured phalanstery, and Brook Farm, beset with economic problems, immediately fell into decline.

Apprentices in the City of Light

On the eve of the Civil War, a different cultural ism — bohemianism — took root in New York City as Atlantic steamship travel increasingly brought Americans to Paris. Some had experienced Parisian café life and did so at a time when Napoleon III's 1852 ascent to the throne placed the cafes under decree, ordering that "all questions concerning the opening, running, and closing of an establishment that sold drink were to be supervised by the prefects of police." Considered by Napoleon III's government as places of disorder and radical secret societies, many old cafés, were, as a result of Baron Georges Eugene Haussmann's urban renovations of Paris, largely destroyed by the 1850s. The implementation of an English-style police beat system and Haussmann's newly widened boulevards made monitoring working-class cafés an easier task for the authorities. Upper-class cafés, on the other hand, were treated as "benign" venues, and the police patrols ensured the safety of strolling boulevardiers.[13] Amid Napoleon III's decrees, bohemia did not display an overt political activism as it had during the late 1840s. However, the city's allure of art and café life drew aspiring artists and writers from England, the Continent, and America. To meet visitors' demands American newspaper reading rooms were opened, and

Parisian restaurants sometimes offered pancakes, pumpkin pie, and baked beans, and in the Latin Quarter, much to the outrage of English students, Yankees celebrated the Fourth of July and ate turkey on Thanksgiving.

Back home at this time, thousands of American readers encountered hints of the bohemian life in novelist William Makepeace Thackeray's anti-heroine, Becky Sharp, of *Vanity Fair* (1852). Caught in her scheming and sexual intrigues, Becky leaves England and wanders around Europe from city to city, addicted to gambling and rogue company. In *Vanity Fair* Thackeray described Becky as becoming "a perfect Bohemian ere long, herding with people whom it would make your hair stand on end."[14] Having experienced the Parisian Latin Quarter while an art student in the 1820s, Thackeray, during a second visit to the United States in the 1850s, commented:

> I like what are called Bohemians and fellows of that sort. I have seen all sorts of society, dukes, and duchesses, lords and ladies, authors and actors, and painters—and taken altogether I think I like painters the best and 'Bohemians' generally. They are more natural and unconventional; they wear their hair on their shoulders if they wish, and dress picturesquely and carelessly.[15]

Though never as popular and widely read as Charles Dickens' works, Thackeray's *Vanity Fair* helped define the bohemian character type, even if their nighttime activities and garret life were lightly touched upon and their immoral aspects left to the reader's imagination.

* * *

As Americans read about or experienced Parisian life, a new artistic avant-garde — realism — had already scandalized the city, as its leading exponent, Gustave Courbet, stripped painting of romanticism's exotic, otherworldly qualities. Courbet's Independent Salon in 1855 symbolized his followers' desire to pursue careers on their own terms. At the same time there were Parisian writers and poets who, like Baudelaire, straddled the line between realism and romanticism. Formal artistic study, stressed Baudelaire in *The Painter of Modern Life*, was necessary during the artist's early years. But he, like realists, believed that a painter's subjects should not wear antiquity's garb, that art should capture meaningful moments of one's own time, the eternal in the ephemeral.

In 1847 Baudelaire discovered the French newspaper translations of Edgar Allan Poe's "The Murders in the Rue Morgue" and "The Black Cat." He then wrote his own translations and essays about the American, collected into a volume in 1865. Following his death in 1849, Poe, if remembered at all by his countrymen, was considered a drunken failure. Unlike previous American writings on Poe, Baudelaire's 1852 essay "Edgar Allan Poe: His Life and Works" emphasized the "ill-fated destinies" of those born with creative genius. According to Baudelaire, Poe had an "alcoholic breath which would have caught fire at a candle's flame." Despite this reference, Baudelaire did not consider Poe a true bohemian but rather a victim of a childish philistine country, "naturally jeal-

ous of the old continent." Poe's image as a doomed alcoholic avant-gardist passed into legend, and on two continents Poe's down-and-outer fate fed the romanticist notion of the suffering artist at odds with an indifferent society.* Bolstering Poe's bohemian image in France, in 1885 famed former Parisian dandy Jules Barbey d'Aurevilly wrote the article "The King of the Bohemians, or Edgar Poe." As Jerrold Seigel pointed out, "Barbey explicitly rejected Baudelaire's suggestions that society was to blame for Poe's fate"—that he was victim of "a pure emanation of the spiritless modern sinkhole of isolated egoist that had reached its most fully developed form in America."[16]

The Poe cult in France came about at time when realism had eclipsed romanticism as the leading artistic avant-garde. Yet traditional notions of art prevailed in America, supported by its leading institutions like the National Academy of Design and the Pennsylvania Academy of Fine Arts. For academic painters, European study was requisite in pursuing a professional career. Until the outbreak of the Civil War, Rome and Florence remained the preeminent places for artistic study. But Second Empire Paris drew American students, and the city's 1855 Exposition Universelle strengthened its image as an art center, while its independent ateliers seemed to adventurous students more intriguing than the imposing art academies of London or Rome.

Among America's visual art apprentices, Massachusetts-born James McNeill Whistler took to painting with an upstart's whim and to Parisian bohemia as befitting an uninhibited, upstart dandy. Embracing art at an early age, Whistler was dismissed from West Point, then failed the demands of regular employment at Washington, D.C.'s Coast Survey Office. Before leaving America in 1855, he read *Scènes de la Vie de Bohème*, studied Garvarni's illustrations of Latin Quarter life, and dressed in bohemian attire. At age twenty-one he stayed in London with the family of his half-sister Deborah before leaving for Paris in the fall of 1855, where he chose to live in Latin Quarter rooming houses, dressing as a dandy in an American straw hat with a trailing black ribbon.

In Paris Whistler encountered an English art student circle that included George du Maurier, whose 1890s novel, *Trilby*, would launch a late Victorian-era bohemian vogue. Whistler found dull his English companions' native cuisine, drink, and ritual of daily exercise and lived instead among bohemian French acquaintances. To avoid the municipal tax on alcohol, he moved in 1857 south of the Latin Quarter to the Montparnasse cafe and entertainment district. With his destitute Parisian "no shirt friends"—artists Henri Fantin-Latour and Alphonse Legros—he formed the Society of Three, and they, like Murger's

*Tormented by personal distrust and jealousy, inept in monetary affairs, Poe was prone to drink. Though sources contend that he either drank in large quantities or fell into drunkenness with a few sips, his biographer Kenneth Silverman surmised that "the truth most likely combines the two estimates: after one drink he could not stop."

bohemians, shared their belongings and meager incomes. Financially irresponsible, Whistler squandered his monthly stipends, routinely pawned his clothes, and when in need of finer attire took loan of a suit. During his three-and-a-half years (1855–1858) in Paris, Whistler lived at several Latin Quarter addresses, frequented cafés and ballrooms, and took various lovers. Parisian streets, restaurants, and ballrooms attracted him equally as his artistic studies.

In Paris Whistler studied at the atelier of the Swiss painter Charles Gleyre. Averse to formal instruction he rarely attended the altier, earning among his English colleagues the nickname "Idle Apprentice." After Whistler's brief bohemian period ended, he spent the next two decades in his adopted London as an artistic autodidact, presiding over an iconoclastic circle celebrating freedom of art and lifestyle. Immersed in an art-for-art's-sake aesthetic, Whistler would be embraced by early American modernists whose works sought to capture what photographer Alfred Stieglitz described as an "envelope of atmosphere."

The Arrival of Bohemia

Taking the lead in bohemia's importation to America, Massachusetts-born Henry Clapp Jr.—a one-time Sunday school teacher, abolitionist, New York newspaper editor, and temperance advocate—experienced 1850s Parisian nightlife and fell under bohemianism's spell. "In London you are amused, in Paris you are delighted," wrote Clapp, in a city where "liberty, equality, and fraternity are rampant." Uninterested in Murger's impecunious characters, Clapp favored the "Parisian bohème of Gallante and Gautier and his followers who guzzled wine from skulls and knelt before women."[17]

Back in New York City in the late 1850s, Clapp, after three years in France, searched for a Parisian-like café and discovered Pfaff's saloon on Broadway. Pfaff's owner, Charlie Ignatius Pfaff, hailed from either Switzerland or southeastern Germany, and he welcomed New York's bohemian element—struggling journalists, actors, and artists. Its walls without pictures or mirrors, its floors bare, and lacking musical entertainment, Pfaff's established its reputation solely upon accommodating its unconventional customers. Below its main barroom, in an under-the-sidewalk "vaulted cave" modeled on European rathskellers and underground grottos, wine casks were stockpiled and a table set out for the bohemian "Cave Dwellers," who dined on mediocre food and imbibed finely brewed coffee, German beers, imported wines, and champagne.

Centrally located on Broadway just north of Bleecker Street, Pfaff's existed in an area intersected by commerce and culture. A shopping district by day, Broadway flourished at night with fashionably dressed sidewalk strollers. One local chronicler observed, "To see Broadway in its glory ... you must wait till six o'clock, P.M. Then ... you will see New York's possible in the way of beautiful women, scrupulously dressed dandies." Like their European models, New

York's dandies affected an indifferent aristocratic manner shielding a "hidden poverty." The cane-carrying Pinchback Dandy wore plaid pants with six-inch cuffs that nearly concealed his foot. Dandies, observed a contemporary, "generally live a worthless, deformed life, and sinks down from a disgraceful youth to a mean manhood and a contemptible old age."[18]

Traveling dandy squads paraded along Broadway and frequented the avenue's hotels, gambling houses, liquor groceries, and grog shops. They moved among slummers and the longhaired Bleecker Street artists, wearers of Vandyke beards, whose unheated studios were cluttered with easels, cigar butts, and boxing gloves. At Bleecker Street opera houses artists heard their favorite singers and joined bohemian journalists and poets at Pfaff's. Heading this unruly crowd, Henry Clapp —"King of Bohemia"— joined with his compatriots in drinking and talking, scoffing at the public and fueling rumors of lascivious sexual activity. In a spirit of competitive jest, Pfaffians told jokes and stories, and upon the publishing of their works members routinely received open scrutiny and mocking comments.

But after the Wall Street Panic of 1857, New York's artistic bohemians and low-paid journalists faced dire circumstances. In January of that year, nearly five months after the crisis, The *New York Times* blamed the bohemians' lack of the work ethic for the growing unrest and described them as "not far removed from a loafer." In 1860 William Dean Howells visited Pfaff's and wrote of its clientele: "their locks were still damp ... and ... neither said nor did anything worthy of their awful appearance, but dropped into seats at the table, and ate of the supper with an appetite that seemed poor."[19]

Howells discovered Pfaff's through *The New York Saturday Press*, a controversial yet popular weekly founded by Clapp in October 1858. Committed to "literary intelligence" as well as to art, drama, and music, the *Saturday Press* proudly asserted that it was "connected with no party or sect, and tainted with no kind of 'isms.'" In the spirit of French feuilletons (newspaper serials), the *Saturday Press*, during its nearly eight-year run, rivaled the *Atlantic Monthly* in readership, carrying scandalous criticism and commentary, stories and poems. One of America's 2,526 mid-nineteenth-century newspapers, the *Saturday Press* was published several years after the introduction of weekly and monthly journals such as *Harper's Monthly* (1850) and the *Atlantic Monthly* (1857). As the *Saturday Press*'s most gifted contributor, Walt Whitman, later recounted, "...the *Press* cut a significant figure in the periodical literature of its time." Howells, who provided several Heinrich Heine-like verses for the *Saturday Press*, asserted that the "paper really embodied the new literary life of the city. It was clever, and full of wit that tries its teeth upon everything. It attacked all literary shams but its own, and made itself felt and feared."[20]

One of the first antebellum journals to rival Boston critics and publishers, the *Saturday Press* benefited from new printing innovations that had given rise to a variety of subversive literature—penny papers, police gazettes, and

cheap yellow-covered pamphlet novels of dark Gothic themes and grotesque stories of outcasts, highwaymen, freebooters, and female land pirates. Yellow novels also featured the exploits of immoral clergy and decadent aristocrats who practiced torture.

Low-paid hack writers produced subversive literature, "yellow-covered pamphlet novels," which could be purchased nationwide and attracted not only the reading public but influenced writers like Poe and Hawthorne who relished the reading of police gazettes. Given to the bohemian cause and capturing the sensationalist literary mood of the times, Clapp's *Saturday Press* sought to shock, and its primary aim was the "denunciation of all things Yankee," most notably Boston Brahmin writers whom it considered "solemn Philistines." Its pages professed the "kicking off political authority and living for the moment," and it "mocked anti-slavery advocates as unmeaning howlers" and Clapp, sounding dangerously seditious, derided Lincoln "as a pure humbug," in that he used the Negro "as a stepping stone to power" only to "leave him aside, and let him go to the devil."[21]

By the late 1850s the *Press* featured Jane McElhenney, aka Ada Clare, an aspiring South Carolina–born poet. Before entering Pfaff's circle, Clare, a social outcast from her native Charleston, had sailed to France and discovered Parisian bohemia. She returned to New York City and after taking the name Ada Clare found local fame in 1855 when the *Atlas* published one of her poems. She discovered Pfaff's, and as the establishment's "Queen of Bohemia" was considered uniquely attractive. John Burroughs wrote of Clare, "She was very beautiful; not characterless, but a singular, unique beauty." Flaunting her liberated lifestyle, Clare symbolized "the New Woman," openly discussing her affair with the flamboyant New Orleans–born pianist and composer Louis Moreau Gottschalk — America's first popular musician of the European concert circuit. Clare's short-lived relationship with the pianist, sometime in the mid–1850s either in Paris or America, resulted in a son, Aubrey. Inviting scandal, Clare traveled throughout America, proudly introducing herself and young Aubrey as "Miss Ada Clare and Son."[22]

Another of Pfaff's female notables, stage star Adah Isaacs Menken, made her career debut as the first woman to play the lead role in *Mazeppa*, appearing in an Albany theater on June 3, 1861. Dressed in flesh-colored tights and tied to the back of a black stallion (former productions had used a dummy rider), she rode up a ramp in the closing scene. This act took audiences by storm, and journalists made it all the more scandalous by reporting that in the footlights the rider appeared to be nude. Defying social conventions, she found success on the stage and in Europe befriended some of its leading writers. Menken, a talented self-publicist, added a burlesque touch to her sensationalistic act that resembled a circus or Wild West Show. While at Pfaff's she aroused Whitman's curiosity and subsequently tried her hand at writing verse in the vanguard poet's style.[23]

Menken, like Clare, entered Pfaff's unescorted at a time when Broadway prostitutes and pimps were appearing in increasing numbers during daytime hours. The few women known to have visited Pfaff's mixed in a circle with which no women of respectable bourgeois society would ever associate and in so doing were often wrongly branded as prostitutes. But Pfaff's bohemia allowed for a rare mixing between the sexes in antebellum America. Rumors of orgies and underground excitement brought to Pfaff's hangers-on and would-be artists. A free-love advocate, Clapp spread rumors of orgiastic sex that may have been more imagined scandal than actual practice. Yet Broadway was an active district of sexual activity, and during the 1840s and 1850s, "a casual relationship could be struck up in bathhouses near Broadway hotels, at bohemian bars like Pfaff's, in dark theaters, aboard ships, along wharves, while strolling in Parks, and even church."[24]

Unique to New York City, Pfaff's became a must-see spectacle that by the end of the decade "vied with Castle Garden, Tammany Hall, and Barnum's Museum as a New York landmark." At Pfaff's visitors commingled with a loose assemblage of American and European-born men and women, a disaffected middle-class group ranging from dandies to criminal types lost in a world of substance abuse and poverty. At Pfaff's Ned Wilkins represented the circle's notorious dandy, who later died in a damp mansard attic. *Vanity Fair* editor Fitz Hugh Ludlow epitomized the bohemian drug user, and his 1856 *Putnam's* article "Apocalypse of a Hasheesh Eater" and subsequent book *The Hasheesh Eater* (1857) — rife with mystical hashish visions and a forerunner of the later 1960s drug trips — took their inspiration from Thomas de Quincey's *Confessions of an English Opium-Eater.*

Newspaper caricatures of Pfaff's hard-drinking patron, the Irish-born Fitz-James O'Brien, gave the circle more notoriety. A bohemian/adventurer, writer and boxer who later died on a Civil War battlefield, O'Brien provoked arguments that often ended with an exchange of fists. Given a passkey by fellow bohemians, O'Brien, without a permanent residence, "slept in any available unoccupied bed or couch." In his 1861 short story "The Bohemian," O'Brien's bohemian protagonist, Zingaro, a reader of Murger's *Scènes de la Vie de Bohème*, set himself apart from the gypsy criminal element in that he claimed to be "clever, learned witty, and tolerably good-looking. I can write brilliant magazine articles.... I can paint pictures, and what is more, sell the pictures I paint."[25]

Despite O'Brien's protagonist's claims, most *Saturday Press* contributors were not exceptional writers, and only one frequent contributor possessed literary genius. Between December 1859 and December 1860, the *Saturday Press* published over twenty pieces by Walt Whitman, including the poem "A Child's Reminiscence," which, under the title "Out of the Cradle Endlessly Rocking," would appear in the 1860 edition of *Leaves of Grass*. Friend of New York City stage drivers, medical students, and bohemians, Whitman searched the city for the company of boisterous and spirited companions. After leaving his job as

editor of the *Brooklyn Daily Times* in June 1859, Whitman spent more time in bohemian company. Often seated at a table reserved for Pfaff's literary visitors, the already gray-haired Whitman quietly sipped his beer. Years later Whitman recalled his visits: "My greatest pleasure at Pfaff's was to look on — to see, talk little, absorb." He enjoyed the spontaneous wit and rapid bursts of conversations with O'Brien and the argumentative poet George Arnold. After visiting Pfaff's, E. M. Allen wrote, "Whitman was there — rough, hairy, and gray-necked; he had his hat on, looking reflective, listening to a neatly dressed young fellow who sat next to him." Genial and looking the part of the elder bard, Whitman had, among the Pfaffians, admirers and detractors. One Pfaffian recalled, "Whitman was the only one who was never tipsy and never broke ... he was an easy borrower, though it does appear that he asked for large amounts and made needless delays in his repayments." When critics condemned Whitman's 1860 edition of *Leaves*, Pfaffians often made "friendly jokes" and publicly ribbed him about the volume's negative reception.[26]

In his notebook Whitman captured his impression of Pfaff's in an unfinished poem, "The Two Vaults":

The vault at Pfaff's where the drinkers and laughers meet to eat and drink and
 carouse
While on the walk immediately overhead, pass the myriad of feet of Broadway
As the dead in their graves, are underfoot hidden
And the living pass over them, recking not them,
Laugh on laughers!
Laugh on drinkers!
Bandy and jest!
Toss the theme from one another!
Beam up — Brighten up, bright eyes of beautiful young men!
Eat what you, having ordered, are pleased to see placed before you — after the work
 of the day, now, with appetite eat,
Drink wine — drink beer — raise your voice.[27]

Drawn to the drinking vault's frivolities, Whitman, while still an undiscovered writer in New York City, also identified with the streetwise "b'hoy," the Bowery's smart and "youthful working-class dandy,"* who, despite his street-wise image, was a theater devotee. The b'hoy's popularity even spread to England, and when visiting America in the early 1850s, novelist William Thackeray went to the Bowery in search of one these wearers of funnel-legged pants and oversized-hats. Portrayed as a character on the New York theater stage, the b'hoy, a street-wise rowdy, cultivated the theater and, sharing the dandy's pastime of drinking, fell victim to the alcohol grog-shop, the three-cent cellar, and the corner liquor grocery.[28]

*The b'hoy entered popular literature as a rowdy fireman in the 1830s and subsequently emerged as a shrewd "working-class man who behaved like a cultured dandy." Both Melville and Whitman included the b'hoy in their work.

Whitman's observations of the b'hoys rubbed off on his own emerging persona. In the 1855 *Leaves of Grass* frontispiece, Whitman is portrayed in his middle thirties, rakishly posed wearing a black felt hat, and his shirt, "thrown wide open at the collar," remarked Malcom Cowley, reveals "a burly neck and the top of what seems to be a red-flannel undershirt. It is the portrait of a devil-may-care American working-man, one who might be taken as a somewhat idealized figure in almost any crowd."[29]

For Whitman, the b'hoy, like the bohemian, remained a subject of interest. However, like most creative people on their way to success, his association with bohemia was short-lived. Of the Pfaffians who found success in conventional writing careers were lecturer and humorist Artemus Ward (aka Charles Farrar Brown) and the *Saturday Press'* associate editor, Thomas Bailey Aldrich. But most Pfaffians met down-and-outer fates. At a dinner held at Pfaff's in 1860, fourteen of its habitués gathered, including O'Brien, Whitman, Stedman, Wilkins, Clare, and Ward. A decade and a half later, nine of those present had died. In April 1861, with the outbreak of war and Lincoln's call for volunteers, the original Pfaff's circle met its end.*

As Pfaff's' original bohemian atmosphere faded, Clapp, unable to raise funds, ceased publishing the *Saturday Press*. From its inception, Clapp struggled to keep his weekly in circulation. Several months following the Confederate defeat in 1865, Clapp briefly brought the paper back into circulation for several more editions, one of which featured Whitman's "Captain O Captain." The *Saturday Press'* November 1865 edition featured Mark Twain's "Jim Smiley and His Jumping Frog." Whatever cause he championed, Clapp always remained a shrewd promoter. In his later years Whitman recalled that, despite financial troubles, his former bohemian friend possessed "abilities way out of common." As Whitman told Horace Traubel:

> I can see how Henry in another environment might have loomed as a central influence.... Somebody some day will tell that story to our literary historians, who will thenceforth see that Henry cannot be skipped, for the Press cut a significant figure in the periodical literature of its time. I have often said to you that my own history could not be written [without mentioning] Henry.

Embittered following the *Saturday Press'* demise in 1865 and the scattering of Pfaff's original circle, Henry Clapp drank to excess and, undeterred by stints in Blackwell's Island's drying-out ward, died in 1875. Despite the down-and-outer fate of its editor, the *Saturday Press* influenced other American cultural rebels who established small publications and attempted to resurrect New York City's transplanted Parisian bohemia.[30]

Answering the call to arms, O'Brien, "the pugilist of bohemia," joined New York's Seventh Regiment and died of lockjaw in 1862. That same year, Whitman took offense at George Arnold's mocking toast to the Confederate cause, left the saloon, and did not visit Pfaff until after the Swiss-German moved his restaurant in 1862 to Twenty-fourth Street, a place that never recaptured the bohemian atmosphere of Bleecker Street. Whitman did not meet Pfaff again until 1881.

II

Gilded Age Vanguards

Bohemian Frontiers

In San Francisco former Pfaffians interacted with bohemians influenced by the *Saturday Press* who drew on Barbary Coast legends and a frontier spirit that would be passed down to future cultural rebels. 1860s bohemian writers and journalist dandies— readers of Balzac, Swinburne, and Rossetti — worked under bohemian pseudonyms and made newspaper offices and saloons their headquarters. Later, local artists, under the spell of French open-air techniques and James McNeill Whistler, also took up the garret life.

Transformed by the Gold Rush, San Francisco's population grew between August and October 1849 from 6,000 to 15,000 residents, making it a wide-open city. To accommodate and capitalize on this "boom town of men" in search of fortune, groggeries, gambling halls, and houses of prostitution sprang up, and newly established hotels accommodated six to ten guests a room. Conventional morality was abandoned for the quest of making money, and various pleasures were satisfied. Amid its growth and technological advances, the city nurtured one of the country's most vigorous bohemian scenes. Its participants haunted the Spanish and French Quarters' dark streets and Barbary Coast saloons and restaurants. In their rooftop apartment studios, they consumed bologna sandwiches, pungent cheeses, French and Italian breads, and inexpensive wines.

New York–born Bret Harte, after spending the 1850s as a northern California journalist, took bohemian newspaper pen names to cultivate a rugged, eccentric image — though, as his biographer noted, he was "more of a dandy and a man of letters than a flanneled-shirt toiler in the red earth."[1] Though unhappily married and chronically in debt, Harte was respectably employed at the San Francisco Mint and attended fashionable salons wearing meticulously arranged colored cravats. While working as the *Golden Era*'s typesetter in 1860, Harte produced writings styled after the Pfaff circle's George Arnold that earned him promotion to the *Era*'s editorial staff. The *Era*'s four-page journal brought readers fiction, poetry, news, and the city's first *Saturday Press* excerpts. In the

Era's office gathered Harte and Prentice Mulford, painter Albert Beirstadt as well as former Pfaffians Artemus Ward, Fitz Hugh Ludlow, Charles Henry Webb, Adah Issacs Menken, and the journal's columnist Adah Clare. During his first year-and-a-half with the *Era*, Harte wrote his column "Town and Table Talk" under the pseudonym "The Bohemian" and subsequently under the pen-name "Bohemian Feuilleton"—titles that more impecunious and rebellious writers considered pretentious.

In June 1864 Mark Twain came to San Francisco from Nevada mining camps searching for journalist work and hoping that his territorial mining stocks would make him independently wealthy. Twain's previous job for Virginia City's *Territorial Enterprise* had exposed him to a hard-living journalist crowd. "Going west," maintained one scholar, "brought him, accidentally, into the company of ... countercultural newspaper society out west in Nevada. A bunch of wild men improvising a whole new newspaper art form with tall tales, lies, and hoaxes, and great writing."[2] In San Francisco he boarded with bohemian reporters, entertainers, prospectors, and acrobats, while covering local events for the *Morning Call* and contributing articles to the *Golden Era*. Longing for more cultivated surroundings and seeing himself on the brink of prosperity, Twain attended the opera and made friends in respectable society. But when his stocks became valueless, Twain despaired and once, with a pistol to his head, contemplated suicide.

When Twain met Harte, his prospects brightened. Harte's "epigrammatic dandyism"—notably his bright-colored cravats—irritated Twain who contrasted his colleague in careless attire and a sarcastic drawl earning him the nickname "The Bohemian from the sage-brush." After Charles Henry Webb founded the cosmopolitan paper *Californian* in 1864, he and Harte lured Twain away from the *Era*. While working at the *Californian* Twain crafted a looser satirical writing style, which he later refined but never completely abandoned.[3]

Subsequently, Twain met the literary bohemians Ina Coolbrith, Charles Warren Stoddard, and Prentice Mulford. Unlike Harte, the salaried family man, both Coolbrith and Stoddard were haunted by troubled pasts. Coolbrith—born Josephine Donna Smith, the niece of martyred Mormon leader Joseph Smith—was married at seventeen and came to San Francisco a divorcée in 1862. She wrote dark and bitter melancholic poems under the pseudonym Ina Coolbrith—works considered by many scholars superior to those of her male bohemian counterparts. Years before, Stoddard had experienced a nervous collapse brought on by realizing his homosexuality and, for a time, sought refuge in Hawaii.

In 1864 Twain met Adah Isaacs Menken, who during the previous year had taken San Francisco by storm in her scandalous stage appearance in *Mazeppa*. The *Golden Era* published Menken's poetry, and she mingled with the paper's bohemian crowd. Though Twain found her "a finely formed

woman down to her knees," he little shared (at least in print) San Franciscans' excitement about her stage talent. Raised in a milieu of anti-Semitism and unaccustomed to such a voluptuary, Twain was shocked by Menken's open sexual* advances. Aspiring to wealth and respectability, Twain soon tired of San Francisco's bohemian community — its "dark histories, nervous break-downs, and other behavioral extremes." With the publication of his story "Jim Smiley and His Jumping Frog" in the *Saturday Press*, and its subsequent nationwide syndication, Twain left for New York in 1866, ending his twenty-one months in a city he castigated as having "a free, disorderly, grotesque society."[4]

The *Californian* met its demise in the summer of 1866; for the next several years Bret Harte wrote for numerous publications and saw his first poems and prose published. In 1868 he became editor of Anton Roman's newly established *Overland Monthly*. As contributors to the publication, Coolbrith, Stoddard, and Harte formed what became known as the "Golden Gate Trinity" or the "Overland Trinity."

Stoddard and Coolbrith's flaunting of a bohemian lifestyle put them in contact with many eccentric characters, such as Cincinnatus Hiner Miller, aka Joaquin Miller, "the Poet of the Sierras." Miller had left an Indiana farm, prospected for California gold, served up bad food, and written popular sentimental verse. Coolbrith introduced him to Swinburne and Rossetti's poetry, and before his leaving for England she suggested Hiner rename himself Joaquin and assisted in assembling his cowboy wardrobe — a ten-gallon hat and beaded moccasins — that he flaunted before English royalty while spinning tales of Western exploits.

Miller's charm was lost on Ambrose Bierce. A distinguished Civil War veteran and acerbic prose writer and critic, Bierce, along with Harte's circle, epitomized San Francisco's Western school of writing that helped Gilded Age America's conception of the Western experience. Bierce's writings about death later delighted H. L. Mencken, with its "hangings, autopsies, dissecting-rooms," as "a sort of low comedy — that act of squalid and ribrocking buffoonery."[5] While working as a night watchman in the 1870s and later as a San Francisco sub-treasury clerk, Bierce drew cartoons and turned to writing and the reading of Thackeray, Swift, and Balzac. He became the *New Letter and Commercial Advertiser*'s editor and in the column "Town Crier" satirized conformity to public opinion with Rabelaisian wit. Around 1870 he met Harte and submitted essays for the *Overland*.

Bierce's handsome military demeanor impressed his fellow San Franciscans, and his longing for respectability found him attending fashionable Nob Hill salons. Yet he also enjoyed the city's rough literary crowd and for a time roomed at the Russ House hotel and drank at its bar with gamblers, cattlemen, ranchers, and the later founder of San Francisco's famed 1880s Bohemian Club, James F. Bowman. Though he spent many years in San Francisco, Bierce openly

castigated the city "as the paradise of ignorance, anarchy, and general yellow-ness." He characterized a San Francisco bohemian as "a lazy, loaferish, glut-tonous, crapulent, dishonest duffer, who, according to the bent of his incapacity — the nature of the talents that heaven has liberally denied — scan-dalizes society, disgraces literature, debauches art, and is an irreclaimable, inex-pressible and incalculable nuisance." Following Miller's path, Bierce left for London in 1872 where he met Swinburne. Back in California three years later, he mined in the Black Hills. Over the next two decades "Bitter" Bierce, though he remained a spirited conversationalist, experienced a deepening self-torment over his lack of recognition.[6]

<p style="text-align:center">* * *</p>

But by the 1870s San Francisco's literary scene became mired in an innocu-ous gentility. Meanwhile, the city's visual artists flourished in the Monterey Peninsula — primarily landscape painters such as Scottish-born William Keith, whose works reflected the open-air techniques of the Barbizon School and impressionism as well as Whistler-influenced tonalism. "Many of these creative individuals," according to art historian Scott A. Shields, "cultivated an assid-uous bohemianism in dress, lifestyle and attitude, which they learned from friends or student days in Paris."[7]

Another artist, Paris-born bohemian painter Jules Tavernier, crossed the plains as a *Harper's Weekly* illustrator. Tavernier then settled in San Francisco where his paintings, reputed for their technique and quality, sold for substan-tial prices. In his studio Tavernier entertained locals, including Robert Louis Stevenson, and Oscar Wilde who visited in 1882. To escape city life and to paint seaside landscapes, Tavernier lived inexpensively in the quiet town of Monterey from 1875 to 1878.

Nearly depopulated by the Gold Rush, Monterey became a small com-munity of Italians, Chinese, Spanish-speaking residents, and bohemian painters. The Monterey Peninsula's foggy atmosphere, multi-colored twilight, cypress trees, and Spanish adobe architecture attracted Tavernier and others who broke with luminist painters like Albert Bierstadt, whose depictions of Yosemite had defined a Californian visual art aesthetic. French-born Jules Simoneau's Bohemian Club, a combination barbershop/tavern and "unofficial bohemian headquarters," displayed works that served as artists' payments to the proprietor.

But Monterey had lost its bohemian quaintness by the late 1870s when summer open-air painters dotted its seaside; in the following decade it became a tourist destination with the coming of the railroad and the building of a sump-tuous local resort. However, eminent painters like George Inness still came to the Peninsula, and bohemianism flourished for a time in San Francisco and nearby Carmel-by-the-Sea.

Lafcadio Hearn's New Orleans

As San Francisco beckoned with hopes of prosperity, writers and artists found in New Orleans' French Quarter a mixture of Spanish, French, and African culture. Among its Spanish-built stucco buildings with iron veranda facades, families of various color and ethnicity engendered a sonorous blend of language, music, religious customs, and cuisine, while popularizing in print the legends of ghosts and voodoo queens. One of the city's earlier literary visitors, Walt Whitman, wrote for the local *Crescent* in 1848, and Mark Twain made regular sojourns to the "Metropolis of the South." Several years later, novelist William Thackeray, experiencing springtime in New Orleans, commented that "it seemed the city of the world where you can eat and drink the most and suffer the least. At Bordeaux itself claret is not better to drink than at New Orleans."[8] After serving in the National Guard in the defense of Paris against the invading Prussian Army, thirty-eight-year-old impressionist painter Edgar Degas began a five-month stay in October 1872. Degas leisured in the city, attending horse races, wandering its streets of decaying architecture, and studying its people of color, whom he referred to as "walking silhouettes."*

During the last year of Reconstruction in 1877, writer Lafcadio Hearn discovered the French Quarter. Whereas the Degas family's economic status sheltered Edgar, Hearn came to the Crescent City unknown and nearly penniless. Son of an Irish-born surgeon serving in the British Army and a Greek mother, Patrick Hearn was born on the Ionian island of Leucadia. Soon after, Patrick's father, upon receiving a transfer of duty to the British West Indies, left the family behind in Greece. Taken to live with his father's Protestant Dublin family, Patrick, abandoned by his mother, was put under his great aunt's charge. In his aunt's library he read books about Greek gods and heroic men — tales that fed his imagination and a lifelong fascination with Greek culture. Sent to an Irish Jesuit boarding school, he rebelled against its teachings. After his great aunt experienced financial ruin, he spent time in decrepit London lodgings before coming to Cincinnati.

Unemployed in Cincinnati, "Paddy" Hearn met English-born printer Henry Watkin who hired the nineteen-year-old as a typesetter and later found him proofreading work. During these apprenticeship years of the early 1870s, Hearn slept in Watkin's office on a bed of paper shavings and earned from his employer the nickname "The Raven" for his Poesque sensibility. Watkin introduced Hearn to Fourierism, deism, and atheism and assisted him in attaining a journalist job. Hearn, living in Cincinnati boarding houses, frequented the African-American Bucktown district and, through his perceptive ear for dialect and ethnographical observation, documented in newspapers and private

*While visiting his mother's brother's family, the Mussons, Degas lived outside the French Quarter at his uncle's residence on Esplanade, where he painted family portraits. One of his most famous works completed during his New Orleans sojourn, The Cotton Office, depicts, among other family members, his uncle, Michel Musson, and his brothers René and Achille De Gas.

writings a culture rarely described in nineteenth-century writings. After a short-lived marriage with a black woman, he became in 1874 a journalist for the *Commercial*, imaginatively writing in macabre detail about Bucktown's crimes, local accidents, and executions.

After coming to New Orleans in 1877, Hearn spent ten years in the city translating works and documenting stories and songs of African-American Creole vendors, laborers, and dockworkers. Under literary romanticism's spell, he immersed himself in New Orleans' exotic vestiges of a colonial past and celebrated his Greek heritage by abandoning the sobriquet Paddy in favor of Lafcadio, in reference to the Ionian island of his birth. Because of his small stature, and milky, bulbous right eye (blinded during an altercation at boarding school), Hearn suffered from a neurotic shyness. A source of amusement to his friends, Hearn's raiment consisted of worn shoes, a wide-brimmed hat, and a short, heavy double-breasted jacket that he wore in all seasons. Hearn considered himself ugly and an outsider within his own Irish/Anglo heritage. In proto-Joycean vision he imagined New Orleans an Aegean Ionian port and himself an orphaned Ulyssesian wanderer. He lived comfortably among New Orleans' people of color who, he believed, treated him without prejudice or ridicule.

Hearn initially marveled at the Vieux Carré but soon encountered its darker side. Destitute, he slept on park benches around the French Market, and during the city's yellow fever outbreak, he contracted dengue and dwindled to ninety pounds. He recovered after a weeklong hospital stay and resumed his hand-to-mouth existence until 1878, when he became assistant editor for New Orleans' four-page publication, the *Item*. As the *Item's* book critic he reviewed Bret Harte's work and later, as a reporter, combed the city for stories of vice and murder. Hearn also translated the works of Victor Hugo, Gérard de Nerval, and Théophile Gautier. As a *Times-Democrat* journalist in the early 1880s, he translated other French romanticist writers and published Japanese writings. At this time he lived among the black Creoles and studied voodooism and Buddhism. Knowing that he was not a genius, Hearn directed his talent toward studying odd subjects to attract attention by utilizing them in new ways and, in his journalistic sketches "Fantastics," distanced himself from his world and the "Beings" of the eighteenth century.

Hearn left New Orleans in June 1887 for a two-year stay in the French West Indies before embarking for Japan. First studying Buddhism, he later immersed himself in Shinto teachings. Until his death in 1904, Hearn lived as a Japanese citizen, marrying the young daughter of a samurai family and attaining a professorship at Tokyo University. While traditional Western art sought divine beauty, Hearn found in the Japanese aesthetic "the simple joy of existence" — a philosophy freeing from the religious and cultural traditions of his Irish/Greek heritage. Hearn's writings introduced the West to Japanese culture, and he became, like Whistler, one of the earliest cultural rebels to look to Asia for spiritual and artistic inspiration.

Bohemian Clubs

1870s America produced few creative rebels of Hearn's bohemian reputation; yet, during the decade, popular journals and newspapers published stories about artists and their respective societies and clubs. Gilded Age artists cultivated images of themselves as unique professionals of the marketplace, while their studios were depicted in the major print media as a "theatrical showrooms," the combination of professional facilities and exotic workspaces.

At the same time, artists, sharing a need for a public life, attempted to make an iconoclastic phenomenon respectable. Since dealers in the 1870s and 1880s promoted European art over American works, art clubs were vital alternative outlets, and New York City's periodicals reported on clubs of bohemian pretense that fed the popular Gilded Age view of a French-imported counterculture. Part of the post–Civil War vogue of establishing professional societies and associations, these artist and writers' clubs attracted full-time professionals— some well established in their careers— who, assuming the roles of unconventional artists, taunted middle-class values.

Founded in 1871 by young artists, the Salmagundi Club (later to be named the Salmagundi Sketch Club) met at Jonathan Scott Hartley's Broadway studio. Given a weekly topic to sketch, the artists met each Saturday to exhibit their work. In bohemian fashion, they then drank, smoked, told stories, boxed, and fenced — rituals that were featured in an illustrated *Scribner's Monthly* article. Of the city's artists' clubs to attract more press attention, the Tile Club, founded in the fall of 1877, brought together painters, illustrators, and writers. Inspired by the "decorative frenzy" set into vogue by Philadelphia's 1876 Centennial Exposition, the Tile Club met every Wednesday at members' studios to paint designs on eight-inch-square ceramic tiles and take part in light-hearted high jinks. Influenced by William Morris' arts and crafts movement, the painting of tiles was a pervasive trend among Gilded Age middle-and upper-class women. As one of the Tile Club's historians noted, they appropriated "without remorse from the these ladies their colors, their chain plaques ... and using mighty brushes heretofore dedicated to more sublime tasks, they began experimenting on potsherds and Spanish tiles."[9]

Tile Club founders were English-born painter Walter Paris, architect Edward Wimbridge, illustrators like Edwin Austin Abbey, the painter Winslow Homer, two land and sea painters, a sculptor, and several newspaper writers. After their first unsuccessful Wednesday evening of painting tiles at Paris' studio at Union Square, the Tilers, none of whom had any previous experience painting tiles, subsequently developed various techniques through trial and error that lent themselves to the fine finishes and colors.

Tile Club evenings began with the painting of tiles; members then consumed crackers and beer, conversed, and told stories— banter sometimes accompanied by a visiting singer or violinist, and guests included theosophy's

high priestess, Madame Helena Petrovna Blavatsky. Tile Club rules required that its membership be limited to twelve and that each new member be selected by unanimous vote. Openings for new members occurred only upon a Tile-man's death, resignation, or expatriation. Eventually, each member received a nickname — Homer became "The Obtuse Bard" and Abbey, "Chestnut."

Among the club's first meeting spots was Napoléon Sarony's Union Square studio. One of America's most commercially successful photographers, Sarony and his wife decorated the studio exotically. A mummy stood at the entrance, and the inside walls displayed a Russian sleigh, Egyptian and Japanese relics, and assorted bric-a-brac and armor; from the ceiling hung a stuffed crocodile.

Upon Paris and Wimbridge's departures in 1878, painter William Merritt Chase joined the Tile Club. That summer Chase and fellow Tilers embarked on the first of their outdoor painting excursions to the shores of Long Island, a trip documented in an 1879 *Scribner's Monthly* article. This ongoing series of Tile Club pieces, written by its members, was filled with cryptic phrases and jokes and exaggerated events that gave the impression of a exclusive circle while courting a popular audience. In the summer of 1879 they took a three-week barge trip aboard the *John C. Earle* to Lake Champlain. In their converted boat studiodecked with tapestries, paintings, Japanese lanterns, and potted plants, they sketched the passing countryside, eating meals served by Chase's African-American servant. The barge trip, recounted in *Scribner's* (1880), was followed by *Harper's Weekly* and *The Century Magazine* articles covering the Tilers' Long Island trips of 1880 and 1882.

In the early 1880s working with tile gave way to conventional painting. Popular articles followed the Tilers activities, earning them international renown when the French publication *L'Art* featured their work (September 1881). Coming upon the *L'Art's* article and a deluxe *Harper's Christmas* edition of 1881 featuring the Tilers, Vincent Van Gogh, whose view of Americans was less than friendly, pronounced their work to be a "a lily or a snowdrop between the thorns."[10] In the 1880s architect Stanford "Stanny" White joined the club's twelve-man membership, as did sculptor Augustus Saint-Gaudens, painters Elihu Vedder and John Twatchman, and journalist Frank (Francis D.) Millet. Beginning in 1882, the club for the next five years established permanent quarters at Edwin Austin Abbey's rented house behind a brick residence on Tenth Street. The club's new headquarters and clubroom, occupying a first-floor parlor decorated by White, had two tiled fireplaces and redwood paneling, where the Tilers' dinners of oysters, roasted duck, Welsh rabbit, beefsteaks, and skewered meats were served by an African-American waiter. Yet by 1887 the Tile Club fell into obscurity.

More legendary in that it survived the Gilded Age to become a twentieth-century millionaire's club, San Francisco's Bohemian Club first convened at James Bowman's home. A San Francisco *Chronicle* editorial writer, Bowman and his wife hosted noon Sunday breakfasts, where journalists and artists decorated

Mrs. Bowman's linen. When uninvited guests began participating in the prac-
tice, Mr. Bowman joined journalists and several artists in founding the
Bohemian Club in 1872, quartered temporarily in the Astor Hotel at Sacra-
mento and Webb Streets. This gathering, its early annals stressed, was intended
to promote "social and intellectual discourse between journalists and other
writers, artists, actors and musicians, professional or amateur," and connois-
seurs of the fine arts and literature. With chairs in short supply at the Astor,
most stood drinking whiskey and wine; humorous pranks were played and
sentimental recitations heard. Five years after its founding, the club moved,
along with its pet owl Dick, to more respectable quarters on Pine Street.[11]

But complaints soon came from those who did not want to economically
support the club's more impecunious bohemians, and its board of directors
subsequently moved to invite moneyed individuals, those not affiliated or inter-
ested in the arts. By 1880 a contingent of writers and painters protested the
departure of the bohemain spirit, that commercialism inspired a new mem-
bership more interesed in manners and morals than art. The club then pur-
chased land at Duncan Mills on the Russian River, the famed Bohemian Grove,
where its summer excursions created interplay between outdoor life and ele-
gant. Honorary membership was extended to Henry George, Bret Harte, and
Mark Twain; an elite of bankers, tuxedoed millionaires, and naval officers
brought with them sumptuous dinners and set rules of conduct.

Stirrings Across the Sea

Clubby bohemian pretense compared little in terms of countercultural
influence with that of English aestheticism. Like most art movements, aestheti-
cism existed more as an attitude than as a coherent set of principles. It held
sacred the notion of the individual's expression of aesthetic truth — that art
should remain the sole province of the creative genius and, like life, should
reveal the beautiful even in ordinary objects. English aestheticism found inspi-
ration in Japanese prints, watercolors, and fine white and blue china. Walter
Pater urged that painting aspire to music, and Whistler — using musical nomen-
clature in his work's titles — reevaluated the purpose and methods of the visual
arts.

Aestheticism — dominated in England and America by John Ruskin and
William Morris' idealism — was embraced by serious artists and amateur dec-
orators and even attracted the Prince of Wales' attention. Some of its adher-
ents looked to Poe and late romantic writers such as Gautier and Baudelaire.
Guiding this more radical aestheticism was the art-for-art's-sake credo advo-
cated by James McNeill Whistler, Algernon Charles Swinburne, and Walter
Pater; as exemplified by Aubrey Beardsley and Oscar Wilde, it overlapped with
the 1890s decadents with their emphasis on unconventional human sexuality.
But England's aesthetic movement by and large placed little emphasis on

Baudelaire's dark consciousness, and French decadence's corrupting influence was given a healthier guise.

Aestheticism's dominant voice, John Ruskin — English critic and Oxford professor — had, since the publication of his influential *Modern Painters* (the first volume was published in 1843), reigned for decades as the country's ultimate art and architectural authority.* By virtue of his writings and popular lectures, Ruskin assumed the role of arbiter of English art and society. In his "truth to nature" aesthetic, Ruskin espoused a Wordsworthian-inspired ethos that inextricably bound art, morality, and nature. He first defended painter J. M. W. Turner, and then championed the artists of the Pre–Raphaelite Brotherhood, formed in 1848. He believed that mechanization's division of labor had subverted the worker's creative processes and urged a return to handmade goods. Ruskin's influence extended to younger aesthetes such as William Morris and Edward Burne-Jones— Oxford graduates who aimed at placing the decorative arts on the same footing with painting, sculpture, and architecture.

One of aestheticism's central influences, though claiming to have no ties to the movement, Whistler, deeply influenced by Japanese art, inspired in late nineteenth-century England a sensibility that freed painting of didacticism and moral purpose. Whistler expatriated himself to England during the late 1850s. His painterly experiments and dandified manner, his quick temper and acerbic wit — satirized and caricatured in the mid–1870s English press— won him admiration in many circles. Whistler's presence at the Royal Academy and at small private galleries soon appeared, according to Ruskin, as deleterious to England's artistic and moral development.

After visiting the Grosvenor Gallery in 1877 where he viewed Whistler's *Nocturne in Black and Gold: The Falling Rocket*, Ruskin condemned the painting as unfinished and offered, in *Fors Clavigera*,† a scathing review. "I have seen, and heard," he groused, "much of cockney impudence before now; but never expected to hear a coxcomb ask two hundred guineas for flinging a pot of paint in the public's face." Quick to rebuke his scoffers, Whistler voiced a generation's frustration over Ruskin's moral dominance and disparaging of new artistic trends. In 1877 Whistler threatened Ruskin with a libel suit. More than a contest over the damage to Whistler's career, the trial pitted "art-for-art's-sake" against Ruskin's "truth in nature." Ruskin's commitment to nature, Gothic art, and early Italian Renaissance painters contradicted the American-born painter, who championed current artistic innovations and self-expression, rather than evoking or attempting to recreate past conventions. By looking to the flat surfaces of Japanese masters (e.g., Hokusai), lacking academic

*Though his work first reached only handful of American readers, including Hawthorne and Emerson, by 1855 Ruskin's influence found a broader audience in the United States.

†Three years before the Grosvenor Gallery opening, Ruskin, during one of his Oxford lectures, described Whistler's impressionist-like work as "absolute rubbish."

linear perspective, Whistler developed new methods and expanded his artistic vision, opposing, as did Ruskin and the Pre–Raphaelites, the resurrection of past themes and styles. As the plaintiff he legally battled Ruskin in hope of destroying the influence of art critics, his most despised enemy. Testifying before a jury of laymen, Whistler asserted that a painter's work needed no explanation, that it be freed of allegory, story line, and poetic themes.[12]

Too sick to attend the trial, Ruskin lost the case to Whistler. Awarded one farthing and left bankrupt by legal fees, Whistler visited Venice and returned to England in 1880, setting up a studio at 13 Tite Street. There he presided over noon Sunday breakfasts. At these affairs guests waited until his appearance, when they were served an American menu of buckwheat cakes, green corn, eggs, bacon, biscuits, and generous amounts of coffee. Once in Whistler's company, guests were rarely disappointed as their host held forth on aesthetic principles.

By the early 1880s a young Irish neighbor, Oscar Wilde, acclaimed Trinity College and Oxford graduate, turned up at Whistler's breakfast table. At first distant toward this newcomer, Whistler slowly accepted the eccentrically dressed poet into his English circle and spent hours conversing with him at his studio. Together at London dinner parties and public events, Whistler and the Irish poet — velveteen jacketed and in knee breeches and buckles—further popularized the dandy cult. A likeable and compelling speaker, Wilde reveled, during his short-lived friendship with the American painter, in the role of aestheticism's (and in many ways Whistler's) publicist. In 1880 George Du Maurier caricatured Wilde in *Punch* as the aesthetic poet Jellaby Postlethwaite. Debuted in April of the following year, Gilbert and Sullivan's theatrical parody of aestheticism, *Patience*, featured the Wildean character Bunthorne.

Following *Patience*'s London success, promoter Richard D'Oyly Carte persuaded Wilde to tour America. Wilde arrived in the United States on January 2, 1882, and at customs stated that he had nothing to declare but his genius. After a week of luncheons and evening receptions, Wilde debuted at New York City's Chickering Hall, taking the stage in a dark purple sack coat, knee breeches, and black stockings—with penciled eyebrows and rouged cheeks. His lecture, "The English Renaissance," was a discourse on the influences of Whistler, Pater, the Pre–Raphaelites, and sunflower mysticism.

On January 18 Wilde visited Walt Whitman's Camden, New Jersey, home. No admirer of aestheticism, Whitman nonetheless welcomed his Irish guest, and over several hours of conversation they finished a bottle of homemade elderberry wine before retiring to an unkempt second-floor room that overlooked the Delaware River and "angular Camden roofs." The elder's poetry was discussed, and Whitman patiently listened to Wilde's comments on aestheticism, Swinburne, and Rossetti, before derisively remarking, "Why, Oscar, it always seemed to me that the fellow who makes a dead set at beauty by itself is in a bad way. My idea is that beauty is a result, not an abstraction." Wilde

respectfully listened and, before departing, downed a glass of milk punch offered by his guest. Whitman then gave Wilde a photograph of himself and another intended for the Irishman's friend Swinburne.[13]

Wilde lectured in Boston, Rochester, and New Haven, and then after stops in Chicago, headed to Nebraska and reached California in late March. In San Francisco—a city he described as "Italy without its art"—he spoke at Platt's Hall and encountered Bohemian Club members who, intending to drink the poet under the table, invited him to dinner and, instead, became victims of their own scheme. In western mining towns Wilde spoke dressed in corduroy and a sombrero. He then crisscrossed the country eastward* and even made appearances in northeastern Canada. During his extended, tour he paid a second visit in May 1882 to Whitman's Camden home, wearing cowboy attire; and in December, a few days before leaving America attended a Tile Club party held in his honor.

Periodicals and newspaper illustrations variously depicted Wilde as a rugged man of the people or an effete dandy or vituperatively mocked him as an aesthetic tramp or a simian regressive in the Darwinian evolutionary chain. San Francisco's Ambrose Bierce dismissed Wilde as a "dunghill he-hen," an "intellectual jellyfish" whose verbal "crass vapidities" were "blown through the bowels of his neck." Despite his detractors and hecklers, Wilde did have his followers, participants of same-sex New York Stock exchange balls, throngs of street boys, and admiring male impersonators. Wilde's flaunting of the effete helped legitimize a gay aesthetic and gave thousands of homosexual American men the assurance that they were not alone in pursuing an ignored and largely condemned lifestyle.[14]

American Aesthetes

Wilde's American tour brought into question traditional gender roles and intensified Gilded Age aestheticism at a time when its only traces were to be found in the flowing women's gowns, decorative tiles, Morris wallpaper, and Japanese screens. As it emerged in 1870s America, aestheticism took on Ruskin's moral dimension and looked to Morris and Pre-Raphaelite paintings. After Morris' building of the Red House in 1859, an arts and crafts movement swept England as a major aspect of aestheticism. Under Morris' guidance, the movement challenged industrialism's rise and urged a return to handmade items. In a reversal of the High Renaissance's elevation of the artist from the role of craftsman, English aestheticism equated the craftsman with painters and sculptors.

English exhibits at the 1876 Philadelphia Centennial Exposition inspired

*By March 1882, Wilde compiled two more lecture subjects: "The House Beautiful" and "The Decorative Arts," inspired by Ruskin and Morris.

a unique American aestheticism dominated by middle-and upper-class women. These moral aesthetes upheld beauty's cult, substituted art for traditional Christianity — imbuing it with a spiritual uplift leading to salvation — and saw in everyday objects and decor the means to enrich the human experience. For the most part, middle-and upper-class women of a Ruskin-inspired morality eschewed Whistler and Wilde's art-for-art's-sake credo and decadent cultural hedonism, while eclectically culling aesthetic designs from *Puck* and *Peterson's*, as well as from Asian, Ottoman, and North African art.

Like their English counterparts, female American admirers of the Pre–Raphaelite Brotherhood's medieval and early Renaissance-influenced paintings* were drawn to the depictions of enchanted longhaired women in loose-flowing gowns, medieval-style garments that inspired aesthetic gowns. In private they offered women an alternative to the physically oppressive corseted dress. In an era rigidly defining the separation of public and private behavior, aesthetic gowns gained a notorious reputation, particularly when worn by prostitutes, which led to local ordinances prohibiting them from being worn publicly.

Aestheticism helped transform cluttered antebellum sitting rooms into aesthetic parlors. Entering these exotic spaces, unlaced women, their hair loose, crossed through rope-tasseled doorways into rooms filled with Japanese folding screens, vases, jars, and pillows intermingled with draped cloth; floors were carpeted in patterned designs and easels stacked with paintings. Incense was burned, and, in some instances, hashish and opium were smoked in decorative pipes.

More than just a fashion source, aestheticism empowered women to become serious artists, equal participants within the male-dominated fine art world. Guided by Morris' arts and crafts movement, aesthetic women elevated the decorative arts— embroidery, tapestry, pottery, silverware and wallpaper design — as spiritually uplifting objects of beauty creatively on par with painting and sculpture.

Most prominent among aesthetic women artists, Candace Thurber Wheeler, a New York-born painter and textile designer, took her inspiration from Wilde and the arts and crafts movement. During her career, she invented a new weaving process and as an amateur painter studied the landscapes of Frederic Edwin Church and Albert Bierstadt. At the 1876 Philadelphia Centennial Exposition she viewed the expert needlework of unemployed English women and decided to transform this handicraft into a means of cultural reform. In 1877 she founded the New York Society of Decorative Art (based on London's Kensington School) and formed a network for women needleworkers

The Pre-Raphaelites, championed by Ruskin, included the brilliant poet/painter Dante Gabriel Rossetti and opposed what they perceived as the staid products of academic art. Instead of the meticulous copying of late Renaissance masters, the Pre-Raphaelites turned to nature as their model for paintings depicting mystical properties of beauty. Americans first viewed original Pre-Raphaelite works at an 1857 New York City exhibit.

in cities across the country. A year later she founded the *Art Interchange*, an art journal that sought to educate and expand her society's membership.

Wheeler's award-winning textiles and wallpaper designs attracted Louis Comfort Tiffany's attention, whose decorating firm, Associated Artists, she joined in 1879. Taking the name Associated Artists for her own firm in 1883, Wheeler established a New York City textile-manufacturing company, employing women workers, and invented a patented weaving process, affecting the look of oil painting on tapestry. Her firm's late 1880s original interior designs and wallpaper enhanced her career as educator, writer, and speaker. She built a Catskill Mountain retreat, Pennyroyal, near Tannerville, New York. Similar to Morris' Red House, she regarded Pennyroyal, with its hand-painted friezes and door panels, as a total work of art.

Reflecting a moral Ruskinian sensibility, she asserted that life be guided by art, tamed of the vulgar and spiritually inspired. Her manufacturing employment opportunities offered women a profession outside the home; yet Wheeler did not subscribe to the Ruskinian notion that the industrial process (e.g., machine looms) threatened America's moral fabric. Commissioned by the wealthy, from Conelius Vanderbilt II to Mark Twain, she hoped that her designs, publications, and lectures would spark a revolution, making women integral designers of their own living spaces. Just as the Pre-Raphaelites and William Morris looked to medieval motifs and symbols, Wheeler incorporated Native American quillwork and female images into her designs and urged that maize be the national symbol.

By the 1890s Wheeler's Society of the Decorative Arts faltered, and the Associated Artists later went bankrupt. These failures coincided with aestheticism's decline, occurring when a new activism celebrated sports-oriented physical fitness and outdoor activities. Among upper-and middle-class American males, the 1890s new activism instilled the need to remasculinize their culture, as exemplified in Theodore Roosevelt's youthful exploits as a Harvard pugilist and western rancher. The new activism, popularized by the image of the bicycle-riding and tennis-playing Gibson Girl, had a popular-culture opposite, a fictional female bohemian who won the hearts of readers nationwide.

The Trilby Craze

The Gay '90s—the era of lavish banquets, bicycle riding, and Chicago's Columbian Exposition — was, for many Americans, a period of unprecedented growth. Rapid urban and industrial expansion produced transformations within Great Lakes farmlands, Midwestern plains, and the rural South — areas that grew increasingly dependent on the railroads and global markets. At this time, cities drew more young people from the hinterlands and immigrants from regions of southern and eastern Europe—countries traditionally viewed by Anglo-Saxon America as backward and possessing people of inferior stock.

A panic on Wall Street in 1893 caused an economic depression, the second worst in the nation's history, a catastrophic event that pitted labor against management and turned farmers against railroads and the banks. But as in other strife-torn decades, Americans sought diversion. They attended local theaters or read romantic Victorian novels, Horatio Alger stories of self–made men, and William Dean Howells' realist fiction, which linked America's rural past with the industrial future — works that pointed to moral purpose, personal integrity, or love's conquest.

During this era of economic turmoil, an 1893 *Harper's New Monthly* travel piece informed readers about Paris and its "flocks of poets" — wearers "of long hair and flowing cravats, and general singularity of dress." It described the Rue Mouffetard, Hemingway's "wonderful crowded market street," and the city's "great colonies of bohemians, déclassés, people who have missed fortune's coach, and who are tired of life."[15]

Howells' 1893 novel, *Coast of Bohemia* (first serialized in the *Ladies Home Journal*) presciently pointed to a bohemian revival; it described a matronly woman's outdated parlor, a leftover of the aesthetic movement's penchant for excessive, exotic ornamentation, and briefly touched upon bohemia, for which, since his meeting Pfaff's clientele, he had nothing but disdain. Despite its title, the novel is not really about bohemians. Yet, one of its characters Charmain, an art student, imitates in her stepmother's New York City flat a bohemian mansard attic by installing painted canvas panels angled toward the ceiling, decorated by a tiger skin, wall hangings, Chinese bronze vases, foils, and a suit of Japanese armor. Defying her mother's maids' efforts to straighten her room, Charmain keeps her studio in fashionable disarray, littering it with pillows and leaving cigars on the bureau.

Whereas Howells' novel mentioned bohemia in passing, George du Maurier's immensely successful *Trilby* (1894) helped promote a bohemian revival. A former *Punch* magazine caricaturist and illustrator famed for satirizing English aestheticism, Du Maurier turned to writing novels. His *Trilby*, serialized in *Harper's New Monthly*, presented readers in text and illustrations with a sentimentalized 1850s Parisian bohemia. Not since Murger's *Scènes de la Vie de Bohème* did a novel attract such a sizeable bohemian cult following. *Trilby's* bohemians — modeled after Du Maurier's fellow English artists and Whistler, who studied at Charles Gleyre's Parisian atelier — included the novel's English trio of inseparable comrades — the Scotch Laird of Cockpen, Taffy, and William Bagot, aka Little Billee. The youngest of the trio, Little Billee, though brought-up in the upper class, scorns "the bloated artistocracy," and all the titles of European lords and baronettes.[16]

These bohemians befriend an attractive artist's model, Trilby O'Farrell, whose bewitching display of her naked foot entices the trio. Typical of popular Victorian novels, sexual activity and vice are not depicted; yet Du Maurier tempted readers with a nonreligious Trilby given to being disrobed and

mixing freely in male company, "naked and unashamed ... an absolute savage."[17] Trilby reads Dickens, Thackeray, and Sir Walter Scott and speaks Latin Quarter slang. Svengali, a musically talented Viennese Jew, casts a spell on Trilby, giving her a singing voice that makes her a stage celebrity. Eventually freed of Svengali, she falls ill and dies; soon afterward, a sickly and broken-hearted Billee meets a similar fate.

Unlike Murger's victims, who died alone in public hospitals and had their bodies spirited to the morgue, Du Maurier's bohemians expire in the company of weeping friends at their bedside. Thus, *Trilby* found acceptance in genteel homes where Murger remained unknown and Zola's *Nana* and Crane's *Maggie* were forbidden. The nationwide Trilby craze inspired a marketing frenzy. A Chicago manufacturing firm made Trilby shoes; a New York caterer marketed Trilby ice cream. Youths ate Trilby chocolates and wore Trilby hats and coats. Gentlemen of means made Trilby cocktails and named their yachts *Trilby*. In Florida a railroad magnate, Henry B. Plant, re-christened a small depot town Trilby, and a Columbus, Ohio, suburb also took the name. A stage adaptation of the novel toured nationally, and parodies *Billtry* and *Drilby* were followed by a Broadway burlesque operetta, *Thrillby*. Youthful vernacular gained "Trilbies" as a word for feet, and young girls purchased Trilby slippers and cultivated Trilbyesque beauty.

Out of the Trilby craze also came the idea of the bachelor girl, bohemia's "less poetic, slightly less intense cousin." Bachelor girls, or b-girls, reflected the increasing female presence in the nation's workforce. Middle-class bachelor girls took part in a seemingly daring trend, yet one without bohemia's inherent hardships or sometime fatal consequences. Apartment-dwelling bachelor girls lived simply by red candlelight, smoked, and ate with their hands. One bachelor girl remarked, "Probably the thing that first appeals to us is our absolute freedom, the ability to plan our time as we will ... bound by no restrictions, except those imposed upon us by a due regard for proprieties." The bachelor "American girls," explained Albert Parry, "wanted to be Trilbies without undressing; they wanted to be Bohemians and yet remain virgins." The subject of several articles and stories in *Scribner's* and *Munsey's*, bachelor girls, in life as in fiction, typically ended their youthful freedom, as did the Latin Quarter grisettes, in marriage.[18]

Bohemian Demimondes

If measured by *Coast of Bohemia* or *Trilby*, 1890s American bohemia seemed an exclusively upper-middle-class youthful impulse — harmless, easily mocked, and without creative substance. One of *Coast of Bohemia*'s characters, well-traveled and acquainted with Parisian culture, intoned: "We Americans are too innocent in our traditions and experiences; our bohemia is a nonalcoholic, unfermented condition ... no better, nor worse, than a kind of Arcadia."

Despite this pronouncement, Gilded Age America did produce a demimonde bohemia not depicted in popular writings—one that included bohemian journalists, art students, and criminals. New York City's poverty-ridden Lower East Side and the Bowery became home to ethnic bohemians and the haunts for others in search of exciting demimonde activity, providing the subject matter of sociological studies, newspaper stories, and novels.[19]

The Lower East Side—"its languages and costumes of the old world, the noncomformity, tolerance, and a sense of the past with an awareness of literature that had hardly reached America"—fascinated Philadelphia-born James Gibbons Huneker, Gilded Age America's leading music and art critic. In the 1870s, having read *Scènes de la Vie Bohème*, Huneker experienced actual Parisian bohemian poverty.* While in the City of Light he encountered writers Victor Hugo, Émile Zola, and Gustave Flaubert, met impressionist painters Manet and Degas, and found the artwork of the 1879 Paris Exposition superior to that displayed at the Philadelphia Centennial Exposition. In 1888 Huneker moved from Philadelphia to New York City and, in preference to the tastes of Manhattan's upper classes, visited Eastside ethnic enclaves to hear various languages and to eat French and German food. He kept company with a journalist crowd at Mould's café, including the poet and absinthe drinker Francis Saltus, the half-brother of Edgar Saltus, whom he described as "a perfect bohemian ... a poet, pagan, therefore immoral." Years later Huneker recalled his friend's café schedule: "He usually arrived at noon and wrote and talked till the last trump, which was two A.M.; sometimes later. The classic type of bohemianism that has quite vanished."[20]

On the Lower Eastside, Huneker met Jewish bohemian painters, writers, poets, Yiddish theater members, and socialist intellectuals, who gathered on East Broadway, Canal, Grand, and Rivington Streets. In Jewish bohemian literary societies and discussion groups talk of Zola and Walt Whitman flourished. Huneker's close association with Jewish writers and artists proved rare among the era's gentile cultural rebels. Portrayed in many novels as insidious moneylenders living beyond bohemia's pale, Jews did form European and American bohemian enclaves.† "Some Jews," noted Christine Stansell, "brought Europe's

Huneker abandoned a law profession for art and music. Dressed as a young dandy, he marveled at the French exhibit "Paris by Night" at Philadelphia's 1876 Centennial Exposition. Recently married and hoping to further his pianistic training, he left with his wife for Paris in September 1878. Having read Scènes de le Vie de Bohème, Huneker naïvely prepared himself for Murger's 1840s Paris scene by dressing in a loose-collared velveteen coat, flaring necktie, baggy breeches, and Scotch cap. After nine months in Paris, Huneker returned to Philadelphia and continued his self-education by reading the latest publications dealing with European culture, and writing for various periodicals including the music publication Étude. He attended Wilde's 1882 lecture at Philadelphia's Horticultural Hall. Six years later he left Philadelphia for New York City.

†*Writers like Murger and Du Maurier had portrayed Jews with extreme prejudice. In* Scènes de la Vie de Bohème, *Murger included a Jewish merchant, Solomon, nicknamed derisively by the Parisian artist community as "Medicis," and Du Maurier's Svengali was Trilby's sinister captor.*

idea of bohemianism with them from stopovers in Paris and London; others transported the closely related boulevardier sensibility from sojourns in Petersburg and Moscow."[21]

Most legendary of New York City's Jewish bohemia, Naphtali Herz Imber came to the city in 1891 after years of traveling to the Holy Land and Europe. Author of the Zionist national anthem "Hatikvah," Imber lived in the city's Lower East Side but traveled extensively in America, visiting San Francisco, Denver, and Phoenix. In the early 1890s he lived briefly in Boston and Indianapolis before returning to New York. Although a Zionist, he believed himself a "rolling stone" and a citizen of the world. Imber studied Kabbalah's mystical teachings and, along with trying his hand at poetry, wrote on a wide range of topics, often with pseudoscientific insight and mystical observation. Eccentric in habit and aware of his homeliness and lack of concern for fashion, Imber explained that being bound to a writing desk prevented him from being "a dude" or "a street stroller." Admittedly careless and plagued by "mind absence," he struggled while hunting "for new ideas and thoughts." A habitual drinker, which reputedly led to his death in 1909, Imber once observed, "The poets and writers may be gamblers and drunkards, if only they produce good work."[22]

Journalist bohemians, like Whitman before them, also combed the Lower East side for unusual sights and good copy. In his study of New York City tenement life, *How the Other Half Lives* (1890), Danish-born journalist and crime reporter Jacob Riis noted the influx of men who crowded into the Bowery. "Nearly all are young men," concluded Riis, "unsettled in life, many — most of them, perhaps—fresh from good homes.... They have come in search of crowds, of 'life,' and they gravitate naturally to the Bowery." With little money, these inexperienced urban newcomers shared ten-cent rooms with alcoholic down-and-outers and criminals.[23]

Riis recorded Bowery squalor, thievery, infant death, and the "reign of rum," but not its sexual vices as exposed by other Gilded Age reform-minded reporters. Along with prostitution and crime, the 1890s Bowery was a haven for homosexuals, and Whitman, fond of young men, recalled that the 1840s Bowery offered "the dearest amusements."[24] The Bowery attracted straight, middle-class slummers and homosexuals who consorted in working-class establishments. In Bowery establishments straight and gay men coexisted in a subculture of clubs, or "resorts," and renowned saloons, known by some neighborhood residents as "fairy places."

The Bowery enticed young journalist Stephen Crane. The son of devout Methodist parents, a twice-failed college student from New Jersey, during the early 1840s Crane roomed at an apartment building between the Bowery and the East River. Like many bohemian types, Crane, though proud of his upper-class lineage, spurned social pretensions and his family's religiousness. Simply dressed, Crane had a lean, thin face and an untamed shock of blondish hair, and a cigarette rested perpetually on his lower lip.

With youthful indifference to making money, Crane as a street journalist worked in a largely anti–bourgeois profession inclined to bohemianism. Far from the quiet of his boyhood New Jersey seaside, Crane took in the city's din, and like Whitman before him, discovered the Bowery. Accompanied by an Irish beer-wagon driver, Mike Flanagan, Crane's Bowery forays yielded a world of toughs, prostitutes, and the B'hoys' dandy descendents—models for his first novel, *Maggie: A Girl of the Streets* (1893). In this naturalist work that broke with Howells' realism, Crane portrayed Maggie, a factory working girl living in Bowery squalor, whose poverty and path to prostitution were a tragic fate in a godless universe. Maggie's young brother, Jimmie, a hard-knuckled Bowery rebel, thought he and his street friends superior to men in "fine raiment," in the belief that "all good coats covered faint hearts."[25]

In the fall of 1893, Crane moved into a studio apartment in the Needham Building of the Art Students League. Crane's art student fellow lodgers rowdily participated in apartment floor soap slides and courteously addressed an adopted anatomy skeleton as "Mr. Jolton Bones." Living simply, Crane knew few pleasures. After surviving weekdays eating delicatessen potato salad, he found respite on Saturday evenings at an inexpensive Sixth Avenue cook shop, the Boeuf-a-la-mode, which his fellow artists—his "Indians"—re-christened "The Buffalo Mud." Under flickering gaslights, Crane's bohemians smoked, argued, and sang to the beating of spoons on tables. Back at the Needham Building, Crane fought to stay warm, and despite inconveniences, he looked back on the edifice as having "all that was real in the Bohemian quality of New York."[26]

Experiencing urban poverty reinforced Crane's Zola-influenced naturalism; like Theodore Dreiser and Frank Norris, Crane wrote about humanity's hopeless struggle in a godless universe. Soon after *Maggie's* publication, Crane, now a famed novelist and war correspondent, fondly recollected the faded letters on a wooden beam in the Needham Building—Emerson's aesthetic dictum: "Congratulate yourselves if you have done something strange/and extravagant and broken the monotony of a decorous age."

Symbolists and Decadents

While realism dominated late nineteenth-century literary America, Europe experienced new avant-garde movements—impressionism and then symbolism. Originally a French literary movement rooted in Baudelaire and the romantic French writers, symbolism, by century's end, encompassed art, theater, and music, entering the twentieth century as an international phenomenon. Counter to Courbet and Zola's realism in portraying everyday life, symbolism, following romanticism's strain of mystery, plumbed inner consciousness, seeking to regain the spiritual. Symbolists stressed that language, as a system of symbols independent of experience, could not concretely

portray the outside world; thus, in their experimental word arrangements opposing literary norms, negation and reduction in fact became constructive.

For French symbolism's "high priest," poet Stéphane Mallarmé, words were potentialities of experience, and poetry's multiple meanings could, through one's own interpretation and interaction, tap into the unconscious — spirit's realm. Mallarmé befriended other talents such as Paul Verlaine, the bohemian "Prince of poets." Since poet Jean Moréas' 1886 manifesto, symbolism had been discussed in French publications, but it was not until 1899 that poet and writer Arthur Symons' *The Symbolist Movement in Literature* provided a comprehensive English survey defining its tendencies. To Symons, realism and scientific positivism had run their course as viable ways of seeing the world, and writers and artists were turning inward. This prompted Symons to state that after "the contemplation and the re-arrangement of material things, comes the turn of the soul."[27]

Largely unknown in 1890s America, symbolism did not escape American influence, notably that of Poe and Whistler. Difficult to categorize, Whistler's works have been associated with aestheticism, symbolism, and tonalism — a term later used to describe paintings and photographs that exhibited the closest approximation of symbolist art in America. Distanced from impressionism, tonalism, like symbolism, concentrated on the inward experience. Those linked with tonalism's anti-realist and anti-scientific aesthetic — Whistler, Albert Pinkham Ryder, George Inness, and Tile Club member John Twatchman — utilized limited colors and dominant tones in their landscapes, exploring the atmospheric conditions of spiritual harmony. Compared to leading European art of the time, American tonalism seemed in many ways as a subdued version of symbolism.

Having abandoned realism in 1865, Whistler, through his Japanese-influenced art, provoked the critics' wrath, and he responded by publishing *The Gentle Art of Making Enemies* (1890), a compilation of essays, letters, and commentaries. This classic work included the famous "Ten O'Clock" lecture, the 1885 manifesto credited by Robert Crunden "as the first official statement of modernist attitudes by an American."[28] The "Ten O'Clock," condemning Ruskin's moralistic aestheticism and his "truth to nature," denied the existence of an artistic age when art had reigned above all other human endeavors, and argued that artists, as observers, have always been perpetual outsiders. It asserted the artist's superiority to nature in that the creator could rearrange its images, and manipulate and capture unseen rhythms, atmospheric moods, and crepuscular shadows. "Nature contains the elements, in colour and form, of all pictures," Whistler insisted, "as the keyboard contains the notes of all music"; thus, the artist is the final arbiter and judge in the arrangement of color and form. Critics, his mortal enemies, he derided as "middle men" intent on examining art through the lenses of Ruskinian morality. By treating painting as literature — attributing its meaning through a nomenclature of written

constructs—they failed to understand art's underlying purpose and abstract nature.[29]

"The Ten O'Clock" reached Parisian readers in 1885, a point in time "from which," noted Roger Shattuck, "we must reckon with the meaning of the word modernism ... when all the arts changed direction as if they had been awaiting a signal."[30] Around this time Whistler met Mallarmé, and their friendship linked Whistler's art-for-art's-sake aesthetic with the symbolist movement. Mallarmé, assisted by the American-born symbolist poet Francis Viélé-Griffin, translated "The Ten O'Clock" into French in 1888. In 1892 Whistler and his wife, Beatrice Godwin, moved to Parisian Latin Quarter apartment. Throughout the early 1890s Whistler, along with Verlaine and Villiers de l'Isle-Adam, attended Mallarmé's Tuesday night salons, the Mardi. Satyr-like with pointed ears, Mallarmé avoided heated confrontation and ably judged his audience's temperament and disposition. From nine to twelve, he held forth near a stove in a combination dining room and living room of his rue de Rome apartment that displayed works given the poet by Manet and Whistler.

With a growing loyal following and the attainment of more patronage, Whistler gained respect and economic security, yet he was still the unconstrained eccentric. In America Whistler's tonalism profoundly influenced early modernist painters, photographers, and art critics. Eminent scholar of Far East studies, Ernest Fenollosa heralded Whistler as "a pioneer of the future." After the painter's death in 1903, Fenollosa eulogized him, declaring that "The simple truth is that [Whistler] is the first great master who comes after the union of East and West, the first who creates naturally and without affectation in their mingled terms."[31]

* * *

Whistler's association with the symbolists occurred at a time when Oscar Wilde and Aubrey Beardsley helped popularize aestheticism's distant cultural relative, "decadence." A vague term for a short-lived vogue, decadence drew its lifeblood from Charles Baudelaire's dark-minded consciousness popularized by followers such as Théophile Gautier and Joris-Karl Huysmans that defied middle-class morality. Traditionally a term describing a deterioration or decline, notably in the fall of an empire or a nation through blatant excesses and internal abuses, decadence came into currency around 1870 as an adjective describing one's licentious lifestyle. Decadence, like symbolism, favored fantasy over reality, while it renounced the beacon of material progress. The 1890s French decadence cultists and writers dealt in "the art of the shocking"— with frank discussions of sex, fashionable absinthe drinkers, and opium users. More often a case of life imitating art, decadent art and literature provided images and characters that bore little resemblance to the lifestyles of their creators.

Though few Americans had come in direct contact with English and French

decadence abroad, Gilded Age Boston produced a circle of European-style decadents. Aestheticism's hotbed, if not its leading American center, 1880s Boston's genteel bohemian scene centered in Pinckney Street within the Beacon Hill district. In the privacy of Pinckney Street's brownstones, said to resemble the character of London's Chelsea, the offbeat dressed in medieval costumes, and men invited women to discuss an array of subjects. One of the district's most famous individuals, architect Ralph Adams Cram, had, before succumbing to decadence's allure, embraced aestheticism, mysticism, Gothic art, and Wagnerism. In Boston's Providence Court, Cram presided over the Visionists, an 1890s decadent writers and artists' circle who gathered in an old brick tenement, a top-floor inner sanctum painted in strange images of "Isis in her Egyptian glory" and Asian designs. Their spiritualist rituals were steeped in Rosicrucianism and William Butler Yeats' mysticism. Herbert Copeland officiated in a ceremonial robe as the High Priest of Isis. Photographer F. Holland Day, Copeland's soon-to-be partner in the publishing firm of Copeland and Day, was a member of a wealthy Massachusetts family and a disciple of Keats, Balzac, and Whistler who made photographs that won him world renown. During the ceremonies—sometimes attended by art historian Bernard Berenson and philosopher George Santayana—Day wore an opera cloak and broad black hat.

Though Cram attested that they neither smoked nor ingested anything stronger than tobacco during their gatherings, there is evidence to suggest that he covered up drug use as he did his homosexuality. For illustrator Stephen Maxfield Parrish, the Visionists were "smugly cliquish, enamored of the exotic and the bizarre, in behavior and in art. They tried to be bohemian of course, but they were frequently self-conscious and played their role with mixed success."[32]

Novels portrayed the affairs and activities of decadence, while poster art and little magazines popularly disseminated its visual elements and those of art nouveau. In 1890 New York City held it first exhibition of French poster art, including works by Pierre Bonnard and Henri de Toulouse-Lautrec. Three years later, illustrator Edward Penfield's signed poster for *Harper's Monthly Magazine* launched an American poster-art craze. As major printers of poster art, magazine, and book-publishing firms took inspiration from French and British avant-garde poster designs. Intended for bookstore and newsstand advertisements, American art posters became collector's items, and out of the thousands produced and advertised in prominent publications from *Century* to *Harper and Brothers*, many revealed art nouveaus and Toulouse-Lautrec's influence.

Art Nouveau-influenced art posters were commonly printed as advertising companions to book and magazine covers. While French illustrators ignited the art-poster craze, America's little magazines were mostly English-inspired. Typically founded by one member or a small circle and subsidized by wealthy patrons, little magazines, limited in their printings and catering to a select

readership, were dedicated to the promotion of vanguard art and ideas. These noncommercial publications — typically underfunded, ill-organized, and repetitive in content — were typically shortlived.

Poster-art advertisements helped stir the public's interest in little magazines. In 1894 American expatriate Henry Harland co-founded London's infamous *Yellow Book.** After finding Paris inspiring, Harland, a longhaired bohemian poseur and Francophile, joined his brilliant English illustrator friend Aubrey Beardsley (both suffered from tuberculosis) in launching *The Yellow Book: An Illustrated Quarterly*, a bookshelf-quality periodical in 1894.† The *Yellow Book*'s finely crafted editions in William Morris' style sold in the thousands. A chronicler of the 1890s English art scene declared, "Nothing like the *Yellow Book* had been seen before. It was newness in 'excelsis': novelty naked and unashamed. People were puzzled and shocked and delighted, and yellow became the color of the hour, the symbol of the time-spirit." In four consecutive issues *The Yellow Book* carried Beardsley's erotic illustrations — its most scandalous content carefully censored by Harland and publisher John Lane. Whistler's disciple and Wilde's artistic collaborator, Beardsley favored a cultural hedonism. If Whistler typified the aristocratic dandy and Wilde the effete poet Beardsley was a "Dandy Grotesque."[33]

To balance its semi-shocking illustrations, the *Yellow Book*'s first issue contained a short story by Henry James who, after seeing the publication, no longer contributed. The *Yellow Book* then carried its scandalous reputation from London to Boston by way of its American edition publishers Herbert Copeland and F. Holland Day, founders of the Boston-based firm of Copeland and Day. Financially backed by Day's wealthy father, the firm, upon its founding in 1892, had close ties with London publisher John Lane, thus linking it with English decadence. Copeland and Day's first publication celebrated the fin-de-siècle by featuring Ralph Adams Cram's *The Decadent* (1893), a derivative work describing a dim opium parlor filled with rugs and divans and Mexican hammocks, where languid figures smoked from short-stemmed pipes. During the publication's six-year existence, Copeland and Day produced ninety-six editions on handmade paper, containing works like Richard Hovey and Bliss Carman's *Songs from Vagabondia* (1894), a cult favorite of the turn-of-the-century college crowd and early modernists. By 1895 Copeland and Day published Stephen Crane's collection of poetry, *Black Riders and Other Lines*, its cover illustrated with art nouveau orchids.

Given priority in republishing the works of John Lane's London-based

In the 1880s, before his English expatriation, Harland lived in New York City, writing Zolaesque stories of urban Jewish life under the pseudonym Sidney Luska. By 1894 Harland's experience as a writer and novelist had won him little acclaim in England, where he attempted escape from his New York heritage.

†*Lane and Matthews first published* Salome *in February 1893, and it became one of the first publications sent to the Boston firm.*

firm of Bodley Head, Copeland and Day became the American publishers of Wilde's *Salome* (1894). On April 6, 1895, while Harland vacationed in France and Lane was in New York City, Oscar Wilde was arrested in his hotel room on morals charges.* A mob assailed Lane's Bodley Head office, called Sodley Bed by detractors, breaking its windows. Compelled by public pressure and his clients' threats, Lane, after defending Beardsley in print as a modern-day Hogarth, acquiesced and fired the art editor, thus putting an end to the *Yellow Book*'s decadent period.

Scandalous and stigmatized, the *Yellow Book* inspired 1890s American independent magazines that followed suit in exploring new artistic trends. America's first significant little magazine,† was the *Chap-Book*. Founded in May 1895 by Harvard seniors Herbert Stuart Stone and Hannibal Ingalls Kimball Jr., the *Chap-Book* measured four-and-a-half by seven-and-a-half inches and sold bimonthly for five cents. Its songs, ballads, stories, histories, reviews, and illustrations were presented in a spirit of French decadence that "set off a literary rocket of pamphlet periodicals during the financial depression of the nineties." Countering the tide of moral outrage over Wilde's trial and imprisonment, the *Chap-Book* boldly asserted that "Even if we should discover that Shakespeare himself had committed sins against a dozen decalogues, it would not alter by one hair's breadth the wonder of his poetry."[34]

Stone and Kimball left Harvard in 1895 and relocated their publishing firm to Chicago, a city where soon afterward a modern spirit in the publishing industry briefly overshadowed that of New York City. Because Chicago had yet to produce a significant countercultural scene, Stone & Kimball's offices were an important meeting place for both unknown and nationally known talents. Their magazine showcased Crane, Hamlin Garland, and painter John Sloan's illustrations. The primarily French-influenced *Chap-Book* featured in French and English translation Mallarmé and Paul Verlaine's works, but after the summer of 1895 its French content declined in favor of English contributions— works by Henry James, William Butler Yeats, and Max Beerbohm, as well as Beardsley's illustrations. By the spring of 1896, the *Chap-Book* had a nationwide circulation of 16,500, and Stone & Kimball endeavored to print poster art. Along with Toulouse-Lautrec they printed the poster art of William H. Bradley, "the American Aubrey Beardsley," who played a major role in popularizing the genre by mid-decade.

The press falsely reported that when detectives escorted Wilde from his room the poet had a copy of the Yellow Book *under his arm (the book had never been identified). Some sources contend that the book was Pierre Louÿs' yellow-covered French novel* Aphrodite.

†Though it has been asserted by Albert Parry and others that the Chap-Book *emerged as a direct imitation of the* Yellow Book, *such a claim is unfounded. As Sidney Kramer has noted, "the correspondence of time of issue [the* Chap-Book *was issued one month after the* Yellow Book] *is too close, and the difference in content too great to permit the* Chap-Book *to be called a mere reflection of the* Yellow Book." *See Kramer, 31.*

The *Chap-Book*, though short-lived, inspired nearly two hundred imitations, notably San Francisco's *The Lark*. The *Lark*'s founders— Gelett Burgess, a civil engineer and University of California instructor; Willis Polk, an architect; and Porter Garnett, a writer and teacher — belonged to a writers and artists circle, the Les Jeunes (The Young), named after exotically dressed 1830s Parisian youths who "claimed to drink punch from the skulls of their mistresses." *The Lark* debuted in May 1895, and according to Burgess, was aesthetically indebted to the *Chap-Book*'s "craze for odd sizes and shapes, freak illustrations, wide margins, uncut pages, Janson types, scurrilous abuse and petty jealousies, impossible prose and doggerel rhyme." Though also influenced by the *Yellow Book* and the French *La Revue blanche*, the magazine sought uniqueness by "demolishing Decadence and its 'precious' pretensions." Printed on brown bamboo paper purchased by Burgess at an open-air market in Chinatown, *The Lark* showcased Ernest Peixotto's drawings, Yone Noguchi's Asian-influenced verse, and Burgess' whimsical lines. *The Lark* had a first-year press run of 3,000 issues, and during its two-year existence, it "echoed and anticipated experimental literary trends in Europe, which remained the focus of intellectual attention of the whole Western world and a growing part of the Far East."[35]

The Lark's West Coast image differed considerably from New York's *M'lle New York*. Founded in 1895 by Vance Thompson — a literary, drama, and music critic who had spent time in Europe and attended Princeton —*M'lle New York* exhibited Parisian flair, with colorful illustrations and wide margins. A monocled and top-hatted dandy, Thompson gathered an able and unpaid staff— illustrators Thomas Fleming and Thomas Powers and, champion of new European cultural vanguard, music critic James Huneker. Looking back on the *M'lle New York*, Huneker commented: "There was no office except under out hats, and the publisher mailed the copies. Frankly, I wonder how we escaped Anthony Comstock.... But the illustrations! Simply gorgeous."[36]

Behind the *M'lle New York*'s 1895 debut cover of pink, buff, and black were six unnumbered pages and the declaration that its "only ambition" was "to disintegrate some small portion of the public into its original component parts— the aristocracies of birth, wit, learning and art and the joyously vulgar mob."[37] While *The Lark* and *Chap-book* were akin in style to English decadence, *M'lle New York*, linked with French symbolist literature, republished some original works in French without the morally expugative practices of its English critics.

M'lle New York spread George Bernard Shaw and Henrik Ibsen's ideas and introduced readers to Knut Hamsun, Stanislaw Przybyszewski, Émile Verhaeren, and Maurice Maeterlinck. Along with Huneker's *M'lle New York* essays, especially those about women's roles utilized in his work *In Defense of Women*, the publication's criticism and prose were largely imitative of Baudelaire and the French symbolists. Without sufficient funds *M'lle New York* ceased operation in 1897; it saw only four final issues in 1898. Its collapse symbolized the little magazine vogue's demise, as its imitators also quickly disappeared.

In the midst of an economic depression and a popular bohemian revival, 1890s little magazines assaulted the American genteel tradition and foreshadowed in their rebelliousness and demand for originality numerous twentieth-century independent publications. As they entered a new millennium, younger European avant-garde followers considered bohemia as a nineteenth-century relic. Yet, as if symbolizing bohemia's persistence in the popular imagination, Giacomo Puccini's 1896 opera, *La Bohème* (based upon Murger's novel), debuted at New York City's Metropolitan Opera House in 1900, and by 1916 a film version of the opera reached the American silent screen. In its many guises bohemia survived, and long after Murger and Du Maurier's novels had fallen into obscurity, cultural rebels, living beyond mainstream society's pale, adapted their way of life for new lifestyles and new art in a new century.

III

Modern Tempers, Modern Times

Crosscurrents of Liberation

When middle-aged Lambert Strether, in Henry James' 1903 novel *The Ambassadors*, comes to Paris to urge Chad Newsome's return to America, he finds the twenty-eight year old to be a charming "pagan," an individual no longer possessing the traits of his native New England. Initially lured to Paris by reading *Scènes de la vie de Boheme*,* Chad studies art and lives in Latin Quarter bohemia before falling in with a rebellious salon set. Though admittedly a man of the previous century drawn to the romanticism of Victor Hugo, Strether is also changed by his Parisian experience, and, while addressing a young American artist, voices one of modern literature's most famed utterances: "Live all you can; it's a mistake not to."[1]

More than an encounter with "the irregular life" and strange communities of high modern salons, Strether's Parisian experience put him touch with the cultural elements of the European liberation. An outburst of new thought, the liberation had at its epicenter a new scientific inquiry — Einstein's theory of relativity and Max Planck's quantum theory — resulting in the fall of a Newtonian cosmos. This revolt against formalism included Sigmund Freud's investigation into the unconscious and William James' stream of consciousness, culminating in the liberation's dissolving of the steel chain of ideas, exploring a universe no longer ruled by ironclad laws or absolutes.

Through the cracks and fissures of its traditional culture, America encountered the European liberation and its aesthetic modernism that aid the foundations for a larger American rebellion, which by 1912 laid the foundations for subsequent twentieth-century aesthetic vanguards. America's rebellion, observed Henry May, was "the beginning of a major change in American civilization" and one of Western thought's most creative and innovating periods.[2]

Henry James had praised Murger's work while in Paris during the 1870s.

The rebellion's most advanced aesthetic, modernism, produced visionary artistic avant-gardists, heroes to a fervent American minority—cultural rebels who formed independent gatherings, salons, and art galleries that advanced their own causes by challenging the status quo.

* * *

Having weathered the 1890s economic depression, Americans entered the twentieth century's first decade with renewed confidence, yet facing new challenges. Unrestricted economic and technological growth that since the Civil War had been welcomed as positive forces for change also produced glaring problems: urban slums, unsafe working conditions, and environmental exploitation. Held to progressive journalists' investigation and criticism, big businesses—allied with corrupt political machines— appeared as menacing giants undermining popular rule. In the spirit of progress, muckraking reporters and numerous reformers sought to rally the American people in their country's regeneration through active government's checking the power of the privileged few.

Embraced by different individuals, progressivism became, in the years leading up to the First World War, a popular impulse and political catchword. Whatever progressives' differences and goals they concurred that the masses had directly to involve themselves in counteracting America's worsening evils by way of corrective measures and not, as more radical voices argued, fundamental transformation. An urban phenomenon, progressivism spread to the states then to the federal government level, where two of the era's most influential presidents, Theodore Roosevelt and Woodrow Wilson, took up its cause.

Wilson's vision of a "New Freedom," symbolizing modernity's positive potential, resonated among American intellectuals. The fields of new history and new jurisprudence were joined by sociology and psychology, exploring man's relationship to a rapidly changing world of aviation, automobile production, and the increasing use of electricity. Social workers, women like Jane Addams, became full-time professionals battling against urban poverty and the plight of European immigrants.

As progressives "Americanized" immigrant populations, elements of the European liberation became a less conspicuous foreign influence. Amid the liberation emerged the philosophy of vitalism, which described the forces of a cosmos in flux, permeated by a world spirit. Vitalism's foremost thinker, French philosopher Henri Bergson, asserted that a life force ran through the universe, what he termed spirit or élan vital, generating a state of "ceaseless becoming." Resembling theistic evolutionism and a Hegelian spiritual approach, Bergsonism held that "Matter is not the condition of existence; it is the medium through which life asserts itself. Everything, including matter, rises up out of the original life impulse and takes on a multiform material character by virtue of creative impetus. But this same impulse ... is 'riveted' to the same material world it struggles to escape. Life itself emerges out of the tension between spirit and

matter and occurs at those very points where these two principles intersect and compete for dominance."[3]

Modernists attracted to vitalism turned once more, as had the romantics and the symbolists, to intuition's creative primacy. By this time realism's and impressionism's materialist depictions of the French countryside and of Parisian life seemed outmoded. Since the 1890s symbolists, at odds with realism, probed art's spiritual dimension that served as a seedbed of the European liberation's influence, bringing forth its most radical aesthetic manifestation — modernism — as artists plumbed man's inner depths and a parallel fourth dimension.

Receptive to Whitman's free verse and Whistler's art-for-art's-sake, the rebellion's adherents required of their age new artistic languages, new expressive symbols. By way of the European avant-garde, 1910s American modernists were reawakened to Poe's conception of an "individual universe," in which each soul represents "its own God." Poe's individualism heartened those autonomy-seeking modernists, and just as Poe and Whitman spoke of "Spirit" as matter's ultimate source, early modernists, swayed by Bergson and Wassily Kandinsky, considered art as Spirit's muse.

1910s artistic avant-gardists — anti-rationalists rejecting naturalism's dictates and Spencerian determinism — embraced a newfound paganism. Guided by Bergson's dictum that "life transcends thought," they flaunted newfound freedoms. Born of the middle and upper classes, early moderns, primarily anarchists or socialists, fused radical politics and art and advocated free love. In New York and Chicago they formed bohemian enclaves, independent galleries, and theaters and found support in upper-class salons.

Not averse to culling from past and present doctrines and aesthetic ideas, modernists delighted, as Henry May noted, in profound contradictions, making it "permissible to prefer violence over peace, creative destruction to building, primitivism to civilization." Arriving in the U.S. after 1900 and lasting through World War I, the liberation launched the America rebellion that helped transform modern culture; and from its crucial vantage point one can view, in retrospect, the avant-garde's subsequent path and its indebtedness to early European modernism.[4]

* * *

1900 saw the publication of Freud's *Interpretation of Dreams* as well as the deaths of a dissipated Oscar Wilde and a mentally ill Friedrich Nietzsche. In the shadow of Wilde's faded aestheticism, numerous early moderns embraced Friedrich Nietzsche's writings and the philosopher's "God is dead" doctrine, freeing them from a Christian "slave morality" and emphasizing a will to power through a Dionysian spirit. In America Nietzschean followers included H. L. Mencken and Jack London, and for a time he entered Emma Goldman's pantheon of heroes. For literary naturalists like London, it was not unusual for

Spencerian determinism to be fused with Nietzsche's view of man's eternal battle with his own species, inescapably struggling to meet an unpredictable end in a godless universe. Without an explicit philosophical system, literary naturalism probed the drama of man's plight as it did away with traditional Christian views on good and evil, thereby placing humanity in an indifferent universe.

Early in his career, Nietzsche considered that all art should aspire to music, and his first book, *The Birth of Tragedy from the Spirit of Music* (1872), lauded his mentor Richard Wagner for reintroducing Europe to the art of tragedy. By conjoining the elements of Greek tragedy — dance, music, and poetry — Wagnerian opera aspired to be a total work of art, Gesamtkunstwerk. Wagner's building of the Bayreuth Festspielhaus during the mid–1870s enabled him to bring these three elements together with architecture and visual art. By the end of the nineteenth century, Wagner's concept of Gesamtkunstwerk produced a tendency among visionary creators to fuse all the arts, and found adherents from Mallarmé to the Russian impresario Sergei Diaghilev.

With the arrival in America of Wagner's former understudy and copyist Anton Seidel in 1885 and his position as conductor with the New York Metropolitan Opera, concertgoers were treated to more authentic performances of the German composer's music than had been previously heard in American concert halls. A gifted conductor, with his raven hair and purple and red clothes, Hungarian-born Seidel, "the high priest of Wagnerism," mesmerized audiences made up mostly of female admirers, and he presided over Coney Island's concerts at Brighton Beach from 1888 to 1896. Founders of the Seidel Society in 1889, middle-and upper-class women made a cult of Wagner — one that saw them find momentary transcendence and cathartic experiences in music and stagecraft.

Initially, Wagnerianism lacked a major American following, so it fell upon aesthetically adventurous Americans to spread its gospel. One the of the first to take up this task James Huneker wrote perceptively of the composer and in the late 1880s, defended Nietzschean philosophy at a time when many Americans thought him a pagan German scourge. Huneker shared Nietzsche's belief that art was a religious substitute — that it alone led to "joyous living." Nearly a decade after the composer's death, Huneker made a pilgrimage to Bayreuth. Nearly alone in his praise among conservative American critics, Huneker produced writings resonating with a European cosmopolitanism, and from his pen flowed images of a versatile, mercurial Wagner, a "wonderful" figure who became a "different being every hour of the day." Yet because Huneker both praised and criticized the German composer, he earned one scholar's label as "a sometime Wagnerite."[5]

Huneker's writings enticed 1890s American followers of Wagner like H. L. Mencken, who later hailed the New York critic as "a divine mongrel," "a divine mongrel," who "more than any other ... delivered the national letter from the

old camorra of schoolmarms, male and female." Born in Baltimore in 1880 and nearly twenty-three years Huneker's junior, Mencken eventually befriended his idol. Before the two met in 1908, Mencken commented that without Huneker, "we Americans would still be shipping union suits to the heathen, reading Emerson, sweating at Chautauquas and applauding the plays of Bronson Howard. In matters exotic and scandalous he is our chief of scouts, our spiritual adviser."[6]

Absorbing Huneker's insights into modern European thought, Mencken — after a period of freelancing, writing poetry, and working on the Baltimore *Herald's* staff — found nationwide fame with his 1908 work, *The Philosophy of Friedrich Nietzsche*. Like the interpretive, secondhand studies of Freud that reached Americans during the early 1900s, Mencken fused Nietzschean ideas with his own views and analysis. Nevertheless, his book connected Americans with a major figure of the European liberation who brought to print language filled with ambiguity, drama, and a fiery reaffirmation of individualism.

Jack London's Piedmont Crowd

A product of the American rebellion's diffusion, Jack London — northern California adventurer and virile outdoorsman — proclaimed himself a Nietzschean superman, a socialist upholding the cult of the Anglo-Saxon. Before his down-and-outer fate, London had kept offbeat company in the first few years of the century, when Bay Area writers and artists lived in the shadow of Gilded Age bohemia, under the California imperatives of "simplicity, health, art."

When London joined the Bohemian Club in 1904, he had already sailed on a sealing ship, hoboed eastward in 1894 with the unemployed workers of Kelly's Army, served a prison term for vagrancy in New York, sought gold in the Klondike, briefly attended the University of California at Berkeley, married, and found fame. In the spirit of the rebellion's intellectual eclecticism he was untroubled by the contradictions involved in combining the ideas of Darwin, Spencer, Marx, and Nietzsche; for as one his biographers asserted, the "mutually exclusive held no terrors for Jack London. He could be an atheist who valued the existence of Christ, a socialist who valued the leveling process of revolution at the same time he raised the superman who would rightfully dominate the stupid herd." London's 1903 novel *The Call of the Wild* transformed the once poor working-class "Boy Socialist" into the country's highest-paid author and marked the apex of his career, which, like his health, would rapidly decline. Because of his years of living in poverty, London justified his wealth as deserved, while snubbing the bourgeoisie as a class plagued by the symptoms "of low blood pressure."[7]

Sometimes labeled a bohemian, London saw himself as a nature-hardened Nietzschean superman, a vagabond of the people. Married in 1900 and moving

to a cottage in the Piedmont hills outside San Francisco, London shirked his familial responsibilities to be with "The Crowd" that included Joaquin Miller, Berlin-born photographer Arnold Genthe, and San Francisco's poet laureate and "uncrowned king of bohemia," George Sterling. New York-born Sterling, once a protégé of Ambrose Bierce, wrote conventional verse while leading an unconventional life of an adulterer, chronic drinker, and a hashish and opium user. Nicknamed the "Wolf" by Sterling, London called his friend the "Greek," and took him to Chinatown, prize fights, Barbary Coast dives; in his Piedmont hills cottage London and his friends consumed spaghetti and chili con carne with plenty of red wine.

The Crowd's leading bohemian, Xavier "Marty" Martinez, wore bobbed hair and handlebar mustache, complemented by a beret, corduroy pants, and a crimson waistband. Mexican-born Martinez had studied at the Parisian École des Beaux-Arts and then at the Academie Carriere and painted tonalist-influenced works. In Paris he became acquainted with Joris-Karl Huysmans, the Nabis, Théophile-Alexandre Steinlin, and Whistler, who, along with the Spanish masters, greatly impacted upon his work. He revered the work of van Gogh and Gauguin and recognized Cézanne's greatness.

Making his way westward, Martinez lived in San Francisco's four-storied Montgomery Block, once the West Coast's largest commercial structure, built in 1853 by Henry W. Halleck of Civil War Union Army fame. Above its ground floor of law firms and newspaper offices, by the mid–1880s artists paid low rent for large, high-ceilinged rooms affording ample light.

London often stayed in Martinez's Montgomery Block studio, and evenings were spent with friends in the building's ground-floor restaurant, Coppa's, San Francisco's first authentic bohemian hangout. Founded in 1904 by northern Italian cook Giuseppe "Poppa" Coppa, the restaurant's thirty-five-cent meals offered abalone soup, seafood, and baked deserts. Coppa extended artists credit and reserved them tables for informal gatherings. When Coppa's artist patrons protested his painting the restaurant's walls crimson, he accepted their offer to repaint them. Artists, fortified by free red wine and sandwiches, turned the main room into a mural of odd images, including a lobster perched on an island named Bohemia, a toasting devil, and Martinez's prowling black cats modeled after those of Montmartre's Chat Noir. Sterling was caricatured as the brooding poet, and the names of Rabelais and Dante, and those more locally recognizable, were lettered on a frieze near the ceiling. To mock their mockers, two female slummers were depicted seated near a table of long-haired artists, with one exclaiming "Freaks!" while her woman friend responded, "Yes, artists!" Coppa's local fame lasted until the earthquake of 1906, when fires caused by its destructive force scorched the Montgomery Block, forcing its proprietor to seek other venues that never lived up to his original bohemian venture.[8]

Meanwhile, Sterling escaped San Francisco in 1905 to help found the

Monterey Peninsula artist colony, Carmel-by-the-Sea. Originally the developers of "Carmel City" lured intellectuals, writers, and artists, hoping that they would in turn make it attractive to more wealthy investors. Early residents, renouncing gas and electricity, lit their cottages with kerosene lamps and candles. They drank inexpensive Italian red wine and ate fish and vegetables purchased from Japanese vendors. Embracing a transcendentalist revival and a neo-Greek paganism, Carmelites communed with nature. They held beach parties, outdoor dinners, and pageants and argued the virtues of socialism, while Genthe made Carmel the subject of new experiments in color photography.

Sterling built a cottage in Carmel, and, after making a circle-shaped clearing among a nearby stand of pines, he erected a pagan altar surrounded by tree-mounted cow and horse skulls. Sterling and London brought vibrant energy to the colony, engaging their well-toned bodies in rigorous physical exercise. Meanwhile, writer Mary Austin endeared herself to fellow Carmelites by wearing a Native American leather gown and spending time in a tree stand, her sacred shelter modeled after a Paiute wickiup. In many ways these activities of "casual bohemianism" foreshadowed the California cult of beatitude, a lifestyle later adopted by the 1950s beat generation.

Visiting Carmel, Ambrose Bierce referred to it vituperatively as "a nest of anarchists," and questioned its longevity in that, he believed it would "go the way of Hawthorne and Brook Farm." Others had fonder impressions. In his autobiography Genthe praised the freedom he felt during the colony's early years, and London, in his 1913 novel *Valley of the Moon* (serialized earlier that year in *Cosmopolitan*), offered a similar outlook. Set in 1907, London's novel centers upon a young, working-class couple — Saxon, the daughter of a poet mother and Billy, a former boxer — who leave behind urban poverty and labor battles in Oakland to tramp northward on foot to become land-owning farmers. In this back-to-the-land tale, Saxon and Billy discover Carmel's charm, its half-ruined Spanish Mission, and the sand hills bordering a "peacock blue" ocean. Living among the crowd's writers, painters, musicians, and critics, Saxon and Billy find them to be "light-hearted young people," uniquely democratic, a tight-knit and hard working "aristocracy of arts and letters," though plagued by brooding aesthetic temperaments. Defiantly proud of their being ostracized by the local bourgeoisie, the crowd flaunted a "rampant bohemianism" that soon disappeared from the colony with the coming of more sober and conventional residents.[9]

Following the 1906 San Francisco earthquake, Sterling's quiet married life ended with Carmel's invasion by alcoholic artists, young women, and artsy neophytes. Though eventually drawing writers like Sinclair Lewis, Carmel became largely "an assemblage of potboiling dilettantes." By 1910 a *Los Angeles Times* article, "Hotbed of Soulful Culture," reported that Carmel was an amalgam of talented and untalented writers, amateur female artists, dramatists," and college professors, "a club of well-meaning neophytes of the arts-and-crafts, esoteric Yogi" and "New Thoughters."[10]

London continued to visit Carmel, but fame and a new lover made him an outsider among his bohemian friends, and he enjoyed notoriety and economic success by indulging copiously in alcohol, near-raw duck, venison, and raw-beef sandwiches topped with onions. A 1906 lecture tour found London espousing his Spencerian-influenced socialism in which he condemned workers and Ivy League students as tools of the bourgeoisie. The subject of a vision of the rise of a fascistic oligarchy and its battle with socialism, London's 1908 novel, *Iron Heel*, sold over 50,000 copies and was reviled by critics and moderate socialists, yet hailed by radicals such as Eugene Debs and the Industrial Workers of the World leader Big Bill Haywood. Two years after *Iron Heel*'s publication, London's health deteriorated, and he lost his creative inspiration, producing a spate of poor novels. Unable to render worthwhile fiction from his thousand-word-a-day writing regimen, he purchased plots from a young Sinclair Lewis.

London's literary demise came at a time when members of two generations of San Francisco artists and writers met bohemian down-and-outer fates. Before his death in 1909, Charles Warren Stoddard spent his last days as a Catholic, wearing Franciscan robes but drinking heavily. After years of self-embitterment, Ambrose Bierce disappeared into Mexico in 1914, at a time when Jack London's once athletic body became "islanded in an expanse of flesh."[11]

London lived as a writer/adventurer and virile outdoorsman, proud of his physical prowess and driven to test its limits against the elements and personal abuse. Drink had ruined his kidneys, and hard drugs filled his body with toxins. On the evening of November 21, 1916, forty-two-year-old London suffered an attack of renal colic. To ward off the pain he took lethal doses of morphine and atropine sulfates and died the next evening, his ashen face bearing a smile as if relieved from the Nietzschean and Darwinian struggle.

Anarchists, Moderns, and the Robert Henri Circle

Thousands of miles from Chicago and New York City, the rustically bohemian Crowd—labeled derisively by eastern literary critics as "the cosmic California School"—came to resemble cultural relics engaged in making conventional art. Intoxicated with the latest European artistic innovations, younger American artists aiming to capture the spirit of their age grappled with modern technological developments and new aesthetic expressions. As part of the European liberation that had arrived in America around 1900, modernism placed artists in the role of autonomous visionaries impelled by self-expression.[12]

Though not bound to aesthetic tradition, early modernists looked to primitive art, while medievalism inflamed Ezra Pound's poetic imagination. Painting produced modernism's first great twentieth-century experiments—works of latent symbolist influence that rejected impressionist "retinal art." Beginning

with painters like Cézanne, Renaissance perspective was abandoned in favor of compositions using nonlinear perspective influenced by primitive, medieval, and Japanese art. In modern literature, particularly poetry, experiments with space and time did away with or made less important the use of metaphor and narrative. Echoing romanticism's main tenet, modernists held that originality was the true measure of genius. Bound inextricably to expression, originality referred not only to uniqueness of form (that is, style and technique), but to the honesty, the intensity — "the truth" — with which an artist creates a work.

In the shadow of Parisian avant-gardists, early American modernists explored a fourth dimension comprehended only by intuition that inspired painters to move away from depicting the material world, writers to abandon literary narrative, and modernist composers to reject program music's extra-musical and literary themes. Art was to reveal a multiplicity of meanings and aesthetic visions, new communicative relationships between artist and audience, a reciprocal process that, according to Herbert Read, is forever bound to what the viewer perceives (the object or basis of emotion) and that which the artist expresses. Yet this age-old process became more taxing to the observer's aesthetic understanding when modernism made abstraction a paramount mode of expression.

* * *

Composer Arnold Schoenberg once boasted, "genius learns only from itself." Joined in this aesthetic individualism, most American moderns until the early 1920s were, by self-proclamation or temperament, anarchists. While few embraced anarchism's "propaganda by the deed" — violent acts advocated by anarchists like Mikhail Bakunin — most embraced "philosophical anarchism," which comfortably fit with Thoreau's and Whitman's transcendentalist spirit. The anarchist path to modernism "was an obvious one," explained historian Robert Crunden, in that "both anarchists and modernists cultivate the self and mistrusted institutions, and both had trouble with dealing with the larger society in personal as well as philosophical ways."[13]

To conservative critics, art was a "bastion of social stability." Threatening this delicate balance, artistic avant-gardists were typically branded by the genteel culture's guardians as anarchists without concern for their actual political leanings. A principal anarchist modern and Emma Goldman's friend, artist Robert Henri, stridently defied the academy and gallery system. Henri's realist circle — soon to form the core of "The Eight," later dubbed the Ashcan School — learned their trade in the 1890s as newspaper artists that rendered Philadelphia street scenes. They gathered nightly, as did most low-paid journalists, to drink and talk. To his Philadelphia circle of realists Henri brought years of artistic experience. Trained at the Pennsylvania Academy of the Fine Arts from 1886 to 1888, he then studied in Paris at the Academie Julian and later the École des Beaux-Arts, making subsequent trips between the French capital and Philadelphia.

In Paris Henri encountered new art and a lifestyle befitting his worldview. Provided five hundred dollars a year by his parents, he lived simply while making art. There was "a charm," he asserted, "about "Bohemian life, this giving up comforts and pleasures that other people think so indispensable, this living in the roofs of houses and being happy there in order that one may follow the nobler pursuits, and get the best of life."[14]

Back in Philadelphia Henri held Thursday-night gatherings at his Chestnut Street apartment; eventually these gatherings were moved to Tuesday in tribute to Stéphane Mallarmé's Mardis. Because few artistically oriented circles existed at this time, Henri's gatherings were vital in the serious interchange of intellectual and aesthetic ideas. Four to twenty visitors typically lounged on the apartment floor listening to Henri discuss art. Exposed in Europe to the Spanish-influenced works of Manet and those of Frans Hals, Henri distanced himself from impressionism and postimpressionism, urging his circle to create artistic works drawn from their street reporter experience. Henri also held forth on the writings of Chekhov, Tolstoy, Ibsen, William Morris Hunt, George Moore, and Bakunin. Because attendees generally disdained government and religion, politics played only a marginal role in these quasi-intellectual gatherings. Talk usually centered on Wagner or more frequently Henri's spiritual hero, Walt Whitman, whom Henri once extolled as the "real art student," whose "work is an autobiography — not of haps and mishaps, but of his deepest thought, his life indeed."[15]

Henri's Chestnut Street circle also found time for high jinks, and its amateur theater featured the *Trilby* farce *Twilby*, staged at the Pennsylvania Academy's assembly room. Painter John Sloan designed *Twilby*'s art nouveau advertising bill and appeared as the production's heroine, wearing a dress, makeup, and exaggerated chicken-like feet. Henri appeared as Svengali, and Everett Shinn — nicknamed "The Kid" — appeared as "James McNails Whiskers."

In 1898 Henri circle members Shinn, George Luks, and William Glackens left Philadelphia to join the *New York World*'s staff. Two years later, Henri moved to New York, and by 1904 his circle regularly met at Mouquin's Restaurant on Twenty-eighth Street and Sixth Avenue, and was joined in lively conversation by newcomers Ernest Lawson, John Twatchman, and former Tile Club member J. Alden Weir.

At the time when the Henri circle regrouped, New York galleries handled mostly conventional European paintings catering to an upper-class clientele. Modern art was largely avoided by galleries in that its showing risked the wrath of the Society for the Suppression of Vice's head, Anthony Comstock, who made any perceived cultural threat into front-page news. It was in this cultural climate that in 1907 the National Academy of Design refused to hang the work of Glackens, Luks, and Shinn in its spring exhibition. In protest, Henri, one of the show's thirty jurymen and whose works were given a number-two rating,

withdrew from the exhibition. He subsequently defended his decision on the premise that artistic innovators—Wagner, Degas, Manet, Whitman, and Whistler—had all defied the academy.

Macbeth Gallery owner William Macbeth risked scandal in 1908 by showing the work of Henri's circle, including Sloan, Glackens, Luks, and Shinn, along with those of Arthur B. Davies, Maurice Prendergast, and Ernest Lawson. Apart from its realists—Henri, Sloan, Luks, and Glackens—"The Eight" were stylistically diverse. Shinn's works of stage and theater life earned him the title of "the American Degas," and Davies' symbolist-inspired dreamscapes contrasted with Prendergast's Cézanne and Paul Signac-influenced works.

Commercially successful for most of its participants, the Macbeth show aroused the critics' scorn. James Huneker dismissed the Eight as vilely anarchistic; another critic labeled the show as the product of a "black gang"—"the apostles of ugliness." Yet critics, fixated on the Eight's vernacular street scenes, avoided mention of Prendergast's and Davies' advanced European-influenced works. Though not as iconoclastic as the leading European modernists, the Eight, contends Barbara Rose, were "at least ... fighters" in opposing tired academic standards and were responsible for introducing "a healthy vitality into American art, proclaiming its independence, and raising the possibility of rejecting European models." Modernist painter and Henri's student Stuart Davis considered the Eight's abandonment of the "art school routine" as "radical and revolutionary" in that it elevated the creator's memory and imagination in depicting everyday urban scenes.[16]

Stieglitz and Stein, Proponents of the New

Having few equals in the zealous promotion of the American avant-garde, Alfred Stieglitz exhibited and published works that exceeded those of the Eight experimentally. A genius of modern pictorial photography and America's first significant European avant-garde art promoter, Stieglitz, in the co-founding of *Camera Work* and New York's 291 gallery, debuted many leading American and European avant-garde artists. A philosophical anarchist of Whitmanesque vision, Stieglitz foresaw in new American the transformation of society, its regeneration through cultural rebellion.

Born in Hoboken, New Jersey, the son of well-to-do German-Jewish immigrants, Stieglitz took up photography as a university student in Germany during the 1880s, achieving a measure of recognition as a talented artistic photographer. After living on stipends from his father, Stieglitz returned to America in 1890 and a year later became editor of *The American Photographer*. With a handheld camera and a brilliant eye for composition, by 1893 Stieglitz had produced "decisive moments"—night and day photographs depicting Manhattan's streets, its people, machines, and architecture. He then co-founded the Camera Club of New York in 1896 and subsequently served as editor of the club's

publication, *Camera Notes*— roles that he considered as central in elevating pictorial photography to the level of fine art.[17]

Stieglitz's photographic organization, the Photo-Secession, founded in 1902 to exhibit and explain pictorial photography, took its name from the 1890s German and Viennese secession movements as it absorbed art nouveau and arts-and-crafts influences. Joined with the European secessionists in rejecting nineteenth-century rationalism, Stieglitz believed that "a new transmaterialistic means of expression" would reveal man's inner identity.[18]

To spread modernism's gospel, Stieglitz and photographer Edward Steichen formed a vital New York–Parisian transatlantic collaboration. Stieglitz met Steichen in May 1900 when the latter, en route to Paris, stopped to see the noted photographer in New York. Born in Luxembourg and raised in an Upper Michigan mining town, Steichen, a commercial artist in a Milwaukee advertising firm, learned photography by trial-and-error. Steichen's stay in Paris (a city Stieglitz disliked) afforded him the opportunity to study painting and led to contact with Auguste Rodin, whom he photographed brilliantly. In 1913 Steichen designed the modernist cover for Stieglitz's *Camera Work*, a renowned publication dedicated to pictorial photography that later opened its pages to avant-garde painting and literary works.

To provide a gallery space for the secession's expanding exhibitions, Steichen selected a Fifth Avenue apartment that Stieglitz leased in 1905. Steichen and his wife Clara set up the Little Galleries of the Photo-Secession and installed its lighting, creating a showplace of art that during its first season drew fifteen thousand visitors, who rode the rickety elevator up to the three-room venue.

In 1908 Stieglitz solicited additional money and rented a new gallery space across the hall, and despite its new location at 293, the original gallery's numerological mystique inspired Stieglitz and his circle to refer to the new space as 291. In April 1908 Steichen's Parisian connections brought about 291's first Matisse show (often considered America's public introduction to modern art) that outraged viewers and critics alike. Also through Steichen's contacts, 291 hosted the first American exhibitions of the Parisian avant-garde: Cézanne, Renoir, Monet, and Toulouse-Lautrec in a group show (1910); Matisse (1910); and Cézanne (1911). Steichen envisioned Picasso's 1911 exhibit — the artist's first American one-man show — as a "red rag" to be defiantly waved at the New York art world. Stieglitz sponsored American artists as well, providing them vital patronage and exhibition space. In 1910 Steichen's Parisian circle made up the core of 291's Younger American Painters Exhibition.* Six of the exhibitors, including Steichen, John Marin, and Alfred Maurer, were members of the New

**Stieglitz's stable of American modernists emerged largely from Steichen's Parisian circle, constituting the New Society of American Artists in Paris, founded in 1908 as a secessionist organization that opposed conservative Parisian-based American artists unwilling to show works advanced beyond impressionism.*

Society of American Artists in Paris, and Max Weber, Arthur Dove, and Marsden Hartley were added to make for a strong showing of American talent.

291 drew an array of talented and influential visitors— poet William Carlos Williams, writer Sherwood Anderson, and anarchists Big Bill Haywood and Emma Goldman. But for the most part, Stieglitz suffered the comments of "droning bores," tourist types—cane-carrying willowy men and rotund women with yapping dogs. Conversely, visitors were often subjected to the impresario's impassioned rants. Hearing one of Stieglitz's impromptu lectures on art, Georgia O'Keeffe, first visiting in 1907, waited out the "storm" in a corner of the gallery. Less intimidated, writer Djuna Barnes commented, "Sometimes I like Stieglitz when he talks too much, and often I find myself liking him when he says too little — very much too little."[19]

291's open-door policy, Stieglitz claimed, taught him as much about his American visitors as his shows taught them about art. Stieglitz referred to his gallery as a "laboratory," a "storm center" of cultural change, where he even exhibited works that he initially found incomprehensible — answerable to no aesthetic authority as they forced the viewer in perceiving, out of disjointed or whimsical expression, their emotive power and profound underlying messages. Works were not to be sold as commodities; prices were negotiable, and if not convinced of a buyer's genuine interest, Stieglitz often refused a sale.

In 1906 Steichen's curiosity about modern art led him to Leo and Gertrude Stein's Parisian apartment at 27, rue de Fleurus.* Born to wealthy German-Jewish immigrants and raised in America and Europe, Leo and Gertrude — the youngest of the Stein children — were bookish, inseparable companions. When Leo attended Harvard and Gertrude studied at Radcliffe, they lived in nearby Cambridge residences. Both studied under William James, who considered Gertrude one of his most gifted students. Later while rooming together in Baltimore, Gertrude pursued a medical degree, and Leo half-heartedly studied biology. Following the path of her dropout brother, Gertrude left Johns Hopkins after four years and pursued the reading of hundreds of English literary works. After writing autobiographically inspired fiction, Gertrude experienced a revelation in modern art.

In Paris Gertrude and Leo made rapid contacts with collectors, artists, and writers and by 1905 had befriended Henri Matisse and purchased his work *Woman with the Hat*. The Steins' apartment resembled a private gallery dominated by fauvist portraits and landscapes by Matisse, who during his regular visits brought friends, initiating the Steins' famed Saturday evening salons. At these gatherings Leo lectured authoritatively on modern art, while Gertrude sat Buddha-like, quietly observing and taking in the conversation. Open to all guests, the apartment invited travelers, scoffers, the curious, such as the

*By 1906 three years had passed since Leo had taken up residence at 27, rue de Fleurus, using the apartment as a studio during his short-lived career as a painter. In the fall of the same year, Gertrude moved into Leo's studio.

flamboyant Parisian poet and art critic Guillaume Apollinaire. In 1906 the Steins held a luncheon that brought Matisse and a newer discovery, Pablo Picasso, together in their apartment, perhaps the only neutral Parisan mileu that could accommodate the two strong-willed painters. Gertrude had met Picasso in 1905, a year after the artist took up residence in Paris. Despite her initial distaste for his art, Gertrude fell for Picasso's charm and genius, and his early paintings were acquired for the Steins' collection. While Gertrude sat for her portrait at Picasso's studio (during winter and spring 1905-1906), the two conversed for long hours, coming to an agreement that modernism should embrace ugliness as an aesthetic virtue.

This notion did not sit well with Leo—self-appointed critic of critics. As cubism pushed him to increasing intolerance of its aesthetic, he came to dismiss Picasso as a sham, the ideal companion for his sister, creator of what he judged as meaningless abstract prose and poetry. While Leo considered Picasso's groundbreaking 1907 cubist work, *Les Demoiselles d'Avignon*, repulsive, Gertrude hailed the painting of contorted Spanish prostitutes as symbolizing a new artistic age.

In 1909 Stieglitz and Steichen visited 27, rue de Fleurus and listened to Leo condemn Whistler and Rodin as third-rate artists. Overwhelmed by Leo's harangues, Stieglitz scarcely noticed the host's reticent sister.* During mid–September 1911, Stieglitz returned with his family to Paris and accompanied by Steichen and artist/critic Marius de Zayas toured galleries and met Matisse, Picasso, and Romanian sculptor Constantin Brancusi.

Not to spoil the fond memories of his first visit, Stieglitz avoided the Stein salon, yet he remained supportive of its resident poet. A *Camera Work* special issue (1912) carried Stein's word portraits of Matisse and Picasso (the first time her writing had appeared in a nonscientific publication) that outraged many subscribers and resulted in numerous cancellations.

Meanwhile, Stieglitz's role as New York's leading avant-garde promoter was suddenly challenged by the International Exhibition of Modern Art, the controversial 1913 Armory Show. Organized by the Association of American Painters and Sculptors† and held at New York City's 69th Regiment Armory,

*By 1913, Leo no longer attended the Saturday salons at 27, rue de Fleurus, letting Gertrude and her resident lover, Alice B. Toklas, host the event. As Gertrude's lover, cook, and personal secretary, Alice moved into the apartment in 1909 and replaced Leo as her inseparable companion. Disillusioned over the Parisian modern art scene and unable to accept Gertrude's increasing notoriety as a writer, Leo divided their art collection (leaving most of the Picassos with Gertrude) and retreated to Italy where he could immerse himself in classicism and the works of European masters.

†The AAPS was founded in January 1912 by New York artists as a secessionist-style organization intended to show art in exhibitions outside the control of the academy and formal galleries. The AAPS brought together former members of the Eight, including the organization's second president Arthur Davies and John Sloan, who served on the Armory Show Hanging Committee.

the Armory Show exhibited 1,300 works that traced modern art's evolution from the eighteenth century to cubism. Because most Americans had not been exposed to advanced European art, the show introduced a broader public to postimpressionism and early modernism.

Visitors, attracted by the media furor surrounding the show's notorious Cubist Room — critically labeled the "chamber of horrors" — viewed works by Matisse, Picasso, Marcel Duchamp, Francis Picabia, and Georges Braque. Sensationalist newspaper coverage did not focus on the founding cubists but upon Duchamp's *Nude Descending a Staircase*, giving rise to mocking analogies of shingle factory explosions and cartoonish parodies. Critical controversy followed the show as it traveled to Chicago and Boston, even while it promoted the vogue of collecting European modern art.

Stieglitz considered the Armory Show "a circus." Yet despite his having a marginal role in the much-publicized event, he claimed that its founding stemmed from his gallery and publishing efforts. As if responsible for New York's modern European art vogue set off by the Armory Show, Stieglitz, further emboldened in his cause, set out to promote American moderns whom he believed could change the course of art and life.

Poetry in Porkopolis

On its second stop of a three-city tour, the Armory Show met with more hostility among Chicago's 189,500 attendees than it had in New York City. In March 1913, when the Art Institute of Chicago exhibited 650 of its works, the institute's students reacted by hanging Matisse in effigy. During the exhibition, painter and principal Armory Show organizer Walter Kuhn described Chicago as "a Rube Town!" and a Philadelphia newspaperman mockingly wrote that its literary set created "poetry in porkopolis." Though a conservative-minded citizenry dominated its art market, Chicago, an American arts and crafts center and a hotbed of architectural innovation, produced cultural rebels who, in the rebellion's eclectic spirit, blended socialism with Freud, infusing Nietzsche with a raucousness that preceded, in playful spirit, 1910s Greenwich Village.[20]

In 1903 muckraking journalist Lincoln Steffens wrote of Chicago as "[f]irst in violence, deepest in dirt; loud, lawless, unlovely, ill-smelling, irreverent, new." Of all the phrases in Steffens' hyperbolic description, emphasis on the "new" best represented turn-of-the-century Chicago, with its burgeoning industry, innovative architecture, and desire of its moneyed elite and genteel citizenry to cultivate the fine arts. To promote its image and cultural progress, Chicago could point to its opera house and the Art Institute. Between 1890 and 1900, 175 books were published in Chicago, and by 1905 the city was second only to New York in the dollar value of books and printed material.[21]

Chicago's cultural guardians reflected a national trend of genteel control of aesthetic taste; upper-class and civic-minded women held teas and banquets,

entertaining moneyed Chicagoans and artistic guests. Representative of many well-to-do Chicagoans, Grace Hemingway, a former opera singer and an amateur painter married to an Oak Park physician, cultivated her children, including young Ernest, whom she insisted study the cello and perform in a family chamber group. Trips to the opera and the Art Institute and readings of the classics were paramount in Ernest's education.

Chicago's feminization of Victorian cultural life was soon challenged by young, culturally defiant writers—radicals and bohemians who contended with "self-righteous" patrons and civic leaders who valued art for educating and cultivating its citizens. Within this movement vanguard women defied the local publishing industry's constraints by founding alternative outlets for modern literature. Premier among them, Harriet Monroe experienced, while serving as an art critic for the *Chicago Tribune*, difficulties in finding a publisher for her romantic verse, and in 1912 at age fifty-two, she launched the independent publication *Poetry: A Magazine of Verse*. The honored poet of Chicago's 1893 World Columbian Exposition and a descendent of President James Monroe with prominent political connections, Monroe raised funds from Chicago's civic leaders and captains of industry for the country's first periodical devoted solely to poetry.

In August 1912 one of Monroe's promotion circulars reached Ezra Pound in England. Since his arrival in 1908, Pound had vowed that a new modern verse would transform America, a country he viewed with increasing bitterness since his expulsion from a small Indiana college for sexual impropriety. For Pound, America's aesthetic stultification prevented it from creating original, vibrant poetry. No less critical of Europe, he castigated nineteenth-century romantic writers as philosophically naive and their creations excessively ornate and instead sought inspiration from thirteenth-century Provençal troubadours, Dante, and Chinese and Japanese poetry, from which he believed new modes of poetic expression could arise.

Since Pound's exposure to Walter Pater's and Oscar Wilde's aestheticism during his college years, he had come to respect England as supporting literary experimentation. In England he befriended William Butler Yeats, introduced him to modernism, and turned him into an understudy. Contemptuous of America's dearth of artists and yet searching for an artistic birthright, Pound slowly came to revere Whitman and Whistler. Since Pound's early school days, Whistler had captivated the eccentric self-confident student.

To help launch an American poetic revolution that would equal Whistler's painterly legacy, Pound believed *Poetry* to be a bright prospect, and he sent Monroe his own work and became a scout for European-based talent. Out of his select English circle—Richard Aldington, Hilda Doolittle (aka H.D. Imagiste)—Pound emerged as founder of imagism—a poetry "movement" (from mid 1912 to mid 1913) that abandoned metaphor and narrative, emphasized clarity, and embraced a poetic rhythm freed from metronomic cadence. Pound

promoted imagist works of Yeats, Indian poet Rabindranath Tagore, and D. H. Lawrence, along with American poets Robert Frost, T. S. Eliot, and his college friend, William Carlos Williams—"discoveries" who, though often subjected to Pound's dictatorial criticism and editorial excisions, also benefited from his skills as modernism's premiere promotional propagandist.

But Monroe tested the liberation's waters with self-conscious restraint, favoring Vachel Lindsay's work over Pound's and Eliot's contributions; she made editorial revisions and omissions of works she considered vulgar or incomprehensible to her less adventurous readers. By 1915 Monroe had lost interest in Pound's modernist poetry, and in turn the latter condemned *Poetry* as being filled with inferior, derivative work. *Poetry* did, however, introduce aspects of the European liberation, showcasing Chicago School poets—Carl Sandburg, Vachel Lindsay, and Edgar Lee Masters, who never completely severed their ties with nineteenth-century verse but who stylistically ventured beyond conventional form.

Though Monroe later condemned modern art, she did, during the 1913 Armory Show and its Chicago appearance, come to its defense in her *Chicago Daily Tribune* column. A year before the exhibition, she perceptively praised, in a *Tribune* review, Arthur Dove's show at Chicago's Thurber Gallery. When critics scorned the modernists, she came to their defense in an approach that "was cautious," noted one writer, yet revealing "her ability to think analytically and independently." Among the few supporters of the Armory Show's touring exhibit, Monroe looked upon its critics as suffering from cultural ignorance.[22]

If Monroe wavered in her support of modern art and looked askance at most poetic experiments, she, by inclination and cultural inheritance as a child of the Gilded Age, could not fully cross over into the emerging modernist camp as did younger Americans. Chicago's early followers of advanced art and bohemia were by and large small-town rebels fascinated with the city and its offerings of employment, culture, and an architectural landscape of glass and steel.

Around 1903 Chicago bohemians founded the 57th Street colony located across from Jackson Park and near the University of Chicago. In this blocklong row of apartments converted from the 1893 Columbian Exposition's one-story midway stores and concession stands, painters, sculptors, and theater people lived inexpensively. During the summer months, the 57th Street bohemians, retreating to nearby Lake Michigan, heard Floyd Dell read Yeats' poetry; others swam nude or slept on the beach.

Married in their native Davenport, Iowa, Floyd Dell and Margery Currey moved to the 57th Street Colony in April 1913. In a modern household experiment, Currey—a well-connected reporter for the *Daily News*—inhabited a studio on Stony Island Avenue (the former residence of University of Chicago economist Thorstein Veblen). Meanwhile, Dell occupied quarters on 57th

Street — their residences separated by a corner studio. Together they established a salon, with Currey serving as its social coordinator and Dell its literary host. They welcomed Theodore Dreiser, Sherwood Anderson, and poets Carl Sandburg, Vachel Lindsay, and Eunice Tietjens, who held forth on the virtues of socialism, feminism, free love, Freud, and poetry. From their Davenport circle came George Cram Cook and his wife Susan Glaspell, soon to become founding members of the Provincetown Players.

A socialist and self-proclaimed poet, better known for his essays, journalistic work, and social reform activities, Dell bitterly opposed what he called Murger's "pig-sty lunatic bohemia," a "pathetic" bohemianism, where people died garret deaths "without an idea in their silly heads." His was a revolutionary bohemia in which "students fought and died behind barricades in each crisis of liberty."[23]

Not a modernist poet, Dell was nevertheless awed by Chicago's Armory Show and recounted that it "exploded like a bombshell within the minds of everybody who could be said to have minds ... it brought not one gospel, it brought a half-dozen." For Dell, modern art was a catalyst for new poetry at a time when influences of cubism and cubo-futurism made most contemporary poetry and prose appear antiquated.[24]

Dell's views set the tone of his 57th Street salon, and during the summer of 1913, he and his bohemian confreres came to accept "almost any modern theory" that advanced a free-spirited way of life. Garrulous bohemians held forth for hours on end, and Dell and writer Sherwood Anderson, and Magaret Anderson observed, would "talk to chairs if they had no other audience." "We were confused, miserable, gay, and robustly happy all at once," Dell later confided. "Perhaps we were groping hot-bloodedly toward friendship; perhaps we were in a desperate scramble after a lifetime's happiness; we hardly knew, and would never know."[25]

Led to the Dell-Currey salon by his artist brother, Sherwood Anderson found a milieu receptive to his artistic pursuits. Nicknamed "Swatty," Anderson had abandoned a successful Ohio business and a Chicago copywriter's job. Anderson, though not formally educated, a poor speller, and unread in Greek or Latin, developed a proto stream-of-consciousness approach that abolished traditional narrative with a disjointedness of form —fragments of memory and experience — that, Robert Crunden observed, "made incompletion an artform." Some of the earliest examples of its kind in America, Anderson's prose exhibited a frank treatment of sex and culled from his earlier rural experience — work-a-day jobs, and laborers' rooming houses— the subject matter of his fiction.[26]

The salon's comradeship was for Anderson "something of the fervor that must have taken hold of those early Americans who attempted to found communistic communities. We were, in our minds, a little band of soldiers who were going to free life (first of all, to be sure, our own lives) from certain bounds." An engaging conversationalist, the divorced Anderson attracted bohemian women and engaged in sex as a spiritual act. Years later he reflected:

"it wasn't exactly free love we wanted. I doubt that there was with us any more giving way to the simple urge to sex among us than among the advertising and business men among whom I worked.... Indeed sex was to be given a dignity."[27]

* * *

Visitors to the 57th Street colony lived in a city that required of them a second job or a wealthy companion for economic survival. Apart from the *Friday Literary Review* and *Poetry*, Chicago lacked publishers to disseminate new work; its newspapers, like most in America, traditionally carried poetry as column filler, thus hindering most writers from full-time artistic careers.

Margaret Anderson, a former *Friday Literary Review* book reviewer, vowed to improve this situation by founding an independent literary magazine. Devoted to modern verse and dynamically resourceful, she seemed ideally suited for the task. Beautifully slender and blonde, Anderson was a rebel in tailor-made robin's egg blue suits. Up to 1908 twenty-one-year-old Anderson had led a leisurely country-club life of a college dropout in her native Columbus, Indiana, until she vowed "to escape mediocrity." In Chicago she rented modest rooms and worked at Browne's Bookstore in the Fine Arts Building, where Harriet Monroe had associated with the Little Room salon and that housed Englishmen Maurice Brown's Little Theater, the country's first experimental stage venue. At Browne's, Anderson attracted the amorous attentions of its proprietor and *Dial* magazine editor, Francis Fisher Browne. Though unable to win Anderson's affection, Browne taught her magazine-editing skills, layout, and design. Because she detested established groups and considered America "clogged by masses of dead people who have no conscious inner life," Anderson soon fell in with the 57th Street colony's bohemian writers.[28]

Anderson founded the *Little Review* by soliciting funds from friends and published in its first issue (March 1914), contributions by Dell and Sherwood Anderson. The *Little Review* printed excerpts from Russian-born painter Vassily Kandinsky's seminal work *Concerning the Spiritual in Art* (1912). This slender volume of neosymbolist ideas about the effect of colors intensified Anderson's obsession with "spirit's" role in the creative consciousness, and she heeded Kandinsky's warning that copying aesthetic expressions of the past would result in stillborn art.

To Anderson, politics were no less important. She embraced anarchism with a passion equaling that of her devotion to modernist aesthetics. Shortly before Emma Goldman met Anderson, America's firebrand of anarchism discovered the *Little Review*, remarking, "At last a magazine to sound a note of rebellion in creative endeavor! The *Little Review* lacked clarity on social issues, but it was alive to new art forms and was free from the mawkish sentimentality of most American publications." Anderson saw in anarchism and art two realms of freedom, writing in the *Little Review* that they were "in the world for exactly the same kind of reason."[29]

A year after the *Little Review*'s founding, Anderson fought to keep it in print, avoiding back printing costs and creditors through her beauteous charm. That summer, Anderson, without rent money, commuted from her *Little Review* office in the Fine Arts Building to Lake Michigan's beachside. There Anderson, her sister Lois, *Little Review* associate Harriet Dean, along with her black domestic, lived in tents, cooking by campfire; Anderson reputedly laundered her one set of clothes in the lake. In February 1916 she met her lover Jane Heap. A Little Theater actress, Heap became the *Little Review*'s editor, and her "wit and ability to extemporize brilliantly complemented Margaret's beauty, poise, and elegance, giving Chicago for a time its own Gertrude and Alice."[30]

During the summer of 1915, journalist Ben Hecht and bohemian poet Maxwell Bodenheim visited Anderson's beachside commune daily, leaving amorous messages pinned to her tent flap. New York City-born and raised in Racine, Wisconsin, Hecht, before coming to Chicago after graduating from high school in 1910, had traveled as a circus daredevil, played in a saloon orchestra, and read hundreds of books from the family library. In his early Chicago years, Hecht took newspaper photos of crime scenes and covered murders and hangings.

Hecht, desirous of becoming a serious writer, attended Dell and Currey's salon where he befriended Anderson and Bodenheim, the hard-drinking seducer of women from Hermanville, Mississippi. Bodenheim, a *Poetry* and *Little Review* contributor, arrived in Chicago during the summer of 1914 after being dishonorably discharged from the army. Arrongantly dandyistic, Bodenheim, or "Bogie," had a sardonic wit and a poet's gift for words. Soon after, he and his new friends, Hecht and Polish-born painter and sculptor Stanislaus Szukalski, formed the Vagabonds. Meeting in Szukalski's top-floor studio in the Kimball Building, the Vagabonds brought women to its gatherings, who sat at Bodenheim's feet lighting his hand-carved, four-foot pipe.

Emerging from the Vagabonds and the Dell-Currey salon, in early 1915 Hecht, Bodenheim, and Szukalski founded an experimental theater and intellectual forum, the Questioners, housed in a tin-roofed apartment on 57th Street, where they spoke on Nietzsche, anarchy, free love, and French decadence. Hecht and Bodenheim also founded, with sculptor Lou Wall Moore and Elizabeth Bingham, the Players Workshop on 57th Street, co-writing and producing several one-act plays. Hecht's one-act play, *Dregs*, shocked and outraged locals on opening night, when, in an Ubuesque opening, a homeless figure, studying his reflection in a saloon window, announced, "Jesus Christ, I'm a cross-eyed son-of-a-bitch if I ain't!" After this pronouncement most left the theater. The disheveled man, convinced that he sees Jesus in the window's reflection, invited his new friend to seek shelter in a nearby brothel — a gesture of goodwill broken with the sudden realization that he is talking to himself. *Dregs* did not last past its third performance.

If not the most talented of Chicago's literary scene, Hecht and Bodenheim were its brilliant pranksters; mockers of fellow artists, they wickedly dueled in

print. Temporarily editing the *Little Review* they composed rejection letters, spelling out the inferiority of contributors' work. Bodenheim, under a pseudonym, thumbed his nose at the emerging European poetic schools of isms by proposing a worldwide "Monotheme" school that called upon all poets to write under one theme, the first being bottles. Hecht took his high jinks to the Chicago streets, once writing verse about a criminal awaiting death row and selling it through the assistance of sandwich vendors who, upon his instruction, wore nooses around their necks.

* * *

For all its activity and creative talent, the 57th Street colony proved short-lived. By 1917 Chicago's bohemia had shifted northward to downtown offices and residences near the Loop, where Sherwood Anderson's Cass Street apartment served as a central meeting spot. Bohemians crowded into Towertown's community of dilapidated houses lining Chicago Avenue, while nearby ethnic neighborhood restaurants offered bohemian atmosphere. Others flocked to Clark, Dearborn, and LaSalle streets on the near north side and to Jack Jones' famed bohemian establishment Dill Pickle, at 22 Tooker Place. Occupying the second floor of a former carriage house in a row of similar outbuildings making up "Tooker Alley," the Dill Pickle had a colorful proprietor, a one-eyed freelance anarchist and saboteur, "a safe blower" who supposedly lost several fingers in a failed bomb attempt. According to poet Kenneth Rexroth, Jones "would have made a wonderful beatnik," because even when conversing with "the grocery man or the letter carrier, [he] sounded like Tristan Tzara and Gregory Corso both talking at once."[31]

For Sherwood Anderson, the Dill Pickle "had a touch of the bizarre, the strange." The Dill Pickle had a coffee bar, little theater, and dance hall. Its poetry readings attracted neighborhood "respectables," who whispered fearful comments during the events; on the Pickle's flat roof, bobbed-haired women and young men talked of Nietzsche, Pierre Joseph Prudhomme, and Havelock Ellis. Scholars and moral crusaders lectured. One evening, a female anti-tobacco activist received the audience's taunts, who called out that her face could have scared Christ off the cross. Jones' crudely painted little theater sets held one-act stage productions, works from Shaw to Weidekind. Ben Hecht's *Dregs* (once again it drove out most of the audience) appeared on a triple bill with *Cocaine* and George Cram Cook's and Susan Glaspell's *Suppressed Desires*.[32]

Though the Dill Pickle remained open into the 1920s, Chicago's Renaissance had already faded by the time America entered World War I. In defining their modern times, Chicago's bohemians flirted with modernist poetry, anarchism, and free love, and between 1912 and 1917, for artists and jazz musicians on their way to New York City, Chicago was the "stop-over capital."[33] On the stage and in print, Anderson and others helped transform American culture, laying the foundations for the flaming youth of the 1920s.

IV

"City of Ambition"

Modernism's Storm Center

Symbolizing modernity's rapid pace, Alfred Stieglitz's photograph *Old and New New York* (1910) depicts a new high-rise looming over rows of nineteenth-century edifices. Marcel Duchamp envisioned New York's rising skyline and its sprawling development as a harmonious "work of art," its growth "like "ripples that come on water when a stone is being thrown on it." Yet artists like Duchamp were typically branded foreign menaces in a city that one conservative critic derisively described as the gateway of "Ellis Island art." In an aesthetic conflict involving many warring factions and isms, the 1910s saw the American artistic avant-garde make its first advances and win its first converts.[1]

In 1910 immigrants made up forty percent of New York's five million residents, and the city's publishing houses, galleries, and theaters were unparalleled in the nation. New York's cultural gravitational pull brought eastward Chicago bohemians Floyd Dell, Margaret Anderson, and George Cram Cook, followed by Ben Hecht and Maxwell Bodenheim, as well as Oregon-born John Reed, who arrived by way of Harvard to establish a new world in a new century. In bohemian and high-modern venues, tradition's subverters, political and nonpolitical, plotted and established vital patronage and publishing connections, making possible the exhibiting and staging of experimental works. Linked to these countercultural activities, little magazines like *Camera Work*, *The Masses*, and *The Seven Arts* helped spread the rebellion's iconoclastic message.

* * *

New York's 1913 Armory Show stirred public opinion, riled reactionaries, and created media stars out of thirty-four-year-old dadaist Francis Picabia and his wife, Gabrielle Buffet. Stieglitz, in the Armory Show's aftermath, still exhibited some European modernist works, yet he vowed that if he could have foreseen the Europeans as gaining notoriety at the expense of American artists, he would have put his foot through European works displayed at 291.

Two years after the Armory Show, Stieglitz's Parisian-influenced inner circle — Steichen, Marius de Zayas, and Paul Haviland — questioned the role of 291's impresario as American modernism's guiding spirit. In 1915 de Zayas and Haviland joined Agnes Ernst Meyer and Katherine Rhoades in establishing 291's commercial outlet, the Modern Gallery. Overcoming his initial disapproval of this venture, Stieglitz contributed monetarily and gave support to de Zayas and Haviland's avant-garde publication *291*, founded in 1915. As the war intensified, Stieglitz, claiming to be "pro-nothing" but sympathetic to Germany defended a German submarine's sinking of the British Cunard liner *Lusitania* on May 7, 1915. Unwilling to condemn German aggression and disdaining the patriotic fervor sweeping America by 1917, Stieglitz hoped for American neutrality and believed that the conflagration might bring positive change. This viewpoint enraged many fellow artists, even as new talents, photographer Paul Strand and painter Georgia O'Keeffe, joined his ever-changing circle.

In 1917 wartime prohibition and a curtailment of staple agricultural product sales reduced his wife's finances — her family's brewery business was Stieglitz's main patronage source — thus contributing to 291's and *Camera Work*'s demise. But before 291's closing, Stieglitz dedicated his last exhibition in the spring of 1917 to O'Keeffe, celebrating a quintessential American artist, his great "woman on paper," who eventually joined him in marriage and in defining modernism's "American moment."

Voices of Young America

Not long after 291's closing, poet William Carlos Williams admired how Stieglitz overcame "colossal difficulties" in championing the American avant-garde. Over the following decades, Stieglitz stayed close to leading critics and literary visionaries — such as Sherwood Anderson and those of the short-lived publication *The Seven Arts* — who shared his cultural views. One of 291's many literary visitors, Williams closed ranks with other word experimenters who embraced avant-garde visual art, cubism and cubo-futurism, containing multi-perspective and the exploration of a hidden inner world.

Aware that their experimental creative efforts lagged behind the visual arts, modernist-oriented poets and novelists rethought their creative roles. At the same time, numerous independent publications in New York supported modern art and literature, while others, in the spirit of H. L. Mencken and Jean Nathan, battered bourgeois mediocrity. Immersed in popular Freudian theories, writers combined psychoanalysis' teachings with socialism, and produced insightful popular essays and written works. Premier in this cause, *The Masses* voiced radical political and social ideas, and its provocative illustrations attracted thousands of subscribers, including O'Keeffe, who found in its stark black-and-white illustrations modern designs devoid of the subtle shade and detail of traditional magazine illustrations.

Founded in 1911 as a forum for socialist uplift, *The Masses* seemed destined for financial ruin; a year later, under Max Eastman's editorship, it became a nondoctrinaire socialist monthly, discussing Freud, anarchism, pacifism, feminism, free love, and birth control. Inheritor of the little magazines' muckraking tradition, *The Masses*' layout took as its models various left-leaning European publications such as the German *Simplicissimus*, French *L'Assiette au beurre*, Italian *L'Asino*, and Dutch *De Notenkraker*.

Eastman — a Columbia University philosophy instructor, verse writer, and novelist — shared with his *Masses* co-editor, Floyd Dell, the "Lyrical Left" objective of fusing socialism and art. In a period before the 1917 Bolshevik Revolution when intellectual and political thought was not dominated by communist party politics, Eastman, a student of John Dewey, blended pragmatism and socialism, supported feminist Margaret Sanger's crusade for birth control, and utilized *The Masses* in the establishment of a collective commonwealth.

Primarily socialists hailing from economically comfortable families, *The Masses*' staff, while rejecting bohemia's extreme individualism, approved of its working-class simplicity and free-love practices. But most mainstream American socialists considered bohemia's hedonism as anathema to a working-class cooperative commonwealth. Averse to Village artiness, the elegantly Eastman wrote that "it was a war of Bohemian artist-rebels against the socialists who loved art," and he fought to distance the Masses from the "artificial, sex-consciousness" of Greenwich Village's "Bacchantes." Yet independent Village socialists living bohemian lifestyles saw no contradiction in their not directly participating in the working-class struggle. "In those prewar days," emphasized Malcolm Cowley, "the two currents were hard to distinguish. Bohemians read Marx and all the radicals had a touch of the bohemian: it seemed that both types were fighting in the same cause."[2]

The Masses' socialist critic's condemnation of its bohemian tinge led to heated arguments over the legitimacy of modernism. Anti-modernist John Sloan mocked the Armory Show in a *Masses* cartoon depicting a box-like figure — "the cubic man" — titled "A Slight Attack of Dementia Brought on by Excessive Study of the Much Talked of Cubist Pictures in the International Exhibition in New York." Though the magazine occasionally carried Sherwood Anderson's short stories and Mina Loy's poetry, Eastman and Dell — opponents of imagism and T. S. Eliot's poetry — vowed that literary experiments would never overshadow *The Masses*' commitment to the working-class struggle.[3]

Regardless of its editors' ambiguity about modernism, *The Masses* was not, as most scholarship suggests, devoid of an avant-garde aesthetic (it once printed a Picasso drawing). Its illustrators ranged from realist newspaper artists— Sloan, George Bellows, Art Young, and Robert Minor — to lesser-known artists like Hugo Gellert, whose advanced illustrative designs impressed Stieglitz and Georgia O'Keeffe. Marginally known and mostly immigrants, the magazine's vanguard artists, including Frank Walts and Ilonka Karasz (whose

work later graced *The New Yorker*), created *The Masses'* most aesthetically advanced content—flat-plane black-and-white images, ideally suited to the printing process.

But cultural rebels looked to *The Masses* less for its aesthetics than for its writing, and the publication thrived until the United States government forced it from the mails in 1917. Yet its demise came at a time when young Greenwich Villagers increasingly considered much of its content as "old-fogeyism." *The Masses'* lasting contribution remained its gritty journalistic style, and, above all, its illustrations, which fascinated Georgia O'Keeffe and social realists who made their creative mark in the 1930s.

* * *

The Masses' end resonated among radicals as did Randolph Bourne's early death from influenza weeks after the Armistice ended World War I. A visionary cultural radical and John Dewey's student at Columbia, Bourne once wrote that he longed to "be a prophet, if only a minor one"—a messianic longing he attained by gaining a cult-like following. Bourne's readers delighted in his attacking sentimental Victorian culture, progressivism's piecemeal reforms, ethnic amalgamation, and America's involvement in a world war that he warned would greatly strengthen the state.[4]

John Dos Passos remembered the diminutive Bourne, hunchbacked, fiery-eyed, a "tiny twisted ghost in a black cloak," making his way across Washington Square. Despite his living in the Village, Bourne was never at home among the oddly dressed bohemian "Village crazies," whom he considered as basking in "mere playfuless." Bourne had never intended youths to abandon familial bonds or social responsibility for a hedonistic life and whimsical experiment.[5]

Nonetheless, Bourne attracted a bohemian-minded audience — readers of his essays for *Columbia Monthly* and the *Atlantic* that were subsequently collected in *Youth and Life* (1913). Though *Youth and Life* sold only 4,000 copies, it helped shape the Village's nonconformity. Villager Gorham Munson praised the book as having "taught us to dodge social and family pressures that made for a narrow life."[6]

Joining *The Seven Arts* in 1917, Bourne infused it with anti-war essays, endangering the publication at a time of heightened xenophobia and the threat of the Espionage and Sedition Acts. Founded by James Oppenheim and Waldo Frank in November 1916, *The Seven Arts* also attracted music and art critics Paul Rosenfeld, Van Wyck Brooks, and later Bourne—collectively known, along with others, as the Young Americans. The voice of a cultural renaissance that urged the overthrow of genteel culture and the removal of a lingering "Puritan past," *The Seven Arts* also criticized the workers' dehumanization by the division of industrial labor that replaced their roles as artisans and craftsmen.

Though the *The Seven Arts* defied bohemia's vagaries by taking an office on Madison Avenue, it shaped its way of life. Inspired by Van Wyk Brooks'

America's Coming of Age (1915), *The Seven Arts*—devoid of illustrations and cartoons—had among its contributors Theodore Dreiser, Sherwood Anderson, Carl Sandburg, Eugene O'Neill, and D.H. Lawrence. Through Frank's and Rosenfeld's immersion in 291's aesthetics, *The Seven Arts* became, as Bram Dijkstra asserted, "an amplification of what Stieglitz stood for." Rosenfeld, drawn to modern art through the music of Stravinsky and Alexander Scriabin, became 291's premier spokesman and described Stieglitz as a "great affirmer of life." Frank deemed 291's impresario a "Jewish mystic"—a modern-day Whitman striving to foster unique American art.[7]

The Young Americans also looked to Nietzsche, Freud, Bergson, and, to a lesser extent, Marx; they drew heavily upon William James and especially John Dewey, whose support of World War I later led the Young Americans to turn on their mentor. Most influential in shaping the Young Americans' intellectual outlook, Dewey outlined a significant role for the arts in a new society. Dewey had insisted in *Art and Experience* that art should speak directly to the public and that it not be held captive in museums or created to fill wealthy parlors. By throwing off genteel dominance, art would once again, as it had in earlier ages, be returned to the people. But most progressive-era Americans of genteel means viewed culture as intellectually edifying, yet subordinate to religious-based morality. Against these prevailing forces the Young Americans set the rebellion's course by implementing usable elements of the past and differentiating, within modern culture, between the viable and the disposable.

For the Young Americans cultural renewal required removing Puritanism's lingering shadow. Yet in despising so-called Puritanism, they held a distorted historical interpretation of a religious people who were neither teetotalers nor averse to premarital sex. More accurately, they warred with Victorian middle-class culture and its New England Anglo-Saxon past, an ethos that had flowered into a way of life that the Young Americans believed oppressed Americans sexually and prevented the rise of true democracy and a viable and ethnically diverse culture.

Central to Bourne's "trans-national" America, ethnic diversity co-existed in a direct democracy that countered the progressive era's notion of a "melting pot." The Young Americans welcomed immigrant Jewish culture, and Waldo Frank emphasized the inherent value of Native American and Mexican folkways—multicultural contributions that would enrich America. But like the progressive reformers, they rarely discussed African-Americans, who ironically were to play a major role in the country's cultural transformation. Whereas European 1910s avant-gardists like Picabia and Duchamp found Harlem's world of entertainment fascinating, the Young Americans did not foresee, or failed to include, African-Americans as playing a role in America's cultural renewal.

Claiming that America had no true cultural tradition, except perhaps the lone voice of Whitman, Rosenfeld and Frank believed those like Stieglitz would cultivate true American art from vernacular experience. The Young Americans

embraced Brooks' notion of a "usable past" and his pioneering concept of a cultural divide between "lowbrow" and "highbrow" that prevented America from cultivating its own unique art, and they searched for indigenous cultural elements that had, since Whitman, faded into Anglo-Saxon gentility.

Art's emancipation from Anglo-Saxon dominance allowed for a greater spiritual communication, making possible an organic society. But by insisting that art have social purpose, the Young Americans burdened it with socio-political ends. Brooks feared that aesthetic experiments without social purpose could make for a new artistic elite. Far more receptive to modernist aesthetics, Frank and Rosenfeld, influenced by Stieglitz, believed in capturing from experience — in pure poetic form, photographic art, and frozen moments on canvas — what Bram Dijkstra has termed "the American Moment," aesthetic expression enabling one to interpret, from the microcosm of experience, a macrocosmic universe.

Rarely addressing modern art, Bourne did praise Amy Lowell's imagist poetry as revolutionary and that it, like all great poetry, should not be "a refined dessert to be consumed when the day's work is done, nor as a private hobby which the businessman will deride if he hears about it, but as a sound and important activity of contemporary American life." Art was to serve America's cultural and political transformation, and for Bourne the youthful life meant openness to new ideas and perpetual enlightenment within a "beloved community" — enriched by its citizens' creative contributions.[8]

Assemblages of a Different Kind

Upon Bourne's death in 1918 Stieglitz lamented the loss of a brilliant visionary. Not long after, Waldo Frank attributed the failure of fusing art and politics to the fact that "The men who listen to Stieglitz have not yet quite joined him in their mind with the examples of Bill Haywood. And the readers of socialist pamphlets have not heard of 291."[9]

Yet numerous modernist-anarchists and social utopians had befriended Stieglitz, among them, eminent New York salon hostess Mabel Dodge. Member of a wealthy Buffalo, New York, family, Mabel (née Ganson) lived in with her second husband, Edwin Dodge — a successful Boston architect — in an Italian villa near Florence.

Over time, Dodge, longing for more stimulating surroundings, experienced a long-awaited revelation in 1911 while visiting the Steins' salon at 27 rue de Fleurus. There, Gertrude and Leo introduced Dodge to modernism, of seeing the world through new prisms of perception. After visiting Paris, Dodge took a copy of Gertrude's *The Making of Americans* back to Florence, considering it a marvel of imagination. Though not a systematic intellectual thinker, Dodge perceptively saw in Stein's literary experiments words used to express the "thing in itself" — words equivalent to postimpressionist painting possessing the power to alter one's perceptions.

In 1912 Dodge and her husband took an apartment at 23 Fifth Avenue, near the edge of Greenwich Village. Soon after, she befriended, through sculptor Jo Davidson, former muckraker Lincoln Steffens, whose encouragement led Dodge to establish an unconventional salon, a center for experiments, which she, in a gesture of shedding her fin-de-siècle sensibility, decorated in all white. Nondoctrinaire, she urged visitors like Big Bill Haywood, Max Eastman, Margaret Sanger, Emma Goldman, and Freudian analyst A. A. Brill to express themselves openly. She also presided over spiritualist rites and an evening of peyote use,* was organized by a guest familiar with Native American religious rituals. To simulate a campfire, red tissue paper was placed over a light bulb, a vase doubled as a drum, and strip of cheese cloth was spread on the floor to symbolize the "peyote path."[10]

Initially an open affair, Dodge's salon eventually imposed a guest list. Two ideologically diverse speakers were typically invited to engage in spontaneous verbal interactions that Dodge believed would soon replace, in their direct communicative power, the written word. Arguments were frequent; one evening sculptor Jane Scudder interrupted Haywood's defense of proletarian art by passionately asserting the artist's individuality. Not all attended for the discourse. The more impoverished waited until midnight when Dodge's Florentine butler opened the drawing room and ushered guests to a table laden with turkey, ham, and other foods.

As a patron of the arts, Dodge soon involved herself with the Armory Show and, like Stieglitz, served as an honorary vice president of the Association of American Painters and Sculptors. She lent money and personal support to the exhibition and envisioned the event as her "own little Revolution," as she promoted, in an article published in *Arts and Decoration*, Gertrude Stein's writing. In her memoir she also told how "I suddenly found myself in a whirlpool of new, unfamiliar life and if Gertrude Stein was born at the Armory Show, so was 'Mabel Dodge.'" Dodge also visited 291 and considered Stieglitz as "the only man in America" responsible for aiding "young artists who were trying to break away from the academic conventions"—visits that resulted in her befriending painters Marsden Hartley and Charles Demuth.[11]

Dodge's avant-garde education benefited by her meeting Carl Van Vechten in 1913. A writer and *New York Times* music critic, Van Vechten met Dodge after returning from Paris, where he had attended 27 rue de Fleurus and the riotous 1913 premiere of Stravinsky's *Le Sacre du printemps*. Protruding teeth, bushy red hair, and a lanky frame physically defined Van Vechten, a boisterous bisexual who dabbled in drugs and hosted orgiastic parties. Accompanying Dodge to the Metropolitan Opera House, he introduced her to symphonic music outside

*In his memoir, Enjoyment of Living, Max Eastman, who attended the peyote party with his wife Ida Ruah and Hutchins Hapgood, told how he could not swallow the bitter buttons, and that he saw Mabel Dodge slipped her peyote buttons under her dress.

the Germanic classical tradition. Enamored with African-American culture, Van Vechten once invited a black banjoist and a black female singer to Dodge's salon; the singer's writhing and lascivious manner appalled Dodge, a woman supposedly open to all matters of sex. Van Vechten never brought such guests again.

Dodge joined *The Masses'* advisory board in January 1913 and four months later met the magazine's poet playboy, John Reed. Raised in an upper-middle-class Portland, Oregon, home and once a member of Harvard's cheerleading squad, Reed lived in the Village churning out, under Steffens' influence, brilliant journalistic work in the spirit of Jack London's outdoor adventurer life. Reed's rebellious temperament exemplified the eclectic socialism of *The Masses* variety. He visited the Armory Show several times and, according to Steffens, likened the cubists to World War I. Reed epitomized what John Diggins has called the Lyrical Left, with its fusing of poetry and radical politics.

Reed's striking personality captivated Dodge. Though short-lived, their torrid love affair led to the Patterson Strike Pageant in 1913, which drew 15,000 people to Madison Square Garden. Reed's arrest during the 1913 World War I–led silk workers' strike in Paterson, New Jersey, gave much-needed publicity to their cause, and Dodge conceived a pageant that would raise money for World War I's depleted strike fund. The 1913 Paterson Pageant benefited from Reed's publicity efforts and skills as the event's producer. The pageant which vividly depicted the strike, brought onto the Madison Square Garden's stage hundreds of strikers turned actors, as thousands of workers and uptown society types attended. Though failing to raise money for the Paterson strike that was eventually lost, the pageant stimulated a vanguard activism aiming to transform through culture the existing capitalist order.

As with so many of her interests, Dodge's flirtation with radical activism and her outspoken opposition to World War I ended with her retreat from New York City, first to the quietude of a Croton-on-the-Hudson mansion in 1916, then to Taos, New Mexico, where she would experience a final revelation of place.

* * *

Contrasting with Dodge's aesthetic capriciousness, Walter and Louise Arensberg hosted New York's most advanced salon. Independently wealthy avant-garde art collectors, the Arensbergs lived comfortably, befriending artists, composers, poets, and dadaist provocateurs. Walter Arensberg experienced a revelation at the Armory Show. By the close of the exhibition's three-city tour in Boston, he had purchased several modern works, initiating his role as a collector of avant-garde art and artists. The Arensbergs' salon, like that of the Steins, displayed advanced works in an atmosphere of drink and conversation. In Marcel Duchamp, poets Williams Carlos Williams and Wallace Stevens, and composer Edgar Varèse, modern art, poetry, and music were brilliantly

represented. At the Arensbergs, wrote Robert Crunden, "Europe and America not only met and intermingled, but cross-fertilized: sexually, obscenely, mechanically, comically, interdisciplinarily, linguistically, and even artistically."[12]

Walter had studied English and philosophy at Harvard and spent time playing chess. Graduating *cum laude* from Harvard in 1900, he then sojourned in Florence and Berlin and lived for a time as a Parisian Left Bank bohemian. Back in America he worked in journalism, wrote poetry, translated Dante and Mallarme, and married a wealthy music student, Louise Stevens, in 1907. The couple lived in Boston until the Armory Show prompted them, in the fall of 1914, to take a spacious New York City two-floor apartment at 33 West Sixty-seventh Street. Initially dominated by Walter's literary friends, the salon came to be populated by artists and a few of the Village fringe. Guests typically arrived unannounced and conversed or played chess into the early hours. Louise, quiet, reserved, and rather plain, often attended the opera or visited friends. Back by midnight, she wheeled out an hors d'oeuvres and dessert cart that, Williams Carlos Williams recounted, offered a spread of "ample feed with drinks to match."[13]

On the Arensbergs' seventeen-foot-high walls hung works by Renoir, Cézanne, Picasso, Braque, Matisse, Derain, Picabia, and their salon's leading light, Marcel Duchamp. In 1915 Duchamp and Picabia arrived in New York within days of each other, bringing to the city two of the leading figures of what became known as New York dada. Through Walter Pach's introduction, Duchamp became the "centerpiece" of the Arensbergs' Sixty-seventh Street salon. Though he fell in with an expatriate French circle, Duchamp considered America the "country of the future" and Europe as decayed, the dustbin of art. Guided by Charles Demuth, Duchamp — now thirsting for American hard liquor — delightedly visited Greenwich Village dives and Harlem's Little Savoy, and other African-American venues, which also inspired Picabia's and Demuth's watercolor depictions of its vibrant entertainers.

After several visits, Duchamp found Dodge's salon intellectually boorish and initially thought Stieglitz "a kind of Socrates." Upon meeting the Arens-bergs, Duchamp encountered an atmosphere receptive to his anti-art sensibility.

New York dada predated by several months Zurich's iconoclasts— Tristan Tzara and others— who, in 1916, coined the term dada for their outlandish aesthetic experiments. Rooted in Benjamin De Casseres' writings and Marius de Zayas' works, New York dada flourished with the presence of Duchamp, Picabia, Man Ray, the maniacal Arthur Cravan, and the mad Baroness Elsa von Frey-tag-Loringhoven. Sharing Zurich dada's belief in "play as its highest human activity" and chance "its main tool," New York dada, being distanced from the carnage of war, took on a more lighthearted, whimsical air. Neither a move-ment nor an established school, New York dada thrived upon humor, paradox, and scandal. Dada's anti-rationality turned the conventional notions of art and

society on its head; by mocking and deconstructing the traditional, this short-lived movement had profound long-term effects on twentieth-century avant-garde art.[14]

One of anti-art's founders, Duchamp savored contradiction, enigma, and rebellion against traditional aesthetics that coincided with the search for a fourth-dimensional experience, illuminated, he believed, only by randomness. Because Duchamp considered America's skyscrapers aesthetically superior to European architecture, he advocated the latter's demolition in that 'the dead should not be permitted to be so much stronger than the living." He shared, along with Arensberg, the futurists' fascination with the machine as tradition's ultimate destroyer. As Arensberg contended: "Man made the machine in his image. She has limbs, which act as lungs, which breathe; a heart that beats; a nervous system through which runs electricity. The phonograph is an image of his voice, the camera the image of his eyes."[15]

Duchamp's befriending of Arensberg came at a crucial time when he abandoned painting to pursue his readymades. While still in France, Duchamp conceived of readymades—everyday items given whimsical, ironic titles, and premised on the idea of their being willed art. A New York hardware store's snow shovel became Duchamp's first American readymade; he proudly carried it gun-like over his shoulder to his apartment and suspended it from the ceiling, naming it *In Advance of the Broken Arm* (1915). Other objects followed, including a bicycle wheel mounted on a stool and an upturned urinal.

Duchamp lived in bohemian simplicity. He often gave works away to friends or sold them for modest sums, while surviving on his father's stipends, earnings from giving French lessons, and monetary donations from female admirers. Actress turned artist, Beatrice Wood described her dadaist friend's studio, cluttered with readymades and a chessboard, as "a typical bachelor's niche, with a wall bed, usually unmade, projecting in the middle of the room, with a table and chair nearby."[16]

Years later, Duchamp recounted that his life during the 1910s "was really la vie de bohème, in a sense, slightly gilded—luxurious if you like, but it was still a bohemian life. Often there wasn't enough, but that didn't matter." Proud of his vocation and possessing a somewhat dandyish persona, Duchamp later asserted that "Helping artists was a virtue of rich people," and that the businessman, like himself, fulfilled a purpose. In an agreement that he would become the owner of Duchamp's *Large Glass* (1915–1923), Arensberg subsidized the artist, and for a time provided him a room at West Sixty-seventh Street. Not burdened by the workaday world, Duchamp, as an artistic anarchist, did not wage war against what a later generation called "the establishment." Later in life, after supposedly abandoning art for chess, he claimed his sole purpose was that of a "respirateur"—one who breathes.

Notoriety little affected Duchamp's cultivation of self-styled indifference, and yet his claim of being averse to publicity was a subtle subterfuge. A

September issue of the *New York Tribune* printed the article "The Nude Descending-a-Staircase Man Surveys Us," with a photograph showing an aloof, expressionless Duchamp reclining in a folding canvas chair. In the article the artist extolled American women as "the most intelligent of her sex," declared America the center of new art movements, and pronounced Europe "finished, dead." Though Duchamp derided Picasso's media stardom, his own works gained celebrity, and, in contradiction to his anti-art stance, found their way into private collections and museums. Being formally recognized by the art establishment as a producer of art put the dadaist in a precarious position. Duchamp well knew that to court popular success would bring familiarity and threaten his freedom as a detached artist living by creative whim, yet he met recognition with calculated indifference and mocked it with humorous insincerity.[17]

Dadaist painter and photographer Man Ray, like his friend Duchamp, did not "want the public's attention," and insisted that "If there's one person interested in what I do, then I consider myself a success from a social point of view." Man Ray later balanced his defiant anarchistic sensibility by willing to work for the advertising industry and, like Stieglitz, sought wealthy benefactors. Allied with Duchamp and Picabia, Man Ray was the only American-born member of New York dada's triumvirate. A student of Robert Henri, he frequented 291, visited the Armory Show, and for a time fell under the influence of vorticism. His anarchism prompted him to contribute cover illustrations for Emma Goldman's *Mother Earth*.[18]

Supportive of dada experiments, the Arensbergs mingled with outside provocateurs as well; gatherings at their salon were far from quiet. Stieglitz, an occasional visitor, found them "too rambunctious for his liking." Two of their visitors, Arthur Cravan and the Baroness Elsa von Freytag-Loringhoven, epitomized in public gestures and spontaneous acts "living dada."[19]

Swiss-born pugilist-poet Cravan, whose reputation preceded him when he arrived in New York in 1917, made newsworthy dadaist scandal. As the amateur light-heavyweight champion of France, Cravan turned the boxing ring into an artistic spectacle, chiding his opponents by calling out to the audience his real and imagined achievements. If he informed them apocryphally that he had been a muleteer, snake charmer, or gold prospector, he rightly claimed to be Oscar Wilde's nephew and a sailor who once jumped ship in Australia. As self-publisher and editor of a little Parisian magazine, he excoriated artists and, noted Hans Richter, handed out deadly "insults as calmly as someone else might pass round chocolates." He mocked the participants of the 1914 Salon des Independents— scandalous and scathing commentary that, at the time, influenced young avant-gardists and surrealism's founder André Breton. He fell in with Barcelona's dada circle that included Picabia, and while there in 1916 fought Jack Johnson only to be knocked out in the sixth round.[20]

Most likely introduced to the Arensbergs by Picabia, Cravan played a part

in several important events. On April 10, 1917, members of the newly founded Society of Independent Artists, including Arensberg and its president William Glackens, held a ball at the Grand Central Palace honoring their first exhibition. Nearly twice the size of the Armory Show, the Independents exhibition displayed 2,125 works in alphabetical order by artist, as suggested by Duchamp. The exhibition's organizers, however, refused to show Duchamp's now legendary readymade, *Fountain*, an upturned urinal signed R. Mutt, recently deemed by a panel of experts as the twentieth century's most influential piece of art. *Fountain* was displayed at 291 and photographed by Stieglitz, but eventually lost.

Cravan plunged the Independents exhibition in scandal, when, upon Duchamp and Picabia's invitation, he gave a Washington Square Gallery lecture on April 19 entitled, "The Independent Artists of France and America." Inebriated and surrounded by an entourage of friends, Cravan, according to Man Ray, began his lecture by opening a valise on a table and throwing dirty linen at the audience. According to a *New York Sun* reporter, he faced the audience swaying and then fell. Hitting the speaker's table, he rose to his feet, and removed his coat, vest, and collar before house detectives rushed him to a car that whisked him to the Arensbergs' apartment.

Not long after, Cravan attended a costume ball held in tribute to the second issue of the little magazine, *The Blind Man*, published in the Arensbergs' apartment. This issue contained Duchamp's *Chocolate Grinder* and Stieglitz's photo of the *Fountain* along with an article entitled "The Richard Mutt Case." The poster for the Blind Man's Ball invited guests to attend an event "at ultrabohemian, prehistoric, post alcoholic Webster Hall." Wearing a bed sheet and turban crafted from a towel, Cravan entered the hall and stripped to the waist. Not to be outdone, near the end of the evening a drunken Duchamp climbed a flagpole on the dance floor and, in tribute to the other partygoers who looked on aghast, tipped his paper party hat.

Of the New York dadaists none compared in their ability to shock as did Duchamp's friend the Baroness Elsa von Freytag-Loringhoven. The baroness was a radical gender provocateur, artist's model, "sexual terrorist," performance artist, talented poet, and maker of dada assemblages, who, by her outlandish appearance and behavior, gained entrance to the leading salons of Europe and finally the Arensbergs' gatherings. Labeled by Robert Hughes as "America's first punk," the baroness is credited with the country's first found art piece, a rusted metal ring titled *Enduring Ornament* (1913).[21]

Born Else Hildegard Plotz in Germany, she studied drawing, painting, and acting, performed in Berlin vaudeville shows and chorus lines, and entered Munich's Kosmiker circle, who were Nietzschean Dionysians connected with poet Stefan George. Upon arriving in America in 1910, she lived for a time with writer Felix Paul Greve on a Kentucky farm, then went alone to Cincinnati and entered the theater scene. In New York City in 1913 she married a minor

German noble, Leopold von Freytag-Loringhoven, and for a short time lived luxuriously at the Ritz. When war broke out in 1914, the near-broke baron left his wife and departed for Germany. In Greenwich Village the baroness survived on handouts and by modeling her wiry, middle-aged body for artists. In her decrepit and object-filled apartment rooms, she kept stray dogs and caged birds. She was frequently arrested for shoplifting, lusted after Duchamp, and pursued with a stalker's passion her "friend-foe" William Carlos Williams. From her thin lips came German-accented ravings and insults; publicly she accosted onlookers, startling them with piercing green eyes and demanding, "Don't look at the woman's face, idiot! Look at the body! Here!" as she unabashedly ripped off her dress.[22]

Typically portrayed as a mad street woman, the baroness had artistic talents. Friend to Duchamp and Hart Crane, she inspired mention in Pound's *Cantos* and found a benefactor in writer Djuna Barnes. From stolen items and discarded objects, she made dada assemblages, portraits, and the readymade, *God* (1918), a "cast-iron plumbing trap turned upside down and affixed to a wooden miter box." As a contributor of poetry and criticism to the *Little Review* (work that appeared in the same issues serializing James Joyce's *Ulysses*), she become the magazine's "star" figure. "The Baroness," proclaimed *Little Review* editor Jane Heap, "is the first American Dada [...] when she is dada she is the only one living anywhere who deserves dada, loves dada, lives dada."[23]

An outrageous dada designer, the baroness made a hat from a coal scuttle lid and painted her shaved head vermilion. Stolen department-store costume jewelry and vegetables draped her body, and once she attached a taillight to her posterior. For socialist Joseph Freeman, she embodied "the revolt of handicrafts against the machine age, and the revolt of the sacred ego against the standardization of Main Street."[24] Driven to reinvent herself, the baroness' dada fashions never settled into uniformity, and she assembled her guises with the same purpose as her other artistic pursuits—constant experiment.

* * *

Equally accommodating as they were to the New York dadaists, the Arensbergs promoted experimental music at a time when most Americans had little or no contact with the musical avant-garde. French modernist composer Edgard Varèse arrived in New York in 1915 and encountered Duchamp's French circle. Treated to food and drink at the Arensbergs' salon, Varèse learned of Louise's passion for music from the baroque to Satie and that she entertained guests by playing Schoenberg's "Six Little Piano Pieces" (1911). But in Varèse the salon had a musical genius, later a hero to bebop jazzman Charlie Parker and Frank Zappa.

But avant-garde music was slower to infiltrate American culture than modern painting and poetry, and having no shocking Armory Show equivalent, modernist European music arrived during the 1910s with "similar frequency"

in Boston, Philadelphia, New York, and Chicago. As Carol J. Oja stressed in her *Making Music Modern*, the first two decades of the twentieth century were American modern music's "mysterious Paleolithic period," a time "when listeners were far more likely to hear Schubert than Stravinsky," while American modernist composer Charles Ives (1874–1954) created works in isolation. Though Ukrainian-born Leo Ornstein dazzled Stieglitz and others with his keyboard experiments, most modernist music performed in America was of European origin, and its followers read more about the music than they heard it played in concert halls.[25]

Under Bergson's influence, Varèse ventured beyond the futurists, whom he believed did not sufficiently seek the transitory in art. Varèse told a *New York Telegraph* reporter that since the conventional "musical alphabet" had been exhausted, musicians should work in conjunction "with machinery specialists" to produce new sounds. Tired of the piano's dominance and averse to violins, Varèse boldly announced, "I refuse to limit myself to sounds that have already been heard," and he subscribed to his former instructor Ferruccio Busoni's dictum: "The function of the creative artist is in making laws, not in following those already made."[26]

At New York City's Hippodrome in April 1917, Varèse received critical acclaim for his debut conducting Berlioz's *Requiem*. As guest conductor of the Cincinnati Symphony Orchestra in 1918 — a time when German music was banned or ostracized — he opened with Wagner's prelude to *Lohengrin*. Following selections by Bizet and Borodin, Varèse conducted Satie's *Gymnopédies* and Debussy's *Prélude à l'après-midi d'un faune*. Though the audience received the Cincinnati Symphony Orchestra's program with great favor, the scandal over Varèse's cohabitation with Louise Norton in a hotel room resulted in the tour's cancellation. To promote modern music and bolster its status in America, Varèse founded the New Symphony Orchestra in 1919 at a time, as Louise Norton recalled, when "the audience for the new music was not even small but nonexistent." The New Symphony's performance of Bartók's *Deux Images* and other modern works on the program were met with criticism, including James Huneker's *New York Times* review. Frustrated over the symphony's inner politics and failing in attempts to please genteel concertgoers, Varèse resigned in 1921.[27]

Portrayed by most scholars as a man much maligned in the media (criticism was primarily leveled at his conducting ability), Varèse did earn praise in newspapers and trade magazines, eventually becoming a 1920s "matinee idol of modernism." But he struggled financially at a time when, explained Aaron Copland, "there were few prizes and no stipends or fellowships at the disposal of the creators of music." Moreover, Varèse's experimental music efforts were fraught with setbacks and disputes that prevented his carrying out his transnational avant-garde vision.[28]

To allay his frustrations, Varèse befriended New York artists and attended

the Arensberg salon. Before coming to America, Varèse had met Debussy, Satie, and Stravinsky, but he preferred the company of scientists, poets, architects, and artists—Rodin, Picasso, Derain, and Gleizes. Once in New York he moved within a French expatriate circle that included Duchamp. No admirer of dada, Varèse, upon meeting Duchamp in 1915, nonetheless found him brilliantly charming, and two years later he encountered Picabia, reputedly the owner of 127 automobiles and an opium user who amazed Duchamp by his ability to consume alcohol. Rooming together, Varèse and Picabia, often nearly nude, regularly entertained young women, including Picabia's lover Isadora Duncan.

Later, in 1917, Varèse roomed with Italian-born painter Joseph Stella, a friend of Duchamp and the Arensbergs' salon guest, whose broken English added European sonority to the salon's French discourse. The lone American modernist painter to fall under futurism's sway—he had seen the 1912 futurist exhibition at the Bernheim–Jeune Gallery in Paris—Stella wandered New York's streets for artistic subject matter. Varèse deemed Stella a paradox of extremes, heavy-set yet graceful, delicate at times, yet often vulgar—a man of voracious appetite; Louise Norton described him as eating a "leg of roast lamb" that disappeared "into his enormous belly." Inspired by Whitman and Poe, Stella envisioned New York as a living mass of steel and electricity that shaped his acclaimed works *Battle of Lights, Coney Island* (1913) and *Brooklyn Bridge* (1919). To prepare for the latter work, he nightly visited the bridge, a structure he likened to a "weird metallic apparition." In both his life and work, Stella had an ambivalent relationship with the city. With his boisterous peasant's heart that harbored a futurist's love for modern urban landscapes, Stella could neither find contentment in living or leaving behind the city that had established his career as an artist.

* * *

Stella's ambiguity about city life was symptomatic of other New York–based artists, who retreated seasonally to upstate New York or the Connecticut countryside. Though a man of the modern city, Duchamp gladly accompanied Walter Arensberg to the rural art colony of Ridgefield, New Jersey, made up of stone houses and renters' cottages surrounded by fruit-tree groves among the Palisades. In the summer of 1913, Ridgefield gained three new residents—fauvist painter Samuel Halpert, artist Man Ray, and poet Alfred Kreymborg. Together they lived in a four-room cottage—one of several built and managed by a retired Polish blacksmith, who, along his wife, sold them milk and eggs. Without indoor plumbing the three lived by chopping firewood, cooking by kerosene stove, and rising at cock's crow; when weather permitted they relaxed outdoors or made the mile-long walk to the next village for mail service.

Ridgefield's Sunday gatherings drew visitors, ranging from Floyd Dell to Belgian-born sculptor and anarchist Adolf Wolff. There, Duchamp, on a fall

Sunday afternoon in 1915, first encountered Man Ray, who engaged the French-
man in a pantomime-like game of tennis, with the American calling out the
score and his French opponent replying only "yes."

But the most memorable of the Ridgefield colony's activities was the
founding of *Others*, a magazine of advanced writing conceived at the Arens-
bergs' salon in July 1915. Funded by Arensberg until its demise in 1919, *Others*
was edited in Kreymborg's Ridgefield communal shack. Printed by anarchist
Sabastien Liberty, its cover boldly asserted "THE OLD WAYS ARE ALWAYS
WITH US AND THERE ARE ALWAYS OTHERS," and its pages carried works
by Arensberg, Wallace Stevens, Mina Loy, T. S. Eliot, and William Carlos
Williams.

On Sunday afternoons physician-poet Williams escaped the "germs and
babies" of his pediatric profession by driving several miles from his Ruther-
ford, New Jersey, home to visit Ridgefield's art colony, which he later credited
as having saved his life as a poet. Like most of Ridgefield's gatherers, Williams
had visited 291, the Armory Show, and the Arensbergs' salon. As a University
of Pennsylvania student, he had befriended Ezra Pound and Hilda Doolittle —
imagist poets who, for a brief time, captured his interest. But imagism, rooted
in Chinese, Japanese, and French Provençal poetry, spoke little to Williams,
who, indebted to Whitman, looked to modern painting for new poetic forms.
Williams soon joined Kreymborg, Loy, and Stevens in pushing poetry beyond
imagism's aesthetic. In the spirited company of painters and poets—"destroy-
ers, vulgarians, obscurantists"— he joined in undermining conventional verse
and took part in "arguments over cubism which could fill an afternoon. There
was," Williams added, "a comparable whipping up of interest in the structure
of a poem. It seemed daring to omit capitals at the head of each poetic line.
Rhyme went by the board."[29]

Man Ray distanced himself from the *Others'* circle, and painted, not long
after moving to Ridgefield, cubist-inspired works and the Cézanne-influenced
watercolor *Ridgefield* (1913). Dissatisfied with conventional artistic techniques,
he made assemblages and painted canvasses by airbrush. Upon his leaving pas-
toral quietude for New York in 1915, Ray piled his up canvasses outdoors, and,
in a dada gesture, set the cubist-like assemblage on fire.

The Village Idea

By the time of Man Ray's arrival in New York, dada had made inroads,
and around Washington Square in Greenwich Village's narrow streets, artists
lived — openly and affordably — alongside Irish and Italian immigrants, in
quaint European-looking residences. A counterculture model community, the
Village was a center for radical politics, avant-garde aesthetic ideas, free love,
and feminism. Its residents visited modern art galleries, and select others
attended uptown salons, entering into a new way of life that they believed would

transform a nation. "In my day," recounted Lincoln Steffens of the 1910s, "the thinking poor and the poor thinkers, the beginners, the youth, were going down there to live and be free." Whether providing a new way of life or a stopover-point on the way to a successful career, the Village was many things to many people. If Duchamp could regard it as "real Bohemia, Delightful," others like Sinclair Lewis derided its communal way of life, and Randolph Bourne wrote to a female companion in 1917, "I am coming to think of Greenwich Village as a poisonous place which destroys souls even of super-villagers like ourselves."[30]

Though a magnet for rebellious youth, Greenwich Village had as its coun-tercultural leading figures, older mentors—a "paradoxical feature" of the Amer-ican Rebellion in that "almost the entire bulk of contributions to the new movement," wrote poet Alfred Kreymborg, "came from men in their thirties and early forties." This description fit the likes of Floyd Dell, in 1913 a Village transplant from Chicago's 57th Street colony. In the Village, recalled Dell, one could rent, for thirty dollars a month, "whole floors in old houses, each with enormous rooms—high-ceilinged rooms, with deep-embrasured windows, and fireplaces—and had a hall bedroom, a kitchen with a gas-range, and a bath-room."[31]

Living among the local immigrant and black residents, bohemians defied standard fashions by creating their own odd attire: men loosened their shirts, rolled up their sleeves, and used neckties as belts. Hatless female bohemians bobbed their hair, wore smocks of vivid yellow, green, magenta, or violet, and drank and smoked in public; homosexuals, though few at this time, flaunted their amorous attachments.

Prior to 1910 Village bohemians had primarily mingled in sparsely fur-nished, candlelit apartments hung with self-made paintings. From these inti-mate settings their activities spread to more public venues like the Liberal Club, an early "cornerstone of bohemia" on MacDougal Street. The Liberal Club's wood floors complemented its bright orange-and-yellow-painted walls, display-ing cubist and fauve art, and its player piano provided ragtime for dancing, which drew a varied clientele. Talk ranged from monogamy to homosexuality to free love. Liberal Club lecturers included Swiss psychologist Carl Jung to Vil-lage prostitutes, and drew Mabel Dodge's regular guests Hutchins Hapgood, Theodore Dreiser, and John Reed. Bourne attended, as did Eastman and Kreym-borg, leftist journalists Neith Boyce and Louise Bryant, and liberal lawyers and professionals. Liberal Club talk resembled a collage of speech, experimental non sequiturs—verbal equivalents to Braque and Picasso's cubism, dealing with subjects the broader public at the time deemed absurd, recondite, or unimpor-tant.

Beneath the street-level Liberal Club, Polly Holladay opened Polly's Restaurant, a basement cafe-eatery serving thirty-five-cent dinners. Holladay's cook, dishwasher, and lover, Hippolyte Havel—best remembered for his shoul-der-length hair and sharp-tongued asides that taunted uptown customers as

"bourgeoisie pigs"— had worked on a European anarchist publication and was eventually arrested for his politics and confined to the mental ward of a German prison. In New York Havel served as Emma Goldman's main assistant on *Mother Earth*, an anarchist publication that printed his essays extolling the virtues of syndicalism and Prince Kropotkin. Like Goldman, he believed in the power of modern art and radical politics to destroy the existing order, and in 1912 he wrote in *Mother Earth* that "today thousands and thousands of earnest men and women listen to our message. Social life in every phase — literature, art, science, and education — is transvalued throughout the irresistible force of Anarchy."[32]

Boosting the Liberal Club's activities was the neighboring Washington Square Bookshop. Owned by Charles and Albert Boni, the shop loaned club members, without charge, serious reading material such as D. H. Lawrence's novel *Sons and Lovers*. When feminist Henrietta Rodman headed the short-lived Liberal Club Theater, the collective, inspired by set designer Robert Edmond Jones, used the Bonis' next-door bookshop for staging original productions.

In 1913 Rodman persuaded Floyd Dell to provide the club's first play, *St. George in Greenwich Village*, which opened in November of that year. A satire of modern ideas, the play — produced without a stage, scenery, curtains, or footlights— included Sherwood Anderson in its amateur cast. Dell also offered the club the feminist works *What Eight Million Women Want* and *The Perfect Husband*. For their thematic content these productions drew upon local presonages, Village gossip, and debates that had raged among the Liberal Club members.

Soon after, club members, including Chicago transplants George Cram (known as "Jig") Cook and Susan novelist/playwright Glaspell, were urged by Lawrence Langner and others to found the Washington Square Players, a modern little theater that produced, in protest of Broadway's formulaic productions, American and European plays of "artistic merit." Among its actors were Ida Rauh, her husband Max Eastman, and a writer-journalist circle including Hutchins Hapgood, Neith Boyce, Mary Heaton Vorse, John Reed, Alfred Kreymborg, Upton Sinclair, and painters such as Charles Demuth. The troupe debuted at the uptown Bandbox Theatre in February 1915 and produced modern European one-act plays, but emphasis was placed on staging original American works. Lack of funds caused the Players' demise in 1918, and although it failed to discover any notable playwrights, it was a driving force behind the new theater movement.

Dissatisfied with the Washington Square Players, Cook and Glaspell aspired to a more experimental theater. Though not a first-rate writer, Cook was a passionate, hard-drinking visionary who with Glaspell's steely Iowan pioneer spirit set out to transform culture by spontaneous theater experiment, cultivating the American vernacular. A Nietzschean anarchist, Jig Cook foresaw a

Dionysian return of pre–Christian paganism, a spirited community, or as he sometimes called it, "a dream city" of free individuals interacting creatively. Cook recruited amateurs and freethinking professionals with the "conviction that inspiration and intoxication, not training and craftsmanship, were the essential ingredients" for a modern theater collective. Though urban-based, Cook believed that the "farmer writer" nurtured a healthier spirit, once asking himself: "Will it be possible to draw among us a community — a less visionary Brook Farm?" Nearly a decade later, Cook attempted this quest on Cape Cod's shores.[33]

In 1915 Cook and Glaspell arrived in Provincetown, where since in the 1880s theater people had summered in seaside cottages built by immigrant Portuguese fishermen. Eventually painters came, as did writers, journalists, and actors, some of whom formed a new theater collective, tracing its origin to Hapgood's excitement over the reading of Boyce's *Constancy* in July 1915. Nine days after this event, Robert Edmond Jones staged *Constancy* and *Suppressed Desires* in Hapgood's beach cottage. The following morning Mary Heaton Vorse offered the use of her two-story fishing shed for further productions.

During Provincetown's 1916 summer season, before their serving as overseas war correspondents, John Reed and Louise Bryant befriended twenty-eight-year-old Eugene O'Neill, an unknown Greenwich Village playwright. Son of a famed stage actor and a morphine-addicted mother, O'Neill, a Princeton dropout, lived for years as a bohemian outdoor adventurer and alcoholic down-and-outer. Inspired by Jack London and Joseph Conrad, he had sailed to Central America, where he searched for gold in Honduran jungles. As a poverty-stricken sailor, he explored the rough-and-tumble waterfronts of Buenos Aires, London, Liverpool, and Southampton and sailed as far as South Africa — all the while fighting societal convention and the expectations of his father.

In 1911, back in his native New York City, O'Neill survived on his father's dollar-a-day stipend, living at Jimmy the Priest's boardinghouse and squandering most of it on five-cent shots of rye whiskey. That same year, he attended the Irish Abbey Players touring company's entire repertoire. This experience awakened him to modern theater, and from tales of the sea, anarchism, and a fondness for Nietzsche and Ibsen, he created works of stark realism. In the fall of 1915, he worked as a freelance drama critic and paid $4.50 a week for a Greenwich Village apartment. Without prospects for seeing his plays staged (the Washington Players rejected them as well), O'Neill despaired in an alcoholic haze, and whiled away his time in a dirty Village bistro, The Golden Swan, nicknamed the "The Hell Hole," drinking with down-and-outers and Irish gangsters, the Hudson Dusters.

More rejections followed, intensifying O'Neill's alcoholism to the point where his father funded his escape from New York's drinking houses. That summer in Provincetown, O'Neill lived across from the Reeds' house in a fisherman's

shack with Terry Carlin, an inebriate anarchist and reader of Eastern philosophy. Through Carlin's intercession, the Provincetown Players, as they now called themselves, were introduced to O'Neill's work. Desperately in need of plays to fill out the second season, Jig Cook immediately put O'Neill's works into production. In the fall of 1916, Provincetowners debuted their season at the Playwright's Theater, a large MacDougal Street brownstone next to the Liberal Club and Polly's restaurant. In November they opened with Louise Bryant's *The Game* and O'Neill's *Bound East for Cardiff*.

Still struggling as a playwright, O'Neill created works that caught the attention of *Smart Set* drama critic Jean Nathan, who, in 1917, oversaw the publication of *The Long Voyage Home* (1917) and *Moon of the Caribbees* (1917). During this time, O'Neill's fascination with literary naturalism — dying sailors and tragic acts of nature — waned as he explored characters who intellectually and emotionally struggle in a complex world. By the late 1910s O'Neill, by blending European expressionism with his own creative vision, soon transformed American theater.

More the lone avant-gardist than a bohemian, O'Neill preferred the company of street people, derelicts, and drunks — individuals free of "artsy" pretension who served as models for his stage characters. By the time O'Neill achieved Broadway acclaim with the Pulitzer Prize–winning *Beyond the Horizon* (1920), a disillusioned Jig Cook emigrated to Greece. In shepherd's clothes he lived among his adopted countrymen until his death, when he was buried on Delphi's summit — his grave marked by a stone from Apollo's temple.

* * *

Despite Cooks' and his fellow Provincetowners' failure to sustain a noncommercial experimental theater, they, as one of the Village's greatest 1910s avant-garde collectives, helped launch the career of a great American playwright. Arriving in the Village in 1918 just as O'Neill's creative star was rising, writer Malcolm Cowley found there older residents who missed its prewar vibrancy. Yet, new émigrés came with different expectations. Ross Wetzsteon, in his study of the Village, wrote that for each generation the neighborhood represented "more a state of mind than a spot on the map." As it would for decades to come, the Village was a no man's land of creative tolerance and lifestyle experimentation.[34]

Though the postwar Village disappointed Cowley's expectations, he realized that it gave rise to what he termed the "Greenwich Village idea," a set of beliefs helping to shape twentieth-century American culture, especially the fashion industry and the morals and manners of youth. The Village dwellers' conception of self-expression was a near-religious tenet and espoused an arts-and-crafts-like vision of living beautifully through creative work. Of paramount importance to this way of life was self-liberation, the fulfillment of inner desires, artistic expression, and political agenda — feminism, socialism, or

anarchism. Early moderns living out the Village idea believed it was their parents, not they, who needed salvation that required emancipation from "Puritanism," or more accurately, Victorianism. As feminists sought parity with their male counterparts, which would allow them to smoke, drink, and take lovers, they broke from Thomas Beer's concept of the culturally dominant matriarch, the "Titaness"; men fought the patriarchal demands of establishing respectable, lucrative careers.

The Greenwich Village idea resurrected romanticism's cult of the child, drawing upon popularized Freudianism and progressive education's emphasis on creativity and spontaneity. Numerous Villagers and progressive educators embraced the cult of the child. Floyd Dell in his work *Were You Ever a Child?* (1919) compared the artist with the child, and Stieglitz's friend, Harold Rugg, authored the influential work, *The Child-Centered School* (1928), that championed the latent creativity of children and a curriculum established around a student's own unique talents.

Along with the cult of the child and self-liberation was a preoccupation with modernism. In modern art's rediscovery of non–Western and pre–Christian cultures, notably the Dionysian Greeks, Villagers embraced a new paganism, freeing them from what they viewed as needless repression and anxiety. Since the Renaissance and the Enlightenment, the dominant Apollonian Greek model had emphasized reason and mathematics as key to discovering universal laws. Villagers, like the romanticists before them, rejected the Apollonian, favoring Nietzsche's Dionysian-based philosophy, reflected in sexually oriented Village balls, or "pagan routs." With bohemian flair and Bergsonian élan, Village paganism's "live for the moment" credo had common threads with 1920s artistic avant-gardes seeking the "American moment," creative images of revelatory experience.

V

Americans in Paris

A Lost Generation?

Before joining the ambulance service in 1917, John Dos Passos took in the sights of Paris. He wandered the Luxembourg Gardens, attended concerts, scoured bookshops, and ate escargot on Montmartre's hilltop. That same year, E. E. Cummings, also on his way to volunteer for the ambulance service, delighted in legal Parisian prostitution, purchased Cézanne and Matisse prints, and attended the Ballets Russes's scandalous production *Parade* (with Jean Cocteau's scenario, Erik Satie's music, and Picasso's stage sets) that shook wartime Paris. Returning to Paris in the 1920s, Dos Passos and E. E. Cummings discovered entire American colonies indulging in art and urban life.

* * *

On the eve of the Great War in 1914, massive armies mobilized, as the avant-garde's artistic combatants raged against or vowed to destroy cultural traditions of ill-fated European empires. The war eventually toppled old regimes, realigned borders, and inspired nationalism among peoples long subjugated by royal families and imperial rule, and forced a generation to come to terms with the mass industrialization that gave birth to modern weaponry — tanks, machine guns, flamethrowers, and poison gas. Some Germans viewed war through the cultural lenses of Wagnerian Gesamkuntswerk, equating its destructiveness with a spiritual force.

Gertrude Stein wrote that the war had given many the time of their lives. Yet no one coming of age during World War I could forget the thirty-million people killed or maimed during the conflict. The French and British, having experienced far more casualties than their American allies, commonly referred to themselves as being part of a "Lost Generation," a term unknown to Americans until the mid–1920s when it passed from popular Parisian usage "into Gertrude Stein's mouth to Hemingway's pencil." Literary scholar Marc Dolan astutely argues that the Lost Generation described a minority of white Americans, creators who like Hemingway and to a larger extent Fitzgerald, fed its

"canonical mythplot of college/ war/ bohemia/ expatriation/ dissipation/ crack-up/ death-or-symbolic humbling." For ambulance drivers Ernest Hemingway, John Dos Passos, and Malcolm Cowley, war service imbued them with a "once-in-a-lifetime spectacle," providing the substance of stories and great novels. During the conflict, other Americans became pacifists; small numbers embraced dada's nihilism or looked to the Russian Revolution for a future model of social and cultural liberation.[1]

However, the Lost Generation did not produce pervasive disillusionment among most Americans, and for every 1920s down-and-outer bohemian or debauched high modern, thousands enthusiastically ventured "toward inno-vation and artistic achievement rather than despair and dissipation." Exempli-fying this dominant mood, composer Virgil Thomson wrote: "I have never really liked the term 'lost generation.' Nobody involved was any more 'lost' than young people are at any other time." Nearly a decade before his death, Hem-ingway, seeking to debunk the lost generation myth, stated: "There was no movement, no tight band of potsmoking nihilists wandering around looking for Mommy to lead them out of a dada wilderness. What there was, was a lot of people around the same age who had been through the war and now were writing or composing or whatever, and other people who not been through the war and either wished they had been or wished they were writing or boasted about not being in the war. Nobody I knew at that time thought of himself as wearing the silks of the Lost Generation."[2]

In the war's immediate aftermath the U.S.'s runaway inflation gave way to economic depression that lasted until 1922. Racists and evangelicalists often worked hand in hand with conservative politicians to promote nativism. Fear of left-wing radicals and anarchists culminated in the Red Scare of 1919-1920. For blacks 1919's Red Summer symbolized, not Bolshevism's threat, but a bloody backlash as thousands of rioters took to the streets of Chicago and Washing-ton, D.C. In these turbulent times of 1919–1924, which historian Robert Wiebe described as the "vicious years," young creative people shared distrust of "big words"— lofty wartime patriotic rhetoric and speeches about honor. These cul-tural rebels, as Ann Douglas emphasized, sought in their work a "terrible hon-esty" that placed upon art the role of revealing the truth, even if it meant presenting the unpleasant or the uglier aspects of the human experience. Writ-ing about the decade, Samuel Putnam observed, "The mirror was being held up now by a number of young writers," and "their reading public was no longer afraid to see itself" in truth's reflective image.[3]

In the 1920s great numbers of artists and intellectuals left the U.S. for Europe's affordable living standards and to serve creative apprenticeships in renowned cities of culture. American moderns searched for new outlets of unique expression, and most gravitated, as had writers and painters in the nine-teenth century, to Paris. Looking back to 1919, Dos Passos commented: "Amer-icans in Paris were groggy with new things in theatre and painting and music.

Picasso was to rebuild the eye. Stravinsky was cramming the Russian steppes into our ears." According to Ezra Pound, the city was a "paradise for artists"— the city of Marcel Proust, André Gide, Jean Cocteau, Louis Aragon, and André Breton, a place that seemed to Cowley a Mount Olympus peopled with transplanted Americans.[4]

* * *

In 1921 six thousand Americans lived in Paris, a population that swelled to thirty-two thousand by 1924. American moderns— men and women — lived and worked in various circles while creating works often focusing on American themes. Visitors enjoyed a favorable exchange rate, and, unburdened by America's Prohibition laws, drank nine-cent pints of cafe wine, while gamblers and equestrians flocked to numerous Parisian horserace tracks. American magazine advertisements of the day bolstered Paris's image as a center of cultural tradition and modern style. A 1925 *McCall's* advertisement for *The World's Greatest Style Book* promised "genuine Paris styles" ... by famed style authority Paul Caret ... and approved by Agnès Souret, the best dressed woman in Paris." The French Line steamship company, advertising in *The American Mercury* promised travelers that France would "illuminate the soul" in its "picturesque, old ... winding streets and little cafes." A language instruction publication, *La Petit Journal*, advertising in *The American Mercury*, asserted that French-speaking Americans would "discover the most fascinating city in the world. From the splendid vistas that radiate from the Place de la Concorde, to the most typically bohemian of all the restaurants in the Latin Quarter."[5]

From such romantic depictions bohemianism resurfaced among Americans in the Left Bank's Montparnasse district, while across the Seine, Montmartre, the Right Bank's hilltop center of vice, was for 1920s African-American performers and writers a cultural home away from home: its black-owned nightclubs employed musicians and satisfied the Parisian craving for jazz. Meanwhile, high moderns and the fashionable wealthy came into contact with cutting-edge art, poetry, and music performances in festive, sometimes racous salons.

For serious creative people, Paris allowed for serving artistic apprenticeships and making contact with mentors and little magazines. In their path of self-study, many writers borrowed books from Sylvia Beach's lending library and bookstore, and aspiring composers like George Antheil and Aaron Copland made the Parisian pilgrimage to undergo musical training and pursue experimental works. In *Terrible Honesty*, Ann Douglas argues that New York dominated as the capital of 1920s modern culture. Yet Douglas does not take into account that Paris also reigned, until Germany's 1940 invasion of France, as the leading artistic avant-garde center. Thus it is more accurate to view a 1920s Paris–New York City axis, or what Steven Watson terms a "trans-continental love affair," as people of talent channeled art and ideas across the Atlantic.[6]

The Left Bank

Contrary to Marcel Duchamp's claim of his desire to see all French cultural traditions obliterated, Americans expected to find in Paris rich vestiges of the past, as well as new creative possibilities. Legendary for its nightlife, Montparnasse, occupying the Sixth Arrondissement, extended from the Seine to Boulevard Montparnasse. In 1921 Duchamp reported that "The whole of Greenwich Village is walking up and down Montparnasse," and Matthew Josephson wrote that in this district Villagers "cling to each other so closely that one tends to forget all the French one has learned in the United States." The district's most popular establishments— Le Select, "a seething madhouse of drunks, semi-drunks, quarter drunks and sober maniacs," and La Coupole — both on le boulevard Montparnasse — were clustered around the Carrefour Vavin, the intersection of the boulevards Montparnasse and Raspail. Larger were Le Dôme and La Rotonde — a combination "cafe, grill room, gallery, dance hall, card room, and boîte de nuit." To meet the growing American presence, after the Dôme underwent modernization in 1923, the Rotonde was quadrupled in size.[7]

Artists deplored Montparnasse's tourists, whose number increased with each coming summer. Sinclair Lewis ridiculed this invasion and the Americanized Cafe du Dôme, "where," he wrote in the *American Mercury*, "all the waiters speak Americanese, so that it is possible for the patrons to be highly expatriate without benefit of Berlitz." Lewis' comments prompted various responses in the Paris edition of the New York *Herald* and the Chicago *Tribune*. Samuel Putnam recalled a hard-working "mixed crowd" on the Seine's banks; another writer noted that "Bad and good qualities alike expand luxuriantly in this soil." Hemingway's friend Archibald MacLeish complained that although the city harbored "a lot of fakes, a lot of phonies," he admitted that he "had the luck to know" those who responded "to that fever of greatness by becoming great themselves."[8]

Nevertheless, Montparnasse, the American colony's "nervous system," engendered a bohemian revival not seen since Puccini's 1890s opera *La Bohème*," as young Americans wore French blue denim workshirts, suits of cotton velveteen, broad-brimmed hats, and rope-soled shoes. Initially condemning this bohemian fashion, Hemingway soon grew his hair longer and wore proletarian clothes and a beret. Unlike the bohemian pleasure seekers, Hemingway made early evenings of drinking at the Dôme and wrote mornings in his notebook at the Closerie des Lilas on the corner of Boulevard Saint-Michel — once a favorite spot for Baudelaire's circle and later for the symbolists.

Most representative of "lost generation" excesses, Laurence Vail reigned as the American colony's "King of Bohemia." Born of American parents in Paris and living on one-hundred-dollar-a-month stipends from his mother, twenty-nine-year-old Vail, a would-be painter who never found a fruitful

creative direction, married the adventurous twenty-three-year-old Peggy Guggenheim in 1922. With Peggy's $450,000 trust fund (initiated in 1919) and her $22,500 yearly allowance, the couple led a lifestyle unknown to struggling artists. Vail's custom-cut clothes were made from drapery and furniture material that loudly complemented his French blue-velvet trousers, strange ties, and sandals. Eccentrically carefree, Vail enchanted his bride, who likened him to "a wild creature." Making violent public scenes, Vail accosted Peggy, threw objects at her in restaurants, and once held her under the water in a bathtub. Cafe to cafe, Vail's roving late-night parties ended with his inebriated band smashing glasses and chairs.

More impecunious Americans wintered in small hotels, "pledging their wardrobe trunk," running up bills until spring's arrival when a job might open at "American or English newspaper bureaus or business offices." While struggling to find work in 1920s Montmartre, Langston Hughes wrote a Harlem friend urging him to "Stay Home!... Jobs in Paris are like needles in hay-stacks for everybody and especially English-speaking foreigners." Others with steady sources of income were able to attain a sense of security as they lived simply, and despite his later portrayal of himself as a "starving artist," Hemingway benefited from his wife Hadley's inheritance, which paid for two apartments, days at the racetrack, and Austrian ski trips.[9]

Arriving in Paris in 1921, Hemingway witnessed the yearly tourist influx, and though he disdained this element, his 1926 novel, *The Sun Also Rises*, made visiting Paris into a must-see spectacle, especially, as one observer noted, for "a new type of tourist"—the student. The novel's Jake Barnes abhors the sight of young American gatecrashers, jersey-wearing collegian-types who, in one scene, provoke his ire by bursting into a dance club, causing him to confess, "I wanted to swing on one, any one, anything to shatter that superior, simpering composure."[10] Hemingway did not intend to portray a generation, lost or otherwise, but rather tragic characters in a state of nature. But, as if guided by a law of unintended circumstances, the novel set young minds aflame.*

Aspiring flappers found a model in the novel's Lady Brett, an alcoholic libertine, and young men, aping its protagonist's slangy speech, held up their glasses in bars, reciting Jake's "let's have another one for friends." *The Sun Also Rises*, like Jack Kerouac's 1950s novel *On the Road*, had a profound effect on the manners and morals of a generation and helped define, for white youths, heroes and heroines unknown to their parents' generation.

In Exile's Return (225–226), Cowley writes that with the novel, "Hemingway's influence had spread far beyond the circle of those who had known him in Paris. The Smith College girls in New York modeled themselves after Lady Brett in The Sun Also Rises. *Hundreds of bright young men from the Middle West were trying to be Hemingway heroes, talking in tough understatements from the sides of their mouths."

The Free City of Montmartre

Hemingway met Fitzgerald in the spring of 1925 in Paris at the Dingo Bar. Author of two best-selling novels and a *Saturday Evening Post* writer, Fitzgerald lived at the Ritz with his wife, Zelda, and their daughter, Scottie. The couple lived apart from avant-garde circles, but often ended their evenings on the Right Bank hilltop of Montmartre, renowned for its jazz, dancing, and late-night soirees. Reporting for the *Toronto Star*, Hemingway informed his North American readers about Montmartre, "the famous Paris place for night activity." At the base of Montmartre, around the Place Clichy — an area of cheap cafes, prostitution, and hashish and opium use — he described tourist traps in which fake arists were hired to encourage the drinking of inexpensive champagne. Yet Hemingway often spent evenings on the hilltop that inspired his creative portraits of the city.[11]

Commenting on Montmartre's unique nightlife in the 1920s, another journalist posed the question: "Why have these few hundred square meters, once the haunt of painters and other bohemians, become, since the turn of the century, a symbol of all the magic of the night?" A refuge for religious martyrs, revolutionaries, artists, and the demimonde, Montmartre was a hill of legends. Before the First World War, Montmartre, spared Baron Haussmann's Parisian redevelopment in the 1850s-1880s, retained its rural character. Cows grazed among its windmills, and on its winding cobblestone streets strolled "transvestites, lesbians, go-betweens, outrageous bluestockings, failed poets declining into pimps, wrestlers, part-time gigolos for either sex."[12]

With the opening of Émile Goudeau and Rudolph Silas's Chat Noir (Black Cat) in 1881, Montmartre played a vital role in transforming bohemia's image. During this time, a transition in the Parisian entertainment world saw noted performers move from the salon to the café, and Montmarte's venues promoted a vibrant interchange of ideas that supported subsequent literary and art movements. Goudeau and Silas' promotional acumen made the Chat Noir more than an entertainment venue, as their in-house publication and poster art by Toulouse-Lautrec and others fostered a Left Bank countercultural mystique. The Chat Noir and Aristide Bruant's Le Mirliton (opened in 1885) set the pace for scores of imitators. The Moulin Rouge's opening in 1889 only lent more fame to the Right Bank district as a place of music and dance.

On "the Butte's" upper slopes had lived artists and writers. Verlaine met Rimbaud on the hill in 1872, and Renoir, Van Gogh, and Toulouse-Lautrec made it the subject of their work. Not long after his Parisian arrival, Picasso lived, drank, and worked in the district, and his literary publicist, poet Guillaume Apollinaire, represented, along with Max Jacob, the presence of innovative poets.

Since Louis-Philippe's reign, asserted Virgil Thomson, Montmartre had existed as "the neighborhood of musicians." In the 1880s famed modern French

composer Erik Satie lived and performed there. During the 1920s, it was home to world-famous music instructor Nadia Boulanger as well as members of Les Six, including Darius Milhaud, whose enthusiasm for jazz inspired his *La Création du Monde* (1925). African-American jazz was heard from Paris to the Riviera. French intellectuals found in the music a latent African primitivism, and symphonic musicians lauded its unique rhythmic quality, while thousands of Europeans commonly held that it was "above all modern," as they took up the Charleston dance craze imported from America in 1925.

Before the war most of Montmartre's artists had departed for the Left Bank. This loss of talent, along with the decline of the dance hall tradition, created a new demand for entertainment, one met by African-Americans— Harlemites and others from America's Bronzevilles. World War I had brought thousands of African-American servicemen to France and created a rage for the ragtime march music of U.S. Army ensembles such as James Reese Europe's 369th Infantry Regiment band, which laid the foundation for France's vogue for jazz. African-Americans experienced in postwar Paris a more relaxed racial milieu than in America, and many promising artists and writers lived on stipends for academic study or artistic training.

Newly installed, glaring electric signs greeted Montmartre's barhopping bourgeoisie who arrived by limousine and taxicab (replacing horse-drawn carriages) to visit the Cozy Corner, the Le Palermo, Gerald's Bar, Royal Montmartre, and the Imperial, where Josephine Baker held forth after dazzling Paris in the 1925 Revue Negre. Zelli's crowds consisted of American and British newspapermen, "sleek-haired" Spaniards, Mexicans, and South Americans. Affable Italian-American Joe Zelli hired two rotating bands and thirty women (whose topless pictures were displayed in the front window) who sat with customers purchasing champagne by the bottle. In Hemingway's *The Sun Also Rises*, when Brett Ashley requests that her late-night drinking party "go up on the hill," she leads Jake and company to Zelli's, a "crowded, smoky, and noisy" place. Once inside Jake described the music's allure, how "Brett and I danced. It was so crowded we could barely move."[13]

That evening Brett introduces Jake to Zelli's African-American house drummer, whom Brett considers "a great friend." The model for Brett's drummer friend was Georgia-born Eugene Bullard,* a boxer, decorated World War I French Foreign Legion hero, and America's first black combat pilot, who flew with the Lafayette Flying Corps. Recruited by Bullard in Harlem, West Virginia–born Ada Louise "Bricktop" Smith came to perform at Le Grand Duc in 1924. Full-figured and "firm-fleshed," with "tinted-brick-colored hair" Bricktop,

During the early 1920s, Bullard, while working at Zelli's as a drummer and the club's artistic director, learned the ropes of the nightclub business. Later he managed then purchased Le Grand Duc that attracted the likes of the Prince of Wales, Picasso, Nancy Cunard, Louis Aragon, Charlie Chaplin, and Gloria Swanson.

called "Bricky" by friends, remembered Montmartre as small, rough-and-tumble place, which changed in the evening from a "sleepy village to a jumpin' place." At Le Grand Duc she went from table to table singing torch songs, jazz, and blues, making each "patron feel like a celebrity." Her dancing of the Charleston captivated Fitzgerald and charmed Cole Porter, whose "Love for Sale" and "I'm in Love Again" were in her song repertoire.[14]

When not dancing or finishing an evening at Le Grand Duc, Hemingway went to hear Montmartre's singing and dance sensation Florence Embry Jones at the Chez Florence, founded by Louis Mitchell in 1924 and later purchased by Joe Zelli. Hemingway admired Jones as being "wonderful on her feet" and often dropped by the Chez Florence early in the morning for an American breakfast of corned-beef hash, poached eggs, and buckwheat pancakes. In 1926 Josephine Baker opened the Chez Josephine, a small cabaret where, after lavish Parisian shows, she appeared for her customers. Bricktop's, most renowned of Montmartre's black-owned nightspots, was opened by Ada Smith in 1933, rivaling Zelli's as a Montmartre legend. A shrewd business women Bricktop, "large and firm-fleshed," sang and danced, but mostly attended to her cash accounts while maintaining order in the cabaret.[15]

In Fitzgerald's short story "Babylon Revisited," Charlie Wales (Fitzgerald), following his drying-out in a Parisian sanitarium, stands outside Bricktop's, a place where he had drunk and "parted with so many hours and so much money." Wales describes the district's dual nature — its exciting entertainment places and tawdry atmosphere. In the vicinity of Zelli's he sees the "black and sinister hotels" and "the great mouths of the Cafe of Heaven and the Cafe of Hell."[16]

One of thousands who regularly trekked up the hilltop, Fitzgerald found enjoyment in a place that invited without discrimination. On its streets were people in evening clothes, Corsican mobsters, and French colonials. Jazz clarinetist Garvin Bushell rubbed shoulders with "Arabs, Algerians, and Africans" at Bricktop's, Zelli's, and the Flea Pit. As Tyler Stovall observed, Montmartre offered nightclubgoers a "little bit of Africa," a glimpse of bygone "Gay Paree" decadence, and allowed African-American performers and entrepreneurs to escape racism while creating a sense of community.[17]

American Enclaves

Isolating themselves from the tourist-oriented nightclubs and cafes, fashionable American high moderns frequented Parisian salons, which became premier cultural and social centers. After the war, Gertrude Stein no longer maintained her Wednesday gatherings, and it was Natalie Barney's salon that attracted numerous expatriates. Born in Dayton, Ohio, in 1876 and raised in upper-class comfort in Cincinnati and Washington, D.C., Barney inherited from her mother — a painter who had studied with Whistler — an interest in

the arts and from her father a substantial inheritance, allowing her to live comfortably in Paris.* Barney moved to Paris in 1902 and by 1909 rented a three-hundred-year-old residence (a detached house with a garden and pavilion) at 20 rue Jacob that a visitor described as looking as though from the time of Madame de Staël. Here, Barney associated with a French literary crowd, including Remy de Gourmont, whose description of Barney as "Les Amazon" referred not only to her penchant for horseback riding but her aristocratic lesbianism. A center of lesbian counterculture, Barney's salon entertained Sorbonne professors, a stray count or countess, as well as Americans Ezra Pound, Sherwood Anderson, William Carlos Williams, Matthew Josephson, and Gertrude Stein, and she offered guests generous amounts of food. Tea was served, and drinkers enjoyed port, gin, or whiskey.

Though Barney's symbolist literary taste appeared to some as outmoded and her salon decor as dated, guests admired their hostess's grace, wit, and "dignified abandon." Pound played tennis with Barney and collaborated in promoting several talented young people. In turn, Barney introduced Pound to Anatole France, Andre Gide, and Paul Valéry. Stein read her work at Barney's salon, and since the hostess did not write modern verse, they enjoyed a non-competitive friendship, and special evenings were held in Stein's honor.

Favoring more intimate encounters, Stein invited visitors to 27 rue de Fleurus on an individual basis, and through Alice B. Toklas' influence, screened out those who did not interest her. Through a letter of introduction supplied by Sherwood Anderson, Hemingway and his wife Hadley called upon Stein in March 1922. Stein immediately took to Hemingway. Customarily sitting separately and talking to Hadley as she did with artists' female companions, Alice grew jealous over Gertrude's friendship with the handsome writer. In accepting Stein's open invitations to visit her apartment any day after five o'clock in the evening, Hemingway quickly learned that her impromptu lectures required listeners' rapt attention when one evening, drunk, his interrupting words nearly drove her to rage.

Freely moving between Pound's and Stein's company, Hemingway discovered that they held no mutual admiration, and a sense of rivalry emerged between the two in that both demanded loyalty among their circle of artists and young mentors. When Pound first visited Stein at her apartment, she considered him a likeable but not amusing man, and he quickly wore out his welcome when, on another visit, he broke one of her favorite armchairs. Later, Stein conveyed that Pound "was a Village Explainer: "Excellent if you were a village, but if you were not, not." Pound simply called her "an old tub of guts." Whereas Pound hailed Joyce as a genius, Stein refused to acknowledge his talent, and even a mention of the Irishmen's name, Hemingway noted, could ruin an

In her youth Barney had been a devotee of Oscar Wilde, who visited her parents' home during his 1882 visit to America. She later had a love affair with the writer's niece, Dolly Wilde.

afternoon at 27 rue des Fleurus. Apart from editing installments of her work, Hemingway absorbed Stein's Socratic lessons on art and literature, urging him to break with journalistic prose and explore a modern distillation of language, or what she referred to as "the rhythm of the visible universe."[18]

Not discounting Stein's contribution to his literary education, Hemingway claimed that Pound most influenced him. After years of vying to become literary dictator of London, Pound relocated to Paris in 1921 and worked as overseas editor of *Poetry, Little Review*, and, for a short time, the *Dial*. As Joyce's champion he had urged, shortly before his own arrival, that the Irishman move to Paris. The restlessly creative Pound wrote, took up sculpture, painting, and finally music, and mixed with dadaists and the surrealists. At his studio apartment at 70 bis Notre Dames des Champs (an apartment building once visited by Whistler in the 1850s when he called upon George du Maurier and others), popular afternoon teas were held, and Americans heard his disquisitions on art and culture.

Pound had numerous understudies, and his brilliant editorial skills paired down a third of T. S. Eliot's landmark poem "The Wasteland." Upon meeting Pound in mid–February 1922, Hemingway initially dismissed the poet for his flamboyant bohemian hair and dress, and his friend Harold Loeb (*The Sun Also Rises*' Robert Cohn) thought Pound — in velvet jacket, fawn-colored pants, and walking stick — looked like "one of Trilby's companions." But Hemingway came to revere Pound as the literary "midwife to the new age." Pound outlined a reading list and introduced Hemingway to Henry James and major French writers; further, his blue-penciled corrections were crucial to his understudy's manuscripts. In turn, Pound learned the art of pugilism from his young friend, who, stripped to the waist, turned the poet's apartment into a makeshift boxing ring.[19]

Together Pound and Hemingway frequented Shakespeare and Company, the bookstore and lending library of Sylvia Beach, Parisian "den mother" to American artists, writers, and musicians. In this cultural way station, writers from the British Isles and America met the French literati. Photographs of the era's most innovative British and American writers were on display, including Man Ray's portrait of a handsome and self-confident Hemingway, who, along with other writers, used the shop's address for forwarding mail. Beach held literary readings, loaned books and money, and became, for over a decade, Joyce's tireless and indispensable champion.

Born in Baltimore, Maryland, in 1887, Beach grew up in Bridgeport, New Jersey, the daughter of a liberal-minded Presbyterian minister who would later count among his parishioners Grover Cleveland and Woodrow Wilson. From 1902 to 1905 she lived in Paris with her parents and, after nearly a decade in Princeton, New Jersey, with several sojourns to Europe, she settled in Paris during the fall of 1916. Three years later she opened Shakespeare and Company on 8 rue Dupuytren. By July 1921 she had relocated her store to 12 rue due

l'Odéon, near the apartment of her lover Adrienne Monnier. A nonreligious freethinker with bobbed hair, the chain-smoking Beach, fluent in French, made many friends among the locals. Her affability, eccentricity, and dislike of snobbishness endeared her to both French and American writers, artists, and musicians.

Initially a strong promoter of Whitman, whose original and pirated editions adorned the bookstore's backroom, Beach took up James Joyce's cause. She met the Irish writer in 1920 and soon after became, along with the wealthy English patron Harriet Weaver, Joyce's devoted supporter. After the *Ulysses* obscenity case in 1921 resulted in the novel's being banned in the U.S., no American firms were willing to be involved in its publication. Beach took it upon herself to publish Joyce's masterpiece, and after countless hours of editing, a duty compounded by the author's penchant for constantly adding material to the manuscript, Beach published *Ulysses* in February 1922, under the imprint "Shakespeare and Company." A work comparable in importance to Picasso's *Les Demoiselles d'Avignon* and Stravinsky's *Le Sacre du printemps*, *Ulysses* presented, Peter Conrad emphasized, "things which, at least according to literature, [bodies] had never done before. A man ponders his own bowel movement, relishing its sweet smell. Later in the day he surreptitiously masturbates in a public place and takes part in a pissing contest, proud of the arch his urine describes. A woman has a noisily affirmative orgasm, or perhaps more than one." Its use of "interior monologue," or what became known as "stream-of-consciousness," profoundly impact on generations of writers and artists. In true avant-garde manner, Joyce confided that "I've put so many enigmas and puzzles that it will keep professors busy for centuries arguing over what I meant."[20]

Looking back on the literary 1920s, Malcolm Cowley observed that Joyce was the "paramount hero of the age ... and his *Ulysses* came to be revered by the new writers almost as the Bible was by Primitive Methodists." Yet in contrast with Joyce's other works, *Dubliners* (1914) and *Portrait of the Artist as a Young Man* (1916), Cowley doubted that many Americans had actually made their way through *Ulysses*' 768 pages. Faithful readers like *The New Yorker*'s correspondent in Paris, Janet Flanner, considered Beach's edition, in words also rich in religious metaphor, as "the most exciting, important, historic single literary event of the early Paris expatriate literary colony."[21]

Even if they had not read the entire work, American moderns identified with the exiled Joyce and his fictional Stephen Daedalus' rebellion against church and family. Being banned in the United States until 1933 only added to *Ulysses*' iconoclastic mystique. Determined to introduce the book to American readers, Beach took part in smuggling it into the U.S. Bennett Cerf of Random House, who eventually published *Ulysses* in America (1934), recalled that during the 1920s, "You couldn't come home from Europe" without a ten-dollar copy," — its paper cover displaying the blue and white colors of the Greek flag.

The novel profoundly influenced numerous young writers and artists, and Hart Crane, possessing a rare smuggled copy of *Ulysses*, hailed it as "the epic of the age." During his youth, director John Huston had heard Joyce's banned book read aloud to him in its entirety by a girlfriend while he painted, and he recounted that "It was probably the greatest experience that any book has ever given me. Doors fell open."[22]

Beach's service in the cause of modern literature had made her countless friends, and for nearly two decades her bookstore remained a literary center. Hemingway, one of the many Americans to benefit from her generosity, remained thankful for Beach's support. In 1944 he and his band of irregulars appeared in a jeep at rue de l'Odéon and liberated her from the Nazi occupiers who had led her to close Shakespeare & Company in 1940, when a German officer demanded to buy a copy of *Finnegans Wake* displayed in the front window.

Independent Presses, Little Magazines

Beach's publishing of *Ulysses* epitomized the importance of independent small presses in printing experimental work. Parisian-based limited editions, like *Ulysses*, garnered such a notorious reputation that American customs marked them for confiscation. Equally hostile toward these works, American reviewers, observed Robert McAlmon, "would not comment on them as books; they were always mentioned as expatriate and Paris publications even when the authors had never seen Paris."[23]

While living in Greenwich Village, McAlmon, a Presbyterian minister's son, bisexual, and reckless drinker, joined with William Carlos Williams to found the little magazine *Contact* (1920–1923). His 1921 marriage to heiress Annie Winifred Ellerman, aka Bryher, a writer and the daughter of British shipping magnate Sir John Ellerman, provided a windfall of money that financed *Contact* as well as a carefree lifestyle, and prompted other writers' behind-the-back jibes referring to him as "Bob McAlimony." Yet his New York and Parisian literary connections benefited in his founding of the Parisian-based Contact Publishing Company (which utilized Beach's bookstore as his mailing address). Along with his work *A Hasty Bunch*, a title suggested by his friend James Joyce, McAlmon published (in editions of three hundred) Hemingway's first book, *Three Stories and Ten Poems* (1924), as well as works by Pound, Williams Carlos Williams, Hilda Doolittle "H.D," and Djuna Barnes. But these works were not adequately distributed, and due to McAlmon's declining interest he published few books after 1926.

In 1924 McAlmon and another budding publisher, William Bird, shared the output of the Contact Publishing Company and Bird's Three Mountains Press (the first two American little presses to appear in Paris). Together under the Contact Editions imprint they collaborated on publishing Stein's *Making of Americans* (1925). A Buffalo-born newspaperman who emigrated to Paris

in 1920, Bird named Pound chief editor of his Three Mountain press. His carefully crafted publications printed on a seventeenth-century press, contrasting with McAlmon's casual manner of process and output, benefited from Bird's insightful monetary investment. Three Mountains Press shared cramped quarters within a dome-shaped vault at 29 Quai d'Anjou with Contact Editions and the little magazine *Transatlantic Review*. Following McAlmon's publishing of *Three Stories and Ten Poems*, Bird brought out Hemingway's collection of vignettes, *in our time* (1924), its modernist cover of newspaper collage design displaying the title in lowercase font. Three Mountains Press also published such works as Pound's *A Draft of XVI Cantos* and William Carlos Williams' *Great American Novel*, until Bird sold his firm in 1928 to Nancy Cunard, heiress of the English Cunard shipping line.

In April 1927 Henry Grew "Harry" Crosby and his wife Caresse (née Polly Peabody), founded a more lasting venture, Black Sun Press, which expanded from initially being a means to publish their own work into the production of limited poetry editions by others. After serving in the wartime ambulance service and the U.S. Army, Boston-born Crosby refused his uncle J. P. Morgan's offer of a banking career and took to reading Baudelaire and the symbolist poets and imitating De Quincey's opium use, which he believed enhanced poetry's alchemic power by linking genius and madness. Produced on a hand press in a shop on the rue Cardinale, Black Sun's editions included works by Hart Crane, Eugene Jolas, and Archibald MacLeish, as well as the letters of Henry James and of Marcel Proust. After her husband's suicide in New York City in 1929, Caresse continued the press's operations into the mid–1930s.

More immediate in reaching the public, little magazines had, since 1912, published approximately eighty percent of the world's leading poets, novelists, and critics and were distributed primarily through bookstore sales. Among the Parisian nurturers of the avant-garde writers of the 1920s, the little magazine *Transatlantic Review* was founded in 1924 by Ford Maddox Ford, best known at the time for establishing the *English Review* in 1908 (which had first published H. G. Wells and D. H. Lawrence) and his literary collaboration with Joseph Conrad. To finance the magazine, New York attorney John Quinn contributed 2,000 dollars, and Ford and his common-law wife, Stella Bowen, covered the remaining costs. During the magazine's short existence between December 1924 and December 1925, some of its most talented contributors included Stein, Pound, Joyce, William Carlos Williams, and E. E. Cummings. Typically numbering one-hundred-and-twenty pages, the magazine also had a music supplement and an art section containing reproductions of works by Braque, Man Ray, and others.

Ford met the twenty-four-year-old Hemingway in Paris in the winter of 1924, and through Pound's intercession, recruited him as the *Transatlantic's* unpaid sub-editor. Around this time, Ford became interested in American writers, and through Hemingway's connections with Gertrude Stein, the

Transatlantic published (from April to December 1924) nine installments of her novel *The Making of Americans*. Entrusted with the job of editing Steins' selections (unknown to Ford, Hemingway had promised her the serialization of *The Making of Americans*' six volumes), Hemingway creatively benefited from their close examination. These installments appeared in the magazine's section entitled "Work in Progress," as did a Hemingway short story, and a contribution by Joyce that would later become *Finnegans Wake*.

Though genuinely supportive of young writers and a pleasant conversationalist, Ford — Hemingway's character Braddocks in *The Sun Also Rises* — with his walrus mustache and unkempt suits, was often targeted for mockery. Nearly fifty, overweight, his mouth habitually half-open, wheezing asthmatically as the result of a wartime German gas attack, Ford seemed to many "a relic of another age even in that age in which he was himself trying to shape." Hemingway, known for being duplicitous toward many fellow writers, came to despise Ford. Once when Ford left Hemingway in charge of the magazine, the latter used the opportunity to print an issue that mocked dada, chastised Cocteau, and took stabs at Gilbert Seldes' *Seven Lively Arts*. But the increasing rift between Ford and Hemingway did not have time to develop into open conflict. Ford's inept business practices (The Transatlantic Review Co. probably had no legal French status), compounded by benefactor John Quinn's death and a failure to attract stockholders, left the magazine in economic turmoil; fraught with financial and distribution difficulties, it folded.[24]

Whereas Ford's publication catered to conventional and modernist writing, Eugene Jolas, poet and mystic visionary, and his wife, Maria MacDonald Jolas, in 1927 founded the most advanced experimental little magazine made by Americans. During its intermittent years of publication, between 1927–1930 and 1932–1938, *transition* explored the mystical power of the word. In an attempt to go beyond the surrealists, Jolas envisioned a new universal language. With Joyce as its forerunner, Jola's "Revolution of the Word" was to invent new grammatical forms and to thrive on paradox, and he walked a fine line with the surrealists, and ultimately embraced Jung.

Jolas and his associate editor, fellow journalist and newspaper editor Elliot Paul, believed that experimental language would transform culture. Embracing romanticism's darker elements, Jolas, in combining spirituality with divine intuition, rejected all artistic schools and looked instead, like the surrealists, to the illogic of madness. He opened *transition*'s pages to German expressionism, dada, and surrealism, and his own metaphysical writings culled from cultural anthropology (that is, primitivism), philosophy, and linguistics. Beginning in April 1927, *transition* carried serial installments of Joyce's "Work in Progress." Jolas went on to publish Stein's "Elucidation," and works by Hemingway, André Gide, the surrealist Philippe Soupault, Hart Crane, and Harry Crosby, who became one of *transition*'s editors. Picasso, Duchamp, and Miró provided the magazine's cover images, and its art reproductions included works by Giorgio

de Chirico, Max Ernst, Joan Miró, and Man Ray; a 1929 edition carried Joseph Stella's *Brooklyn Bridge* accompanying Hart Crane's poem "Bridge."

Life Among the Dadaists and Surrealists

In Jolas' *Paris Tribune* column "Rambling through Literary Paris" of 1924, he wrote: "Nowhere does the visitor from America face such a plethora of ideas, revolutionary concepts, boldly destructive philosophies, ferociously new esthetic principles." At the vanguard of these impulses, dada made inroads in postwar France after New York City's proto-dada scene had declined with Picabia's and Duchamp's departure from America. Tristan Tzara's Zurich dada circle defined in theory and practice beginning in 1916, an iconoclastic aestheticism that spread to Berlin, Hannover, Barcelona, and Paris, where its international coterie included several Americans.[25]

Upon the Parisian dadaists' urging, Tzara migrated to Paris in January 1920. Before Tzara's arrival, Parisian dadaists, or dadas as they were called, were nominally led by Andre Breton* and associated with Picabia, including Philippe Soupault, Louis Aragon, and Paul Éluard. This predominately literary circle sought a revolution of the mind in which words—potent symbols—tapped into the unconscious. Dadaists despised the novel as aesthetically invalid and any traditional or clearly understandable writing as mere journalism. Modern advertising prompted the "poem-event," word arrangements "of a living attitude" that could bring forth a new consciousness. To avoid poetry's formalism, Breton practiced automatic writing—a method introduced in the eighteenth century that he credited to Gérard de Nerval and Thomas Carlyle. Though not the founder of automatic writing, he was, "perhaps," noted biographer Mark Polizzotti, "the first to see in the practice something other than either a literary technique or pure therapy."[26]

The dadaists published *Littérature*, and Tzara encouraged theatrical programs, soirees, outrageous demonstrations, and mock trials. Inheriting Zurich dada's absurd cacophony, its French counterparts held local theater soirees, where Tzara played his Dadaphone (a homemade instrument resembling a coffee mill). For the dadaists' presentation of "The Silent Canary," staged in Montmartre, a participant climbed up a tall ladder "and talked nonsense with a philosophical air, while a stage girl proudly announced herself as Messalina, and a black man insisted many times that he was Gounod." One demonstration claimed that Charlie Chaplin, as a dada convert, would appear onstage, and another that dadaists would shave their heads (an act they failed to perform). Dadaists entered a church

*As a medical student turned soldier, Breton had, during 1917, served in a psychiatric center for "shell shock" victims in St. Dizier. While at St. Dizier the writings by leading French psychiatrists led him to the work of Freud. To escape the dominance of classical logic and Christian religion, he joined the dadaists after the war, and pursued experiments exploring the unconsciousness.

and on another occasion followed Aragon into a brothel. Though Breton came to see dada soirees as a failed Zurich import, they did fly in the face of Parisian audiences, who, during performances, bore the dadaists' rude insults regarding their lack of intelligence. On one such occasion, Breton defiantly wore a Picabia-made signboard on stage with a bull's-eye slogan reading: "Before you can love something, you have to have Seen and Heard it for a LONG TIME heap of IDIOTS." Incited by the nonsensical acts and insults of these perceived madmen, audience members showered their mockers with vegetables and beefsteaks.[27]

Within months of Tzara's arrival, dada had made an impact on the modern Parisian cultural scene. The visiting American composer Virgil Thomson recounted that he "loved the climate of [dada], its high, thin, anti–establishment air." But acceptance was not the dadaists' ends, and to their abhorrence dada skits and popular songs made their way into Parisian stage shows; though once reviled in its pages, dada became the subject of jokes in the press.[28]

Arriving in the summer of 1921, Man Ray walked among the Parisian eight-story buildings, feeling more at ease than he did among New York's towering skyline. Unable to make inroads into New York's art world, Ray established himself in Paris and received from his "machine-mad" dadaist admirers a warm welcome and acceptance into their circle. Ray discovered how fast this coterie launched into playful nonsense, when on a July day, Tzara, Breton, and company took him to a Montmartre amusement park, where, in a childlike abandon, they rode midget bumper cars, merry-go-rounds, and steam swings and made scenes at concession booths. Though seemingly an "artistic chameleon," Ray, while only peripherally connected, never joined the dadaist fold; he successfully endeavored to take photo portraits and create new film-processing methods. In Paris Ray continued experimenting in the medium of moving pictures and combined materials and visual-art methods.

At a gallery-bookshop exhibition in 1921 featuring Man Ray's machine objects and "Rayograms," Matthew Josephson encountered the Parisian dadaists. A former Columbia University student and Greenwich Village resident, Josephson had come to the land of Flaubert to broaden his literary education. Initially only "half-serious" about the dadaists, he joined them in provocative acts of anti-art, following their advice that he abandon the sedentary cafe life to "go forth into the streets to confront the public and strike great blows at its stupid face."[29] He attended dadaist excursions and mock trials and discussed the acts of "unmotivated crimes" against society that had no apparent underlying motive. Typifying the 1920s cross-continental trade winds of modernism, Josephson found that the dadaists revered American mass culture — black jazz and the "silent cinema of "Douglas Fairbanks, Tom Mix, Rio Jim, and the bank robberies, the swift abductions, the incredible gold strikes, and the cigar-chewing tycoons in sumptuous offices."[30]

In Paris Josephson's friend Malcolm Cowley also took part in the dadaist ferment. Cowley, like Josephson, was at first ambivalent about the dadaists, but

after attending their meetings and signing a joint document in 1923, he wrote to Kenneth Burke, "I suppose now I am now officially a Dada." Cowley considered the dadaists "the very essence of Paris" and its participants as being "on a level far below Joyce's ambition and Valéry's high researches into the metaphysics of the self." While living in the art colony of Giverny forty miles northwest of Paris, Cowley, in trying to impress visiting dadaist Louis Aragon, spoke out against book fetishism. Then in a dada gesture, Cowley tore off the covers of French publications and placed them on an asbestos fireplace apron, setting them on fire, until E. E. Cummings ceremoniously urinated on them. Cowley's defiant act soon led to a public gesture, when, in the spirit of "the unmotivated crime," he punched the owner of La Rotonde in the face for no other reason than that he disliked the man's dog-like features. Cowley, arrested for attacking the man, "realized that by punching a cafe proprietor in the jaw I had performed an act ... for reasons of public morality; bearing no private grudge against my victim, I had been 'disinterested,'" and in doing so "performed an 'arbitrary' and 'significant gesture.'"[31]

But dadaist fisticuffs meant little to some. Expatriate Harold Stearns thought Americans wasted their efforts to shock bourgeois Parisians, who "did not even know who they were" or the meaning of their acts. Yet at this time, dadaism was much talked about among artists, and it became *The Little Review*'s dominant theme. Since its Chicago inception and its banning in New York City, *The Little Review* had made its way to Paris in 1923, where Jane Heap took charge after Margaret Anderson, taking up with singer Georgette Leblanc, severed her ties with the magazine. After losing the 1921 *Little Review* trial over *Ulysses*' serialization, Heap experienced a renewed sense of rebellion that rejected Anderson's anarchism and embraced dada's activism. When Picabia became an editor in 1923* (an issue was dedicated in his honor), dada surfaced in full force — manifestos were reprinted and Man Ray's art featured.[32]

Parisian dada debates filled pages of little magazines, and argumentative letters were exchanged. In 1921 Hart Crane wrote to Matthew Josephson, "I cannot figure out just what Dadaism is beyond an insane jumble of the four winds, the six senses, and plum pudding." That same year Kenneth Burke, in his *New York Tribune* article, "Dadaisme Is France's Latest Literary Fad," condemned the "Dadaists as petulant children," yet he "could also understand that their joy of creation is here unlimited, it is carried to the extent of anarchy." On the other hand, Waldo Frank argued that its nihilism had no place in America, and by 1924 he railed, "Europe called for Dada by antithesis: America for analogous reasons calls for the antithesis of Dada. For America is Dada." Looking back on the movement's influence, Virgil Thomson shared Frank's attitude when he wrote, "I think all Americans are a little Dada-minded. What else is our freewheeling humor, our nonsense, our pop art?"[33]

*Under Heap's editorship the magazine appeared intermittently until its demise in 1929.

In 1924 Hemingway facetiously announced: "Dada is dead although Tzara still cuddles its emaciated little corpse to his breast and croons a Rumanian folk song ... while he tries to get the dead little lips to take sustenance from his monocle." Recognizing dada's growing decline, Breton by 1922 spent the next two-and-a-half years trying to formulate a new avant-garde movement that would, under his leadership, blaze new paths into the unconscious. Breton's experiments with automatism and spiritualism, "dream recitals," and "sleeping fits" led to his 1924 *Manifesto of Surrealism*.[34]

Appropriating Apollinaire's term surrealism for its title, Breton's manifesto defined a revolutionary avant-garde of world-changing consciousness. Enigmatically advocating a nonrationalist rationalism, Breton rejected dadaism's "nonsense for its own sake" and in surrealism conceived of a more constructive program incorporating Freudianism and later communism. But just as Breton rejected dadaism, surrealism inherited many of its attributes as it did aspects of cubism, abstraction, and futurism. Surrealism's psychic automatism delved into dream revelations, and automatic writing sifted the unconscious for word association, revealing aspects of the human condition that science had yet to discover. Mesmerism and séances became means of collecting the inner-world's essence.

Unlike dada's making art out of everyday objects and fusing them with abstract ideas and images, surrealism creatively plumbed the unconscious and looked upon mental illness and abnormality as freeing the mind from "reason's cage" and unleashing natural impulses and parallel worlds. Whereas Freud viewed neurosis as a malady to be alleviated, Breton sought its preservation and believed madmen to be oracles. Yet Breton's fascination with Freudianism never impressed its founder, who considered the surrealist a poet rather than a man of science.

While delving into changing human consciousness, surrealism retained dadaism's provocation, inheriting public scandal and outlaw behavior from figures such as Arthur Rimbaud, Alfred Jarry, and Arthur Cravan. Surrealism's "pope," André Breton selected among its pantheon Poe and Duchamp, as well as Matisse, who rejected his inclusion. Avowed enemies of frivolous cafe life, the surrealists avoided venues that smacked of a touristic bohemian pretense. They gathered primarily on the Right Bank, scouring the city for unusual spectacles, revelatory experiences, and chance encounters, which they described as "Marvelous." The surrealists, explained Polizzotti, were "like typographical psychoanalysts ... covering the lost byways of Paris—flea markets, proletarian cinemas, out-of-the way parks."[35]

An honorary surrealist, Man Ray took part in their nonsensical games held in homes far from the city's bohemian quarters. Ray showed works at surrealist exhibitions that had also appeared at earlier dada events, and he entered surrealism's orbit as did other avant-garde artists such as Giorgio de Chirico (in his early period), André Masson, Max Ernst, Yves Tanguy, Joan Miró, and

later Salvador Dalí. In his *Surrealism and Painting*, published in 1928 and dedicated to these artists' work, Breton contended that the artist's inner vision, like that of the surrealist poet, predominated over the physically observable.

As Breton reigned over his changing circle, which by 1925 embraced the French Communist party as a tenuous revolutionary partner in overthrowing bourgeois values, some Americans saw surrealism as having only a marginal impact. In 1938 Robert McAlmon noted that "not much of contemporary importance in French literature came either from the Dadaists or surrealists, and their passionate intergroup battles had long since ceased to be taken seriously." But surrealism's legacy, as with dadaism, later resurfaced in many forms, and its international coterie greatly influenced the abstract expressionists, while its efforts to combine art and life laid the groundwork for such later manifestations as 1960s happenings, conceptual art, and pop art.[36]

A Musical Training Ground

Surrealist experiments in literary and visual art occurred apart from those made in music, and the French capital, while sharing the rage for jazz, was the center of modern symphonic experiments. Isolated from and defiant of the Germanic symphonic tradition, France produced music of unique expression and tonality. Breaking from the Germanic symphonic form, Claude Debussy, Maurice Ravel, and Erik Satie composed music of an ethereal, colorist style more reflecting a symbolist aesthetic than the label "impressionist" given it by critics and historians. This modern French music thrived on "unresolved dissonances, lush chords with added sixths, sevenths, and ninths, and whole tone scales."[37]

During The Cocktail Age, musical ideas traveled freely between America and the European continent. Debussy's music fascinated jazz trumpeter Bix Beiderbecke. In Paris Stravinsky had many young American followers. Within these creative crosscurrents there occurred the first attempts to fuse jazz and symphonic music. Vastly different musical forms that had never been successfully wed structurally or stylistically, modern symphonic and jazz music fed off each other thematically, providing composers with motifs, rhythms, and other elements useful in their works. In postwar France, Les Six — a group associated with Erik Satie that included Darius Milhaud, Arthur Honegger, Louis Durey, Georges Auric, Francis Poulenc, and Germaine Tailleferre — was linked for a time with Jean Cocteau, who professed the principles of their music and the themes of childhood, the circus, music halls, bal musette, and jazz. Fascinated with jazz and Charlie Chaplin, Milhaud composed "Le boeuf sur le toit" (1920), a stage work set in a prohibition-era American speakeasy. Three years later, Milhaud's ballet *La Création du Monde* debuted at the Theatre Champs-Élysées with Cole Porter's *Within the Quota*, the latter labeled as "futuristic" — "the first jazz ballet."

For numerous American composers born during the last two decades of the nineteenth century, like Cole Porter, modern French music was extremely influential. After World War I American symphonic musicians and composers, less constrained by the Germanic music tradition, increasingly produced works of American themes and innovations—and many of these composers came to study in 1920s Paris. Home to Satie, Stravinsky, and the Ballets Russes, Paris inspired American music students Aaron Copland and Virgil Thomson, and later, a visiting George Gershwin.

Escaping what he perceived as America's creative stultification, Thomson studied in Paris where there was greater potential for performing and publishing his experimental music. Born in Kansas City, Missouri, Thomson had attended Harvard where, through the intercession of an instructor, he had read Stein's *Tender Buttons* and discovered Satie's music that he credited with transforming his life. First visiting Paris in 1921 on a Harvard fellowship, Thomson returned in the winter of 1925-1926 to study with Nadia Boulanger. For nearly half a century Boulanger instructed young composers like Walter Piston and Philip Glass as well as numerous modern jazzmen. Boulanger left an indelible impact on high art music of the 1920s, for what endeared students to this matronly brunette was her conviction that American music, like that of Russia before it, was on the brink of a great artistic flowering.

While in Paris, Thomson visited Shakespeare and Company bookstore and met Sylvia Beach, whom he described as an eighteenth-century "French milkmaid"—"Alice in Wonderland at forty." At the shop Thomson also met James Joyce and a fellow American composer, George Antheil. Antheil, the self-proclaimed "bad boy of music," noted Robert Crunden, "was perhaps the most flagrantly youthful, both in his age and in his personal and musical behavior, of all the young men abroad." The twenty-year-old Antheil and his Hungarian lover, Boski Markus, lived in an apartment above Beach's bookshop. To Beach, Antheil appeared "like an American high-school boy" with bangs and to Thomson, a "truculent, small-boy genius from Trenton."[38]

Son of a Trenton shoe-store owner, Antheil studied piano with a student of Liszt and for a short time with Ernest Bloch. By 1919 he encountered in New York City Leo Ornstein, Paul Rosenfeld, Alfred Stieglitz, and various avant-garde artists, especially dadaists and their machine-inspired works who in turn inspired his musical compositions. From New York he traveled to Europe in 1922, and in November his *First Symphony* debuted in Berlin, where he met Stravinsky. Once in Paris after a series of concerts in Germany, Austria, and Hungary—for which he demanded being billed as "Futurist Terrible"—Antheil met Ezra Pound in 1923, whom he described, with a touch of sardonic humor, as a "Mephistophelean red-bearded goat." Antheil's avant-garde approach to music impressed Pound, and the poet wrote a friend that the young American was "possibly the salvation of music." Pound believed that Antheil's music best captured the age, for as the poet commented, "music is the art most fit to express

the fine qualities of the machine." Though written out of reverence, Pound's *Antheil and the Treatise on Harmony* (Three Mountains Press, 1924) revealed his naiveté and lack of formal musical training, as it rarely dealt with Antheil's music. Pound's musical and harmonic limitations notwithstanding, he possessed a strong rhythmic sense, and Sidney Huddleston remembered him as "a supreme dancer ... ignoring all the rules of tango and of fox-trot, kicking up fantastic heels in a highly personal Charleston." When Pound debuted his "Sonata for Drum and Piano" at a Montparnasse music hall, he played the bass drum, with Antheil on piano.[39]

Antheil proclaimed rhythm as music's paramount characteristic, and decades before John Cage's experiments he predicted that "Sometime in the future we will have forms, which will not last a half hour, nor an hour, but eight hours, sixteen hours, or two days." This assertion anticipated the works of Robert Wilson and John Cage. Whereas Stravinsky had looked to Russia for folk sources, Antheil, like Aaron Copland and Virgil Thomson, found in African-American jazz the rhythmical potential for musical change, and he celebrated African "primitivism," especially after his first trip to the continent in 1923.[40]

For musical avant-gardists, as with painters and poets before them, select Parisian salons put them in touch with a philanthropic elite in a milieu rich in favoritism to critics and the newspapers. At Natalie Barney's salon Antheil debuted his *First String Quartet*. But private performances little advanced Antheil's career, and his written discussions of his music remained largely the province of little magazines.

In search of scandalous promotion (which depended upon philanthropic funds), Antheil launched his Parisian debut with the help of two early supporters, Margaret Anderson and her lover Georgette Leblanc. A singer in Marcel L'Herbier's film *L'Inhumaine*, Leblanc thought Antheil's music would add the crowning touch of riotous scandal for the filming at the Theatre des Champs-Élysées. In October 1923 invitees to the theater — Picasso, Satie, Darius Milhaud, Pound, James Joyce, Man Ray, and other surrealist members — were utilized as extras to stage a simulated riot to chase Leblanc off the stage. Caught on camera, they and the audience watched as Antheil performed "Mechanisms" and "Sonata Sauvage," which set off a riot (during which Ray allegedly punched someone), thrusting the composer into a storm of publicity and scandal.

The apex of Antheil's Parisian celebrity came with the performance of his *Ballet Mécanique* in 1926. First conceived as a composition to accompany Fernand Léger's experimental film the work possibly took its name from Picabia's drawing of a car axle that appeared on his *391* magazine cover (1917). Antheil was not the first to incorporate machines into symphonic music; Erik Satie's symphonic work *Parade* (1917), with its use of whistles, gun shots, and a typewriter, had already paved the way for other avant-garde experiments. Antheil's use of the player piano was also preceded by Stravinsky's *Les Noces* (1914–1921),

a work that became one of 1923's major events for Europeans and visiting Americans in Paris. Scholars have typically evaluated *Ballet Mécanique* as having little innovative qualities (the original score was lost, and Antheil revised the work in 1953). But Antheil's original full-length work, despite its cacophonous reputation, argued music scholar Carol Oja, featured unique qualities, such as its "prolonged stretches of silence.... Occurring irregularly and disjunctly, these tears in the basic fabric of sound perilously suspended the musical momentum, and they were announced by electric bells, which were a well-established Dada signifier." Antheil's 1926 score included four bass drums, three xylophones, a tamtam, whistles, electric bells, two pianolas, two pianos, and three airplane propellers (two wood, one metal).[41]

Antheil's *Ballet Mécanique* performance equaled that of any avant-garde event held in 1920s Paris. To garner publicity, Antheil leaked stories to the European and American press about his being missing in Africa; some reported that a lion had eaten him. On hand for *Ballet Mécanique*'s debut at the Theatre des Champs-Élysées on June 19, 1926, Antheil, seated at one of the eight pianos, looked out upon a sold-out crowd of 2,500. But mishaps abounded. The airplane propellers' hurricane-like force nearly blew away the front-row concertgoers. The audience divided into belligerent opponents and whistling and clapping defenders, and others who cowered under open umbrellas. To counter derisive catcalls and hisses, someone commanded, "Get out if you don't like it!" and Pound stood furiously shouting "Silence, imbeciles!" However, at the concert's end, as the thunderous applause died away, all passed without violent incident.[42]

To repeat the scandal on a larger scale, Antheil expanded *Ballet Mécanique*'s instrumentation for its New York debut at Carnegie Hall on April 10, 1927 — an evening of music that began with his First String Quartet, Second Violin Sonata, and W. C. Handy's Orchestra performing *Jazz Symphony*, and concluded with *Ballet Mécanique*. But Antheil's scandalous closing composition suffered from mishaps and miscues. The airplane's propeller, mistakenly aimed at the eleventh row, caused audience members to clutch their hats and programs while the borrowed fire siren failed to sound at its given point during the performance and did not do so until conductor Eugene Gossens took his final bows. Though several people got up and left during *Mécanique*'s performance, and someone was heard to mutter "it's all wrong, it's all wrong," most, according to William Carlos Williams, stayed until its conclusion. The concert failed to have the desired effect that had greeted its Parisian debut, and critics excoriated the performance. In response to what he viewed as the media's shallow-minded criticism, Williams believed it to be a knee-jerk reaction to something entirely new to the American concert hall. In an essay on the Carnegie Hall performance, Williams responded to a remark by a woman musician who considered the sound of the subway "sweet" in comparison to Antheil's music. In words foreshadowing the future musical avant-garde of Cage and others,

Williams explained: "By hearing Antheil's music, seemingly so much noise, when I actually came upon noise in reality, I found that I had gone up over it."[43]

But Williams remained in a distinct minority. After the New York City performance, Antheil went back to Paris, never again to regain his "bad boy" prestige, instead following Stravinsky's neoclassicism, and ultimately became a composer of Hollywood film scores. As Thomson later wrote, this "bad boy of music ... merely grew up to be a good boy." But Thomson also recounted that at one time, he envied Antheil's "freedom from academic involvements, the bravado of his music and its brutal charm." Reassessing *Ballet Mécanique*, Oja stressed that it "stands as a remarkable manifestation of the machine movement and Dada, showing energetic interchanges between musicians and visual artists during the 1910s and 1920s."[44]

In 1928, two years after the *Ballet Mécanique*'s debut, George Gershwin came to Paris and met Ravel, Milhaud, Poulenc, Stravinsky, and Prokofiev. That experience, along with an earlier trip to the French capital, became the inspiration for Gershwin's *An American in Paris*, a "rhapsodic ballet" that opened with music inspired by Debussy and Les Six. "My purpose here," explained Gershwin, "is to portray the impression of an American visitor in Paris, as he strolls about the city and listens to various street noises and absorbs French atmosphere." Whereas Antheil's *Ballet Mécanique* fell into obscurity, Gershwin's Lisztian *Rhapsody in Blue* (billed during its 1924 debut as an "Experiment in Modern Music") and his *Concerto in F* (1925) have survived as classic American works, renowned attempts at fusing elements of blues, jazz, and the symphonic tradition.

Beyond Gershwin's music, there were other American experimentalists who either created abstract compositions devoid of jazz influences or drew upon folk music and themes in a search for America that coexisted in literature and the visual arts. In 1921 Edgard Varèse formed the International Composer's Guild, and in 1927 the Pan American Association of Composers, who rejected European trends and dedicated themselves to works composed in the Americas. Among the latter's members were Charles Ives, Henry Cowell, Carl Ruggles, Roy Harris, and Wallingford Riegger. Varèse returned to Paris in 1928 and was present when the Pan American Association, financially backed by Ives, gave a 1931 concert series. Back in America during the 1930s Varèse experimented with compositions dedicated entirely to percussion instruments. Unlike Varèse and the "ultramodernists," Virgil Thomson, dubbed American music's greatest "Francophile," went on to incorporate African-American sacred music and Native American themes, eventually collaborating on two operas with Gertrude Stein, America's grande dame of avant-garde Paris.

Moderns on the Riviera

In 1921 Cole Porter discovered the French Rivera in winter, quaint and devoid of tourists. Porter subsequently summered at the Antibes' Château de la Garoupe, a house surrounded by a large garden and cypress trees near a small seaweed-covered beach. Through Porter's urging, Picasso visited, as did Gerald and Sara Murphy, American high moderns of impeccable fashion and cultural taste. Porter returned to Château de la Garoupe in the summer of 1922, where he joined the Murphys, the French Riviera's modern trendsetters.

Son of a New York City leather-goods storeowner, Gerald Murphy, a Yale graduate and Skull and Bones member, abandoned his Harvard study of landscape architecture and married Sara Wiborg (four years his senior) of the millionaire Wiborg family. The couple came to Paris in 1921; that October, Gerald experienced an epiphany when in a gallery window he saw works of Pablo Picasso, Georges Braque, Juan Gris, Maurice de Vlaminck, and André Derain. Intent on becoming modernist painters, he and Sara, a former art student of the Académie Julian in Paris and the Art Students League of New York in 1912, studied with Russian-born Natalia Gontcharova, set designer for Diaghilev's Ballets Russes. Under Picasso and Derain's supervision, Gerald painted the sets for the Ballets Russes, including Stravinsky's ballet with chorus, *Les Noces* (1923). Gerald befriended Fernand Léger, rented a Paris studio, and painted modern precisionist works—large canvasses foreshadowing 1960s pop art. One thematically depicted a watch's internal workings. Another, poster-like, captured an ocean liner's smokestacks and ventilators, while others were inspired by the cultivated good life: a library, paper currency, cocktail shakers, and cigars. Because Murphy produced only fifteen works, his influence never equaled that of Stuart Davis and others, yet his paintings are recognized as exceptional for their time.

Among American expatriate circles in Paris, the Murphys were epitomes of taste and intelligence. They attended dada balls and modernist aristocratic-sponsored Montmartre galas, one that found Sara wearing chauffeur's goggles and wrapped in tinfoil and Gerald in tights and custom metallic tunic. In 1923 the Murphys held a barge party on the Seine honoring Stravinsky's premiere of *Les Noces*. This event brought out a who's who of the Parisian art world, including members of Les Six, Tristan Tzara, and Picasso, whose infatuation with Sara resulted in several 1920s works said to show her sensual impact.

In September 1924 the Murphys bought the fourteen-room Châtelet des Nielles at Cap d'Antibes, calling it Villa America, and spent two years remodeling it, adding rooms and creating the area's first sunroof. A converted shed served as Gerald's art studio, and the seven-acre grounds were made into a "horticultural marvel," a landscape of citrus trees and Lebanese cedars. In one of the cement-entry gateposts, encased behind glass, Gerald installed his painting *Villa America*, displaying five stars for the members of the Murphy family and large letters of the work's title.[45]

Nearly a decade older than most of their artist friends, the Murphys led "a relatively stable existence that centered largely on their children," and which little resembled Montparnasse bohemianism.[46] They set the Riviera colony's aesthetic tone and remained in touch with the latest American trends, from jazz to household and kitchen innovations. Gerald's record collection ranged from Bach to Louis Armstrong, whose 1928 recording "Weatherbird" inspired the name of Gerald's hundred-foot schooner (completed in 1933).

F. Scott and Zelda Fitzgerald's 1924 visit formed the background for the opening of Fitzgerald's 1934 work, *Tender Is the Night*. Already famous for *This Side of Paradise* (1920) when he met the Murphys in Paris earlier in 1924, Fitzgerald greatly admired Gerald, who served as a model for *Tender Is the Night*'s main character, Dick Diver. Along the "mysteriously colored" Mediterranean, among fig trees, hand parasols, and wicker chairs, the Divers," wrote Fitzgerald, were "fashionable people" who "represented externally the exact furthermost evolution of class."[47]

The Murphys' tranquil family life contrasted with that of the Fitzgeralds. Envious of those with money and in constant need of attention, F. Scott chronically annoyed his hosts, and Gerald once banished the badly behaved drunken writer for three months. However, Zelda, a ballet student, writer, and self-proclaimed flapper with unconventional beauty and penetrating eyes, exuded an innocence that endeared her to the Murphys. Gerald once wrote: "Zelda had her own personal style; it was her individuality, her flair. She might dress like a flapper when it was appropriate to do so, but always with a difference. Actually, her taste was never what one would speak of as à la mode — it was better, it was her own." Able to tolerate F. Scott's excesses and Zelda's unstable mental condition (she once attempted suicide at the Villa), the Murphys graciously hosted visitors Joan Miró, Juan Gris, John Dos Passos, and Ernest Hemingway.[48]

Hemingway thought the Murphys "grand people" who "give each day the quality of a festival," and Gerald wrote of the Hemingways: "There's not a seismograph that can record our feelings of what we owe you.... Your values are hitched up to the universe." In Paris the Murphys had enthusiastically listened to Hemingway's reading of *The Torrents of Spring* and sections of *The Sun Also Rises*, and loaned the author a Parisian apartment to allow him a sense of privacy while honing his craft.[49]

By the time of Hemingway's arrival in 1926, the Riviera had been transformed from a fall-winter resort to a flourishing summer hot spot. Fitzgerald bemoaned the change. Hemingway noted that Fitzgerald was fond of "the Riviera, as it was then before it had all been built up, with the lovely stretches of blue sea and sand beaches and the stretches of pine woods and the mountains of Esterel going out into the sea." In 1923 Antibes had one restaurant and a cinema. Three years later, new hotels and restaurants opened almost daily. Americans crowded its shoreline, and in 1927 Sara wrote Zelda, "The Old guard of past years has changed, giving place to a new lot of American Writers &

Mothers." The Murphy family faced changes as well. Gerald, saddened by his son Patrick's contracting tuberculosis in 1929, stopped painting; two years later the Murphys, disheartened by Patrick's illness and the rise of European fascism, put the Villa America up for sale.[50]

The Murphys' departure from Europe coincided with the collapse of European banks and the rise of French political unrest. But it did not take the international economic crises to impel Americans artists and writers to leave Paris. Malcolm Cowley, who left France in 1923, noted that in the years leading up to the Wall Street crash in 1929, serious artists were part of a slow "yearly two-by-two" exodus. In 1927 Matthew Josephson re-crossed the Atlantic and found Montparnasse "Americanized. Gone were the "old dim-lit cafes" and their "black-hatted poets." A year later Josephson, in his "An Open Letter to Mr. Pound, and the other 'Exiles,'" urged their coming home — "that it was far more advantageous for serious artists to brave the industrial landscape and tides of commercial images so as to shape the mass media" than to lose themselves in a "hollow land" overseas.[51]

VI

The Search for America

The Primacy of Place

A vast number of Americans who had spent time in Europe returned home to make art in the "American Grain." In 1920 William Carlos Williams asserted that the true American artist, if he is "to be blessed with important work," must have an "informed contact with the locality." Voicing a common attitude, the various contributors of the influential compendium *Civilization in the United States* (1922) regarded American culturally diversity, and its editor Harold Stearns argued: "whatever else American civilization is, it is not Anglo-Saxon." The book's art contributor, Walter Pach, added that unique arts would require "a local tang." This sense of locality prompted artists to find inspiration among Southwest Native Americans or in Harlem, where African-Americans were pioneering new art and entering new markets.[1]

* * *

Americans returning home from extended European stays found by 1923 a more relaxed atmosphere as compared to the early postwar "vicious years" of race riots, labor unrest, and government raids on suspected radicals. Following the depression of 1920-1921, the expansion of mass production engendered unprecedented prosperity. New forms of credit created a democratization of consumerism as Americans bought automobiles, radios, electric appliances, and products once enjoyed only by the wealthy.

The new consumerism's advertising revolution recruited brilliant modernists, including those associated with Stieglitz, whose cutting-edge images helped disseminate 1920s fashions. Georgia O'Keeffe's paintings commissioned by the Cheney Brothers to help promote their silk fabrics, exhibited together at the department stores Marshall Field in Chicago and B. Altman in New York, helped set advertising styles for stores nationwide, while making her considerable sums of money. Man Ray's photographs appeared in *Vanity Fair*, Charles Sheeler's in *Vogue*, and Edward Steichen's Picasso-influenced photographs aesthetically transformed New York publications glamorously advertised women's clothes, jewelry, and other consumer products.

Echoing modernism's cult of the new, these advanced commercial images prompted a break with the work ethic by stressing leisure over hard work, spending over frugality, and hedonism over sobriety. Influential to this new consumption ethic, Greenwich Village bohemia — the birthplace of the American cocktail party — helped set the tone of the "New Era." Though not mass consumerism's main source, the "Village Idea," contended Malcolm Cowley, gave it form, as fashion designers and illustrators culled from Village bohemia new stylistic ideas, and its offbeat minority provided writers with models for rebellious young characters.

Free love's milder equivalent, the petting party, was practiced in automobiles and movie theaters, and the Village's sexually liberated New Woman had in the flapper a popular cultural cousin. Smoker, drinker, and a dancer of the latest jazz steps, the flapper made popular the flattening of breasts, bobbed hair, and short skirts fashionably depicted in magazines and novels. Flappers inspired even middle-aged, overweight matrons to wear their trademark short hair and attire. In his 1920 *Saturday Evening Post* short story, "Bernice Bobs Her Hair," Fitzgerald portrayed a shy society girl longing for peer acceptance. Bernice's bobbing her hair symbolized what literary scholar Peter Conrad saw as "a transition between two periods of life and two historical epochs," which "conferred erotic allure on girls once dismissed as wallflowers."[2]

Stieglitz's Constellation

As popular culture absorbed bohemian and avant-garde elements, artistic modernists quested for what Bram Dijkstra labeled as the American Moment, with indigenous art capturing the mountains and open plains, as well as urban skylines and electric signs. Exemplifying the American Moment, Georgia O'Keeffe painted Southwest images, William Carlos Williams wrote poems about the Passaic, and Paul Strand and Charles Sheeler made one of America's first art films, *Manhatta* (1920). Titled from one of Whitman's poems, Strand and Sheeler's short film captured, in innovative angles and sweeping shots, New York's vistas. But the celebration of things American meant different things to different people, and the machine's celebrants, the mechanists, clashed with the anti-industrial organicists who sought the country's regeneration in nature or in more primitive cultural expression.

Integral in guiding this search, Alfred Stieglitz had, since the 1913 Armory Show, become adopted as an American culture hero by a new generation. Despite this veneration, Stieglitz experienced doubt about America's advancement in the visual arts until Georgia O'Keeffe, whose work he showed at his last 291 exhibition, had come to New York in 1918. O'Keeffe's stunning paintings, and her joining his stable of artists — Paul Strand, Marsden Hartley, Arthur Dove, and John Marin — gave him confidence that Americans were not aesthetically enslaved to Europe.

With 291's closing in 1917, Stieglitz held shows at N. E. Montross and Mitchell Kennerly's Anderson Galleries at 489 Park Avenue. In 1925 Stieglitz, in the spirit of 291, opened the Intimate Gallery (Room 303 of the Anderson Galleries), and over the next four years held sixteen regularly reviewed exhibitions. Allied with him artistically were writers Sherwood Anderson, William Carlos Williams, and former *Seven Arts* members Paul Rosenfeld and Waldo Frank.

Sharing little of Stieglitz's anarchism, Frank foresaw evolving organic communities upholding the medieval guild tradition.* Like Van Wyck Brooks, he urged America's cultural rebellion to be led by a utopian vanguard. Averse to working-class revolt and largely hostile to mass culture, Frank viewed the machine warily. But he believed "Stieglitz's machine," the camera, could, in such a visionary's hands, produce art. He found in cinema few redeeming qualities, except for Charlie Chaplin's genius which he equated with that of Stieglitz. By the 1920s Frank was attacked by writers who, under dada and surrealism's influence, saw modern urbanism as a means to subvert the genteel tradition.

In his cultural visions, Frank, like Lewis Mumford, feared the rise of impersonal cities and the machine's dehumanizing effects, stressing the importance of artistic "seers" in creating culturally transforming artistic symbols. Like Stieglitz, he had a Whitman-like belief in art's potential through its crystallization of everyday experience. Frank increasingly insisted that modern life's best model lay in the ancient world — in "momentary flashes of divine illumination, which the prophetic artist might seize upon the use of his or her work and which others might then draw upon in their efforts to master modern society."[3]

"Land of Buried Cultures"

Under Stieglitz's influence and in the spirit of the American Moment, artists were to avoid otherworldly realms—"no fairy lands"—and by avoiding superficial reportage were to explore the "thing in itself," capturing the universal in the particular. Some blended primitivism with the machine aesthetic, and, while not true of Stieglitz, others drew creative and spiritual sustenance from the country's nonwhite inhabitants. 1920s transcendental utopians, contrary to Henry May's contention that the World War had shattered such visions and ended America's "age of innocence," held that the country's salvation depended upon the mainstream's adopting African-American or Native-American culture.

Changing locales nearly as many times as she did husbands, Mabel Dodge

*Not all of the former Seven Arts *circle accepted Stieglitz's modernism. Van Wyck Brooks, one-time hero to prewar cultural rebels as the writer of* America's Coming of Age, *fell back on Emersonian principles and longed for a new intellectual elite, thus losing his following among the avant-garde.*

found in New Mexico spiritual inspiration. After her Greenwich Village phase (1912–1917), Mabel married Russian émigré and modern painter Maurice Sterne in 1917, and they lived briefly in rural upstate New York, where she motivated him to take up sculpture. Then, to enhance his creativity, Mabel sent Sterne to New Mexico, where, for a short time, he enjoyed its colorful open landscape.

In Santa Fe Sterne encountered an art colony growing in reputation and residents. After New Mexico had attained statehood in 1912, Santa Fe had grown from a small community of "health seekers" into an artistic community of painters and writers intoxicated by its colors, climate, architecture, and non-white inhabitants in an exotic landscape. Willa Cather and John Sloan had been among Santa Fe's first creative residents, and the colony's charm was praised in *Scribner's* and *House Beautiful* and in Harriet Monroe's literary verse and prose.

Mabel arrived in Santa Fe late in 1917 and, while visiting Taos, experienced her final revelation. On Taos' pale pink-and-yellow landscape, adobe dwellings appeared to Dodge as cubist, reflecting, in their random layout, the land's natural rhythm. A transcendental modernist, Dodge came to see New Mexico's Native Americans as crucial in the reuniting of body, mind, and spirit. She savored the Pueblo's dance, drum, and song, a life-affirming communal music that, as she asserted, never betrayed a wistful note. Waldo Frank shared this view. Taos Pueblo life was for Frank superior to that of the white civilization that had nearly destroyed it. Frank wrote in *Our America* (1919) that "Indian art is classic, if anything is classic," and "its content is [a] pure emotional experience of a people who for ages sublimated their desire above the possessive into the creative realm."[4]

Frank and Dodge's reverence for Native Americans surpassed in its revelatory enthusiasm that of others of more academic background. At this time anthropologist Franz Boas and his Columbia University protégée Ruth Benedict studied Native Americans and valued their culture's uniqueness. Boas and Benedict's cultural relativism, however, did not seek Dodge's utopian ends in claiming that Native American life, if emulated by the broader population, could rescue a materialistic country from spiritual ennui.

Her mission now clear to her, the domineering Dodge sent Sterne away in 1918 and joined Tiwa elder Tony Luhan, her former chauffeur whom she married in 1922, in building Los Gallos, an adobe residence to which she invited intellectuals and artists* in hopes that they too would have a transforming experience. At Mabel's parties inebriates were satisfied by locally made "hootch," called "Taos lightning," and Los Gallos drew from the Stieglitz circle John Marin, Paul and Rebecca Strand, Andrew Dasburg, and Marsden

Her guests included psychologist Carl Jung; writers Aldous Huxley and Jean Toomer; Provincetown set designer Robert Edmond Jones; dance innovator Martha Graham; and photographer Ansel Adams.

Hartley, who as early as 1919 considered the Native American as America's only indigenous spiritual esthete. Georgia O'Keeffe arrived in 1929 and spent two summers that yielded eighteen works that have since become iconic images of the American Southwest.

In 1922 D. H. Lawrence and his wife, Frieda, accepted Mabel's invitation to visit Los Gallos, but their hostess' sexual advances to D. H. and her attempts to break up their marriage drove them away and into the company of Harvard educated poet, essayist, playwright, and Santa Fe resident Witter Bynner. Bynner's friends included Carl Sandburg, Amy Lowell, and Edna St. Vincent Millay. Independent and well-connected, he little countenanced Mabel's controlling personality.

Unlike Mabel, Bynner shared his friend Carl Van Vechten's interest in African-American art and thought, and he became a civil-rights advocate and sponsored the Witter Bynner Undergraduate Poetry Award given to Countee Cullen and Langston Hughes. To those close to him, Bynner was Hal, "America's greatest minor poet," whose translations of T'ang poet Li Po's works and Lao Tzu's *Tao Te Ching* became classic works. To pursue his cultural interests, Bynner had traveled throughout Europe and Asia. When Bynner arrived in 1922, Santa Fe possessed 7,000 residents; once there he received D. H. Lawrence, Van Vechten, Huxley, and Stravinsky as guests, and his raucous parties welcomed Santa Fe's intelligentsia and an element that Ansel Adams described as "a mélange of strange life-styles."[5]

Mabel Dodge Luhan and Bynner feuded regularly — he mocking her in art and life, and she disparaging him for supposedly bringing "homosexuality" to the Southwest. But Mabel, living at Los Gallos in comforts unknown to the region's Native Americans, failed in spreading her transcendental utopianism. By the 1930s, left-wing intellectual Mike Gold came to the ranch and, appalled by the Pueblo's poverty and squalor in this so-called utopia, published an article, "Mabel Dodge's Slum," condemning her bourgeois lifestyle. As leading members of the Southwest cultural scene, Mabel Dodge Luhan and Witter Bynner, for all their shortcomings, brought into question America's materialism and initiated a search that upheld the Native American as the true American able to redeem a nation succumbing to industrialism and mass consumerism.

Hollywood Decadence

Center of the mass consumerism rejected by the Southwest modernists, 1920s Hollywood — what F. Scott Fitzgerald described as "a mining town in lotus land" — symbolized a glamorous urban decadence. Having shifted westward from New York and Chicago to southern California, the film industry mirrored onscreen the revolution of manners and morals and the Hollywood set's alternative lifestyles. 1920s Hollywood advertised licentious behavior and produced films showing scantily clad women drinking with wild-eyed men —

images akin to Greenwich Village bohemia and Flaming Youth recklessness. In its more racy releases, handsome, healthy youths, as opposed to European upper-class decadents, partied and caroused on dazzling sets of modern fashions and décor. Fame's temptations and the Hollywood set's practice of excessive drinking and illegal drug use was reflected in films that, by showing flapper types, petting parties, and reckless automobile rides, helped to subvert traditional morality and widened the generation gap that surfaced during the 1920s. Jill Jonnes' *Hep-Cats, Narcs, and Pipe Dreams* has documented that several hundred 1920s movies portrayed "cinematic addicts (hooked for a variety of reasons, some medical, some pleasure) as once decent citizens who would betray family, work, and honor for a sniff or a shot." Most films, however, ended with the addict's eventual downfall and death, or redemption.[6]

If some of its films depicted lifestyles akin to a gin-soaked bohemianism and urban vice, Hollywood and the greater Los Angeles area did not at this time produce a bohemian scene of any note. California historian Harry Carr wrote in the 1930s: "I doubt if there is another large city in the world where there is so little of Bohemia as in Los Angeles. There are no hang-outs where the newspaper men meet after the papers go to press. No resorts where actors dream dreams and carve their initials on the table tops or on beer-stein pads." As Carr concluded, "Hollywood has too much money to be Bohemian." But the greater Los Angeles had its exclusive salons, and by the 1930s avant-gardists from Schoenberg to Stravinsky made the city their home, as did poet Robinson Jeffers and writer Aldous Huxley.[7]

But lone avant-gardists and writers— such as William Faulkner who liked nothing about Hollywood — do not make for bohemia, and because the Hollywood set worshipped the body beautiful, fortune, and fame, high art was held in little esteem among its set. In the homes of the Hollywood wealthy large libraries were assembled, but the books went largely unread. Stars were discovered while working everyday jobs. These film-star celebrants "marked," according to film historian Robert Sklar, "the dawning of the Aquarian Age — nearly a full half century before 1960s youth culture." Among Hollywood's smart set were gays and straights pursuing lifestyles unknown to most Americans.[8]

Yet there was one circle that emerged in the European salon tradition. As scandals gripped 1920s Hollywood, Alla Nazimova brought together gays and heterosexuals in a vibrant West Coast countercultural circle. A native of Ukraine and an understudy of the Moscow Art Theatre's Konstantin Stanislavsky, Nazimova (née Miriam Edez Adelaida) came to New York in 1905, where her acting captivated anarchist Emma Goldman. Upon Goldman's urging, journalists attended the actress' performances and wrote reviews that brought greater numbers of theatergoers as well as famed actors. Nazimova's appearance in Anton Chekhov's *The Seagull* (1905–1906) compelled James Huneker to describe it as having "splendid emotional powers." Nazimova subsequently made a name for herself performing in Ibsen's *Ghosts* (1905),

Hedda Gabler (1906), and *Doll's House* (1907).* Nazimova was the first Stanislavsky-trained actress to play leading Broadway roles, and as a 1920s film star, she "was the first to cultivate an image of the 'foreign' sexual sophisticate, and supplied the original theme on which Pola Negri, Garbo, and Dietrich created variations."[9]

Like other homosexual actors, Nazimova[†] entered into a faux or "lavender marriage," while pursuing women. Signed to the East Coast–based Metro Picture Corporation, she joined a roster that included Ethel Barrymore and other famed stars. When Metro moved her to Hollywood in 1918, Nazimova paid over 65,000 dollars for a tile-roofed and stucco-walled Spanish villa and spent nearly half that amount in remodeling the residence. The three-and-a-half acre estate at 8080 Sunset Boulevard, named by Nazimova the Garden of Ala (also known as the 8080 Club), had a lighted pool that the mansion's owner likened in shape to the Black Sea, where all-female parties were regular Sunday events. Nazimova's regular guests included Charlie Chaplin and Norma Talmadge, and by 1922 her gatherings also drew Rudolph Valentino, who twice married lesbians from her circle, one of whom, Natacha Rambova, costarred with a semi-nude Nazimova in *Salome* (1922), a film of homoerotic scenes that incited the censors' wrath.

Lavish film eroticism alarmed conservative Americans, and to avoid direct governmental censorship of the industry Hollywood moguls joined in forming the Motion Picture Producers and Distributors of America (MPPDA), hiring in 1922 President Harding's postmaster general, Will H. Hays to clean up the industry. As a result of Hays' campaign, films were to be made to conform to a traditional moral ending, and any sexual content was offset with "pious platitudes." Certain plots based upon serious novels and plays were banned, because their serious content could pose a moral threat to small-town sexual mores. Though conforming to new censorship restrictions banning nudity after 1922, motion pictures still depicted adulterous wives and other scandalous content that influenced the revolution of manners and morals. Though most moviegoers may have not engaged in the depicted sexual behavior, Hollywood films fanned the flames of the Flaming Youth, America's first youth-oriented mass cultural trend.

"Paris in My Own Backyard"

After visiting 1920s Hollywood that he described as a creation of "crass mechanical perfection," poet Hart Crane found New Orleans to be "unspeakably

Her work in Hedda Gabler *so impressed the young Eugene O'Neill that he attended the performance ten times.*

†*With the birth of her actress friend Edith "Lucky" Luckett's child — Anne Frances Robbins (nicknamed Nancy) — in 1921 she became, Nancy Reagan's godmother, the later wife of President Ronald Reagan.*

mellow and gracious," rife with "absinthe speakeasies and wonderful cooking." Leisurely, affordable, and offering ample illegal liquor, New Orleans accommodated writers. Briefly visiting in 1924, John Dos Passos lived in a small room on Esplanade Avenue, and, taking time out from writing *Manhattan Transfer*, described New Orleans "a fine town" of fine food, "scorched palms" and palmettos, wrought iron-decorated-buildings, paint-peeled and sun-faded.[10]

Numerous budding writers and artists who stayed longer formed an art colony around Jackson Square. This section of the city gave rise in 1916 to the Quarter's little theater, the Drawing Room Players, which staged one-act plays by local playwrights and Eugene O'Neill in its 500-seat venue on St. Peter Street. In 1919 journalist-writer Lyle Saxon presided over one of the Quarter's most prestigious salons, and, two years later, photography studios and bohemian tearooms opened their doors to the area's visitors and inhabitants.

Oliver La Farge, product of Groton and Harvard and a scholar and writer of "New England restraint," wrote that in 1920s New Orleans, "Anything could happen there, in the blocks of houses where the signs on the trolleys along Canal Street showed that one line ran to Desire and one the Elysian Fields." A member of the French Quarter's small art colony in the mid–1920s, La Farge, a conservative in art and politics, found himself at ease in this varied crowd. At his St. Peter Street apartment, "The Wigwam," he held all-night absinthe and whiskey parties, while artist/architect William Spratling presided over the Quarter's main gathering spot, providing visitors with his own distilled Pernod and bathtub gin.[11]

Some of this bohemian community's writers moved within *The Double Dealer*'s little magazine circle. A renowned modern publication in an aging riverboat city, *The Double Dealer*—founded by John McClure, Julius Weiss Friend, Albert Goldstein, and Basil Thompson — announced in its 1921 debut issue (dedicated to Lafcadio Hearn): "To myopics we desire to indicate the hills; to visionaries, the unwashed dishes.... We mean to deal double, to show the other side, to throw open the back of windows stuck in their sills from misuse, smutted over long since against even a dim beam's penetration." During its five-year existence, *The Double Dealer* published Ezra Pound, Amy Lowell, and Carl Van Vechten; translations of Chinese poetry by Witter Bynner and Kian Kang-hu; and other talents less recognized at the time, including Hemingway, Hart Crane, and Jean Toomer. Though H. L. Mencken dismissed the South as "The Bozart of the Sahara," he praised *The Double Dealer*, that reached readers as far as India and the Gold Coast.[12]

By the early 1920s influential writers like Eugene Jolas entered the *Double Dealer* circle.* Among this diverse group of men and women, Sherwood

Jolas moved to New Orleans in 1926 to work on the Item Tribune, *and subsequently met Sherwood Anderson. According to Douglas McMillan in* transition: The History of a Literary Era, 1927–1938 *14, Jolas contemplated taking over the* Double Dealer *but found New Orleans life too provincial, and moved back to Paris.*

Anderson first experienced the French Quarter in 1920 and openly embraced his southern comrades. Gleaning from small-town life the subjects of his novels *Winesburg, Ohio* (1919) and *Poor White* (1920), Anderson hoped to attract a French Quarter literary bohemia and wrote, "Perhaps if I can bring more artists here they will turn out a ragtag enough crew."[13] *The Double Dealer's* circle encountered Anderson in 1922 and found this wearer of "racetrack style" tweed a pleasant drinker and conversationalist. In a 1922 *The Double Dealer* article, "The Modern Movement in America," Anderson disdained America's commercialization and cultural standardization of life. For Anderson, America's cultural redemption lay in the arts, when creative people again had ample time to cultivate them, thus making works of quality than those produced quickly to satisfy consumer society's taste.

By March 1922 Anderson left New Orleans and did not return until the spring of 1924, when he and his new wife, Elizabeth Prall, rented a Vieux Carré apartment. While reading the proofs for his novel *A Story Teller's Story* (dedicated to Alfred Stieglitz), Anderson encountered in his morning walks sailors fresh from a night's drunk and rotund Italians standing outside storefronts. He saw various African-Americans—basket-carrying women and plaintive-singing workers and stevedores, whom in his novel *Dark Laughter* he described as an American minority unburdened by the white man's dehumanization.

In September 1924 Anderson and his wife moved into a three-room apartment in the Upper Pontalba Building just off Jackson Square. In October Anderson finished the first draft of *Dark Laughter* and turned to writing short stories. In early November Elizabeth encountered at her doorstep the aspiring poet William Faulkner, who had worked at her Doubleday bookstore in Greenwich Village in 1921; she introduced him to her husband, and together the two writers spent hours drinking together in the Quarter.

After a brief return to Mississippi, Faulkner arrived back in New Orleans during February 1925 and sublet a room from William Spratling in New Orleans Alley (renamed Pirate's Alley). Faulkner lived marginally, worked on his fiction, and contributed to *The Double Dealer* and *The Times-Picayune*. Socially withdrawn, wearing worn tweed, Faulkner, while fallaciously claiming to be a wounded Royal Air Force pilot left with a limp and a steel plate in his head, impressed Quarterites with his having read Verlaine, Pound, Joyce, and Elliot, as they had only made their way through Melville and Conrad.

To enrich his literary background, Faulkner crossed the Atlantic in July 1925. Landing first in Italy, he then walked alone to Paris, where he chose not to take advantage of his written introductions to Pound and Stein. Instead, he acquired a few words of French, grew a beard, and visited the Louvre, and in Latin Quarter galleries he viewed works by Cézanne, Picasso, and the futurists. He frequented the Moulin Rouge, Sylvia Beach's Shakespeare and Company bookshop, and a Montparnasse café, where he spotted Joyce.

Faulkner briefly visited England, then went back to Paris before returning

to New Orleans' French Quarter in September 1926, where he and Spratling lived in a fourth-floor attic room. Once back in the city, he cooled his relations with the *Double Dealer* circle and drank nightly with members of *The Times-Picayune* staff. Before his European trip, Faulkner had already distanced himself from Anderson, whose novel *Dark Laughter* resulted in the author being excoriated and mocked by former admirers. Several months after *Torrents of the Spring*, Hemingway's satire of Anderson's writing, in December 1926, Faulkner and Spratling self-published *Sherwood Anderson & Other Famous Creoles*, a biting parody that carried Spratling's sketches of locals with satirical prose dedicated "To all the Artful and Crafty Ones of the Quarter." *Famous Creoles'* foreword ridiculed Anderson's literary style; though less scathing than Hemingway's satire, it nonetheless hurt the older writer whose connections had helped Faulkner break into the major publishing market. Faulkner's underlying message came as no surprise to Quarterites "hipped on Freud" as a "graphic example of the son asserting his freedom by slaying his father."[14]

Faulkner left New Orleans in late 1926 a confident writer with two completed novels, *Soldiers' Pay* (1926) and *Mosquitoes* (1927). Debuting after *Sherwood Anderson & Other Famous Creoles*, *Mosquitoes* further criticized Anderson and the *Double Dealer* circle. Based on an actual experience, *Mosquitoes* centers upon a Lake Pontchartrain yacht outing funded and organized by a wealthy spinster and naive collector of artists, Mrs. Maurier, who invites aboard her yacht a moody modern sculptor, a pretentious New Orleans poet manqué, and a loquacious writer, Dawson Fairchild. Thinly disguised as the middle-aged Anderson, Fairchild bores listeners with folksy stories, literary theories, and diatribes against modern poetry that he likens to "a pair of shoes that only those whose feet are shaped like the cobbler's feet, can wear; while the old boys [poets of previous epochs] turned out shoes anybody can wear." As Stephen B. Oates observed, though *Mosquitoes* appeared to be a flawed apprentice novel, it was a "bold and explicit tale for 1926 America," especially in its references to "constipation, masturbation, incest, lesbianism, perversion, and syphilis." After *Mosquitoes'* publication Faulkner, as Anderson had urged him, creatively explored his "own postage stamp of native soil," where in his mythical Yoknapatawpha County he created some of the most enduring stories of American literature.[15]

By 1927 most of New Orleans' talented writers had left the Quarter, and local writer Hamilton Basso complained that "too many country boys and girls are coming in to be Bohemians and immorality lacks that calm, professional dignity it held in the corrupt era prior." Efforts by writers to make the Quarter a Greenwich Village of the South faltered. Other great talents took refuge in the Vieux Carré, but no vibrant literary or art scene subsequently emerged, and the city became best known for Mardi Gras parades and as the cradle of jazz.[16]

The Chicagoans

New Orleans' musical confluence of European opera, Creole society bands, Cuban music, traveling minstrel shows, brass bands, and ragtime bordello piano music was a musical culture enhanced by the influx of rural blues and African-American sacred music. The ragtime craze of the 1890s and 1900s swept America and Europe, leaving in its wake a written piano music that greatly influenced other instruments and whole instrumental ensembles—experiments that were heard in most American cities with substantial African-American populations. But it was New Orleans that produced a distinctive African-American musical style, sometimes referred to as "jass," a hybrid of ragtime, bordello piano music, and brass-band tradition that featured increasing improvisation, with rhythms and tonal inflections enriched by blues.

During the 1910s, jazz entered into American culture, and, in less than a quarter century of meteoric development, produced an avant-garde that helped shape several countercultures. Though rejected by some modernist composers like Henry Cowell, jazz "was the non–European music with greatest impact" upon musical high modernists. Waldo Frank deemed jazz a crude folk expression, an insipid outgrowth of mass culture and the machine, while F. Scott Fitzgerald defined his times as "The Jazz Age." Many African-American intellectuals disliked the music as well, and Marcus Garvey tolerated it with the notion that blacks would soon create more sophisticated musical expression. Enamored of spirituals, W. E. B. DuBois considered jazz as entertaining but not a music destined to produce high art. Counter to DuBois, there were those like African-American scholar Alain Locke who thought spirituals, blues, and jazz as the basis for the composing of modern symphonic works, in that he already heard "the soul sounds of Negroes in the music of new European composers: Milhuad, Dvorak, Stravinsky."[17]

Improvisation, an African musical aesthetic common to African-American sacred and folk music, became a jazz hallmark, and in its syncopated rhythms appeared a modern music of a modern nation that spawned new dances and vernacular speech. Under the music labeled jazz, however, numerous styles evolved—from banal dance music to serious instrumentalists who sought to play in the "hot" African-American style. 1920s jazz, especially in the form of phonograph records, entertained diverse countercultures in America, Paris, and Berlin. In February 1926 pianist Sam Wooding took a quasi-jazz band, the Chocolate Kiddies, to the Soviet Union, and other African-Americans performed in China, Singapore, and India. The Great African-American Migration (1916–1919) brought north hundreds of thousands of workers and family members as well as numerous musicians, many of whom had already traveled as far north as Minnesota playing Mississippi riverboats. Without offering steady musical employment, New Orleans could not hold younger musicians intent on establishing full-time careers. Attracted by the prospects of

employment and a better life, numerous African-American musicians settled in Chicago's South Side. Similar to the pattern that saw Chicago become an important publishing center in the 1910s, its early 1920s jazz scene rivaled that of New York City, attracting musicians from New Orleans, St. Louis, and other cities. Many South Side cabarets and dance halls were controlled by organized crime; and known as "black-and-tans," they maintained a biracial policy. Accompanied by a "fixer" — a paid black guide — whites were taken to the leading venues where they danced to African-American jazz and intermingled with its nonwhite clientele.[18]

Segregated from working the northern and western sections of Chicago, the province of white commercial bands, leading black musicians such as cornetist King Oliver, pianist Earl Hines, clarinetists Jimmy Noone and Johnny Dodds, and drummer Warren "Baby" Dodds became South Side musical stars. When Louis Armstrong accepted an offer to join Oliver's band and came to Chicago in 1922, the South Side soon hailed him as a musical hero. Armstrong, with his innovative phrasing and melodic sensibility, almost single-handedly transformed jazz, influencing not only how the trumpet was played, but nearly every instrument of the idiom.

Armstrong and his older jazz contemporaries were heroes to numerous young white musicians, among them the Chicagoans who sought to play in New Orleans "hot" style. Named after their middle-class neighborhood of Austin, the "Austin High Gang" comprised saxophonist Bud Freeman; cornetist Jimmy McPartland; banjoist Dick McPartland; pianist Dave North, clarinetist, alto saxophonist, and violinist Frank Teschmacher;, and tubaist and bassist Jim Lannigan. Most of this well-dressed, youthful circle still lived at home, but they made nightly forays into the city in search of jazz. Swept up in the era's cultural ferment, Freeman recounted that at first the Austin High Gang constituted "a little intellectual cult.... All of us were somewhat ambivalent; we didn't know if we wanted to be writers, poets, or musicians."[19]

Initially admirers of the Original Dixieland Jazz Band's recordings (a New Orleans–based white band that made the first jazz recordings in New York City during 1917), the Austin High Gang discovered African-American stylists. In contrast to the ODJB's cornetist-leader Nick LaRocca, who erroneously claimed that whites had originated their music, the Austin High Gang revered black jazzmen with a near-religious fervor and became the first white musicians to immerse themselves seriously in urban black culture.

By the mid–1920s another important musician joined the Austin High Gang, Oak Park's Dave Tough, the circle's drummer and leading intellectual. A slim, "hollow-looking" high-school drop-out, Tough studied literature at Lewis Institute. Poet Kenneth Rexroth deemed him "just about the first hipster," who lived "with gay women" and composed "real far out poetry." Tough urged fellow musicians to read H. L. Mencken and Hemingway and to attend the Cézanne exhibition at the Art Institute of Chicago. During the late 1920s,

Tough performed in Europe, took in the Paris scene, and made friends with F. Scott Fitzgerald and Japanese artist Tsuguji Fujita.[20]

Like Tough, Bix Beiderbecke, legendary trumpeter and Flaming Youth hero, met an early alcohol-induced death. Beiderbecke had urged the Chicagoans to further their musical education by studying the music of Alexander Scriabin, Igor Stravinsky, Gustav Holst, Maurice Ravel, and Claude Debussy (he recorded solo pieces based on Debussy's harmonic conceptions). However, not all agreed with Beiderbecke's taste for European modernism, and the Austin High Gang's clarinetist Milton "Mezz" Mezzrow, a marijuana-smoking hipster who adopted a black identity, defied these influences. A fervent blues and New Orleans jazz follower, Mezzrow believed that adopting written notation and advanced European harmony would taint jazz music's purity,* and that it flew in the face of like-minded jazz traditionalists seeking, as he related, freedom from "the hand-cuff-and-straight-jacket discipline of the classical school."[21]

Unlike most white jazz fans in the 1920s, the Austin High Gang searched the South Side of Chicago for their black jazz heroes, and they held "music appreciation classes" in various homes to study the recordings of Armstrong and Beiderbecke. Gathered around a wind-up Victrola they drank gin and smoked marijuana, known as golden leaf, mutta, or muggles. Immersed in music to the point of fanatic obsession, Austin High saxophonist Bud Freeman recounted, "We did not live as other people did."[22]

"Harlem Nocturne"

Chicago, the birthplace of the legendary 1920s recordings of the Louis Armstrong Hot Five and Hot Seven recordings and Jelly Roll Morton's Red Hot Peppers, could not hold leading musicians and writers intent on attaining better employment opportunities, and perhaps fame, in New York City. Unlike in Chicago, where the largest white-owned clubs outside the South Side barred blacks during the 1920s, New York offered African-American musicians (dancers and actors) lucrative employment in Broadway ballrooms. But it was Harlem — a city within a city — that fueled the imagination of thousands of African-American musicians and entertainers who saw it as a northern promised land, and like Montmartre and Montparnasse Harlem became a must-see spectacle for adventurous white American and European nightclub visitors. Though white visitors rarely saw daytime Harlem's overcrowding and poverty, the community's variety of cabarets and ballrooms allowed for an intermingling of the races unprecedented in American history.

Meanwhile, New York's primarily middle-class black artists and writers

*One Chicagoan, Benny Goodman, whose reading skills separated him from the improvised playing of the Austin High Gang, came to bridge this world, and eventually made recordings with Béla Bartók.

grappled with bringing their message to a biracial audience. At the helm of the Harlem Renaissance's inner bohemian circle, Utah-born Wallace Thurman, a talented critic and editor, came to Harlem in 1925 with the hope of writing a great American novel. In his writing he satirized his early Utah experiences, observing that they inspired him only "to drink gin with gusto, and develop new techniques for the contravention of virginity." Tubercular and openly bisexual, Thurman led a lifestyle reminiscent of nineteenth-century decadents (just days following his arrival in New York, he was arrested on a morals charge for making sexual advances in a public restroom). Yet while looking upon himself in a self-deprecating way as "the incarnation of the cosmic clown," he pursued literature seriously, brilliantly edited for the *Messenger*, and copyread for Macaulay.[23]

Thurman's circle included poet Langston Hughes; anthropology student, writer, and playwright Zora Neale Hurston; and writer-artist Richard Bruce Nugent. Together they defied the black bourgeoisie (derisively labeled as "dicty"), whom Thurman's bohemians condemned as imitating the white man's acquisitive ethos and his Eurocentric culture. Nerve center of this revolt, Thurman and Nugent's boarding house at 267 West 136th Street in Harlem — known by Hurston's nickname as the "Niggerati Manor"* (a snub of Harlem's older intellectual and literary elite) — invited black and white, straight and gay. Bootleg gin drinkers mingled with African-American artist Aaron Douglas, novelist/physician Rudolf Fisher, and on occasion poet Countee Cullen.

The most bohemian of Thurman's circle, Nugent, a Washington, D.C. native, worked in New York City as an openly gay bellhop, attended Harlem and Greenwich Village soirees barefoot with a gold stud earring, and took art classes. He was "the first African American to write from a self-declared homosexual perspective," and his phallic Beardsleyan drawings were displayed on Niggerati Manor's walls.[24]

In the summer of 1926 Nugent, seeking to express himself outside the mainstream press' censorship, joined Langston Hughes in publishing a little magazine and recruited Thurman as the quarterly's editor. Thurman embraced his job zealously, organizing the publication at Niggerati Manor and other public venues. Debuting in November 1926, *Fire!!* (its title daringly using two exclamation points and its masthead asserting that it was "a non-commercial product interested only in the arts") aimed at throwing off the influences of black elitists like W.E.B. Dubois as well as the white publishing world. Eclectic in content, *Fire!!*, as Robert Hemenway noted, symbolized "an uncompromising race pride, a fascination with the masses, and an iconoclastic, belligerent attitude toward the accepted wisdom." Aaron Douglas' defiant sphinx graced its modernist cover, and its pages included a free-verse poem by Langston Hughes and

*Others to appear at times within the "Niggerati" circle were sculptor Augusta Savage, Boston-born writer Dorothy West, or Harlem schoolteacher Harold Jackman.

Wallace Thurman's short story "Cordelia the Crude," which centered around a fifteen-year-old prostitute. But most shocking was Nugent's erotic "Smoke, Lilies, and Jade, Part I," a stream-of-consciousness piece about a young Greenwich Villager, Beauty, and his opiate-induced androgynous fantasies. Emerging as the literary scandal of the Harlem Renaissance, "Smoke, Lilies, and Jade," opined David Levering Lewis, "was like nothing done before by an Afro-American writer." *Fire!!* also featured the work of Zora Neale Hurston, the bohemian "Queen of the Niggerati," who contributed her play *Color Struck* and a fine short story, "Sweat."[25]

Financial troubles and lack of sales limited *Fire!!* to one issue. Its avant-garde provocation outraged DuBois and black literary academics. Containing content unknown to the NAACP's *Crisis* or the Urban League's *Opportunity*, *Fire!!*, according to David Levering Lewis, was "a flawed, folk-centered masterpiece," fighting the Harlem Renaissance's moralism and the white exploiters of black stereotypes.

Disappointed in his creative shortcomings, Thurman also criticized black writers who catered to Harlem's vogue, which he believed was the sole source of their recognition. Thurman's 1929 novel *The Blacker the Berry* condemned Carl Van Vechten's Harlem "Know the Negro crusade," and the novel's Truman Walter (Thurman) heads up a hard-drinking bohemian circle of poet Tony Crews (Langston Hughes) and Paul (Bruce Nugent), an urban vagabond "possessed of Greenwich Village wit."

Nugent also appeared in Thurman's *Infants of the Spring* (1932) as the writer/artist and bisexual Paul Arbian, a worshipper of Oscar Wilde who prefers Debussy to Schubert and lauds George Antheil's musical genius. In *Infants of the Spring* Jean Toomer is considered the Harlem Renaissance's only true genius. More closely associated with the literary avant-garde than other figures of the Renaissance, Toomer authored one of the era's most brilliant books, *Cane*.* Born in Washington, D.C., Toomer lived in privilege, largely due to his grandfather P. B. S. Pinchback, one-time acting governor of post–Civil War Louisiana. After years of aborted attempts at studying at various universities and eking out a living at various jobs, Toomer began writing in 1918. In 1920 he met Waldo Frank and two years later entered into a circle that included Frank, Kenneth Burke, Van Wyck Brooks, Gorham Munson, and Hart Crane. Among this circle, Toomer remained closest to Frank and addressed him in letters as "Brother." Through Frank, Toomer met Stieglitz, a figure whom he lauded as leading "a being-centered life." Toomer dismissed what he believed was the socially imposed category of race that prevented a transcendental oneness; his "story," explained S. P. Fullinwider, "is one of a young man tangled in the skein of race

Toomer's early 1920s' works appeared in the Little Review, Dial, *and the* Liberator, *and his contributions to the* Double Dealer *impressed Sherwood Anderson, with whom he soon corresponded.*

relations in America. But it goes beyond that. For a time, at least, it was the story of modern man, the story of a search for identity—for an absolute in a world that had dissolved into flux."[26]

In 1921 Toomer, while working in rural Georgia as a substitute school principal, heard spirituals that, along with Sherwood Anderson's novel *Winesburg, Ohio*, served as the inspiration for writing his brilliant modernist novel *Cane*. Filled with poetic, impressionistic scenes of rural and urban black life, *Cane*, observed Nathan Huggins, presented "symbols that served as metaphors to allow a reader, whether white or black, to enter the crux of those tensions that tugged at the Negro self."[27]

Though *Cane* sold less than five hundred copies, it was critically well received by Thurman and praised by Waldo Frank and prompted his friend Anderson to encourage Toomer to further explore African-American themes. But Anderson's preoccupation with the black man's "primitivism" disappointed Toomer in its opposition to the latter's transcendentalism. Aesthetically, Toomer was at odds with Van Wyck Brooks, Charles S. Johnson, and Alain Locke, who insisted that creative beauty and meaning lay in the immediate and tangible world, while, Fullinwider explained, Toomer "was saying just the opposite: turn for beauty and meaning in your inner essence." Though Toomer's aesthetic idealism disappointed Stieglitz and other early supporters, he had, and would have in decades to come, like-minded searchers among those of a more mystical consciousness.[28]

* * *

While African-Americans little interested Jean Toomer's friend Mabel Dodge Luhan, they became Carl Van Vechten's obsession, and during the 1920s he served as "a middle man in marketing African-American literature to the white literary establishment." Van Vechten first visited Harlem in 1924 when NAACP officer Walter White took him to Happy Rhone's Club, thus beginning an infatuation with black cabarets, speakeasies, and drag balls. A decade earlier modern artists such as Demuth, Picabia, and Duchamp had visited Harlem, yet their passion could hardly match Van Vechten's infatuation with this part of the city where he first heard blues singer Bessie Smith and the Fletcher Henderson Orchestra. Van Vechten had affairs with Harlem notables such as the handsome man about town Harold Jackman; he took Mabel and Tony Luhan, Witter Bynner, and William Faulkner to nightspots, wrote on black culture for *Vanity Fair*, and urged leading magazines to publish black writers. He helped Hughes get his first volume of poems, *The Weary Blues* (1926), and his second volume, *Fine Clothes to the Jew* (1927), published by Alfred A. Knopf.

At their West Side apartment, Van Vechten and his wife Fania Marinoff held multiracial parties, where Gershwin played piano and Dreiser brooded. Once a drunken Bessie Smith knocked her hostess to the floor, and actress Tallulah Bankhead attended when singer Adelaide Hall played the drums; on

another occasion, film actor Chief Long Lance did an Indian war dance. Van Vechten's Harlem contacts provided background for his best-selling melodramatic novel, *Nigger Heaven* (1926). Fascinated with jazz clubs, Van Vechten illustrated how the novel's African-American middle-class characters, would-be-writer Byron Kasson and librarian Mary Love, both suffer in trying to rediscover their deeper racial identities. Byron is unable to write about the Negro experience. Mary does not dance until meeting Byron, and while she oversees a library's African art exhibition and urges patrons to read *Cane*, she remains unable to tap into her African self.

Tired of Mary's constant urging him about writing and the need for a steady career, Byron takes up with the wealthy and sensuous Lasca Sartoris, a former stage actress modeled after Van Vechten's friend Nora Holt. Enraptured by this femme fatale, Byron engages in sadomasochistic sex and indulges in cocaine. Lasca and Byron, during their ill-fated romance, visit Harlem nightclubs. At a cabaret, the Black Mask, and in scenes reminiscent of the European decadents, a champagne fountain flows and "happy dust" (cocaine) is ingested, and as part of the entertainment a nude sixteen-year-old black girl appears, knife in hand, suggesting ritualistic suicide.

Nigger Heaven sold over one-hundred-thousand copies. Though not read by the majority of African-Americans, the novel sparked debate and upset DuBois and other black elites. At the same time, its defenders ranged from Walter White and Rudolf Fisher to Thurman and Hughes, who furnished its blues lyrics, and to Van Vechten's publisher, Alfred A. Knopf, who saw in the novel a new market for African-American culture.

The Village Transformed

Whatever liberties Van Vechten's *Nigger Heaven* took with its description of Harlem nightlife, it pointed to a cultural world that made 1920s Greenwich Village seem tame by comparison. Following its incorporation into the city, the Village's Washington Square neighborhood came to resemble an amusement center — a cheap "Coney Island" — for uptown slummers and the boroughs' poorer youths, and sensational articles in the *Literary Digest*, *Vanity Fair*, and the *Ladies Home Journal* only heightened its commercialization. Gullible dilettantes absorbed third-rate and amateur art in venues that "made the candle ... a Village symbol," and Village tearooms, which in prewar years had served as places for artists to escape cramped living spaces, became tourist venues. Affluent professionals moved into the Village, remodeled their living spaces, and commuted to their midtown jobs (the nearby subway had been built in 1917). To artists living among Italian and Irish tenement dwellers, the Village's gentrification was the creation of "bourgeoisie pigs."

One of the great draws to Greenwich Village was its offering of wine and hard drink, as one of America's first communities to break with Prohibition.

Italian grocers sold homemade wine through a look-the-other-way policy and supplied scores of Village speakeasies. But the more glamorous Prohibition-era jazz clubs and cabarets became the wealthy slummers' preferred haunts, and in gay Village cabarets, such as the Red Mask, the Jungle, and Trilby's, gangsters, homosexuals, and heterosexuals watched floor shows featuring outrageous gay comedians.

For "the Thrillagers" there was Dick Dickermann's Pirate's Lair. In a jail cell–themed venue, convict-stripe-suited waiters served customers; the Nut Club had "topsy-turvy decorations," and in another spot with a barn-and-country-fair-theme, overalled hayseed-looking employees danced, and old-fashioned bicycles were ridden. Pseudo-bohemia had its pseudo bohemians, and fakes abounded. Some Village nightspots promised visitors the opportunity to look at a bona fide bohemian. Self-proclaimed genius Guido Bruno, a "publicity-stunter" who sponged off the rich, published obscure little magazines and held, at his Thimble Theater, "free concerts— of phonograph music." Slummers glimpsed local oddity Doris the Dope bathing in Washington Square's fountain.[29]

But the Village represented a stratum of characters, some manqué, some madly brilliant. During the early 1920s, the Baroness Elsa von Freytag-Loringhoven still paraded her dada fashions, Maxwell Bodenheim recited poetry and drank, and Edna St. Vincent Millay wrote verse. Until they moved to Paris in 1923, Margaret Anderson and Jane Heap struggled to publish the *Little Review*, and the same year, Matthew Josephson brought his little magazine *Broom* from Europe to the Village. Throughout the twenties the editorial offices of Scofield Thayer's *Dial* remained on West Thirteenth Street.* Often overlooked in favor of more obscure little magazines, *The Dial* included writings by James Joyce and William Carlos Williams, featured T. S. Eliot's "The Waste Land" and "The Hollow Men," and counted E. E. Cummings as its sole discovery.

As little magazines struggled, the little theater tradition continued, notably the Greenwich Village Theater at 3 Sheridan Square, where O'Neill staged *The Great God Brown*. Though O'Neill had left the Village in 1918, he did not turn his back on the Provincetown Players or the Village's Provincetown Playhouse. After Jig Cook's departure in 1922, the "Triumvirate" of O'Neill, Kenneth Macgowan, and Robert Edmond Jones continued staging important plays by European and American playwrights, emphasizing dramatic experiments and stage technique. Their efforts included O'Neill's controversial *All God's Chillun Got Wings* and a revival of his *Emperor Jones*, both starring Paul Robeson. After O'Neill broke with the Provincetown Players, they continued with modest success and made an impressive comeback with E. E. Cummings's 1928 experimental play *Him*.

*By 1925, when The Dial *reached a readership of thirty thousand, Thayer resigned as editor and departed for Europe, leaving the magazine under the editorship of poet Marianne Moore until its demise in 1929.*

The stock market crash of 1929 triggered the Provincetown Players' demise and wrought important changes in the Village. Vital to the area's transformation was the building of the Sixth Avenue Subway (1927–1930), the completion of the Holland vehicular tunnel (1930), and the expansion of the area's main thoroughfare. Though many artists and writers had moved out, artists and intellectuals like John Dos Passos frequented Village parties. But for some 1920s arrivals and those weathering the Depression years, the Village was more expensive, yet still quaint, creative in spirit, and tolerant socially and politically.

VII

Radicals and Moderns

Often labeled as "The Red Decade," 1930s America was not dominated by left-wing activity any more than it lacked avant-garde experimenters and promoters, who took part in what Steven Watson termed the "mainstreaming of modernism." The artistic avant-garde's commercial entry points—printed media, fashion window displays, galleries, and museums—carried its aesthetic into the mainstream. Surrealism made its way in the pages of *Vogue* and *Town and Country*, and *Time* discussed Mabel Dodge, Marcel Duchamp, and Ezra Pound's *Cantos*. Despite economic hardship, avant-gardists created vital works. In 1931 Edgard Varèse composed *Ionization*, a symphony dedicated solely to percussion instruments. Early in 1933 Diego Rivera's three-paneled mural, "Man at the Crossroads," in the lobby of the RCA Building in New York City's Rockefeller Center created controversy that led to its forced removal, in what *Time* reported as "1933's biggest art story." Between 1936 and 1939 Frank Lloyd Wright built his residential modern architectural tour de force Fallingwater in Pennsylvania, and Stein and Stieglitz became celebrated figures.[1]

The Turn Leftward

In 1933 Prohibition's repeal coincided with a United States court decision lifting the ban on James Joyce's *Ulysses*, and Gertrude Stein's finding fame with *The Autobiography of Alice B. Toklas*. In the turbulent year of 1933, Hitler gained power in Germany, and Hoover's loss of the 1932 election resulted, between November and March, in a five-month leaderless drift, while American workers suffered twenty-five percent unemployment. To stem the crisis President Franklin Roosevelt, during his first one hundred days, introduced emergency legislation that included the Federal Emergency Relief Act and the National Industrial Recovery Act.

Most left-wing Americans, witnessing their country's worsening economic condition and envisioning the Soviet Union's government-sponsored programs as guiding the future by "scientific" Marxism, considered the artistic avant-garde and bohemianism as expressions of bourgeoisie individualism — selfish

indulgences of a dying way of life within a system on the verge of collapse. Though most cultural rebels never officially joined the left, there were conversions to a contingent later dubbed by beat poet Allen Ginsberg as "delicatessen intellectuals." Just as they had experienced bohemianism and dadaism, Malcolm Cowley and Matthew Josephson embraced communism as a liberating force. For director/actor John Houseman "[t]he Left was clearly where the action was to be found. For many — writers designers, directors, actors, musicians— a radical orientation of their creative activity was the era's equivalent to today's foundation — grants and subsidies in the performing arts." At the same time, independent Marxists like Edmund Wilson embraced leftwing ideology while promoting modernist literature. Of this left-wing minority, Alfred Kazin, a reader of Randolph Bourne and Van Wyck Brooks, recounted, "I thought I could see across the wasteland of the Twenties to our real literary brethren in the utopians and socialist bohemians of 1912.... We would improve on the nihilism of Hemingway, the callousness of Mencken, the frivolity of Sinclair Lewis."[2]

* * *

In 1928 leading Soviet party leader and theoretician Nikolai Bukharin predicted capitalism's imminent demise, and to those on the left the 1929 stock market crash seemed to fulfill scientific Marxism's predictive power. Since the 1927 execution of anarchists Sacco and Vanzetti, numerous writers, Theodore Dreiser among them, had praised the Soviet Union as offering a rational and scientific explanation for the world crisis. "In an age when all truths seemed relative and fragmentary," explained John Diggins, "Marxism could provide a rare glimpse of the totality of existence, an exciting synthesis that broke down the classical dualisms between self and society, idealism and realism, contemplation and action, art and life."[3]

Communists and fellow travelers were further inspired by the Communist Party of America's involvement in strikes in Gastonia, North Carolina, and Harlan County, Kentucky, as well as the International Defense League's defending of nine African-American youths—"the Scottsboro Boys"—falsely accused of raping two white women. Communist-led parades and public demonstrations also prompted intellectuals and artists to reevaluate their creative purpose, and for some, like Waldo Frank, communism offered a possibility of a collective commonwealth, a beloved community he had so long envisioned.

To win artists' allegiance and steer them away from the avant-garde and bohemianism, communists initially sought to create a counterculture, an aesthetic vanguard in the working-class struggle. At the Comintern's Sixth World Congress in 1928, a declaration called for dividing post–World War I history into three stages: the initial, or First Period, beginning with the 1917 Bolshevik revolution and lasting until Hitler's failed 1923 putsch, followed by five

years of capitalism's partial stabilization, until 1928 which initiated the Third Period, when the Soviets announced an unrelenting ideological war against capitalism. The Third Period was marked by Stalin's order that communists not collaborate with social democrats or liberals in their attempts to salvage capitalism, and those defying such orders were branded "social fascists." Third Period policy demanded that communists join in a united front from below by forming alliances with African-Americans, socialist unions, and rank-and-file labor parties. Because Stalin deplored American culture as "the decadent expression of monopoly capitalism," he sought its destruction by trying to establish a communist counter-culture.[4]

Unlike Stalin, Leon Trotsky did not spurn the avant-garde, and by 1923 he "advocated internationalist styles of experimental modernism" over Stalin's proletcult (art and propaganda) aesthetic. Because Stalin condemned modernism, communism's 1930s aesthetic lacked the revolutionary period's avant-gardism that, in the 1910s and 1920s, saw the rise of Kasimir Malevich's suprematism and the constructivism of Vladimir Tatlin, El Lissitzky, and Aleksandr Rodchenko.

Lenin, though wary of modernism, allowed artistic innovations under the auspices of the Commissar of Education Anatol Lunacharsky, whose "intense and very Russian belief in the social centrality of art," wrote Robert Hughes, "would give the *avant-garde* its daily bread." In 1924 Soviet citizens again listened to jazz in Leningrad nightclubs opened under Lenin's National Economic Policy (NEP), ushering in an era of limited freedoms that historians have termed the "Red Jazz Age."[5]

That same year, the Moscow Art Theatre visited America; a year later revolutionary poet Vladimir Mayakovsky, attending a Greenwich Village party held in his honor, listened to jazz records and drank bathtub gin. Writers Mike Gold and Joseph Freeman and artist Louis Lozowick returned from the Soviet Union in the 1920s "as vangardist mentors for younger American artists and writers." Exposed to 1920s Soviet suprematist and constructivist art, Lozowick played a crucial role in their "transatlantic circulation" in Europe and America. Suprematism and constructivism profoundly influenced Lozowick's 1920s cubo-futurist works depicting American industrial life. Dedicated to popularizing the Russian avant-garde, Lozowick returned to New York in 1924 and wrote on Soviet art and theater in *Broom*, *Menorah Journal*, and the *Nation*, and his lectures at Katherine S. Dreier and Marcel Duchamp's Société Anonyme were published as *Modern Russian Art* (1925). By 1924 he joined Mike Gold in poetry-writing workshops under the auspices of the Workers School on New York City's East Fourteenth Street.[6]

But whatever tolerance for American popular culture existed among communists waned as Stalin consolidated power by 1928 and initiated a policy suppressing jazz music and modernist artistic expression. Trotsky, having been driven out of the party by Stalin in 1927 and exiled from the Soviet Union two

years later, formed the Socialist Workers Party and gained a small number of American adherents, including Iriving Howe. Other left-wing Americans looked to Jay Lovestone and his "exceptionalists," who astutely warned that mechanically imposing Soviet ideas on America's "peculiar conditions" would prove futile.

With Trotsky's exile and Lunacharsky's death, hopes for Soviet modernist expression faltered. In 1932 Stalin declared social realism as the Soviet Union's revolutionary aesthetic that two years later defined the official state culture. Social realism involved little artistic innovation, and its stark propagandistic aesthetic often resembled Nazi or Italian fascist poster art. Following this trend during the early 1930s, American artists Louis Lozowick and Hugo Gellert abandoned modernism for social realism's images of muscular white workers that tended to alienate blacks and female workers.

Proletarian writers and critics debated socialist realism's legitimate political content. Far from being a new form of literature, the proletarian novel, Walter Rideout asserted, relied on formulaic plots and "a realist form adapted to radical ideology." Predictable themes, such as strikes and a character's conversion to the left, ran from book to book as writers were expected to portray working-class life and struggle. During the early 1930s, Joseph Freeman wrote that "Ibsen, Shaw, D. H. Lawrence, Dreiser, Joyce fought their audience. The Soviet writers were en rapport with their audience." For Cowley the proletcult provided left-wing writers with a new vocabulary so they could effectively attack the publishing industry and its best-selling authors, and he felt empowered in joining with other left-wing artists in forming an avant-garde.[7]

In 1926 a circle of left New York intellectuals established *The Masses'* heir, *The New Masses.** Initially internationalist in scope, *The New Masses* embraced diverse gender, race, and class perspectives, and various forms of artistic expression. Its early editorial staff included older Villagers Floyd Dell and Susan Glaspell, Art Young, Mary Heaton Vorse, Sherwood Anderson, Van Wyck Brooks, Waldo Frank, Lewis Mumford, and Eugene O'Neill, as well as Harlem Renaissance talents Jean Toomer and Claude McKay and independent Marxists like Edmund Wilson. Its early issues featured avant-garde and popular writers, known and unknown talent. Its first two issues contained poetry by Alfred Kreymborg, Robinson Jeffers, and William Carlos Williams and short fiction by D. H. Lawrence. But *The New Masses'* honeymoon with modernists and non-party intellectuals proved short-lived. When Mike Gold and Hugo Gellert revived *The New Masses* in 1928 to make it an extension of Soviet proletariat publications, they purged it of lingering bohemian influence, expelling the

At first the magazine, under the direction of Mike Gold and Freeman was not solely a voice of Soviet communism, and sought instead to establish a united front of liberal and radical writers. Its tentative list of contributors included Cowley, Josephson, Dos Passos, Edmund Wilson, E. E. Cummings, Hart Crane, and Jean Toomer.

"Trotskyite" Max Eastman and the independent Marxist V. F. Calverton from its editorial board.

In the fall of 1929, *The New Masses'* editorial staff, inspired by Soviet cultural organizations, came together to establish a fifty-member organization, the New York City John Reed Club (JRC)—a diverse organization of writers, artists, musicians, photographers, and filmmakers. Divided into two sections, the New York JRC sponsored photography and cinematography classes; its Writers Club included instructor Kenneth Burke, and its John Reed School of Art was staffed by Gellert and Robert Minor. The JRC's symposia on modern and revolutionary art featured speakers such as Louis Lozowick, and its exhibitions of revolutionary art, photography, and lithographs toured the country. Along with its guerrilla theater productions—which dealt with such subjects as the Scottsboro Boys and lynching—symphonic concerts, jazz performances, and poetry readings, the JRC showed Soviet and German left-wing films. It sponsored mass pageants, and a 1928 *New Masses Ball*, billed as a "big red carnival," offered "hot jazz, dancing, and a costume contest."[8]

By 1932 thirteen John Reed Clubs existed under a New York City executive board. The JRC draft manifesto demanded that "all honest writers and artists ... abandon decisively the treacherous illusion that art can exist for art's sake, or that the artist can remain remote from the historic conflicts in which all men must take side." By 1934 the JRC's national membership numbered twelve hundred, and its thirty chapters were divided into various subcommittees specializing in the arts.

Malcolm Cowley considered JRCs the forums of friendship and revolutionary artistic opinion, where one could "hear about cheap places to live, and possible ways of earning money, and parties to which girls would be coming." Other members walked a fine line between Communist party expectations and their devotion to modern literature. JRC member William Phillips commented that fellow writers of "a bohemian and a more freewheeling literary tradition were willing to go along with what they thought the Communist Party ultimately stood for, however disillusioned they were with current practitioners."[9]

Recognized by the Soviet Union as bastions of a communist counterculture, the John Reed Clubs and *The New Masses* were subjects of the 1930 Soviet Union Karhkov Conference of Revolutionary Writers. There, Mike Gold and others were instructed to uphold the Soviet struggle by adopting a broader, more radical American program to battle capitalism and fascism. A ten-point "Program of Action" criticized American delegates for lacking a coherent understanding of Marxist literary criticism and for not reaching out to African-American workers. In affiliating the John Reed Clubs with the International Union of Revolutionary Writers, the program insisted that JRCs form a tighter coalition among clubs, mass produce pamphlets, and organize agitprop troupes.

To showcase and cultivate left-wing writers, the JRCs produced little

magazines, published in New York, Chicago, Detroit, and other cities* — magazines, noted Walter Kalaidjian, containing an "uncanny hybrid of revolutionary agit-prop and middle-brow Americana that made up these enclaves of depression era leftist culture." Most prominent of the JRC's little magazines, New York City's *Partisan Review*, founded by literary critics William Phillips and Philip Rahv in 1934, survived the decade as a first-rate publication of commentary and culture.[10]

In 1934 Moscow branded the JRC's little magazines as expressions of bohemian individualism and demanded that JRC clubs be disbanded and replaced by the League of American Writers. Unlike its predecessor, which had courted unknown talents, the League enlisted only known writers for the United Front cause, thus narrowing the movement and smothering it in politics. "Had a free and autonomous Communist movement developed in the United States," argued Daniel Aaron, "or had the *New Masses* and the John Reed Clubs remained politically unattached, the middle class malcontents would undoubtedly have entered the Left movement in larger numbers and stayed longer."[11]

The Third Period counterculture failed in America due to the lack of state funding that similar efforts enjoyed in the Soviet Union and from its realist aesthetic that alienated potential converts and often "repulsed non-initiates." Proletcult did not lure Americans, white or black, away from Hollywood films, radio, and the Swing Jazz craze's new dances and fashions. Socialist realism's images of capitalism's downtrodden victims could not compete with the media's created fantasyland that historian Robert Wiebe described as the "culture of compensation."[12]

By 1935 Stalin's faith in the proletcult's revolutionary potential and his prediction of German and Italian fascism's quick demise proved to be costly misjudgments. In Germany communists had been driven underground, imprisoned, or sent to concentration camps. To counter Nazism's rise, he discarded the Third Period's countercultural agenda and announced the Popular Front in 1935, urging liberals and socialists to join communists in a broad anti-fascist coalition. Stalin's proclamation of the Popular Front established a new imperative promoting communism as "one hundred percent Americanism," a slogan promoted by communist presidential candidate Earl Browder during the 1936 campaign. The CPUSA gave an American face to the movement, and at parades and rallies portraits of Washington and Lincoln, as well as the American flag, accompanied images of the hammer and sickle.

At this time, the Soviets hailed folk art as the true "people's culture," and they wrestled with jazz music's popularity, concluding that as an African-American art form it represented an oppressed underclass' folk expression. But by

Such JRC little magazines were New York's Dynamo, Boston's Leftward, Hartford's The Hammer, Chicago's Left Front, Detroit's The New Force, Grand Rapids's The Cauldron, Indianapolis' Midland Left, and Hollywood's The Partisan.

1936 there emerged a Soviet backlash against jazz, and many of its fans perished in labor camps, while a nationally sanctioned "jazz orchestra" sought unsuccessfully to satisfy public demand. Although jazz had accompanied many American communist Third Period gatherings, it was no longer tolerated during the Popular Front. Instead, the left heralded folk musicians such as the Weavers' banjo-player and singer Pete Seeger and Louisiana-born blues and folk singer William Huddie Leadbetter, better known as Leadbelly, who emerged as a voice of the proletariat fulfilling "the party's call for a 'Communist Joe Hill.'"[13]

The anti-fascist crusade intensified by the Spanish Civil War's outbreak in 1936 furthered the left-wing cause as the communists rallied, raised money, and found sympathetic support among celebrities like Hemingway and Dos Passos. Thirty-two hundred Americans enlisted to serve in the Lincoln Brigade to fight Franco's anti–Republican forces and their German and Italian allies. Hemingway and Langston Hughes made the pilgrimage to the Spanish front, but the former became disillusioned with the Soviets after finding out that while supporting the Spanish Republic they were exterminating rivals— Trotskyites and anarchists— within the anti–Franco coalition.

* * *

In the 1930s, when most Americans held to democratic ideas, most of Greenwich Village embraced the red banner of communism —"the Moscow idea." Yet not all Villagers fell in line. Alfred Kazin, a literary radical with a passion for Eliot and Joyce, recounted Village parties at V. F. Calverton's apartment. Editor of the *Modern Monthly*, Calverton and his guests— obstinate older rebels— defied the "the cult of Stalin." Calverton's dimly lit apartment accommodated dissenters— Jews, "bony Yankee individualists with ruddy faces and booming laughs, the old Harvard dissenters, leftover Abolitionists, Tolstoyans, single-taxers, Methodist ministers, Village rebels of 1912, everlasting Socialists and early psychoanalysts."[14]

In the Village non–CPUSA members, labeled "fellow-traveling bohemians," saw themselves as genuine radicals in a decade "marked by the end of Mencken and the beginning of Marx." In major urban centers, bohemian fellow travelers— attired in proletarian blue jeans, work shirts, and lumber jackets— shared food and living space, addressed each other as comrade, and called the police "Cossacks." Their weekend parties blended folk music with conversation. Though fellow-traveling bohemians were averse to attending official party functions, it was not unusual for noted communist organizers and intellectuals to attend their bohemian parties and sleep with female comrades— "vanguard groupies"— in the name of their radical cause. Playwright Arthur Miller saw left-wing bohemians as precursors of subsequent countercultures. He recalled their "Army-Navy surplus store" look and slangy working-class speech, and that their reverence for black jazz and folk legends Woody Guthrie and Huddie Ledbetter as "authentic because they were not creations of the merchandiser but a cry of pain."[15]

Political convictions aside, Greenwich Village bohemians enjoyed a respite from the previous decade's slumming hordes, as visitors now arrived infrequently in pairs or small groups. Specialty shops and tearooms still catered to tourists, but Webster Hall's events lacked the scale and excitement of earlier pagan routs and drag balls. Still, bohemia described those sharing Village studio apartments, frequenters of parties, and cafeteria loiterers. "A cafeteria, curiously enough," noted a WPA-compiled *New York City Guide*, "is one of the few obviously Bohemian spots in the Village, and in the evenings the more conventional occupy tables in one section of the room and watch the 'show' of the eccentrics on the other side." Group Theatre co-founder Harold Clurman described Stewart's cafeteria on Sheridan Square as a "sort of singing Hooverville," filled with down-and-outers, intellectuals, and "sweet young people without a base," who spoke "superb Gertrude Stein by the hour."[16]

The Village's amusements changed with Prohibition's repeal in 1933, and its underground clubs, once a free mix of gay and straight customers, fell victim to a citywide "moral" reform effort. New laws enforced by New York's State Liquor Authority branded homosexuals as "undesirable" elements, and bars catering to them risked losing their liquor licenses. "Ever the home of the free, the old Greenwich Village had always included homosexuals in its groupings," explained Alan Churchill. "Members of the third sex had mingled with everyone else and had been tolerated, if not encouraged, as an example of Bohemian broad-mindedness." The segregation of gays resulted in the opening of exclusive gay clubs that appeared in the Village in an area known as the Auction Block.[17]

While gays carved out their own Village counterculture, the aging poet Maxwell Bodenheim and writer Joe Gould, not heeding Henri Murger's warning about the dangers of making bohemia a permanent home, would meet down-and-outer fates. Once a friend to poets like E. E. Cummings, Gould, claiming to be the author of "An Oral History of the World," carried notebooks and manila folders said to contain pages of his so-called voluminous work in progress. He lived by handouts, what he called contributions to "the Joe Gould Fund." "Gould wasn't young or really a writer," recounted Cowley. He "was a little man with a goatee whose clothes were spotted with ketchup; he sat apart from others (or perhaps it was the others who sniffed and moved away from Joe). He sometimes uncapped a fountain pen and scribbled an entry in one of the half-dozen greasy notebooks piled beside him on the floor."[18]

Gould and Bodenheim's mid–1930s hangout was Max Gordon's jazz nightclub, the Village Vanguard, which later became famous in another basement location. Without money for a liquor license, Gordon used barrels for makeshift chairs and tables, and opened the club in 1934 with Eli Siegel as the house poet and emcee attracting Bodenheim, Gould, Harry Kemp, and other poets and writers. Gordon described Vanguard evenings as a "night of Greenwich Village high jinks, of poets, WPA. writers, hustlers, insomniacs, college students from

the Bronx and Brooklyn, tourists, broads on the make, musicians, moochers, all of them crowding the place every night to let off steam."[19]

* * *

Most communists, however, equated bohemianism with social degeneracy. Even Joseph Freeman, who could objectively see in bohemia a force that could help undermine bourgeois society, condemned it as a permanent playground for self-seeking "Village Don Juans." At mid decade, Freeman criticized the "reactionary" followers of self-expression as "cracked mirrors reflecting the bourgeois world which they thought they had escaped, but whose cult of rugged individualism they retained."[20]

In the late 1930s a bohemian fringe surfaced in the Trotskyist Socialist Workers Pary. SWP member Irving Howe wrote how he "was afraid of the rumored dissoluteness of these bohemians who moved in and out of one another's apartments." Soon to join the growing number of independent Marxists, Howe constituted a small minority questioning Stalin's legitimacy. Among other of these New York Jewish intellectuals were William Phillips and Philip Rahv, who had established the John Reed Club publication *Partisan Review* in 1934. Through their cultural criticism, Phillips and Rahv sought to guide a new left-wing movement. Both had read T. S. Eliot and other moderns and believed that, unlike sectarian communists, writers could learn from various literary traditions to create left-wing literature rooted in realism but open to experimentation. Phillips and Rahv defied Moscow's 1934 directive to disband their magazine and continued to publish *Partisan Review*, which subsequently promoted new left-wing literature and became a rival of the overtly political *New Masses*.

Although the *Partisan Review* did not openly criticize the Soviet Union until after 1937, its rejection of the Popular Front's regionalism and folk art charted a new course for a Marxist-inspired modernism. Phillips and Rahv, though influenced by Randolph Bourne and Waldo Frank, rejected ethnicity and localism as potential breeding grounds for nativism and cultural backwardness. Preoccupied with literary expression, the *Partisan Review* did not give equal voice to the other arts and thus remained aloof from the decade's most radical aesthetic experiments. "The *Partisan Review* was," Thomas Bender explained, "a brilliant afterglow of an older vision of intellect that was undercut and bypassed during the 1930s and 1940s by a series of cultural initiatives in both elite and popular culture which valued the image and the sound at least as much as the word."[21]

Influenced by Edmund Wilson's seminal work of literary criticism, *Axel's Castle* (1931), which traced the persistence of symbolism in the works of Joyce, Eliot, Stein, and others, Phillips formulated a unique Marxist literary dialectic envisioning modernism being superseded by a left-wing literary vanguard. According to the first stage of Phillips' thesis (or dialectic), during the 1910s

American writers like Dreiser, Anderson, and Sandburg were still immersed in Zolaesque naturalism (ignoring avant-garde trends, he did not account for early modernists like Stein and the dadaists). The antithesis arose amid bohemian-style 1920s decadence, when symbolism supposedly dominated the works of Eliot and others. Finally, there occurred in the 1930s a synthesis fusing naturalism and modernism that would bring about a new visionary literature, an American Marxist creative individualism freeing writers from the dominance of the French moderns and the staid supporters of a dying bourgeois society.

This flawed but systematic approach to modern American literature retained modernism as an element of a usable past — literary antecedents that Phillips deemed necessary for a new dynamic literature of the left. Phillips contended that the *Partisan Review* stood "for purity in politics and impurity in literature ... a radicalism rooted in tradition and open to experiment, and an awareness that the imagination could not be contained within any orthodoxy."[22]

Since the beginning of the Moscow trials in 1936, the *Partisan Review* had supported Trotsky and increasingly criticized the Popular Front. It soon broke with the CPUSA and enraged pro–Soviet intellectuals over its criticism of Stalin's purges. But debates among independent Marxists and Stalinists took a turn with the Nazi-Soviet nonaggression pact signed in August 1939, which nullified the Popular Front and tarnished communism's allure, as scores of intellectuals and artists abandoned its cause.

Theater of Revolt

Of all the efforts by the 1930s cultural left, the theater, stated Robert Crunden, was "the most politically committed field in American culture." Because a right-wing American theater was nonexistent, the left found a vast opportunity to further its cause, as Marxists and left liberals infused subversive elements into independent and federally funded theaters. Ideal for collectivist activity, as it could reach its audience directly, the left-wing theater, while it never made significant popular inroads, had lasting creative influence.[23]

Though the left-wing theater produced new methods and techniques, it placed limits on modernist experimentation, and thus American social realist plays produced two important innovations: Soviet-style street corner agitprops and inexpensive theater productions like the living newspaper, a kind of staged newsreel, which, unlike agitprop, influenced American stagecraft. Though he could appreciate playwright Clifford Odets' simple sets, a young Alfred Kazin found the left-wing theater's sparse productions lacking scenery and "particular settings to fit the particular people," and their dull-black-painted platform sets as "stark, muddy, awful, a battlefield."[24]

While their own organizations were creatively restricted to social realism, communist playwrights, directors, actors, and left-wing fellow travelers often worked in non-communist theater companies. Erroneously labeled by its

Depression-era critics as a left-wing organization, the Group Theatre was an art for art's sake collective that distanced itself from Marxist analysis and party politics. Defying Broadway's commercialism, Harold Clurman, Lee Strasberg, and Cheryl Crawford — "a midwesterner, graduate of Smith, a lesbian and something of a bohemian" — founded the Group Theatre in 1931. Strasberg, former director of a New York settlement house's productions, joined forces with Clurman, who had studied in 1920s Paris, worked with the Greenwich Village Theatre, and had befriended Stieglitz.[25]

Embarking on their own search for America, the Group Theatre strove to create productions that were distinct from the European theatrical avant-garde. While in Paris during the 1920s, Clurman attended productions that he considered creatively lagging behind avant-garde painting, literature, and music. "There are avant-garde performances here and there," he admitted. "Yet, despite all this, what I actually see on the boards lacks the feel of either significant contemporaneity that I get from lesser concerts of new music — not to mention the novels of Gide, Proust, D. H. Lawrence."[26]

Clurman and his colleagues sought the theater's cultural elevation, making the playwright and director equals in a collective that "shared a bias in favor of reform rather than revolution." Eclectically gathering new material, the Group produced works by communist playwrights such as Clifford Odets' *Waiting for Lefty*, *Awake and Sing*, and *Till the Day I Die*, and John Howard Lawson' *Success Story*. Unknown to the Group's directors there was a communist cell inside their theater. Actor Elia Kazan, an agitprop director and future cofounder of the famous Actor's Studio, was ordered by party functionaries "to take over the Group Theatre." This directive was unattainable, for, as Morgan Y. Himelstein has concluded, the Group Theatre was primarily made up of "nonconformists ... totally unsuited for the Party's political activities" and demands of uniformity, and it "was collective, but primarily onstage — not off."[27]

Meanwhile, the Group Theatre absorbed modernist influences from the Moscow Art Theater* and its former member Konstanin Stanislavsky, creator of the "method" or "system." The method, as it was known among Americans, "sought to negotiate," wrote Nick Worrall, "the flux, the relativity, the contingency of human reality and to found it on some inner psychological, and ascertainable 'truth,' convinced that this was no idealist mirage or spiritual fiction." Because few Americans visited the Soviet Union, Stanislavsky's theory was largely disseminated by his autobiography *My Life in Art*, published in America in 1923. The Moscow Art Theatre also had influence when former member Richard Boleslavsky, after arriving in early 1920s New York, wrote for

*Founded in 1898, the Moscow Art Theatre emerged as one of the most innovative in the world. Stanislavsky did not come to prominence as an actor in the Moscow Art Theatre until 1908.

publications like *Theatre Arts* and taught Clurman and other Group Theatre members.[28]

A prime mover in the use of Stanislavsky's method, Strasberg adapted its teachings, and Clurman asserted that the method enabled "the actor to use himself more consciously as an instrument for the attainment of truth on the stage." It encouraged improvisation through "affective memory" in which actors plumbed the depths of their experiences for details that would stir them into a certain emotive state, an intended "mood."

To enrich their cutting-edge stagecraft, Clurman and Crawford traveled to the Soviet Union in 1935 and in five weeks attended thirty-five productions, including the Moscow Art Theatre, Theatre of Revolution, and the Jewish State Theatre. They met with Stanislavsky, who, as Crawford wrote, "did not believe [theatre] should be merely a reflection of life but an exaggeration, totally theatrical. Greatly influenced by the street theater of the sixteenth-century Italian commedia dell'arte, he urged that the theatre should guide spectators to use their imaginations. He opposed lifelike naturalism in acting and made great use of scenic space."[29] Crawford and Clurman also visited Vsevolod Meyerhold, whose formalist, experimental productions contributed to Stalin's call for social realism. They also met the brilliant filmmaker Sergei Eisenstein, whom they introduced to photographer Paul Strand.

Back in America Clurman and Crawford instilled the Group with greater discipline while keeping political influences at bay. With a series of plays by Clifford Odets and Paul Green and the musical fantasy *Johnny Johnson* (1936), co-written by Green and Kurt Weill, the Group struggled for survival during an era when Hollywood began recruiting its members and Broadway still lured mass audiences. Though the number of independent theaters increased during the mid–1930s, the Group Theatre, until its 1941 demise, survived on wealthy donors' subsidies and contributors like Eugene O'Neill.

Not until the 1935 founding of the Federal Theatre Project did scores of out-of-work theater professionals find employment in what Orson Welles described as the country's first and only "sort of national theatre." The FTP not only provided work; it offered for some an outlet for theatrical experimentation. Founded under the Works Progress Administration's auspices in 1935, the FTP was one of four divisions, which included the Federal Music Project headed by Nikolai Sokoloff, the Federal Writers' Project by Henry Alsberg, and the Federal Art Project by Holger Cahill that nourished the talents of Stuart Davis, Jackson Pollock, and Willem de Kooning. To head the FTP's Federal Theatre Project, Hopkins selected his friend and former classmate, Hallie Flanagan, director of Vassar's Experimental Theatre. The first woman to win a Guggenheim Fellowship to study European theater, Flanagan observed the Soviet Union's Moscow Art Theatre in 1926. At the FTP's helm in 1935, Flanagan, believing art could evoke social change, proclaimed: "Let us create a theatre conscious of the past, but adapted to new times and new conditions.... The

stage must too be experimental — with ideas and psychological relationships of men and women, with speech and rhythm forms, with dance and movement, with color and light — or it must and should become a museum product."[30]

A federally directed theater intended to cultivate regional talent in urban-based theater units, FTP productions ranged from puppet shows to vaudeville. Of the FTP's five main units, including the Living Newspaper, the Popular Price Theatre, the Tryout Theatre, and the Federal Negro Theatre Project, Virgil Geddes and James Light's unit was dedicated to "experimental theatre for new plays in new manners." As co-head of the FTP's Harlem-based Negro Theatre, Romanian-born John Houseman (son of an Alsatian Jew and an English-Irish mother) joined forces with twenty-year-old Orson Welles. Recalling this often strained partnership, Houseman wrote that his role was "to supply Orson ... with the human and material elements required for his creative work; second to shield him not only from outside interference, but, even more, from the intense pressures of his own complicated and self-destructive nature."[31]

In 1936 Houseman and Welles staged a Negro FTP production of *Macbeth*, and during its preparation, Welles, in a flash of imagination, reset *Macbeth* in early nineteenth-century Haiti, replacing Shakespeare's witches with voodoo priestesses while streamlining the script and revamping its design scheme. Houseman — already recognized for collaborating with Gertrude Stein and Virgil Thomson on the staging of the all-black production of their opera *Four Saints in Three Acts* (1934) — staged *Macbeth* at Harlem's fifteen-hundred-seat Lafayette Theatre, home to Duke Ellington and other famous jazzmen. Virgil Thompson's music and authentic African drumming backdropped the actors who, as Hallie Flanagan described, "walked on the edge of a jungle throbbing with sinister life," as "Hecate with his bull-whip lashed at witches," and "Macbeth, pierced by a bullet," plunged "from the balustrade."[32]

Before the production moved uptown and toured nationally, the Lafayette sold out sixty-four performances, and critics generally hailed the voodoo *Macbeth*. That same year, Houseman and Welles left the Negro Theatre Project to establish an independent FTP unit, Project 891. Its first production, the 1936 farce *Horse Eats Hat*, showcased Welles' acting and Paul Bowles' music, a "surrealistic mélange of Satie and Offenbach, a pastiche of gypsy waltzes and turkey trots, bugle calls and piano rags." Project 891 next produced Christopher Marlowe's *Tragical History of Doctor Faustus*. With Welles playing Faust in grotesque makeup and enhanced by Abe Feder's innovative lighting, *Doctor Faustus* was wizardry of stagecraft, as actors appeared and disappeared into the darkness by way of isolated lighting and traps doors. By the end of its run, *Doctor Faustus* had played to eighty thousand theatergoers, and as Alfred Kazin pointed out, it was "the quick draught of the lightning we went to theater for."[33]

In June 1937 Houseman and Welles teamed up with thirty-one-year-old pianist/playwright Marc Blitzstein to stage the controversial FTP musical *The Cradle Will Rock*. A student of Schoenberg and Nadia Boulanger and a former

soloist with the Philadelphia Orchestra, Blitzstein dedicated his left-wing musical (written in the Kurt Weill–Hans Eisler tradition) to Bertolt Brecht. *The Cradle Will Rock*'s anti-capitalist theme that pitted the workers of "Steel Town U.S.A" against big industry attracted negative newspaper coverage. WPA budget cuts prevented the play's official opening on June 16, 1937. Defiantly, Houseman informed the press that it would open as scheduled. On the evening of the sixteenth, Houseman, Welles, and Blitzstein, with nineteen cast members and scores of theatergoers, took a "renegade" version of the production to New York City's Venice Theatre.* At the Venice Blizstein, seated at the piano, offered a one-man production with Welles offering occasional explanations about the change in scenery. Amid Blitzstein's playing, cast members stood up in the audience and recited their lines. What began as a work about a prostitute flourished into a "sociological light opera," what Blitzstein called "a play with music" about the workers of fictitious Steel Town and their triumph over big business. FTP historian Jane DeHart Matthews emphasized that Blitzstein's play "was the first serious musical drama written in America which provided a new vernacular for the man on the street."[34]

During 1937, the FTP was reorganized, and in the following year Texas Democrat Martin Dies, head of the House Committee on Un-American Activities, launched an investigation into its alleged communist infiltration. On the witness stand, Flanagan and other FTP members faced charges of staging subversive productions. Congressional opposition to the FTP intensified as opponents joined with newly elected Republicans in a "culture versus relief" battle over federally subsidized entities tainted with charges of communism; failing to receive congressional appropriations, the FTP met its end in 1939.

The Mainstreaming of Modernism

Meanwhile, as left-wing aesthetic experiments vied for America's interest against the tide of popular culture, chic wealthy urbanites enticed by the artistic avant-garde and its influence on fashions and décor heralded the mainstreaming of modernism. During the 1930s, Edward Steichen and Man Ray made photographs for *Harper's Bazaar* and other leading magazines that advertised furs and beauty products. Gertrude Stein returned home a celebrity, and surrealism's media star, Salvador Dalí, worked for clothing designers, creating scandalous American displays.

The avant-garde's increasing commercialization had its virulent opponents. Modernism's indefatigable champion Alfred Stieglitz denounced the

As Frank Brady points out, contrary to legend, Welles did not lead a parade of theatergoers up the street from the Maxine Theatre twenty blocks north to the Venice, a scene depicted in Tim Robbins' film The Cradle Will Rock. *The audience, along with some cast members, did walk, but most of the theatergoers made their way by subway and taxi.*

Rockefeller-funded Museum of Modern Art. In need of a new independent modern art gallery and pressed by Dorothy Norman and Paul Strand, who offered to find patrons and sign a lease in their name, Stieglitz agreed to preside over a new venue. Opened in 1929, An American Place occupied a corner suite of a newly built edifice at 508 Madison Avenue. The gallery's ten-foot-high white walls and cement floors, painted gray upon O'Keeffe's insistence, were illuminated by windows that faced west and east, and a bluish-white glow from receptacles in the ceiling. Though *Time* magazine described the gallery as "bleak" and "hospital like," photographer Ansel Adams thought An American Place "beautifully barren" with walls of "indescribable tone," displaying few works as if they were "thrusting like jewels into the cool light." Over its seventeen seasons under Stieglitz's direction, the gallery promoted its Americans, dominated by the "Big Three"—O'Keeffe, Dove, and Marin. From the mid 1920s O'Keeffe's work drew large crowds, and the money made from her paintings contributed to An American Place's expenses and the apartments O'Keeffe shared with Stieglitz.[35]

In 1932 O'Keeffe accepted, without Stieglitz's approval, a commission to paint Radio City's women's powder room. This defiance unleashed Stieglitz's fury. At a time when her works were selling for five-thousand dollars apiece, O'Keeffe accepted the commission under modernist designer Donald Deskey to paint the mural on four walls and ceiling for fifteen hundred dollars. Stieglitz, the driving force behind O'Keeffe's art-market success, hated mural art and viewed the Rockefellers as symbolic of greed and dilettantism, and he vehemently opposed her taking the job. When O'Keeffe defied him, Stieglitz intervened, informing Deskey that she would paint the work without charge but required a $5,000 materials fee. After weeks of Stieglitz's vicious hounding, a nerve-wracked O'Keeffe began preliminary work in mid–1932. But after noticing that the walls had not been properly prepared (the canvass was pulling away from the new plaster surface), she fled the building in tears; diagnosed with psychoneurosis, she was confined to a hospital ward. Stieglitz duplicitously told friends that her near-two-month hospitalization was due to heart problems, and his subsequent threats led the Rockefellers to break her contract.

While straining his relationship with O'Keeffe, An American Places' impresario faced both adulation and dissention among his circle, as he thundered against communism, art museums, and the Mexican mural art of José Clemente Orozco and Diego Rivera. Yet Stieglitz's crowning moment came in 1934, when Doubleday published *America and Alfred Stieglitz: A Collective Portrait*, a Literary Guild selection that sold thirty thousand copies. Edited by Waldo Frank, its twenty-five contributors included Gertrude Stein, William Carlos Williams, Jean Toomer, Lewis Mumford, Paul Rosenfeld, and influential progressive educator Harold Rugg who expressed that Stieglitz's gallery be a model for every classroom in America.

But Stieglitz's individualism placed him at odds with those of the collectivist

left like Frank, Anderson, and Strand, who were cast from his circle. Yet while many broke with him, Stieglitz met new talents like Ansel Adams, to whom he gave a show in November 1936.

* * *

In *America and Alfred Stieglitz*, Gertrude Stein wrote, "There are some who are important to every one whether any one knows anything of that one or not and Stieglitz is such a one." Emerging from obscurity as a Parisian salon hostess and avant-garde writer and poet, Stein became a 1930s cultural icon. While at her French retreat at Bilignin during 1932, Stein, in a six-week rush of inspiration, finished *The Autobiography of Alice B. Toklas*. First serialized in the *Atlantic Monthly* in 1933, *The Autobiography*, published that same year by Harcourt Brace, brought her instant fame and inspired numerous American articles, including a *Time* cover story (experiencing an economic windfall, Stein purchased a new Ford automobile and hired two servants). Written from Alice's perspective — the most reliable of the couple in recounting events — the *Autobiography*, a vividly descriptive modernist memoir, reduced Leo Stein's role in events, and, while anecdotes about salon guests fascinated readers, Stein enraged Hemingway with her comments about him.[36]

In 1934 Stein's opera *Four Saints in Three Acts* garnered further American publicity. Composed in 1927–1928 and featuring Stein's libretto and Virgil Thomson's music, the work was lauded by Aaron Copland as a healthy alternative to other American attempts at the composing and staging of opera. Thomson performed *Four Saints in Three Acts* in salon parlors on both sides of the Atlantic. It generated interest but no active supporters until he encountered several 1920s Harvard graduates making up a modernist network of American cultural tastemakers, collectively known as the Harvard Moderns, prominent in visual art, music, museology, architecture, and dance.* As Steven Watson asserted, "This handful of Harvard men set the course of 'official' modernist culture in America's most prestigious institutions for nearly half a century."[37]

While at Harvard, Thomson credited the reading of Stein's *Tender Buttons* and discovering Erik Satie's music as life transforming. First visiting Paris in 1921 on a Harvard fellowship, Thomson returned in 1925 to study with Nadia Boulanger. While at Shakespeare and Company, he met George Antheil — whom he called "the truculent, small boy genius from Trenton." While Antheil envied Thomson's education, the latter envied his friend's "freedom from academic involvements, the bravado of his music and its brutal charm."[38]

When Stein invited the much-talked about "bad boy of music" to 27 rue

*Known among their circle as "The Family," most of the Harvard Moderns had studied under art professor Paul Sachs, who, though not a champion of modernism, nevertheless did not deter his students from pursuing its study. This circle included modern-dance impresario Lincoln Kirstein; Henry-Russell Hitchcock, author of Modern Architecture (1929); and architect Phillip Johnson.

des Fleurus during the winter of 1925-1926, Antheil persuaded Thomson to accompany him. Of the two composers, Stein found Thomson more engaging, and they struck up a friendship that greatly altered her view of music. Because of the repetitive terseness of Stein's writing, Thomson believed his music did not require him to illustrate their meaning. After pleasing Stein by setting her poem "Susie Asado" to music, Thomson then suggested they collaborate on an opera with a theme about saints, and Stein suggested that it be set in Spain and centered around the Spanish saints Teresa of Avila and Ignatius Loyola. The irreligious Thomson imparted to John Houseman that the opera, in its dealing with St. Ignatius and St. Theresa, "had their counterpart in the literary and artistic life of Paris in the twenties— St. Theresa being Gertrude and St. Ignatius being James Joyce (or possibly André Gide) surrounded by disciples." For Stein the opera, finished in July 1928, was like "a landscape, where many elements are represented simultaneously, stretching the horizon without a center. One discovered it piece by piece rather than following a predetermined path."[39]

Thomson returned to New York in November 1928 as an unknown composer. Frustrated by the lack of progressive music audiences, he gave a solo performance of *Four Saints in Three Acts* at Van Vechten's apartment in 1929 and repeated the performance at the Stettheimers' salon. Three years later, Thomson gave a living-room performance of the opera at the home of Arthur Everett "Chick" Austin Jr., a handsome "cosmopolitan dandy" and a Harvard Modern, whose aesthetic taste ranged from baroque to twentieth-century modernism. As Austin's biographer Eugene R. Gaddis asserted, "His eye for quality and his courage to promote the unfamiliar were not surpassed in his time." Austin had studied and taught at Harvard until accepting, in 1927, the directorship of America's first art museum, the Hartford, Connecticut Wadsworth Athenaeum. Under Austin the Wadsworth Athenaeum underwent major transformation, including the founding of the Friends and Enemies of Modern Music in 1928, followed a year later with the screening of avant-garde films. Austin's money-raising efforts and his inspiring of trustees resulted in the building of the museum's new Avery Memorial, "the world's first architecturally modern museum wing," with a lighted interior of "rectilinear balustrades, doors without transoms, and radiator grills." Through the auspices of the Friends and Enemies of Modern Music, Thomson received the economic backing and most of the creative talent needed for staging the opera.[40]

Before *Four Saints in Three Acts'* opening in 1934, Thomson had made vital connections through the Harvard Moderns. In 1933 he lectured on the opera at Muriel Draper's high modern salon. In the all-white sitting room of her unimposing New York home, Draper put to use her interior designer skills as well as her ability to gather influential guests— Harvard Moderns, members of New York cafe society, independently wealthy high bohemians, and artistic avant-garde disseminators. Showing a new sensibility among the wealthy, young high bohemians considered title and birth as of lesser importance than a freer

attitude premised upon the amusing and the chic, as they collected modern art and experienced Harlem nightlife.

Thomson's most important connections were made at the home of Harvard Moderns Kirk Askew and his beautiful wife Constance. In comparison to Draper's fin-de-siecle salon, the Askews' New York brownstone apartment at 166 East Sixty-first Street bristled with a more youthful avant-garde atmosphere. The well-to-do Askews wintered in New York and spent the spring and summer in London, where Kirk represented the Durlacher Brothers art firm. In New York City the Askews entertained every Sunday at five o'clock in a large drawing room overlooking a garden, visited by composers such as Copland, Antheil, and Thomson, and literary notables like Carl Van Vechten, E. E. Cummings, and Nicholas Nabokov, and art critic Henry McBride.

At the Askews, Thomson met John Houseman, who would direct *Four Saints and Three Acts*. Houseman, when entering the Askews' salon, discovered a unique place "well-organized" and one mixing the genders "with a clear and consistent objective." At the Askews Thomson also met choreographer Frederick Ashton, who agreed to lend his talents to *Four Saints and Three Acts*. Another New York salon hostess, Florine Stettheimer, agreed to create the costumes and set design, and Abe Feder was to do the lighting. Thompson, an admirer of African-American vocal music and Harlem nightlife, recruited an all-black cast that spent the winter rehearsing in the basement of Harlem's St. Phillips Church.[41]

Through Austin's promotional genius, *Three Saints in Four Acts* shared its debut with Picasso's first American retrospective housed in the Avery Wing on the third floor of the Wadsworth Atheneum. On February 6, 1934, a crowd of 299 arrived by private train car and luxurious automobiles to watch *Four Saints in Three Acts*' debut at the Avery Theater. The performance's close was greeted by a half-hour of curtain calls. Van Vechten wrote Stein, "Four Saints, in our vivid theatrical parlance, is a knockout and a wow ... I haven't seen a crowd more excited since *Le Sacre du Printemps*." After its Hartford run, *Four Saints* became the longest-running opera in Broadway history.[42]

On October 24, 1934, nearly nine months after the opera's debut, Stein was welcomed in New York by Carl Van Vechten and her Random House publisher, Bennett Cerf.* Heading up Stein's American tour, Cerf found his client's domineering personality and passion for publicity balanced by her down-to-earth "plain as a banker" talk that charmed "photographers and newspapermen," movie stars and the public alike. Stein's pensive profile graced *Time*'s cover (September 11, 1933), and its accompanying article noted that "there is nothing precious or arty" about the fifty-nine-year-old, who "has moved from the legendary borders of literature to the very marketplace, to face in person a

Cerf saw to the printing the Three Saints in Three Acts' *libretto and other earlier works of Stein, and helped set up her speaking engagements in America.*

large audience of men-in-the-street." After a thirty-one-year absence, Stein had expected the New York skyline to be higher. She lamented that America lacked original paintings and considered as more unique the variety of wooden houses, billboard advertisements, and drugstore lunch counters. On a cross-country speaking tour, Stein appeared at colleges and women's clubs and spoke on an NBC radio interview program. She visited Eleanor Roosevelt at the White House and traveled by plane to Chicago (her first trip by air) for the performance of *Four Saints* at Louis Sullivan's Auditorium.[43]

Four Saints entered the culture at large, and American youths commonly uttered its libretto's "pigeons on the grass alas." Satirized by Al Hirschfeld, the opera inspired a Gimbel's Fifth Avenue window display entitled "4 Suits in 2 Acts." Epitomizing modernism's mainstreaming, *Four Saints in Three Acts*, Steven Watson emphasized, attracted a large audience while attacking theatrical convention, and its success, unlike previous avant-garde events, "was the calculated work of a new generation of cultural tastemakers."[44]

* * *

While Austin introduced Americans to modern art in provincial Hartford, another Harvard Modern, Alfred Barr Jr., was New York's prime mover of modern art. Lauded by art critic Robert Hughes as "the person who did the most to change art in the last half century," Barr first gained recognition in 1929 as the director of the newly established Museum of Modern Art. Barr was Paul Sachs' student at Harvard and traveled to Europe on a scholarship in 1927-1928. At Wellesley College in 1927, he taught America's first systematic modern art course, involving field trips to study aesthetics from everyday life. The class discussed the Ballets Russes and Fritz Lang's film *Metropolis* and listened to piano recitals of Debussy, Ravel, Stravinsky, and Milhaud.[45]

Barr organized the Museum of Modern Art's 1936 Cubism and Abstract Art show(which included five Duchamp works), and in December of the same year, he launched the much written-about exhibition Fantastic Art, Dada, Surrealism. Reviewing the exhibition, *Time* magazine — its cover depicting a sinister-looking, thirty-two-year-old Dalí— attempted to explain fantastic art while reviewing paintings and objects by Duchamp, Picabia, Max Ernst, and Man Ray. Failing to mention the movement's radical politics and sidestepping Breton's leadership role, the article derisively described surrealism — sounding more like a survey of dadaism's nihilism — as an "art movement without hope or object."[46]

The leading subject of *Time's* article, Dalí, first arriving in America in 1934, imported elements— which the media portrayed as the product of madness— of Breton's Parisian-based, pan–European movement. Though surrealists vehemently opposed bohemianism, they were, especially through their visual artists, heroes to subsequent countercultures. Taken up by New York's chic salon set, Breton and his circle, though anti-commercial, faced the

challenge of radicalizing a larger audience when the consumer market was absorbing elements of its visual aesthetics. More than a decade after its founding, surrealism, largely due to Dalí's publicity, infiltrated America as "the first avant-garde movement," as Dickran Tashjian explained, to be mass-media consumed "and broadly disseminated to the public in a sanitized, that is, in a depoliticized guise."[47]

Surrealism's most conspicuous figure — its reputed lone madman — Dalí reveled in publicity and the tabloid press' negative coverage, while receiving major promotion through Harvard Modern Julien Levy, who held the artist's first American one-man show in 1931. That same year, the Wadsworth Athenaeum's *Newer Super–Realism* exhibition moved, with modifications, into Julien Levy's New York gallery. Before establishing his gallery — New York's premiere surrealist showplace — Levy, a well-to-do New York real-estate-broker's son — had studied at Harvard under Chick Austin and, after dropping out in 1927, accompanied Duchamp to Paris.* In 1931 Levy and his wife, Joella, founded the Levy Gallery at 602 Madison Avenue. On the gallery's curving wall were shown some of the most advanced art of its time benefiting from the couple's transatlantic connections and Julien's eye for talent.

The gallery held parties and showed avant-garde films, such as Fernand Léger's *Ballet Mécanique*, backed by Antheil's piano rolls, and Man Ray's *L'Étoile de mer*, which influenced the Museum of Modern Art's film department.

In 1939, concurrent with his third show at the Levy Gallery, Dalí designed a surrealist Bonwit Teller window display. Without Dalí's consent, Bonwit Teller replaced the display's turn-of-the-century mannequins with modern clothed ones. Outraged, Dalí overturned the display's water-filled, fur-lined bathtub that sent him and the prop crashing through the store's front window; artists Jackson Pollock and Peter Busa arrived in time to see Dalí, glass-covered, being led away by police. This much publicized event, which Henry Miller termed "the Bonwit Teller epsidoe," made Dalí synonymous in America with surrealism. Writing about his country of birth in the 1940s, Miller asserted, "Surrealism, if you should happen to ask any one off-hand, means Salvador Dalí," while at the same time he recalled Breton walking about "Manhattan practically unknown and unrecognized."[48]

Carrying the making of art exhibitions into intermedia aesthetic events across the Atlantic, the surrealists and their dadaist allies Duchamp and Man Ray helped shatter art's conventional display.† Having just participated in the 1938 Parisian International Exhibition of Surrealism — where visitors encountered at the entrance his *Rainy Taxi*, which misted water over its mannequin

Among New York City's galleries that showed modern art were the Valentine, Kraushaar, Downtown, Reinhardt, John Becker, and Weyhe.

†*These events had their antecedents in the dada events like the First International Dada Fair in Berlin and the Cologne Dada Show held in 1920, which required visitors to enter through a beer hall men's restroom.*

passengers covered with live snails—Dalí accepted an offer to design a "surrealist funhouse" for the 1939 World's Fair in New York. The pavilion was originally conceived by Levy as a combination midway-carnival attraction and high art installation to attract both chic and everyday visitors. Dalí, pursuing this objective, redesigned the surrealist fun house, naming it the Dream of Venus. Constructed in the fair's amusement area, the pavilion contrasted with the beaux-arts buildings and the streamlined modern architecture. Behind its soft, aquatic-looking exterior of protruding objects were painted murals, assemblages, and two glass tanks (appearing like store windows)—one water-filled and swarming with half-nude "liquid ladies," the other dry featuring a custom-made rubber female figure with piano keys. Though it failed as a major attraction and in evoking a *succès de scandale*, the Dream of Venus foreshadowed modernist postwar art installations and performance art.

Long at odds with Breton for his "publicity-seeking tactics" and commercial collaborations (especially with fashion designer Elsa Schiaparelli), Dalí was anagrammatically branded by surrealism's pope as "Avida Dollars" and banished from his circle. During Breton's New York exile (1941–1945), his leadership tenuously prevailed among a network of painters—Polish-born John Graham, Armenian-born Arshile Gorky, and Chilean-born Roberto Sebastian Matta Echaurren. By introducing Jackson Pollock and others to automatism, these painters were crucial in shaping America's first unique art movement, abstract expressionism. As Robert Hughes asserted, "the Surrealists' very presence was a tonic. The young Americans felt marginal, ignored by other Americans, provincial in respect to Paris." The surrealists' in their "sense of mission," he concluded, "heartened American artists who wished, above all, to believe in the avant-garde."[49]

VIII

"Bohemia After Dark": Modern Jazz and the Beat Generation

Bebop Makes the Scene

By the time Breton returned to postwar Paris, a cultural shift had made New York City the avant-garde arts' capital. Away from Parisian café life, Breton had distanced himself from the New York school of painters as well as experiments in dance, theater, and music — realms of modern art that had been banned during the German occupation. The emigration of numerous European artists to the United States bolstered New York's cultural status as its postwar avant-garde looked to Carl Jung's popular teachings, existentialism, gestalt therapy, and Alfred North Whitehead's philosophical work. As vanguard American painters rebelled against Depression-era realism and regionalism, the beats, a small literary cluster of university students, dropouts, and their streetwise friends, thrived on illegal drugs and jazz, and over time found aspirants who in their musical taste, speech, and dress longed for inclusion into this underground fraternity.

* * *

Finding in the African-American jazzman an outsider hero, the beats drew creative sustenance from swing jazz and its modernist hybrid, bebop. A product of 1940s Harlem, bebop thrived on musical experimentation outside the commercial dancehall market and was seen by some as a revolution threatening the music's creative validity. Young and musically literate, bebop musicians considered uniqueness their highest artistic virtue in a music that, along with abstract expressionist painting and modern dance, most poignantly captured America's modernity at mid-century, its urban landscape and pace of technological innovations.

As early as 1930, stride piano master James P. Johnson, recognizing jazz's demand for change, recorded the instrumental "You've Got to Be Modernistic." Meteoric in its development, jazz advanced from New Orleans bordello piano

music, along with parade and riverboat entertainment, to professional, musi-
cally literate ensembles playing large dance venues within black urban com-
munities. Hailed in the media as "The King of Swing," jazz clarinetist Benny
Goodman and his orchestra popularized in 1935 a music that had its own dances,
fashions, and speech. White bandleaders of "hot" jazz were indebted to the
African-American big bands of Fletcher Henderson, Duke Ellington, Chick
Webb, and others who, by the early 1930s, had already created all the musical
foundations that defined swing jazz.

In 1940s New York City, jazzmen in their off-hours from professional
engagements improvised at jam sessions—competitive forums where commer-
cially oriented material was musically transformed by departing from steady
dance-oriented rhythms and introducing more complex harmonic patterns.*
Typical of most iconoclastic art movements named by outside critical sources,
this new jazz style received the onomatopoeic label bebop — synonymous in the
popular imagination with a drug-crazed minority, wild creators of a nearly
unintelligible music.

Central to bebop was the flatted fifth, or tritone. Though occasionally uti-
lized by pianist/composer Duke Ellington, saxophonist Coleman Hawkins, and
pianist Art Tatum, the flatted fifth had been a harmonic exception within jazz.
Western high-art music had traditionally condemned the flatted fifth by label-
ing it "the diabolus in musica" (the devil in music), but with bebop it became
a modern jazz hallmark. Bebop was largely made up of standard thirty-two-
bar popular song forms (AABA) and blues progressions—"ready-to-hand"
material that could be harmonically resubdivided (by using various chord sub-
stitutions) and improvised upon in small groups. Popular standards were
reworked by implementing complex chord substitutions and chromatic har-
mony in groups typically comprising two horns and playing the main melodic
line, "the head," in unison that served as the "opening and closing statement"
for the extended solo sections. Into modern jazz flowed new influences includ-
ing modernist European music and Afro-Cuban music — both vital in bebop's
expanding musical horizons— while some young musicians eventually looked
to African, Arabic, and Eastern music traditions as well.[1]

Bebop musicians cherished improvisation, exercising a sense of creative
democratic spirit at a time when America's segregated military was fighting in
a world war and a large segment of the black population faced discrimination.
Drummer Max Roach contended that "Our music reflects the democratic way
more than anything else. You know, a guy introduces a thing, and we all get
a chance to say something about it, get a chance to make it something." This

*Unlike swing, largely intended for dancing, bebop's fast-paced tempos were meant for lis-
tening. As opposed to swing bands made up of fourteen or more musicians (though smaller
ensembles recorded and entertained audiences as well), bebop was born of quartets, quintets,
and sextets, and helped bring to the fore harmonic and rhythmic innovations.

freedom principle later surfaced in compositions like Sonny Rollins' "Freedom Suite" and led to the free jazz movement in which musicians performed music without specific chord changes or time signatures.[2]

Significant in the founding of bebop, alto saxophonist Charlie Parker, trumpeter Dizzy Gillespie, and pianist Thelonious Monk were also postwar subculture heroes. Celebrated in poems and novels and later depicted on the motion-picture screen, Parker, born in Kansas City, Kansas, in 1920, was by age sixteen living with his mother in Kansas City, Missouri, as a married high-school dropout drawn to drugs and the self-study of the alto saxophone. Veteran of several prominent big bands and having a photographic aural memory, Parker studied Lester Young's tenor saxophone style and Tatum's piano virtuosity, and listened to Bartók and Stravinsky, as well as country-and-western, European folk music, and the street sounds of Salvation Army bands.

Parker's drug-ridden life and tragic end contrasted with Gillespie's showmanship and respected professional manner. Nearly three years Parker's senior, Gillespie found in Roy Eldridge his main trumpet inspiration; along with Parker he played in the big bands of Earl Hines (1943) and Billy Eckstine (1944) until the two horn players made their own ground-breaking small-group recordings in 1945. Though they never performed with one another for any extended period, Parker and Gillespie established a duo frontline that defined the new music.

Unlike Parker and Gillespie, bebop's "high priest" Thelonious Monk matured musically during the 1930s outside the big-band circuit. In a prolonged stint playing behind a female evangelical faith healer, he freely worked out his own harmonic variations and developed a uniquely percussive piano style derived from elements of stride and Duke Ellington's instrumental approach. Musically unique among (and sometimes placed outside) those grouped in the bebop pantheon, Monk composed streamlined music built upon blues and popular song forms.*

A modernist working within musical form, Monk, like Parker, composed intricate twelve-bar blues—personal musical statements of angular melodies and colorful harmonic conceptions. In his unorthodox piano technique, his hands remained straight without arching the wrist, and, between chord clusters and flourishing notes, he pounded and stabbed at the keys as if searching, as Jack Kerouac wrote, for a "wooden off-key note." Seemingly aloof and reticent yet physically intimidating, Monk had an unrelenting musical vision. While economically supported by family members and patrons, he played low-paying nightclub jobs, not earning notoriety until the 1950s. For instrumental compositions like Monk's, modernist titles, recalling avant-garde visual art, ideally suited bebop's more abstract sensibility; other titles reflected the music's onomatopoeic nomenclature, such as Gillespie's "Oop Bop Sh'Bam," "Ool-Ya-Koo," and "Jump Did-Le Ba."

*Monk's younger protégé Bud Powell had a more far-reaching musical influence in that his style was more adaptable in the shaping of a more standard jazz piano sound.

Monk, like other bebop musicians, honed his skills at Harlem jam sessions. Among its premier venues was Minton's, an unpretentious room adjoining the Cecil Hotel on 118 Street. In 1940 the club's owner Henry Minton, a former saxophonist and the first black delegate of musicians Local 802, hired former bandleader Teddy Hill, who assembled a house band comprised of drummer Kenny Clarke* and pianist Thelonious Monk. With Clarke's innovative drumming — that "shifted rhythmic accents from the skins to the cymbals, replacing the thud-thud-thud of the bass drum with the sibilant pulse of the ride cymbal," and Monk's harmonic explorations— Minton's attracted a musical cross-generation, from Ellington and Count Basie to Gillespie and Parker. Passing Minton's front bar, patrons entered a backroom with white linen-covered tables set with glass vases and flowers. Under Minton's smoke-filled lights, wrote Ralph Ellison, nightly crowds experienced a "mysterious spell created by the talk, the laughter, grease paint, powder, perfume, sweat, alcohol, and food ... brought to a sustained moment of elusive meaning by the timbres and accents of musical instruments locked in passionate recitative."[3]

At the 4:00 A.M. curfew hour, Henry Minton closed the night by shining a bright light suspended from a rope into the patrons' faces. Afterward, many headed to Monroe's Uptown House at 198 West 124th Street, which opened at 4:01. A former tap dancer, Clark Monroe made his Harlem basement establishment a "comfortable musicians' hangout," and eventually recruited young local musicians including Max Roach, an innovative drummer following Kenny Clarke's rhythmical path. On the bandstand swing players performed with Parker or Gillespie, and on any given night film stars such as Lana Turner and John Garfield could be seen among the audience.

By the mid–1940s bebop found its way into Midtown's Fifty-second Street — a stretch of small clubs between Fifth and Seventh Avenues—called Swing Street by the hip, Swing Lane by the sophisticated, and Jive Alley by the square. Fifty-second Street's Victorian brownstone homes had been transformed in the 1920s from rooming houses into speakeasies, and thrived until Prohibition's end in 1933. But the area's entertainment reputation lingered, and Fifty-second Street's close proximity to Music Hall, Broadway, and the East Side and its one-way traffic that forced the theater crowd to pass through the district made it an ideal area for opening nightclubs. In these basement "shoebox" shaped nightspots, small ensembles, from Dixieland, to piano trios, to bebop attained much-needed employment as musicians went from club to club sitting in between their scheduled sets. In late 1943-1944 Gillespie and bassist Oscar Pettiford co-led a small group at a small fifty-seat club, the Onyx, the first to formally present bebop to the general public.

Though pianist Billy Taylor recalled that "Color was no hangup" and that

*As a bandleader, Hill had once fired Clarke, the father of bebop drumming, for playing outside the norm.

mixed groups were common along Fifty-second Street, the influx of black musicians and their nighttime followers— reefer smokers and heroin users, "homosexuals of all races"— also attracted white sailors, whose interaction with this crowd caused racial tension along the strip. "The Street" was many things to many people. Trumpeter Miles Davis, newly arrived to the city in 1944, found Fifty-second Street " the place for white people to come to and spend a lot of money" and listen to a music that had been invented and nurtured in Harlem. But for saxophonist Dexter Gordon it "was the most exciting half a block in the world. Everything was going on — music, chicks, connections," and Dizzy Gillespie looked upon his first job at the Onyx as crucial in helping "spread the message to a much wider audience."[4]

Confined to jam sessions and small clubs, bebop musicians faced economic hardships. But once bebop reached 78 rpm recordings, the new music gained a small following of listeners nationwide. In 1944 Coleman Hawkins, the father of the tenor saxophone, recorded the first bebop-oriented (or prebop) sides with Monk, Gillespie, Roach, and others. But it was not until Gillespie and Parker's 1945 groundbreaking recordings that bebop was recorded in its hybrid style. Parker and Gillespie's Guild recordings introduced bebop to young listeners and aspiring jazz musicians throughout the country. Their sides "Groovin' High" and "Dizzy Atmosphere" were followed by "Salt Peanuts," "Shaw Nuff," "Hot House," and "Lover Man" sung by Sarah Vaughan.

These 1945 recordings divided the jazz community over bebop's musical legitimacy. Most critics, with the exception of perceptive writers like Barry Ulanov and Leonard Feather, thought bebop disturbing. Dissenting critics, however, could not hold back the floodgates against bebop's influence, and what was thought a passing fad continually attracted young followers. By the late 1940s cities like Philadelphia, Chicago, Detroit, and Los Angeles gave rise to small jazz subcultures and nightspots featuring the new music. As the postwar years saw the decline of jazz along Fifty-second Street, as it turned into an area of strip joints, bebop musicians sought new commercial avenues for their music. Bebop moved into Broadway clubs, like the Royal Roost and Birdland, where its namesake Charlie Parker was ultimately barred. Musical modernists dependent upon making a livelihood, Parker and Gillespie hired promoters, performed on radio broadcasts, made television appearances, and as avant-gardists sought to enter the market on their own terms.

The Epitome of Hip

Bebop musical innovations accompanied personal displays of fashion; just as Ellington had popularized the string tie, and Billy Eckstine the rolled-Eckstine collar, Monk and Gillespie came to be associated with eccentric styles— Monk, dark shades and various hats; Gillespie, goatee, beret, and horned-rimmed glasses. But for the most part, bebop jazzmen wore up-to-date and best-cut

suits that stressed elegance over extravagance. When a member of Parker's band during the late 1940s, Miles Davis received a fashion lesson from saxophonist Dexter Gordon: "Dexter used to be super hip and dapper, with those big-shouldered suits everybody was wearing in those days. I was wearing my three-piece Brooks Brothers suits that I thought were super hip, too." Gordon instructed the young trumpeter to get some "hip vines" (clothes), and Davis saved forty-seven dollars for "a gray, big-shouldered suit."[5]

Reflecting Parker's erratic way of life, his suits were routinely rumpled and unkempt; he sometimes dressed like a lumberjack, in a Pendleton shirt and suspenders. At club dates his young devotees were known to show up in imitation crumpled dress pants. But Bird's disheveled look never caught on, and Gillespie reigned as bebop's primary image-maker in a hipster look that was culled out of a pragmatic selection of attire. His beret was a piece of portable headgear that he could stuff in his pocket or use as a trumpet mute; his horn-rimmed glasses were sturdier replacements for prescription eyewear that he found himself constantly breaking; his goatee was to protect an area often irritated by his trumpet mouthpiece. Standard hipster wear, these items were even co-opted by Benny Goodman when in 1949 the "King of Swing" attempted to make bebop seem harmlessly respectable by posing as a beret-wearing band-leader of younger musicians.[6]

To the hipster composite Monk added dark glasses (an article Gillespie never wore due to his weak eyesight) and his ever-changing collection of odd hats. Traditionally attired "up to the neck," Monk, as Laurent De Wilde explained, wore "headgear" that equaled Dizzy's beret and glasses as a bebop trademark, and added that in this musical underground, "you either got 'hip' or you were nowhere.... You had to think modern. For Monk, being modern was essential."[7]

Gillespie dismissed the media's portrayal of bebop musicians as eccentrics and outlaws as "jive-ass stories," and contrary to the drummed-up magazine images and photojournalist stories, its leading practitioners were musically literate, thoughtful, and generally well read. The media also linked bebop musicians with drug use, a practice not uncommon to the jazz and entertainment business. From jazz culture's inception, marijuana use was common. Unknown to most fans, especially in the white community, Louis Armstrong was a life-long marijuana smoker. Former Austin High clarinetist Mezz Mezzrow's involvement with the use and sale of marijuana led it to be called "mezzroll" or "mezz," and bandleader/drummer Gene Krupa's 1943 arrest and conviction for marijuana possession shocked the white community. Even if Gillespie defended marijuana use as a mild form of escapism in comparison to the heroin abuse that plagued the bebop scene, the media painted most jazzmen with the same condemnatory brush.

Largely responsible for bebop's cult of heroin use, Charlie "Bird" Parker, celebrated as a tormented genius, was for the postwar jazznik," Ralph Ellison

explained, "a suffering, psychologically wounded, law-breaking, life affirming hero ... a latter-day François Villon." Though bebop founders like pianist Bud Powell suffered from mental illness and underwent electro-shock therapy several times, "Bird" remained the ultimate subculture hero. Parker, ever the sybarite, reveled in excesses and lived out his thirty-four years hustling money, getting around cities by cab, and crashing at friends' apartments. While a member of Jay McShann's band in 1942, Parker developed a persistent pattern of uneven stints of employment, and his drug-ridden bohemian lifestyle linked him with the criminal underworld. Ironically, though Parker claimed that heavy alcohol or narcotic use did little to enhance a musician's performance, his warning seemed to fall on the deaf ears of a legion of admirers.[8]

Bird's heroin use enamored young white hipsters— zoot-suit-wearing marijuana smokers who dated black women. When encountering this prototype of Norman Mailer's "White Negro" in the early 1940s, Malcolm X referred to them as "hippies," who "acted more Negro than Negroes," and that some "talked more 'hip' talk than we did." To Ralph Ellison, Parker was a 'white' hero ... for the educated white middle-class youth whose reactions to the inconsistencies of American life was the stance of casting off its education, language, dress, manners, moral and standards: a revolt, apolitical in nature, which finds its most dramatic instance in the figure of the so-called white hipster."[9]

When Parker appeared in Greenwich Village (which was, according to poet Ted Joans, the saxophonist's favorite part of New York), he was greeted "like a god," recounted saxophonist Jackie McLean. But by the early 1950s Parker was suffering from severe health problems (ulcers, as well as liver and heart ailments) and drank heavily to ward off the effects of drug addiction. Toward the end, unable to keep together a regular group, he played jobs with pick-up musicians. As Gary Giddins emphasized in the documentary *Jazz*, Parker was, at the time, "leading three lives"— that "of a jazz musician" and "of a junkie," while maintaining a "middle class life of a father and husband, living in the East Village of Manhattan, where he was known by his neighbors as somebody [who] always had a smile on his face."[10]

Between his career and strained family life, Parker took an interest in the arts, attending George Balanchine's New York City Ballet's performance of *The Firebird*. He tried his hand at drawing and painting, extolled the virtues of Italian painter Amedeo Modigliani, and was once introduced to Jean-Paul Sartre. Although his common-law wife Chan rarely saw Parker read he did on occasionally write poems, one reflecting a modernist Steinian quality:

> To play is to live
> Play is to live and vice-a-versa
> Live play is vice perverse
> Live verse is play

To shun to run
Running is shunning
But to shun running
Is shining shunning of running.[11]

During his last years, Parker, believing that his jazz improvisational pow-
ers had reached their peak, intended to study formal music composition. Fas-
cinated by large orchestral works, he talked of commissioning a work by Stefan
Wolpe and studying under Edgard Varèse. Parker visited Varèse's New York
apartment on several occasions, and the composer remembered him saying:
"Take me as you would a baby and teach me music. I only write in one voice.
I want to have structure. I want to write orchestral scores."[12]

The Varèse-Parker association never materialized. In March of 1955, Parker
visited Baroness Pannonica "Nica" de Koenigswarter* at her Stanhope Hotel
apartment, a fashionable Fifth Avenue residence located across from the Met-
ropolitan Museum of Art. There, on the night of the twelfth, three days after
arriving, he died of lobar pneumonia, slumped in a chair watching television.
After Parker died at the Baroness' hotel, headlines read, "Bop King Dies in
Heiress' Flat." Poetic requiems followed.† Thomas Pynchon in his cult novel V
observed, "Charlie Parker had dissolved away into a hostile March wind.... He
was the greatest alto on the postwar scene and when he left it some curious
negative will — a reluctance and refusal to believe in the final, cold fact — pos-
sessed the lunatic fringe to scrawl in every subway station, on sidewalks, in pis-
soirs, the denial: Bird Lives."[13]

Beats of the New Vision

Nearly six months after Charlie Parker's death in the fall of 1955, Jack Ker-
ouac, while living in a Mexico City rooftop room, celebrated the fallen saxo-
phonist in his series of spontaneous poetic "choruses." In the penultimate
choruses making up Mexico City Blues (1959), Kerouac depicted Parker as a
wielder of a messianic horn whose profundity of beatific message and looks,
his "lidded" and "calm eyes," he compared to Buddha. Two years after com-
pleting Mexico City Blues, Kerouac, in his 1957 novel On the Road, introduced
American youths to a new counterculture that, in capturing the years between
1947 and 1950, revealed the early impact of modern jazz on white cultural rebels.
The novel's Sal Paradise narrated that in 1947 "bop was going like mad all over
America" and "was somewhere between its Charlie Parker Ornithology period

*A renowned patron of jazz musicians (including Thelonious Monk) and the youngest sis-
ter of Lord Rothschild, Pannonica earned the New York press's title the Jazz Baroness, while her
black jazz friends affectionately called her Nica.
†Beat poet Gregory Corso's 1955 volume, The Vestal Lady on Brattle, included "Requiem
for 'Bird' Parker, Musician."

and another period that began with Miles Davis." Vital to the beat generation's rhythmical pulse, modern jazz became both an artistic inspiration and the recreational background music of the beats' underground circles.[14]

The beat generation's spokesman and idol Jack Kerouac was born in the industrial city of Lowell, Massachusetts, in 1922. He attended Columbia University on a football scholarship and came to campus with visions of heroic achievement. In the fall of 1940, after breaking his leg on the football field and dispirited by university cliques, he left Columbia. He resumed training the next fall, but then left the university for good, first joining the merchant marine in 1942 then the navy, where he lasted nearly three months and was honorably discharged after undergoing psychiatric evaluation.

In the summer of 1944, Columbia University student Lucien Carr introduced Kerouac to another student, Allen Ginsberg. The son of Russian-Jewish immigrants, Ginsberg's father, Louis, taught high school and wrote conventional poetry; his mother, Naomi, joined the Communist party and spent most of her son's childhood as a diagnosed paranoid schizophrenic confined to mental institutions. Embracing his mother's left-wing politics, Ginsberg first determined to study labor law or economics at Columbia until becoming inspired by poetry and literature that served as an outlet for years of suppressed homosexuality and suffering over his mother's mental illness.

While at Columbia in 1943, seventeen-year old Ginsberg met Lucien Carr. Under French symbolist poet Arthur Rimbaud's influence and the use of marijuana and benzedrine, they proclaimed themselves to be proponents of a "New Vision," creators of great literature. Carr's connections resulted in Ginsberg meeting Kerouac and an older kindred spirit, William Burroughs. Grandson of the inventor of the Burroughs adding machine and a Harvard graduate,* the sophisticated-looking Burroughs, in Chesterfield coats and bowlers, lived off a monthly stipend that helped feed his morphine habit. Ginsberg and Kerouac had been little exposed to modern literature at Columbia, and it was Burroughs who introduced them to Franz Kafka, Louis-Ferdinand Céline, and Jean Cocteau. He gave Ginsberg Yeats' *A Vision* and a collection of T. S. Eliot's poems, and presented Kerouac with a copy of Oswald Spengler's *Decline of the West*[†] that profoundly shaped the New York beat's intellectual and historical consciousness.

Ginsberg's literary "Secret Heroes" were Rimbaud, Spengler, Dylan Thomas, and Céline, French author of *Journey to the End of the Night* (1932)

*Burroughs graduated from Harvard with an American literature degree in 1936, and in 1938 briefly studied anthropology (pre–Columbian cultures) at Harvard. After graduating from Harvard, Burroughs traveled through Eastern Europe and experienced the homosexual scenes of Germany and Austria. By 1942 he worked as an exterminator in Chicago and then moved to Greenwich Village, where he lived in an apartment at 69 Bedford Street.

†Kerouac's boyhood friend Sebastian Sampas had first introduced him to Spengler's Decline of the West in 1940.

and *Death on the Installment Plan* (1936). Céline's anti–Semitism and wartime support of the Nazis disturbed Burroughs and Ginsberg, yet he was a living literary hero, a dark-minded man with a pen, who Ginsberg lauded "the greatest French prose writer," and Kerouac hailed as the founder of a "wild and beautiful nighttime form." World War One hero, doctor, traveler, Céline lived in the seedy surroundings of Depression-era Montmartre and produced work filled with Parisian argot, anti-heroes, misanthropy, and black humor that immediately attracted Burroughs. In Céline's work Burroughs found a West already in decline, "an illustration," noted Erika Ostrosky, "of the view that existence is an endgame played out on a cannibal isle or in a cosmic jungle, in an irrational and vicious setting with a multiple decor of slaughterhouse, asylum, and dunghill." Opposed to critics who condemned Céline as a dark prophet of earthly perdition, Burroughs read the Frenchman's work and found it "very funny," adding that his detractors "seemed to have missed the point entirely."[15]

Céline's fictional underworlds paralleled the beat ethos that reflected traditional bohemia's major characteristics—art, voluntary poverty, and criminality. In art and life, the beats identified with Céline's down-and-outers and Dostoyevsky's nineteenth-century underground men, fallen souls of a rotting empire living alongside sainted peasants. Drawn to homoeroticism and sadism, enamored with handguns, Burroughs introduced Kerouac and Ginsberg to a criminal underside that had been unknown to them in their respective hometowns of Lowell and Patterson. Through Burroughs they met heroin addict and underground hustler Herbert Huncke,* a local criminal contact and guide to the once grand theater and vaudeville district of Times Square, surrounding the intersection of Broadway and Seventh Avenue just above Forty-second Street.

In Ginsberg's amphetamine-inspired visions, Times Square glowed in apocalyptic neon; under its glare streetwalkers plied their trade, and wartime servicemen met male partners. Kerouac's debut novel *The Town and the City* (1950) depicted strolling Times Square girls, "hitchhikers, hustlers, Negroes, twinkling Chinese, the dark Puerto Ricans," white hustlers and hitchhikers, and blue-jean and leather-jacket-wearing maritime workers and mechanics. This element gathered at L-shaped cafeteria counters and rendezvoused at automats, cafeterias that offered prepared foods in vending machines. Burroughs judged automat food to be excellent and inexpensive, yet as "drug meeting places," he warned, "you had to be careful that the manager didn't spot you."[16]

Mixing in criminal circles, Burroughs and Kerouac became involved in the murder investigation of David Kammerer, who had stalked former pupil

Huncke appeared as Herman in Burroughs' autobiographical novel Junkie, *and in Kerouac's works as Elmer Hassel in* On the Road, *as Huck in* Visions of Cody *and* Book of Dreams, *and as Junky in* The Town and the City.

Lucien Carr from St. Louis to Chicago. During an August evening in 1944, Kammerer met Carr in a New York City park and threatened to kill the young writer if he did not have sex with him. Refusing Kammerer's demand, Carr stabbed him to death; on the same evening Carr went to Burroughs for advice and, while accompanying Kerouac on the way to have a drink in Harlem, dropped the murder weapon down a subway grate. Burroughs and Kerouac were both arrested as material witnesses to a homicide. They were finally released, and Carr served time in the state reformatory for manslaughter.

Kerouac's meeting Neal Cassady in 1946 brought to the beat circle a petty criminal, passionate for literature. A handsome son of an alcoholic Denver barber, Cassady, bisexual and a chronic car thief, talked incessantly in jazz-like improvisation. Not long after meeting Kerouac, Cassady quickly seduced Ginsberg and became Kerouac's kindred spirit and his model for *On the Road*'s Dean Moriarty. Shy compared to Neal when it came to sexual liaisons, Kerouac viewed his energetic friend as a near extension of himself, the alter ego he longed to express in everyday life.

In 1948 Kerouac coined the term Beat, which he appropriated from Huncke, who had picked up the term from Times Square argot, to describe his band of literary visionaries. Kerouac later explained that the beats were a circle first formed in 1940s New York City and then among a West Coast vanguard devoted to art and alternative lifestyles. To disassociate himself from the lazy bohemian *ignorée* (later the beatnik) and to emphasize his working-class roots, he laid claim to being a Jack London–inspired hobo, a railroad brakeman, and a merchant seamen.

For Kerouac and Ginsberg, writing was façade-effacing and confessional, as when in *Dharma Bums* (1958) Kerouac excoriated suburban middle-class life: row houses of television watchers "thinking the same thoughts," using their "white-tiled toilets" to send away waste "to convenient supervised sewers and nobody thinks of crap any more or realizes that their origin is shit and civet and scum of the sea." No matter how much Kerouac and the beats despised middle-class life, they did not, as did the so-called 1920s Lost Generation, wallow in alienation or seek radical political solutions, as did the 1930s left. Instead, they accepted the reality of capitalism's avarice and threat of atomic war by the Buddhist first precept that "life is suffering." Kerouac later explained the beat ethos as "sympathetic" and eventually connected it with "beatitude," as exemplified by Christ's Sermon on the Mount. The beats empathized with those suffering in the byways, unburdened by the proprieties and mores of what they perceived to be a dying Western world.[17]

Spengler's *Decline of the West* provided the beats with a historical explanation for the West's decay and rebirth. Spengler's book (the first volume appeared in 1918) outlined the laws of a cyclical historical process that saw each civilization growing plant-like from the founding of peasant cultures that,

as they advanced technologically and intellectually, gave rise to large cities populated by automatons. Once civilization reached this state, its citizenry would experience a need for the reclamation of earlier and simpler ways of life — "the nonhistorical state of fellahs."[18]

The beats championed the poor fellahin* of the city streets, back alleys, Negro slums, and railroad yards as the inheritors of the West's decline. Like Whitman, Kerouac keenly observed everyday life and captured in prose his cross-country trips, vestiges of a disappearing old West, Depression-style hobo jungles, anything that remained of a pre–1950s America. Kerouac mystically pronounced, "My voice is the voice of genius hobos, cowboys, musicians, and wanderers." Novelist Ken Kesey explained that Kerouac "was part of the ongoing exploration of the American frontier, looking for a new land, trying to escape the dust bowls of existence." In *On the Road*'s closing pages its trio of travelers, observing southern Mexican Indians, imagine themselves kindred members of the fellahin who will survive the apocalypse to once again live in an Adamic Eden.[19]

Black poet LeRoi Jones encountered the beats in the Village and discovered a new consciousness of interracial and creative interaction. The Village, wrote Jones, is "where I first met white [people] in any social situation portending equality," and interracial couples were an accepted reality. But not all black writers were impressed with the beats' portrayal of their race. Ginsberg's friend James Baldwin, author of *Giovanni's Room* (1956), a cult novel inspired by the 1944 Kammerer murder case, considered the beats' reverence for urban black life naive. Baldwin thought Kerouac's obsession with black hipsters "absolute nonsense" and stated, "I would hate to be in Kerouac's shoes if he should ever be mad enough to read [his work] aloud from the stage of Harlem's Apollo Theatre."[20]

Because of their romanticized views of blacks, the beats saw the Negro as a noble soul — his jazz a revelation of human spirit. While Burroughs displayed almost no interest in music, Ginsberg revered African-American jazzmen as "angel-headed hipsters," and Kerouac embraced swing and bebop with religious fervor and opined that "Bop is the language of America's inevitable Africa." Kerouac visited Minton's in Harlem and looked upon Parker, Gillespie, and other bebop artists as serious musician-thinkers. "In the forties when I heard them at Minton's," he confided to David Amram, "they were wearing berets and horn-rimmed glasses to show their allegiance with Picasso, Jean-Paul Sartre, and the revolutionary artists because they wanted the same respect shown to them as American musical visionaries."[21]

At New York City's Horace Mann prep school (1939–1940), Kerouac had

*Arabic for a peasant agricultural laborer of a Middle Eastern country, the word "fellah" came into the beats' lexicon, and Kerouac often used it to describe the downtrodden "beat" of city streets as well as Mexican peasants.

written for the campus paper and contributed an article about Glenn Miller and a review, "Count Basie's Band the Best in Land; Group Famous for 'Solid Swing." As avid a follower of jazz as he was of sports, Kerouac noted Basie's outstanding talent and the exemplary musicianship of tenor saxophonist Lester Young—initiating a lifelong fascination for the saxophone that took him from Young to Ben Webster, Dexter Gordon, Charlie Parker, and later Stan Getz.

In September 1943 Kerouac, aboard an Atlantic merchant ship, wrote to his girlfriend Edie Parker, "I miss my jazz." Back in New York a year later, while making the rounds in the Village, he and Edie, now his first wife, met Lester Young—deemed by Kerouac as a "great hero of the beat generation"—who then accompanied them by cab to Minton's. That evening in Harlem, according to Edie, Young introduced Jack to marijuana.[22]

Kerouac heard bebop at Minton's; yet evidence suggests that, like other jazz enthusiasts raised on swing, he was slow to embrace the new music. In *The Town and the City* (covering the period 1935 to 1946), Kerouac made mention of the word bebop only once, and wrote that his characters were beginning "to sense the thrilling new music that is about to develop without limit. There are rumors of Benny Goodman in the air, of Fletcher Henderson and new great orchestras rising." In Kerouac's second novel *On the Road*, covering the author's activities from 1946 to 1950, Parker and Gillespie are only mentioned in passing. Instead, the novel's Sal Paradise and Dean Moriarty are more enticed by tenor saxophonists Dexter Gordon and Wardell Gray. Though Kerouac had vowed in a 1950 letter to write a third novel about "jazz and bop," his third effort, *Visions of Cody* (written in 1951–1952), mentions, in its plotless music-inspired improvised narrative, which incorporates tape-recorded transcriptions of conversations, a plethora of jazz artists. Represented are traditional swing players and bebop musicians, and while Miles Davis receives a laudatory mention, Parker is given only a few passing comments.[23]

Kerouac came to revere bebop, especially through his friend Seymour Wyse's musical explanations of Parker's music, and it was in his 1958 novel *The Subterraneans*, (written in 1952) that Parker entered into Kerouac's fiction as the "king and founder of the bop generation." Though Kerouac had begun listening to bebop several years before writing *The Subterraneans*, it had yet to become crucial to his writing technique and rhythmical literary sensibility.* Kerouac often claimed that jazz surpassed literature in the shaping of his writing style, meaning that, as he told David Amram, it should "flow in a natural way ... like a Charlie Parker solo, straight from the heart, through the horn and out into the entire universe."[24]

A fan of white jazz modernists like pianist Lennie Tristano, Kerouac's "Spontaneous Prose" technique came about under the influence of white jazz alto saxophonist Lee Konitz, a key figure of the "cool jazz" sound, and a featured soloist on Miles Davis' groundbreaking Birth of the Cool sessions (1949–1950).

San Francisco's Angel-Headed Hipsters

Kerouac's spontaneous writing, swing jazz, and Charlie Parker's bebop musical ideas were crucial in shaping Ginsberg's 1955 poem *Howl*, which, following its reading in San Francisco, cleared the way for his and Kerouac's subsequent fame. Kerouac once described San Francisco as "a muttering bum in brown beat suit," and in 1947 he related to Neal Cassady that "There's a part of Frisco that's very Greenwich Villagey ... everybody looks like a junkey ... on Turk Street and Fillmore and Jones and Geary and Howard etc." At the time of Kerouac's visit, San Francisco still had a rustic nineteenth-century countercultural spirit among poets drawn to pacifism, public protest, philosophical anarchism, and eastern religion.[25]

Since the 1930s Bay area clubs and museums sponsored poetry readings largely as part of a scholarly and pedagogic movement emphasizing classic Greek and English literature. At this same time, local poets read at their own private gatherings, and, on occasion, produced little magazines. Following Berkeley's first informal readings in 1946, the practice spread to bars and coffeehouses. In their public readings poets practiced inflections and rhythms, verbal nuances that could not be otherwise expressed on the written page.

For decades San Francisco's leading poetic mentor was Kenneth Rexroth, a philosophical anarchist conversant with history, literature, and the translation of Asian and European verse. As a young student at the Art Institute of Chicago he painted under the influences of Wyndham Lewis and the German expressionists. In 1920s Chicago he delivered radical rants from corner soapboxes; at the club the Green Mask, he read poetry accompanied by a jazz pianist and visiting musicians like Austin High Gang's drummer Dave Tough. Later Rexroth visited Mabel Dodge in Taos and Witter Bynner in Santa Fe, and in Paris he met the dadaists and painter Fernand Léger.

Deemed a "one-man anti-establishment university"— San Francisco's equivalent of Alfred Stieglitz — Rexroth held Friday gatherings of ex–Wobblies, pacifists, and longshoremen. Rexroth founded San Francisco's John Reed Club in the early 1930s and during Stalin's Popular Front joined the Communist party but left to embrace a socialist-inspired anarchism. At his Friday gatherings Rexroth discussed, in "cracker barrel style," European modernism, surrealism, and Robinson Jeffers and Henry Miller's literary regionalism. He subsequently oversaw Wednesday night gatherings attended by a libertarian circle that held monthly fund-raising dances and spawned the city's first jazz poetry readings. By reading or reciting their work to musical accompaniment, Rexroth believed, poets could return to the "entertainment business, where it was with Homer and the troubadours."[26]

Jazz poetry soon made its way to North Beach, a seaside Italian enclave — "Bohemia between the hills and neighbor to the sea." In the 1920s on nearby Telegraph Hill goats grazed, and artists, living inexpensively on its slopes, spiced

their talk with mentions of Freud, Picasso, T. S. Eliot, Stravinsky, and Isadora Duncan, read *transition* and the *Dial*, and smuggled copies of *Ulysses*, arriving by way of Mexico. By the following decade, North Beach was home to "The Forty-Strong," a Prohibition-era Italian gang of bootleggers. When beat types began appearing in North Beach, 60,000 to 70,000 Italian-American residents lived there. On Broadway garlic wafted from Italian restaurants, accordion and jukebox music catered to nightclub crowds, and bohemians streamed into Montgomery Street's Black Cat, a popular gay bar of the postwar years, where homosexuals mixed with artists, bohemians, and "hoity-toity slumming parties."[27]

Poetry readings were held at the Cellar on Green Street, the Place on Grant Avenue, the Coffee Gallery and the Co-Existence Bagel Shop. In tribute to the latter venue, black beat jazz poet Bob Kaufman, "The King of North Beach," a one-time Greenwich Village resident who had befriended Charlie Parker, composed "Bagel Shop Jazz," which described the locals as "Mulberry-eyed girls in black stockings.... Turtle-necked angel guys, black-haired dungaree guys.... Mixing jazz with paint talk...."[28]

In 1955 Neal Cassady, with only spare clothing and a typewriter, arrived at North Beach and quickly came under police surveillance for selling marijuana. In North Beach marijuana, poetry, and jazz blended; Eileen Kaufman recounted how "spontaneity was the key word" of the community's lifestyle; as she added, "no one knew in advance just who might show to read a poem, dance, play some jazz, or put on a complete play." Almost a hundred years after George Du Maurier's novel and nearly fifty years following Puccini's opera, stirrings of *La Bohème* surfaced when Eileen Kaufman met Bob Kaufman; she thought him a modern-day "Rodolfo from '*La Bohème*'" and equated local poetic gatherings to the opera's meeting of artistic friends.[29]

To provide a literary meeting place, Lawrence Ferlinghetti and Peter D. Martin in June 1953 founded City Lights Bookstore at 261 Columbus Avenue. America's first paperback bookshop, City Lights was routinely open until midnight on weekdays and two in the morning during weekends. After Martin's departure, Ferlinghetti launched City Light's publishing firm and his Pocket Poet series in 1955. Before coming to San Francisco in 1951 New York–born Ferlinghetti had lived in Greenwich Village as a World War II navy veteran, earned a degree from Columbia University, and attended the Sorbonne. Parisian cafe life had so impressed Ferlinghetti that once back in America he longed for its inviting atmosphere. Ferlinghetti found his surrogate refuge in San Francisco, writing art criticism and poetry and painting under abstract expressionism's influence. He attended Rexroth's weekly gatherings, and echoing the elder poet, urged the creation of unique "oral poetry" of the street so as to get its creators "out of the inner esthetic sanctum where he has too long been contemplating his complicated navel."[30]

Alternative art galleries offered much-needed performance space for San

Francisco's poetry scene, and underground galleries and coffeehouses, like various New York City venues, hosted artistically diverse events. In 1955 a combination art show and poetry reading, featuring Ginsberg's newly composed "Howl," unexpectedly attracted nationwide headlines, making the San Francisco Renaissance a known movement and the beats a countercultural phenomenon.

By way of William Carlos Williams' typed introduction, Ginsberg met Rexroth and became fast friends with Ferlinghetti. Encouraged by his psychiatrist to embrace poetry as a vocation and urged by Williams and Rexroth to cultivate his own literary voice, Ginsberg completed "Howl's" first section in August 1955. A confluence of sources flowed into "Howl" — street argot and jazz intonations filtered through the poetic voices of Blake, Whitman, Apollinaire, Artaud, Williams, and Spanish poet Federico García Lorca. Each of the poem's lines were measured in a single breath as if blowing an extended cadenza on a saxophone, and were inspired by tenor saxophonist Lester Young's 1939 jazz instrumental "Lester Leaps In."* In its imagery, "Howl" was a painful cathartic lament. The poem was dedicated to Carl Solomon and all the other institutionalized and "angel headed hipsters," who Ginsberg described, as "destroyed by madness" — those, like his mother, Naomi, were sent to the "bug house" and subjected to "brain burning" lobotomies.[31]

Conceived in a revelatory rush, "Howl's" first section benefited from William Carlos Williams' urging that Ginsberg abandon traditional poetic diction and meter and find his own voice. Williams' dictum "No ideas but in things" served as a rallying call for young poets such as Ginsberg, Robert Duncan, Robert Creeley, Gary Snyder, and Philip Whalen. After hearing the sixty-six-year-old Williams versify at the Guggenheim Museum in 1950, Ginsberg corresponded with the renowned poet/doctor. He learned that Williams listened "with raw ears" to local speech patterns and advocated the primacy of capturing the American moment. Acknowledging the impact of imagists, notably Pound and Williams, Ginsberg related that "We were the first generation after them to learn the lesson and begin applying it to 'our own conditions,' our own provincial speeches, mouths of Denver and New Jersey, our own personal physiologies and personal breathing rhythms." Unlike Williams' short poetic units, Ginsberg favored long patterns resembling shouted religious incantations and extended jazz improvisation.[32]

In October 1955 Ginsberg created postcards and put up signs around North Beach to promote a poetry reading at Fillmore Street's Six Gallery† that would

*The jazz classic "Lester Leaps In," featuring soloist Lester Young, was recorded by the Count Basie and the Kansas City Seven (September 5, 1939, for the Columbia label).

†Three years earlier, the Six Gallery Space had been the King Ubu Gallery, an alternative showcase for art exhibits, plays, and theater, founded in 1952 by poet Robert Duncan and five visual artists. The reading was initiated by artist Wally Hedrick, who put Michael McClure in charge of organizing the event to coincide with Fred Martin's art. McClure, in turn, gave the task to Ginsberg, who made the postcards and advertisements.

showcase his new poem. Nearly a hundred artists and writers turned out and crowded the dirt-floor venue, surrounded by Fred Martin's surrealistic found objects covered in muslin and plaster of Paris. Bow-tied and wearing a second-hand cutaway coat, master of ceremonies Rexroth mounted a makeshift ply-wood dais introducing Ginsberg, Snyder, Whalen, Michael McClure, Philip Lamantia, and Lew Welch. Drunk, with wine jug in hand, Kerouac cheered the poets like a jazz fan urging soloists to greater creative intensity.

Part vatic-like chant, sermon, and agonized lament, "Howl" astounded the Six Gallery's audience. In August 1956 Ferlinghetti's City Lights Bookstore published *Howl and Other Poems*, with an introduction by Williams, as part its Pocket Poets series. In May the head of San Francisco's Juvenile Bureau ordered the arrest of City Lights Bookstore's manager, Shigeyoshi Murao, for selling a copy of "obscene" material to an undercover policeman. When Ferlinghetti and Murao were acquitted in early October 1957, the verdict marked a victory for free creative expression and made Ginsberg's work a bohemian must-read in cities across the country.

Ginsberg later confided that he was unaware of "Howl's" potential impact, believing that "only a few companions of the [Holy] Grail would recognize the humor of a lot of the rhythms and images." Yet Snyder, writing to Whalen a month before the Galley Six reading, sensed that the event would be "a poet-ickall bombshell." As a former marketing analyst, Ginsberg had a business back-ground, and in concert with Ferlinghetti, became a renegade entrepreneur, stirring national support during the trial and making the Gallery Six reading into a legend, a ritual to be copied wherever would-be poets gained the will-ing ears of beat-intoxicated listeners.[33]

The Beat of the Beat Generation

San Francisco's poetry scene spread eastward to Greenwich Village, where visual art, music, and poetry thrived in a matrix of modernist activity. In fol-lowing the original beat cluster's footsteps, a circle that had rarely made the Village their home, their followers crowded into local bars. They lingered long hours under the San Remo's tin ceiling, at the White Horse Tavern, where Dylan Thomas overindulged in ale, and in the Cedar Tavern, legendary for the abstract expressionists' drunken fistfights.

Artists flocked to the Village low-rent district of "Tenth Street," home to Wiilem de Kooning Phillip Guston and other noted painters. By 1957 Tenth Street's cooperative galleries included the Tanager, Camino, Brata, March, and the Area. At this time, bebop and its hybrid hard bop once more infiltrated the Village, offering musicians much-needed employment at clubs like the Open Door, the Half Note, Cafe Bohemia, and the Village Vanguard. When perform-ing at the Cafe Bohemia in the 1950s, Miles Davis encountered appreciative audiences. "Instead of being around a lot of pimps and hustlers," recounted

Davis, "now I found myself around a lot of artists—poets, painters, actors, designers, filmmakers, dancers."[34]

In this milieu of creative experimentation, Kerouac played a vital role in bringing jazz poetry to the Village. In the spring of 1957, he and classically-trained pianist David Amram (a French horn sideman with Gillespie, Mingus, and Monk) performed at informal gatherings and at the Cafe' Figaro on Bleecker Street, collaborations that Kerouac believed "would show these boys how Baudelaire and Erik Satie are reborn in the Village." In October Kerouac and visiting San Francisco poet Phillip Lamantia and drummer/poet Howard Hart took part in New York's "first-ever jazz poetry reading" at Tenth Sreet's Brata Gallery. Mimeographed handbills distributed in the Village helped to draw a packed house, and as Amram recounted, "We had no idea if anyone would even come, or if they would like it.... The reading proved to be memorable. We didn't know it at the time, but the seeds were sown."[35]

More New York jazz poetry performances followed, some amateurish,* others more successful. But jazz and poetry proved a short-lived performance genre, and this brief interaction — stereotypical of the beatnik image — never clearly defined the creative integration between jazzman and poet. Though poets like Rexroth foresaw jazz poetry as a serious new art form, the jazz accompanist's lack of interest in poetry or the poet's lack of musical knowledge did not successfully coalesce. As performed by novices, it produced at best mediocre experiments, and Ferlinghetti admitted, "Most of it was awful."[36]

But it was Kerouac's novels that captivated young readers and helped establish a new counterculture. In 1957, after six years without a publisher and nearly a decade after *On the Road*'s described events, the novel through Malcolm Cowley's intercession reached publication. *New York Times* book reviewer Gilbert Millstein compared *On the Road* with Hemingway's *The Sun Also Rises*. While Hemingway had written a book that popularized bohemian Paris, *On the Road* provided disaffected youths with the beat image that suited their generation's social and cultural outlook.

Made into a celebrity after weeks of photography shoots and television interviews, Kerouac, shy yet defiant, shouldered the unwanted burden of becoming a counterculture's founder while suffering critical condemnation. John Updike wrote a *New Yorker* parody entitled "On the Sidewalk," and Dan Wakefield and his fellow New York writers, seeing themselves as "writers, writers," considered *On the Road* full of "Wow" and "Wowee" excitement and further despised its author for giving their "generation a bad name ('beat')."[37]

On December 19, 1957, less than a month since On the Road's *publication, the Vanguard's Max Gordon booked Kerouac for an extended jazz poetry engagement, backed by trombonist J. J. Johnson's group. Without Amram's presence or someone who could provide personal support, Kerouac, trying to overcome his shyness, took the stage over-intoxicated and once got sick into the piano.*

Kerouac's most vocal opponents were influential university-trained intellectuals—the New York Intellectuals, also known as "The Family." The New York Intellectuals included Lionel and Diana Trilling and *Partisan Review* founders Philip Rahv and William Phillips. The circle's Norman Podhoretz described the beats as "The Know-Nothing Bohemians" and complained that the "spirit of the Beat Generation strikes me as the same spirit which animates young savages in leather jackets who have been running amok in the last few years with their switchblades and zip guns." By portraying beats as anti-intellectual social deviants, Podhoretz blurred their image with those of bikers, greasers, and rock-and-roll hotrodders. He condemned them as sybaritic primitives out to destroy the notion of the hardworking artist, deeply intellectual by training and temperament. Also severely critical were the New Critics—Kenneth Burke, Allen Tate, John Crowe Ransom, Cleanth Brooks, and Robert Penn Warren. These literary formalists, champions of T. S. Eliot and dedicated to the close reading and interpretation of texts, opposed Kerouac's spontaneous literary approach because it dispensed with the need for polish, a method they feared would lead to literature's decline.

Unaffected by the established literary community's attacks on the beats, young Americans considered them voices of their "generation"; some, like Ann Charters, a student at the University California at Berkeley, identified with the circle "even if," as she argued, "we didn't go on the road with Kerouac or take our clothes off with Ginsberg." Bob Dylan first wrote poetry under the spell of Ginsberg's "hydrogen jukebox world" and considered *On the Road* the catalyst of "the great city, looking for the speed, the sound of it."[38]

Voices of the Village

Before this new youth invasion, postwar Greenwich Village entered into a period of countercultural lull, when GI loans made possible the opening of bookshops stacked with second-hand editions and piles of literary magazines. Italian hood-types—"Bleecker Street Goths"—hung out in doorways, and drug users drifted into small drinking and music venues. In the postwar Village soaring rents saw villagers paying 90 dollars for a closet-sized room with a fireplace, and young people's initiation occurred rapidly as its transients—writers, copy editors, private secretaries, illustrators and actors—formed party-going cliques. They discussed Sartre and Camus and the method of psychological treatment they were undergoing; intellectually oriented stragglers scoured nightspots searching for the like-minded, and some came sentimentally looking for the faded dreams of La Bohème.

Others came to the Village to connect with literary heroes of the past. As a New York University student working as a night copy boy for the *New York Times*, Arthur Gelb came "paid dreamy homage at the houses where some of my idols had lived and worked: the brownstone at 60 Washington Square where

Willa Cather and Theodore Dreiser had rented flats, and a neighboring brown-
stone that had housed both John Reed and Lincoln Steffens.... I traced the foot-
steps of e.e. Cummings and Edna St. Vincent Millay, and, on the west side of
the square, found the site of the vanished rooming house of Eugene O'Neill,
whose plays I had eagerly borrowed from the library."[39]

Sparse at first, females came to live around Washington Square, some
"eager to sleep with an American Picaaso," a soon-to-be famous writer, or a
bohemian-type. When Kerouac's former girlfriend Joyce Johnson first saw
Washington Square she became filled with wonder, instantly longing to fall in
love with a rebel. These young women, Brenda Knight noted, "took chances,
made mistakes, made poetry, made love, made history." Of the original beat
circle wives, Joan Volmer, Edie Parker, and Carolyn Cassady, dressed fashion-
ably in high heels and tightly cut blouses and skirts. Their younger female
counterparts, however, commonly wore dancer's black tights— hip fashions,
that Hettie Jones described as "dirt-defying, indestructible" garments that freed
them "from fragile nylon stockings and the cold, unreliable, metal clips of a
garter belt."[40]

A *Village Voice* survey published around this time asked employed Villagers
between the ages of twenty-five and forty to describe locals of the opposite sex.
Most were quick to dismiss the transient bohemians. One male resident (waiter,
single) described the strata of Village women, first outlining the "liberated"
and "intelligent" college girls, cold-water-flat residents and buyers of "clothes
from Bonwit Teller," who "talk about sex more, and do it less." The second
type was labeled the "in-between"— "half-educated, half-liberated, promiscu-
ous" who indulged "in sex more than they talked about it," and a third, "the
flip" wannabe hipster with "sort of a 'dig-man'" front. A young single secre-
tary found the Village men "wonderful" artist types, but they "tend to be talk-
ers and not doers." A single secretary complained that Village men were mostly
divorced, "always broke" and eighty per cent alcoholic, while another single
female (advertising, 21) considered male residents "interesting" but largely
"irresponsible" cafe idlers.[41]

Many Villager types of this time were captured in James Baldwin's 1962
novel *Another Country* that dealt with biracial relationships, bisexual couples,
and down-and-outer fates. Baldwin's characters haunt MacDougal Street where
black and white couples elicited contemptuous looks from Italian laborers as
people "who gave their streets a bad name." They encounter suit-and-tie busi-
nessmen in Washington Square Park, chess players, and readers of *L'Espresso*
among the various street people, with bluejean-wearing, shorthaired girls read-
ing Kierkegaard and "talking distractedly of abstract matters, or gossiping or
laughing."[42]

Baldwin's rebels spent hours in Italian-owned coffee shops, trimmed in
dark wood and marble. Postwar Village cafes were quiet, quaint places. Writer
Diane di Prima fondly recalled them as safe havens in a neighborhood that

"had never heard of poetry readings and beatniks." But this was before the wave of beat commercialization created beret-wearing, bongo-playing, self-styled hipsters who turned neologisms and African-American jazz argot into a pastime of trite jivespeak.[43]

Beatnik Bohemias

In 1958, a year following the publication of Kerouac's *On the Road* and the Soviet Union's launching of its Sputnik satellite, *San Francisco Chronicle* journalist Herb Caen coined the term "beatnik" in reference to North Beach's bearded, sandal-wearing young people—coffeehouse talkers, loafer poet manqués, and dilettante modern jazz listeners. Major magazines recognized the trend, and an article in *Life*, "The Only Rebellion Around," depicted a wearer of sandals, chinos, and a turtleneck sweater holding a Charlie Parker record and condemned the beats as "sick little bums" who "emerge in every generation." Beatnik cartoons in leading publications blended aspects of bebop attire with a West Coast beachcomber look. Magazines advertised bebop-style sunglasses (shades) and berets, and sales of bongo drums increased—faddish commercialism that Kerouac deemed "Beatnik crap"; he viewed with contempt amateur poets and their bongo-playing accompanists, lamenting, "They don't know that bongos are our link to Africa and have religious connotations. They don't know about Afro-Cuban influences on American music, or Chano Pozo or Machito's contributions to the history of jazz right here in New York City. They're just kids, guided by money-grubbing merchants, who no longer read books or sit in Bhodovista silence, digging the sounds of the last genius pioneers of bop."[44]

Following a pattern of previous countercultures, the young embraced the beatnik, and the Village became just one of many urban communities to be infiltrated by pretenders and "the squares." A sociological study of 1950s North Beach in San Francisco described its residents as "a drab lot, easily overlooked," most men wearing worn business suits, women "the Black costume"—black leotards, sweaters, stockings, and sandals. North Beach youths indulged in alcohol, marijuana, amphetamines, peyote, and to a lesser extent, heroin. As early as 1953, busloads of gawkers made Grant Avenue "into a sideshow,"* and the press portrayed North Beach as peopled by hoodlums—where "the smell of marijuana smoke was now stronger than garlic." Police harassment intensified and soon would drive out North Beach's beat-types to other parts of the city, making early inroads in what would be known as the Haight-Ashbury district.[45]

Some North Beach beats left for rural Big Sur; others fled further south to Los Angeles' Venice West. Built during the turn of the century in the image

As early as 1953, tourist buses traveled up Grant Avenue.

of its Italian namesake, just south of Santa Monica, by the 1950s ocean-front Venice had become a "slum by the sea" dominated by scum-covered canals, oil derricks, and hotels turned into boarding houses, captured in Orson Welles' 1958 film *Touch of Evil*. In rejection of the nine-to-five workaday world of "moneytheism," Venice Beach residents— young people from Seattle, San Francisco, and New Orleans— took a vow of poverty and worked part-time as repairmen or arts-and-crafts teachers. White bohemians lived alongside Mexican families in inexpensive living spaces or "pads," typically with kitchenettes lit with one light bulb, where they held jazz poetry readings and listened to recordings of Charlie Parker, West Coast jazz, blues, modern symphonic music, and Indian ragas.[46]

At this same time, itinerant beat youths visited New Orleans' French Quarter. The occasional home to Tennessee Williams and a one-time refuge for William Burroughs, the Quarter was for Henry Miller one of the few places in America where "one could feel like a human being." Yet during Miller's mid–1940s visit, he decried the industrial world's steady encroachment on the Vieux Carre. Nearly a decade later, a local literary scholar described most beat Quarterites as "raffish bohemians ... a set composed of painters who do not paint, writers who do not write, and composers who do not compose. What they like to do is talk, and of course drink and above all else they like to argue: any subject will serve as pretext, and when they argue they will gesture violently as they imagine is done on the Left Bank, unaware that this sort of thing went out of fashion in Paris at least a quarter of a century ago." Most were modern jazz enthusiasts, followers of Freud and Suzuki's Zen Buddhism, interested in literature but not having read much beyond the beat canon.[47]

* * *

B-films were quick to exploit the beatnik manqués. Low-budget films fused the finger-snapping hipsters with hotrod hoodlums, making for fictionalized crazed beatniks prone to madness and criminality. Exemplifying this trend in 1959, MGM released *The Beat Generation* (directed by Charles Haas), and Roger Corman made the melodrama *Bucket of Blood*. *The Beat Generation*'s characters quickly fall into a crime melodrama , while Corman's *Bucket of Blood* opens with a coffeehouse poet pompously declaring the death of the written word and his spontaneous verse as modernity's only valid aesthetic. In the era of jazz poetry and the folk movement, the film's guitar-playing bard performs ballads among coffeehouse artwork, and undercover policemen scour the district for heroin. The film quickly turns into a house-of-wax horror tale when a socially inept busboy-turned-sculptor covers his murdered victims in clay.

MGM's 1960 release of *The Subterraneans*, directed by Ranald MacDougall and based on Kerouac's novel, starred George Peppard and featured jazz music by Gerry Mulligan, Carmen McRae, and Shelly Manne. A *Time* movie review

panned it as dull and "basically just a remake of *La Bohème* with a happy ending and bop instead of Puccini."[48] The beatnik finally arrived on television with CBS' *The Many Loves of Dobie Gillis* (1959–1963), featuring Bob Denver as a suburban, goatee-wearing beatnik, Maynard G. Krebs. Kerouac's road novel inspired CBS' *Route 66*, which debuted in 1960.

Cropping up in motion pictures and television, a contrived beat image reached American youths with meteoric speed. In defining the beat generation Gregory Corso later confided, "All it was was four people. I don't know if that's a generation.... That's more a Madison Avenue thing. It was like here we were, speaking in our own voices, and the mass media couldn't control us, so they did the next best thing, they 'discovered us.'" Gary Snyder also emphasized that the term beat referred to a small group of writers—the immediate group of Kerouac, Ginsberg, Burroughs, including Corso and a few others like himself, who had participated in the San Francisco Renaissance.[49]

From their once obscure circle, the beats, emphasized Steven Watson, "were greeted as something akin to American literature's first rock stars." Yet Kerouac and Ginsberg, sincere in their literary messianism, saw themselves playing a vital role in the regeneration of what they perceived to be a dying Western civilization. Not taking well to fame, Kerouac retreated to his mother's Florida home and died, bloated, embittered, and alcoholic, in 1969. In tribute, Seymour Krim described Kerouac as a handsome 50s noble savage, "something like a Jazz Prophet who worked in the form of the novel but whose main concern is in rhythmic sermonizing; A White Storefront Church Built Like a Man, on wheels yet, whose goal is chanting salvation for himself his friends and the whole human race."[50]

Sincere in his creative mission, Kerouac nevertheless created a myth of himself. More importantly, he and Ginsberg's writer-performer roles spread to younger cultural rebels, from Ken Kesey to Bob Dylan, and helped shaped the lifestyles of a broader revolution dominated by sex, drugs, and rock and roll. As the cult of heroin pervaded the bebop subculture, and marijuana and alcohol the beat movement, LSD became the drug of the 1960s counterculture. Swing and bebop jazz, the music of the beats, lost its appeal to rock music's electronic spectacles that the counterculture embraced as its premiere cultural inspiration.

IX

The 1960s
Musical Avant-Gardes

Experiments of the Mind, Experiments of the Machine

For the first time, music, not literature or painting, became the counter-culture's primary vanguard. Originally a teenage dance-oriented music, rock and roll — an amalgamation of blues, rhythm and blues, and country music — incorporated more progressive elements culled from non–Western music and avant-garde performance art and music. In this evolutionary process electric rock guitarists were raised by their fans to heroic heights, and, following in the footsteps of Chuck Berry and rockabilly musician Carl Perkins, they came to supplant the pianist and saxophonist as popular music's leading instrumentalists. Rock's intensified volume and light shows thrilled young audiences, and, by adding modern performance art elements into its live acts, it broke from tightly rehearsed R&B-derived review shows, as its festivals drew increasingly larger crowds and media coverage.

The sixties' musical legacy is portrayed popularly as sequined-dressed girl groups, male singing idols, and mop-topped British invaders, with electric folk and acid rock mesmerizing dreamy, face-painted hippies. However, for a segment of the African-American population and a small vanguard of white musical enthusiasts, the 1960s was the era of the black musical avant-garde — Ornette Coleman's Free Jazz, John Coltrane's spiritually-inspired explorations, and Miles Davis' electronic "Space Music." Joni Mitchell confided that Miles Davis' recordings existed as her "private music," as equally inspiring to her as Picasso's art. More college students broadened their musical interests by listening to John Cage, avant-garde jazz, and Indian sitar master Ravi Shankar. Festivals, concerts, and hippie coffeehouses booked avant-garde jazzmen or traditional bluesmen on the same programs with popular rock acts. Modern jazz played a behind-the-scenes role in musically shaping the Jimi Hendrix Experience, the Doors, the Allman Brothers, the Grateful Dead, and many others. By the decade's end, Miles Davis had helped to found a new electrified genre that saw jazzmen sharing stadium concert bills with rock acts.[1]

178

Among book-reading college students and former beat followers were adventurous rock musicians who incorporated avant-garde elements. The Velvet Underground had musical connections with John Cage, as did Frank Zappa, who also borrowed ideas and concepts from Edgard Varèse. By the end of the 1960s, observed music scholar Joan Peyser, if "art music abandoned a beat, rock revived it" as it embraced "massive social change and political events" while musically absorbing "everything from Gregorian chant to techniques of the avant-garde."[2]

Electronic Composers

Since World War II, formally trained avant-garde composers of "The New Music" had incorporated new instruments. With the use of recording machines, sounds could be overdubbed, and their magnetic tape spliced, played in reverse, and altered in speed or volume. America's first New Music concert of recorded music, held at the Museum of Modern Art in October 1952, used a Columbia University–owned Ampex machine and cabinet-mounted loudspeaker to play tape compositions that broke from western music's high-art performance tradition. Italian composer Luciano Berio and jazz writer Nat Hentoff hailed this pioneering concert, and the New York *Herald* announced that it had "been a long time coming, but music and the machine are now wed." Because the most elaborate electronic recording equipment had been previously housed in universities and other laboratory settings, New Music composers had been limited in their access to appropriate equipment. Yet in the programming and controlling of recorded material, great strides were made with the appearance of portable tape machines, computers, and in 1955 with RCA's self-contained synthesizer.[3]

New recording machinery enabled Varèse to realize his dream of creating music without musicians, and New Music composers, in the spirit of futurists and dadaist "Noise Music," increasingly looked upon "noise" (sounds outside the western music tradition) as a natural element of twentieth-century life. Recordings made from either environmental sounds (as exemplified by the Parisian Music Concrete) or those generated by computer or tape manipulation (Germany's Cologne Studio) opened music composition to vast possibilities. A sound or a segment of silence, as measured by time on the recording tape, became a measurable means of a composition, while synthesizers produced sounds outside the western symphonic tradition.

Most composers of live electronic music were typically part of performance ensembles or collective projects, and among them John Cage (1912–1992) attained a connoisseur following. Although having studied with Arnold Schoenberg, he sought to free himself of the latter's twelve-tone method. Admittedly not gifted with a talent for harmony, he made rhythm central to his music and concentrated on the elements of pitch-duration and overtones. As a

philosophical anarchist who believed that his music could evoke social change, Cage refused to recognize traditional musical hierarchies. He blamed Beethoven for perpetuating standardized musical formulas in high-art music and claimed that he was "more interested in a mediocre thing that is being made now, which is the avant-garde, than I am in the performance of a great masterpiece from the past." He further defied tradition by performing his compositions in gymnasiums and arenas, public spaces that he believed to be as legitimate as the concert hall. Conductorless and without lead instrumentalists, Cage's music made the composer equal to his participants by allowing them vital roles in making spontaneous decisions while performing a work, thus making them co-composers in an ensemble of equals. As he explained, "the old idea was that the composer was the genius, the conductor ordered everyone around, and the performers were the slaves. In our music, no one is boss." This outlook stemmed from Cage's personal study, beginning in the late 1940s, of Zen Buddhism and readings from the *I Ching*. Thus he considered music as neither entertainment nor individual expression — that it should, in essence, "say nothing." His Zen consciousness also inspired Cage's indeterminate music, which utilized elements of chance, so that compositions would never be performed in the same way twice.[4]

Delighted by atmospheric sounds, Cage treated "noise" (sounds outside traditional western harmony) and silence as equal musical elements, one enhancing the other. These two elements were exemplified in his scoring music for twelve radios for *Imaginary Landscape No. 4* (1951), and in the performance of *4' 33"* (1952), which called for four minutes and thirty-three seconds of silence. His "noise music" included the replacement or manipulation of conventional instruments, the use of found objects (such as a toy piano), and recording tape. Early in his career he presciently stated, "I believe that the use of noise to make music will continue and increase until we reach a music produced through the aid of electrical instruments which will make available to composers any and all sounds that can be heard." Cage's bringing of aural elements of modern life into the concert hall was aimed at stimulating listeners to find inspiration in the sounds around them. Cage also wrote compositions for "prepared piano"—works that called for the use of an altered piano—its strings fixed with wire and other objects, producing sounds reminiscent of eastern or Balinese music.[5]

Although ostracized by the 1960s New York music establishment, Cage associated with neo-dada visual artists Robert Rauschenberg and Jasper Johns, as well as his long-time friend and sometime collaborator, dancer and choreographer Merce Cunningham. Because of his varied creativity as a composer, visual artist, writer, and collaborator in multimedia productions, Cage has been called a "polyartist." His most valuable legacy, similar to that of his friend Marcel Duchamp, has been the propagation of aesthetic ideas, and he has been described "as an antithetical catalyst who leaps ahead so that others may move forward by steps."[6]

The Jazz Freedom Principle

Though Cage disliked jazz, its avant-garde made great creative advances, and, unlike the New Music composers, it attracted more followers in the sixties counterculture, notably creators of "cosmic" jazz — John Coltrane and others — whom poet Amiri Baraka (LeRoi Jones) called God-seekers." While Miles Davis admired Karlheinz Stockhausen's compositions, avant-garde jazz pianist Cecil Taylor dismissed the New Music composers, claiming that their work was musically incompatible with jazz and that they ignored the black experience and venerated the machine over the human element. Nonetheless, these two musical genres represented the decade's two leading musical vanguards that inspired rock music's progressive tendencies throughout the decade.

Similar to modern painting and poetry in its moving toward increasing abstraction, avant-garde jazz employed greater use of modes that removed the constrictions of standard chord progressions. Since the mid–1940s modern jazzmen had integrated Afro-Cuban music and by the next decade had increasingly absorbed musical ideas from Africa and the Middle East. Harmonically, modern jazz, wrote John F. Szwed, "represented for Western music a kind of pre-electronic distortion, an irruption into the system, a breaking of the rules of musical order; later electronic distortion itself became a technological emblem of the black component of Western art." On the eve of the 1960s, avant-garde jazz and the New Music simultaneously moved toward a suspension of time, and both increasingly made "rhythm unreliable, giving listeners no sense of regularity."[7]

Venturing most radically beyond traditional harmony and rhythm, jazz alto-saxophonist Ornette Coleman pushed jazz music's boundaries. Coleman's two-month stint at New York City's Five Spot (November–December 1959) signaled a revolution in jazz. Critics and musicians from Miles Davis to Charles Mingus to Leonard Bernstein attended the performances; avant-garde composer Steve Reich compared the music's impact to the Parisian debut of Stravinsky's *Rite of Spring.*

Coleman's pioneering of Free Jazz, or "The New Thing," abandoned an established tonal center and standard metrical rhythm, though Coleman saw himself as extending rather than breaking from jazz tradition.* His reliance on free-form compositions sharply divided the jazz community, finding a supportive minority in Bernstein, pianist John Lewis, and critic Martin Williams. Modern jazz bassist/composer Charles Mingus thought that Free Jazz was a new musical avenue that needed to be explored, and Miles Davis, though initially dismissive of Free Jazz, later came to see Coleman's music as a logical development within the genre. Born during the late 1950s artistic cult of spontaneity, Free Jazz symbolized the youthful unrest that permeated a protest-minded era — one that encouraged experiments in art and life.

It must be noted that modern jazz pianist Lennie Tristano recorded the first "Free Jazz" sides in 1949.

Free Jazz had other practitioners. Tenor saxophonist Albert Ayler, known for his atonal shrieks and sounds, was described as a "jazz Dadaist," and he asserted that in his music, "It was not about the notes anymore." A musician echoing Cage's iconoclasm, Ayler "wanted to shake things up, to make jazz musicians rethink their entire process of music making, and help them escape the European mode of thinking that had increasingly dominated the music of the Fifties."[8] Distinct from Free Jazz musicians, jazz modernists still worked within form (designated compositional frameworks) while exploring experiments in pitch, timbre, and composition, as exemplified in Charles Mingus' "spontaneous compositions" that showcased sections of free-form playing.

Mingus' avant-garde stance maintained that the twin principles of truth and freedom were non-negotiable, a perspective shared by avant-garde pianist Cecil Taylor. "In music I am for a new truth," stated Taylor, "a truth beyond the money principle — a truth that will make people treat each other like human beings." Sixties modern jazz was a turbulent music for turbulent times. Yet as much as Coltrane's heart-wrenching saxophone cries expressed deep anguish, they also offered a path to spiritual transcendence. But Coltrane's move into Free Jazz put a "great distance between ... music, inspired by 'the people,' and one that would actually reach a mass audience." White popular music that drew upon blues, R&B, and avant-garde elements and made millions of dollars in sales infuriated musicians such as Miles Davis, Charles Mingus, and saxophonist Archie Shepp, who insisted that jazz be called "black music." Multi-instrumentalist Rahsaan Roland Kirk* demanded for his music the categorical title of "black classical music," and Mingus referred to his creative output simply as "music."[9]

For jazzmen coming of age during the 1960s civil-rights movement, the term freedom took on sociological as well as an aesthetic meaning. In contrast to Max Roach's clear political statement in *We Insist! The Freedom Now Suite* (1960), other titles blurred such distinctions and emphasized limitless modernist experiments. This was exemplified in Ornette Coleman's albums *Shape of Jazz to Come* (1959) and *Free Jazz* (1960), Cecil Taylor's *Looking Ahead* (1959), and other recordings such as saxophonist/flutist Eric Dolphy's *Outward Bound* (1960) and *Out to Lunch* (1964).

Jazz venues were few, and the jazz festival (the precursor of the rock festival) did not offer enough compensation or commercial exposure for musicians largely relegated to playing nightclubs for a living. Some of the most renowned of these committed artists played European concerts and music festivals, while others, including Eric Dolphy, moved permanently to Paris.

*In his 1966 work, Encyclopedia of Jazz, *Leonard Feather observed that Kirk was beyond category "either as avant-gardist or as a traditionalist." Similar to his former bandleader, Charles Mingus (one of his unflagging supporters), Kirk looked to the whole spectrum of jazz, from New Orleans music to Coltrane. He idolized Stravinsky, Varèse, and Luciano Berio.*

Described by Frank Zappa as "the music of unemployment," jazz had evolved from being America's popular music to a modern art form enjoyed by a much smaller, if highly devoted, number of followers.

Of a mixed racial background, Mingus— garrulous, combative, and some-times violent — uninhibitedly railed against racism and black America's economic plight. In *Time* magazine (1962) he addressed the second-class status of jazz music's African-American founders in a white-dominated entertainment industry, one that largely ignored the black musical avant-garde. Portrayed as the angry man of jazz, Mingus expressed in the article his disillusionment with America and threatened exile to a Mediterranean island. This stance was later voiced in his surrealist-style memoir. Written with the intention of trying "to upset the white man in it," Mingus' book dismissed white musical copyists and stated, "You had your Shakespeare and Marx and Freud and Einstein and Jesus Christ and Guy Lombardo, but we came up with jazz, don't forget it, and all the pop music in the world today is from that primary cause."[10]

Mingus' outspoken defiance made headlines in 1960 when he and other African-American jazzmen defied the Newport Jazz Festival. Since its founding in Newport, Rhode Island, in 1954, the jazz festival had featured modernists Miles Davis and others among its mainstream acts. The festival's mixed crowd of hipsters and blue bloods, fashion editors and filmmakers, contributed to "a new form of leisure," and in 1960 thousands of white college students, preppies, and hooligans came to Newport. The holligans' drunken rioting, property damage, and beer-bottle throwing was quelled by police and National Guardsmen, and caused the festival to be canceled before its remaining two days of scheduled performances.[11]

Meanwhile, Mingus, Max Roach, and others challenged the Newport Festival and its links with the mainstream music establishment. Encouraged by jazz critic Nat Hentoff (and Newport Festival founder Elaine Lorillard), they held an anti-festival several blocks from the main event at the Cliff Walk Manor, a seaside inn and restaurant. A defiant gesture likened to the Salon des Refusés, the anti-festival addressed iniquities and voiced protest against racist music industry practices, while finding "a serious audience for an artistically adventurous and intellectually challenging music."[12]

At Cliff Walk Manor, the musician rebels erected tents for sleeping, built a crude stage, took tickets, and alternated as announcers. Mingus made hand-bills and yelled out to Newport residents from a convertible passenger seat, "Come to my festival!" Gaining much press attention, the anti-festival featured many famed musicians including Coleman Hawkins and avant-gardists like Ornette Coleman and Eric Dolphy. After 1960 Mingus came to symbolize a new militancy among black avant-gardists, articulating his frustrations both musically and verbally whenever he was asked or interviewed about his art.

But such avant-garde displays against the musical establishment were rare. In 1962 Ornette Coleman organized a concert of his music at New York City's

Town Hall, which prompted other musicians to promote themselves through self-made posters and underground magazine advertisements. The 1964 October Revolution in Jazz, a six-night concert series at New York City's Cellar café, and the subsequent New York Jazz Composer's Guild brought together Sun Ra, Cecil Taylor, and Archie Shepp. Such informal gatherings played a key role in fostering spirited cooperation and support needed in the absence of more commercial channels for musicians performing their art.

Trane and Miles

One of the participants in the New York music collectives, John Coltrane, was more economically fortunate than most young African-American jazzmen and earned from $25,00 to 50,000 a year from an ABC-Impulse recording contract until his untimely death in 1967. Coltrane's formation in 1960 of a quintet — comprised of drummer Elvin Jones, pianist McCoy Tyner, and eventually bassist Jimmy Garrison (often augmented by other musicians) — marked a watershed in jazz. This formidable ensemble's formation provided the ideal unit for Coltrane's extended improvisations and accompanied the saxophonist on recordings that won him international fame.

Like Charlie Parker, Coltrane opened new paths of improvisation by expanding the musical vocabulary of jazz. Apart from bringing the playing of chords on the saxophone into vogue, he often led groups that employed either two bassists or two drummers. His solemn manner and spiritual outlook made him an avant-garde cultural hero among countless jazz artists and rock musicians. As early as 1964, critic Ralph J. Gleason noted that Coltrane was "linked inexorably with those creative artists such as Joseph Heller, Ken Kesey, Lenny Bruce and others searching for ... a new way to look at the world, an attempt to locate a better reality." Inspired by music from Africa, India, and the Far East, as well as modern Europe, such as that by Igor Stravinsky, Coltrane brought together disparate musical and cultural elements that made him a true pioneer in modern world music.[13]

Before the Beatles accented their pop songs with sitar music, Coltrane had studied the drones and ragas of Ravi Shankar's music. Coltrane's transcendentalism fused elements of world religions from Kabbalah to Christianity to Islam, and his most popular-selling album, A Love Supreme (1964), is dedicated to God as a Supreme Being. In its liner notes, Coltrane wrote, "Thought waves — heat waves — all vibrations — all paths lead to God.... One thought can produce millions of vibrations and they all go back to God ... everything does."[14]

In 1965 Coltrane's album Ascension marked his entrance into Free Jazz, dismaying most critics and fans. A musical dialogue with ten other musicians and without an explicit tonal center or recognizable musical constructs, Coltrane's Ascension put great demands on listeners. The album's liner notes warned: "Be advised that this record cannot be loved or understood in one

sitting, and that there can be no appreciation at all in two minutes in a record store." Nevertheless, the album profoundly influenced many leading musicians, and Coltrane's subsequent performances sought further to capture elements of an ethereal spiritual plane. Posthumous releases such as *Interstellar Space* (recorded in 1967 and released in 1974), with its four compositions "Mars," "Venus," "Jupiter," and "Saturn," looked to the vast reaches beyond. During his last years, Coltrane used LSD as a catalyst to spiritual enlightenment and once while using the drug claimed to have "perceived the interrelationship of all life forms."

Coltrane's musical and transcendental worldview captivated young jazz and rock musicians. Guitarist John McLaughlin, whose music eventually reached arena audiences, said that *Ascension* put him in a trance as he envisioned himself "flying over Africa," experiencing nature's "pulsating, teeming life." Coltrane's rock followers also included guitarists Eric Clapton and Duane Allman. Carlos Santana commented that the saxophonist's music had "changed everything around" in modern music.[15]

Coltrane's music inspired Ralph Fasanella's paintings and was likely the "focus of more poems" than any other jazz musician. He inspired writings by Amiri Baraka (LeRoi Jones), San Francisco's Michael S. Harper, and Al Young; a teenage Patti Smith, mesmerized by the saxophonist's music, imagined herself as a jazz poet. Poet and activist John Sinclair authored *Song of Praise: Homage to John Coltrane* and asserted that the saxophonist was an important voice of social change as progressive rock bands played "the music of right now, every minute, pounding and screaming at your head."[16]

* * *

In 1967, amid the Summer of Love, race riots in Newark and Detroit, and the international popularity of the Beatles' *Sgt. Pepper's Lonely Hearts Club Band*, Coltrane died of liver cancer, leaving behind a legion of black and white followers. By the 1970s his album *Love Supreme* had sold over a million copies. For a sizeable segment of America's 1960s music aficionados—those who found that the assembly-line rock 'n' roll of singing idols lacked the rebelliousness of 1950s rhythm-and-blues-influenced bands—Coltrane and other jazz avant-gardists offered a vibrant alternative. New York City remained the music's epicenter. Though it lacked enough nightclubs to support its wide range of talent, its experimenters found creative outlets in Greenwich Village and East Village coffee shops, small theaters, art galleries, settlement houses, churches, bookstores, and corner bars. "Loft jazz" concerts with inexpensive cover charges allowed serious musicians and poets to perform in an atmosphere of intent listening where audiences sat on floors or folding chairs, smoked, and drank coffee or alcohol from flasks. This eclectic creative atmosphere afforded fertile ground for creative performers, artists, and filmmakers to mingle with music followers.

Modern and avant-garde jazzmen performed in the same clubs featuring poetry readings and folk performances. Living in 1960s Greenwich Village, Bob Dylan attended performances by Monk, Davis, Coltrane, and Cecil Taylor (with whom he once performed a traditional folksong), as well as visual-art exhibitions, foreign films, and plays. Dylan recalled how the "scenes were very much connected, where the poets read to a small combo, so I was close up to that for a while." Crossing paths, if sometimes working at cross-purposes, the New York folk and jazz scenes (two previously separate realms) entered into emerging 1960s rock music from entirely different directions.[17]

The jazz avant-garde's rhythmically complex instrumental music placed black modernists beyond the mainstream culture. But hippies, college students, and music connoisseurs commonly had among their record collections albums by Miles and Coltrane. One of thousands of young people introduced to modern jazz by way of record albums during the sixties, Duane Allman asserted, "Miles does the best job, to me, of portraying the innermost, subtlest, softest feelings in the human pysche. And John Coltrane was probably one of the finest, most accomplished tenor players." Thus, elements of the music were carried into rock's creative cross-fertilization by musicians who had their ears open and their minds attuned to new creative possibilities.[18]

* * *

In 1967 *Down Beat* magazine announced on its cover that "Jazz as We Know It Is Dead." A publication that had denounced bebop in the 1940s, *Down Beat* made another drastic shift in policy when, earlier in the year, it had started featuring electric instruments and Beatles-endorsed product advertisements as well as rock music articles. The magazine's editorial change signaled a growing eclecticism in American popular music, at a time when *Jazz & Pop* magazine seriously discussed Dylan, Coltrane, and Hendrix. Even mass-produced trade pop-music-oriented paperbacks discussed Jimi Hendrix, Janis Joplin, and Frank Zappa, interspersed with articles featuring Cecil Taylor and Pharaoh Sanders.

In 1969 *Rolling Stone* magazine carried a feature story on Miles Davis. Five years earlier Davis' second great quintet—eventually comprising saxophonist Wayne Shorter, pianist Herbie Hancock, bassist Ron Carter, and drummer Tony Williams—had earned the jazz community's praise. By 1966 Davis was a grandfather and by youth culture standards "was already an old man, one of yesterday's men"; some jazz critics questioned Davis' innovative capacity, that his remaining years would be spent playing in a hybrid hard-bop style. But the trumpeter remained one of jazz's most popular and innovative artists; with a Columbia Records contract, surrounded by an ever-changing line-up of young sidemen, he recorded brilliant music and eventually the best-selling album in jazz history, *Bitches Brew*, all the while asserting creative independence. As Carlos Santana affirmed, "Miles was not an entertainer, he was a seriously brutal artist, musician, [who] would not comply with the plastic system."[19]

Popular black music's electronic instruments caught Davis' ear, notably the funk-edged electric guitarist Joe Zawinul's electric keyboard work in saxophonist Cannonball Adderley's quintet and the electric bass' rich undercurrent that freed the instrument from playing steady metrical patterns. By 1967, with each subsequent album release, Davis increasingly flirted with electronic sounds and began replacing walking four-beat swing rhythms with broken bass patterns. He urged Hancock to use an electric piano and began recording with electric guitarists. At the same time, Davis' Columbia producer Teo Macero employed postproduction editing techniques, splicing hours of improvised recordings into various compositions. Such studio innovations occurred at a time when leading rock bands like the Beatles were incorporating postproduction techniques, culminating in 1967's *Sgt. Pepper's Lonely Hearts Club Band*, and others like Jimi Hendrix were using various multitracking recording techniques.

More than just musical influences, Hendrix and soul musician Sly Stone prompted Davis to abandon his custom-cut Italian suits for dashikis, wraparound sunglasses, and bell-bottoms. Though he may have claimed that rock was "a white man's world," Davis listened closely to bands like Santana and the Jimi Hendrix Experience. Conversely, Hendrix, predominately a product of blues and R&B, listened to modern jazz, and his drummer, Mitch Mitchell (heavily influenced by Coltrane's bandmember Elvin Jones), introduced him to the music of multi-instrumentalist Rahsaan Roland Kirk.* "I like Charlie Mingus and ... Roland Kirk," expressed Hendrix. "I like very different jazz ... the free-form jazz. The groovy stuff instead of the old-time hits—like they get up there and play 'How High is the Moon' for hours and hours—it gets to be a drag." Hendrix told an interviewer that he and Kirk were "doing the same things" musically. "We have different moods and I think some of the moods are on the same level that Roland Kirk is doing."[20]

Hendrix befriended Davis in 1968, and they had planned to record together in a collaboration to be arranged by the guitarist's manager. But because Davis demanded a fifty-thousand-dollar studio fee, their project was put on hold. Though Davis condemned white rock as "half-assed new" and claimed it displayed little advanced musicianship, he looked upon Hendrix in a different light; he learned much from the musically self-taught guitarist, whom he admired as a modern blues master. "Jimi wanted to add more jazz elements to what he was doing," Davis explained. "He liked the way Coltrane played with all those sheets of sound, and he played guitar in a similar way." Hendrix's mod look impressed Davis, who bought clothes from a Greenwich Village boutique frequented by Hendrix and also patronized the guitarist's hairdresser.[21]

Like Miles Davis and his producer Teo Macero, Hendrix, along with his talented studio team that included engineer Eddie Kramer (an avant-garde jazz

*Early in 1967 Kirk jammed with Jimi Hendrix at Ronnie Scott's jazz club in London.

fan), were independently exploring electronic innovations and postproduction techniques, including multitracking and "backwards guitar solos"—recording lead guitar sections with tape installed backwards on the machine's spool. Hendrix's guitar distortion, feedback, and the use of a wah-wah pedal (Davis too would soon use a wah-wah pedal on his trumpet as well) were used as harmonic coloring, producing sounds never heard before on the instrument. Mutual friends and admirers of each other's music, both Davis and Hendrix played before large rock audiences. While Davis received far less for his appearances and recordings than those of his guitarist friend, a segment of the countercultura saw in his music a fount of spiritual message.

Before his electric period, Davis' acoustic music impacted upon numerous rock musicians, and one of Davis' most popular albums, *Kind Of Blue* (1959), was a cult favorite among progressive rock musicians (according to Davis, Hendrix particularly liked the album). Guitarist Duane Allman of the Allman Brothers Band related: "[my] kind of playing comes from Miles and Coltrane, and particularly [Davis's] *Kind of Blue*. I've listened to that record so many times for the past couple of years I hardly listened to anything else." *Kind of Blue*'s composition "All Blues" served, along with Coltrane's "My Favorite Things," as blueprints for the Allman Brothers' classic instrumental number "In Memory of Elizabeth Reed," recorded on *The Fillmore Concerts* (1971) and considered by many critics as one the finest rock live albums ever recorded.[22]

But as rock musicians were still absorbing the music of Davis' pre-electric period, the trumpeter, in the spirit of twentieth-century modernism, embarked on a path of sustained creative development. His use of electric instruments, approached cautiously at first, was set center stage with the 1969 release *In a Silent Way*, featuring electric keyboards and guitar, and culminated with the following year's release, *Bitches Brew*, a double-length album that sold 400,000 copies during its first year. Davis recorded the album in several sessions and used twelve or thirteen musicians, including two basses and two drummers; in this improvised setting only the keyboardists were given written musical sketches and the band had only one brief rehearsal. Compositions were developed spontaneously from musical fragments that, with cohesive interaction, took on expressive depth and communicative power. Producer Teo Macero's masterfully edited the studio tapes, rearranging sections of performances—postproduction skills that gave the project a greater sense of cohesiveness and placed the producer in the position of music arranger.

Bitches Brew struck a chord with acid-taking countercultural types who listened to the album's extended numbers that included "Miles Runs the Voodoo Down," inspired by Hendrix's rock blues masterpiece "Voodoo Chile" (*Electric Ladyland* 1969). Through the urging of Columbia records producer Clive Davis, Miles took his new electric sound, no longer suited to intimate nightclub settings, to rock concert halls. At Fillmore West and East concerts, Davis performed on shows with Steve Miller, Neil Young and Crazy Horse, the

Grateful Dead, Santana, and Blood Sweat and Tears. But Davis never catered to the youth market, and his Fillmore East and West performances (recorded live in 1970), and those at outdoor festivals and stadiums, contrasted with the song-oriented pop groups in that each show was played strictly instrumentally as one continuous set of spontaneous explorations. Backed by a quintet that included Chick Corea and bassist Dave Holland, Davis appeared in May 1970 at the University of Michigan campus. In Ann Arbor, where a music reviewer commented that most young people were followers of the MC5 and Iggy Pop, the Davis concert received "an overwhelming reception —far out, freaky, heavy" were among the many approving phrases the young crowd used to describe the trumpeter's music.[23]

Two months later Davis opened for the Band at the Hollywood Bowl. One of the decade's finest American rock groups, the Band, great admirers of Davis' *Sketches of Spain* (1960), chose Davis to open for their concert. Twenty-thousand people turned out — "middling executives with their tolerant housewives, boppers, suede-covered mods"— jazz and rock fans as well as hip black listeners in African garb, hippies, and celebrities like Henry Mancini. The Band's drummer Levon Helm watched Davis, in wrap-around blue sunglasses, back turned to the audience, pour "fire into the crowd ... playing and scaring the shit out of the audience," recounted Helm. "But he never took them over the edge, and that's why he was a master, an outrageous artist." A month later, Davis, on the same bill with Hendrix at England's Isle of Wight Festival,* took the stage in a red leather jacket and silver-studded bell bottoms, pouring out his electric sounds before a crowd estimated at half a million — the largest gathering a jazz group had ever played. When asked the title of his free-form-one-composition set, he answered "Call it anything."[24]

Though Davis as an opening act was paid considerably less than rock headliners, his recording sales increased and allowed for a lifestyle unknown to most jazz musicians; he purchased a twenty-thousand-dollar Lamborghini and had an interior designer remodel his home. After decades of struggle, Davis had entered the market on his own terms.

*After the concert, Hendrix was to return to New York City and record with Davis's friend and arranger Gil Evans. But the guitarist's untimely death of a drug and alcohol overdose on September 18, 1970, ended another potential collaboration that would have elevated Hendrix from a pop music setting into the burgeoning rock jazz movement.

X

The Adversary Culture

"Revolution in the Air"

Heroes to the emerging counterculture and its musicians, Davis and Coltrane reached a young audience when a cult of spontaneity nurtured multimedia experiments, which in turn influenced rock music indebted to beat poetry and performance art. At the forefront of this artistic cross-fertilization, New York's Greenwich and East Villages held loft concerts, happenings, and neo-dada art shows. Eyewitness to this period between the beats and the sixties counterculture, Bob Dylan remembered how "Abstract painting and atonal music were hitting the scene, mangling recognizable reality. Goya himself would have been lost at sea if he tried to sail the new wave of art." New York's creative experimentalists were dubbed "The New Bohemians" and the "Combine Generation"—inheritors of Kerouac's "spontaneous prose," abstract expressionism, avant-garde jazz, Duchamp's conceptual art and its neo-dada manifestations, who, in the '60s counterculture's predawn, created some of the most adventurous art in the latter part of the twentieth century.[1]

Duchamp's Shadow

In 1964 artist Hans Richter commented, "Nobody knows what direction art will take, in its present chaotically disoriented state. But one thing is sure: a new generation has taken up Duchamp's experiments, with optimism, with conviction, and in the spirit of a new artistic humanism." Under Duchamp's spell and defying high-art academic standards, 1960s neo-dadaists Robert Rauschenberg and Jasper Johns, along with pop artists Claes Oldenberg, Roy Lichtenstein, and Andy Warhol, were influenced by dada's assertion that art's importance lies in the idea behind its creation — the artist's intent — and not in the object itself. Though most pop artists were less interested in ideas than dadaist absurdity, they too found in Duchamp elements of the whimsical and often heeded their hero's assertion that "when the seriousness is tinted with humor, it makes a nicer color."[2]

An American citizen living in 1960s Greenwich Village, Duchamp, though he still attended parties and helped organize galley exhibitions, projected the image of a retired artist, living a quiet married life and playing chess. Under the pretense of studying chess from his French friend, John Cage spent many hours in Duchamp's apartment, learning, asking him little, and reverently observing. Cage once described Duchamp's aging face as having a beauteous look as "with the coming of death or, say, with a Velasquez painting." Cage found in Duchamp someone who blurred "the distinction between art and life and produces a kind of silence in the work itself." Duchamp, who had met Cage in 1944, took the stage for several of the composers' performances, including the 1968 musical event *Reunion*. Onstage Duchamp and his wife Teeny played chess on an electrified playing board outfitted with contact microphones that amplified movements of the chess pieces and any other disturbance on its surface. Later that same year, Duchamp and his wife were honored by Cage's friends Merce Cunningham and Jasper Johns in the production of *Walk Around Time*, inspired by Duchamp's *The Large Glass*. Made in posthumous tribute to Duchamp in 1968 and named after a remark made by Johns, Cage created the artwork *Not Wanting to Say Anything About Marcel*, made up of verbal fragments, arrived at by chance, on sheets of plexiglas stacked in front of one another.[3]

But it was Duchamp's 1963 comprehensive retrospective held at the Pasadena Art Museum that put him back in the art world's spotlight. At the black-tie event he was treated like a hero, and Los Angeles socialites, artists, and collectors turned out to see the 114 works on display. Actor and art collector Dennis Hopper showed up with a stolen hotel sign that the aging dadaist gladly autographed.

Andy Warhol attended the Pasadena retrospective and conversed most of the night with Duchamp and his wife. Considered by art writer Calvin Tomkins as Duchamp's truest heir and pop art's most famous exponent, Warhol ventured from advertising into art during the heyday of neo-dada's breakdown between life and art and subsequently sought to remove the division between high art and the market. Son of a working-class immigrant family, Warhol made fame and money pop art's highest virtues.[4]

In contrast to Warhol, Duchamp lived simply, as though disinterested in fame, rejecting all isms except "eroticism," while covertly creating his last effort, *Étant donnés: 1. la chute d'eau/ 2. le gaz d'éclairage (Given: Maria, the Waterfall, and the Lighting Gas)*. Exploring Duchamp's contrariness, art critic Donald Kuspit wrote that in claiming to negate the creative process Duchamp was in fact "negating his negation by making art secretly." A member of the upper-middle class, Duchamp never had to earn an income from his art, and never wanting to be an "organized citizen and without having the "need — to draw morning, noon, and night," he lived modestly with "no luxuries."[5]

Owing much to Duchamp's conceptual art, Warhol embraced that which he found "boring," and he made its his goal to cross-fertilize the arts, to, as Wayne Koestenbaum explained, "transpose sensation from one medium to

another — to turn a photograph into a painting by silk screening it; to transform a movie into a sculpture by filming motionless objects and individuals; to transform tape-recorded speech into a novel." Warhol's reproduction of everyday objects, use of pop culture images, and focus for lengths of time, as he did in his films, on particular subject matter brought boredom into conceptual art. Duchamp, admiring Warhol's concept behind his soup-can paintings, commented that as retinal images they had "no interest," outside that fact that it was "the concept that wants to put fifty Campbell soup cans on a canvas" that made them of interest.[6]

In 1963 Warhol set up his New York base of operations, "the Factory," at 231 East 47th Street. Factory inhabitant Billy Name, influenced by New York gays, "design queens"— whose collecting fetishes turned their apartments into private galleries— decorated the Factory's all-silver space in paint, foil, and Mylar. Silver-wigged in his silver workplace, Warhol made art as pop music recordings played and a television, its sound turned off, flashed images. Curious outsiders were attracted by an open-door policy. Ginsberg admired the Factory's creative productivity, commenting, "I always thought it seemed to be a good project," while Burroughs had little to say about his host's company. Regulars, like Name, came from Judson Memorial Church, an alternative modern dance and "low-budget ballet" venue. Others hailed from the Village's infamous drinking spot the San Remo, while Harvard supplied youthful upstarts like Edie Sedgwick, and Factory amphetamine users, known as "Factory–A men," were primarily homosexual. Warhol shyly attended parties surrounded by his limousine-driven entourage — a bevy of youthful talent constituting the beautiful and the physically strange — and mingled with movie stars; evenings often ended in Greenwich Village nightspots.[7]

During the mid–1960s, tired of artistic processes requiring extensive hands-on creativity, Warhol turned to making experimental films. Factory visitors became his subjects. Ginsberg and his lover Peter Orlovsky, along with Kerouac and Gregory Corso, were featured in Warhol's *Couch* film series, three-minute short works (five hundred of these shorts were made) shot from a side angle while subjects sat on the Factory's couch. Duchamp took part in Warhol's twenty-minute film *Screen Test for Marcel Duchamp* (1966), which showed him seated, smoking a cigar. Beginning in 1963 Warhol made, with his Bolex camera, the films *Kiss, Haircut, Eat,* and the eight-hour *Sleep,* followed by *Blowjob* and *Tarzan and Jane Regained.* Warhol filmed daily, without concern that many of the reels would be lost, stolen, or never screened.

Warhol's creative purpose was to bring viewers a new awareness about life around them. Looking back on the decade, he stated, "we were the art exhibit, we were the art incarnate and the sixties were about people, not about what they did; 'the singer / not the song,' etc." But this assertion did not describe all the decade's most creative experimentalists, and Duchamp, surveying New York's pop art scene and its rapid output and marketed hype, lamented, "the great artist of tomorrow will have to go underground."[8]

The Living Theatre

Duchamp's and Cage's influence infiltrated 1960s experimental theater as well, notably the Living Theatre's Julian Beck and Judith Malina. Beck and Malina had met in the 1940s and, throughout their open marriage of tempestuous love affairs, founded the Living Theatre in 1951, a nomadic cooperative seeking man's salvation through pacifist utopian anarchism. From its early New York years the theater collective followed an underground evolutionary path that took it from obscurity to international fame. Part of the "New American Theatre" movement, the Living Theatre broke from Tennessee Williams' sexual-psychological drama and Arthur Miller's semisocial realism. Under Bertolt Brecht and surrealist Antonin Artaud's influence, Beck and Malina treated "symbols and interpretations of reality" and by abolishing the likable hero, explained Richard Kostelanetz, they removed all the "traces of sentimentality that unfailingly prompt heart-warming admiration."[9]

Beck — wearing bargain-shop clothes, thin framed, pale complexioned, his bald pate ringed with stringy hair — and Malina, outlandishly gypsy-looking, invited stares while interacting with a who's who of the New York music, art, and theater world. Readers of Stein, William Carlos Williams, and Brecht, Beck and Malina met stage designer Robert Edmund Jones and visited the institutionalized Ezra Pound. Bisexual and an aspiring avant-garde painter, Beck encountered in still charming 1940s Provincetown Tennessee Williams and a drunken Jackson Pollock, and for a time fell in with Peggy Guggenheim's salon. Meanwhile, Judith wrote poetry and drank at the infamous Village hangouts, the San Remo and Cedar Bar, meeting and making love to an array of men.

Oft-jailed anarchists, Beck and Malina foresaw in their nonviolent, free-love theater collective a new consciousness-raising force in abolishing all forms of government. Though seen by many young critics and theatergoers as a leading avant-garde group, the Living Theatre's act-in-the-moment experiments resulted in an artistically uneven output. Writer John Gruen commented that the Living Theatre's strength lay in its ability to "theatricalize" contemporary social-political elements and not with "working with trained actors" or staging classical plays. "Still," he argued, "they were an important force in American theater."[10]

In 1951 Beck and Malina's Cherry Lane Theatre opened in the Village on Commerce Street. There they staged Alfred Jarry's *Ubu Roi* and Gertrude Stein's *Doctor Faustus Lights the Lights*, which William Carlos Williams judged as being "so far above the level of commercial theater that I tremble it might fade and disappear." The Living Theatre also staged works by T. S. Elliot, and a surrealist farce by Picasso, as well as holding concerts by John Cage and David Tudor, and a Dylan Thomas poetry reading. After Cherry Lane closed in 1952, Beck and Malina occupied a loft theater at One Hundred Street until moving the

Living Theatre Playhouse to a former Fourteenth Street department store in 1958. This 162-seat performance space operated as a nonprofit avant-garde center, sponsoring stage productions, films, dances, one-man shows, and talks. After staging William Carlos Williams' *Many Lives* in 1959, Beck and Malina hosted poetry readings by Ginsberg, Corso, and Paul Goodman.[11]

Beck's vision of the theater was greatly altered with his reading of a 1958 Grove Press translation of Antonin Artaud's *The Theatre and Its Double* (1938). A French stage and film actor, poet, and playwright, Artaud had more followers in 1960s America than in Europe, and discussions of happenings or experimental theater were rare without mention of the French surrealist's name. A follower of Poe and of the occult — surrealism's "dark angel" — Artaud was a member of Breton's circle (1924–1927), and later spent nine years in mental asylums receiving electric-shock treatments until dying of drug addiction in 1948. *The Theatre and Its Double* contained several seminal essays—"The Theater and the Plague" and "Theater of Cruelty"—that appeared as "first manifesto" and "second manifesto." From Artaud's *The Theatre and Its Double*, John Cage explained that he "got the idea ... that theater could take place free of a text, that if a text were in it, that it needn't determine the other actions, that sounds, that activities, and so forth, could all be free rather than tied together."[12]

Indebted to Artaud and echoing Brecht, Pirandello, and O'Neill, Beck and Malina debuted Jack Gelber's play *The Connection* on July 15, 1960. A Charlie Parker-inspired "jazz play," *The Connection* depicts heroin addicts waiting for their connection, Cowboy. Confronted by characters in a play lacking a moral social theme, the audience (some of whom supposedly fainted during the performance) took on voyeuristic roles of looking in on the drug users, who are aware of being observed. Beck's murals of Egyptian pyramids and palm trees, illuminated by a single green light bulb, were hung on the back wall of the near-bare, dirty tenement stage set. A jazz quartet led by the play's music composer/pianist Freddie Redd and including noted hard-bop alto-saxophonist Jackie McLean, played to one side of the stage while occasionally engaging the actors. Attesting to the play's spontaneous spirit, McLean commented: "Some nights it would be about the musicians playing, and other nights it would be about the kinds of things that the actors got into. By the time we stopped playing it, we had forgotten what the original lines were, and I know they were better than in the beginning."[13]

Panned in New York's leading newspapers, *The Connection* subsequently found support in the *Village Voice* and *Partisan Review*. Despite its flaws, the production intrigued New York's theater crowd and found advocates in Lillian Hellman, Tennessee Williams, and Norman Mailer. In his first *New Republic* assignment, critic Robert Brustein heralded *The Connection* for giving New York its "first hipster drama" that stirred up a moribund commercial theater scene. Brustein recognized that it was "not probably a 'good' play by any stan-

dard we now possess to judge things"; but also asserted that "it lives in that pure, bright, thin air of reality which few of our 'good' playwrights have ever dared to breathe." One of Off-Broadway's longest-running productions, the play was made into an underground film by Shirley Clarke in 1962, and Freddie Redd recorded *Music from the Connection* for the Blue Note label (1960).[14]

Afterward, the Living Theatre interspersed its theater productions with poetry readings featuring Ginsberg, Corso, Paul Goodman, Kenneth Patchen, and Frank O'Hara, as well as performances showcasing Cage's music. By the early 1960s, while the anarchic collective moved further from conventional theater, its members began using LSD; they also listened to Indian music, and through Cage's influence, consulted the *I Ching*. Once more culling from Artaud, the Living Theatre's 1963 production of Kenneth H. Brown's *The Brig* (eventually made into an underground film by Jonas Mekas) was for John Tytell a Cage-like example of avant-garde stagecraft. Barbed wire strewn on the stage separated actors and audience; four sadistic guards screamed commands at incarcerated marines behind chain-link fencing. Following Artaud's concept that a play's director was free to change its text and presentation, Malina infused her own ideas—brutal sound images, repetitious rituals, and spatial concepts— that were considered by critics, even devout theatergoers, as formless.

Before the end of *The Brig*'s run in October 1963, the Internal Revenue Service shut down the Living Theatre for tax arrears, padlocking its Fourteenth street theater space. After illegally re-entering the theater and mounting a subsequent production of the play, Beck and Malina were arrested and sentenced to five years' probation. They then found exile in Europe, and when the Living Theatre returned for an American tour (1968–1969), it encountered a new counterculture, as they became heroes to Ginsberg and rock singer Jim Morrison.

Happenings

In a Greenwich Village hotel courtyard during the fall of 1962, artist Hans Richter and his friend Duchamp encountered a towering scaffold structure covered with black cardboard and plastic bags with a black dome. Around the tower moved nonactor-actors representing a new performance art, the happening. First staged indoors, these performance art events—known as happenings—ranged in size and content and were held in city streets, open lots, and even refuse piles.

Proto-happenings had their roots in Zurich dada, the German experiments of Kurt Schwitters and Max Ernst, and surrealist soirées. Often considered the first happening, Cage's Black Mountain College experiment in 1952 saw each participant assigned by chance method an activity that required no rehearsal, scripts, or costumes. At Black Mountain (near Asheville, North Carolina) the dining-room rafters were draped by Robert Rauschenberg's all-white paintings

and the half-black, half-white work of Franz Kline. On a stepladder, Cage read a Zen lecture followed by his reciting of the Declaration of Independence and the Bill of Rights, while Charles Olson and Mary Caroline Richards lectured. Merce Cunningham danced to David Tudor's piano accompaniment, and Rauschenberg played Edith Piaf records at double speed on a wind-up Victrola.

Out of the performance-art tradition and in the spirit of abstract expressionist action paintings and Neo-dadaist experiments came the happening. Tired of traditional gallery settings, Cage's former student, artist Allan Kaprow, founded the happening in a process that first saw him displaying paintings by adding atmospheric elements—found objects and visual and aural devices such as flashlights and sound effects. Around 1958 participants joined these events, not as conventional actors but nonprofessional volunteers, whose presence was equal to the production's props. Kaprow's first happening production, *18 Happenings in 6 Parts*, took place in 1959 and featured different unrelated performances that occurred in divided box-like spaces (e.g., "compartmented structures"). Kaprow's events provided participants with no scripts, only outline instructions, giving them freedom — as in the example of a participant instructed to push a broom though not confined to any particular way to do so— to carry out the role as they chose.

During the mid–1960s, modern art curator Henry Geldzahler attributed the happenings' vogue to a movement against the traditional theater's proscenium stage and the domination of literary themes and standard written dialogue — trappings that, for him, plagued most films as well. Geldzahler saw happenings as a new means of a primarily visual expression and considered them successful only through their imagery and the "carrying power of ... props, situations, costumes, and sequences. "In this," he argued, "they relate, perhaps nostalgically, rather more to silent movies with their forceful visual nonsense than to anything in the highly verbal Theater of the Absurd." Duchamp commented that he liked happenings "very much because they are something diametrically opposed to easel painting.... Happenings have introduced into art an element no one had put there: boredom. To do a thing in order to bore people is something I never imagined!" As he added, "it's the same idea as John Cage's silence in music; no one had thought of that."[15]

But the happenings creators did not all agree upon the purpose or underlying ideas behind this new aesthetic. Painter Jim Dine, whose *Car Crash* became a well-known happening, claimed that the term had little meaning: "It's Kaprow's word, and it does not refer to me. I do not know what it meant." For Dine the happening fused art and life — painting with everyday occurrences. First performed in galleries, gymnasiums, and lofts, happenings moved outdoors, as in the case of Claes Oldenburg's 1963 debut of *Autobodys* in a Los Angeles parking lot.

Unintended by Kaprow as a trivial pop form, happenings became so through media hype and created a flood of imitations. As Warhol later

recounted, "Almost every group event in the sixties eventually got called a 'happening'.... Happenings were started by artists, but the fashion designer Tiger Morse made them more pop and less art — by having fashion shows in swimming pools and just generally staging big crazy parties and calling them 'happenings.'"[16]

East Village Others

Happenings made their way into the newly christened "East Village," an ethnic neighborhood along and near Seventh Street between Avenue B and Avenue C that engendered a network of artists and bohemian-types. In 1961 an East Village store window displayed Robert Whitman's happening, *Mouth*, and Oldenburg's notorious *The Store* — part happening and part neo-dada was exhibited in a shop on Second Street. Oldenburg's *The Store*, commented Robert Hughes, was a "parody of an art gallery," a "low shop with low art in it" — displaying everyday objects made from "rags and papier-mache, all covered with shiny house enamel" — clothing and food "all unwearable, all absurd."[17]

Happenings shocked the East Village's ethnic residents — working-class Jews, Italians, Ukrainians, and Puerto Ricans. Since 1905 Slavs had called this area "Vostochnaya Derevnia," the East Village. When he arrived in New York City in 1949, an impoverished Andy Warhol, unable to afford Greenwich Village, resided on the Lower East Side. This influx of artists gained momentum by the early 1960s when an article with Jim Dine's photograph, captioned as "a well-known East Villager," gave the area hip cachet, as did articles in the *Saturday Evening Post* and the *Herald Tribune* in 1964. Real-estate developers advertised "bathtub-in-kitchen apartments" for twenty dollars a month under the sales pitch of "Join the Smart Trend." While some ethnic locals considered beat-types good for business, most detested them. Property owners and city inspectors played cat-and-mouse games with those living by the art of "scuffling" — setting up studios and lofts in tenements (illegal by city code), and evading rent, gas, and power bills.[18]

Earning a hip image once monopolized by Greenwich Village, the East Village, until the street riots of 1967, remained a multiethnic, racially diverse area. Hettie Jones, wife of beat poet LeRoi Jones, described it as a neighborhood "in the original sense of the word — not a place but the people who lived there." To Warhol the East Village, until it experienced open racial confrontations, "was, in a way, a very peaceful place, full of Europeans, immigrants, artists, jazzy blacks, Peurto Ricans — everybody all hanging around doorsteps and out windows." Even before violence flared on the streets, burglaries were common, muggings occasional. Among Slavs — Ukrainians, Slovaks, Russians — "the poorest and most visible," lived Puerto Ricans and a small number of Jewish and Irish families. Generally more affluent than their ethnic neighbors, bohemian types evoked their resentment, and criminals often targeted these youthful invaders for break-ins and burglaries.[19]

Yet the East Village allowed vital interaction between black and white artists, writers, and musicians whose experiments often overlapped with the independent theater and film scenes with the burgeoning beat poetry, jazz, and folk scenes. Home to what John Gruen called the "Combine Generation," this "New Bohemia" surfaced on the cusp of the hippie movement. The neighborhood's multistory tenements were, by the mid-sixties, home to six prospering off–Broadway theaters, collector's bookshops, paperback bookstores, and a music store. That same year, Ginsberg wrote to Ferlinghetti describing the East Village's "excitement, parties, tragedies, masterpieces in lofts, etc. Best thing in NY."[20]

Around 1963 East Village poetry readings were held at Le Metro Cafe on Second Street, where patrons drinking twenty-five-cent cups of coffee heard Ginsberg and Burroughs read, while on Mondays amateur readers with mediocre verse often tested their audience's patience. Readings soon moved into Second Street's St. Mark's-in-the-Bouwerie. Built in 1799 and the East Village's oldest building, St. Mark's Church, a center of avant-garde activity, resembled Greenwich Village's Judson Memorial Church. At St. Mark's Houdini had performed magic, Isadora Duncan had danced, and Frank Lloyd Wright and William Carlos Williams had lectured. St. Mark's 1966 programs included Joel Oppenheim's St. Mark's Poetry Project, jazz concerts, and Warhol's early films. Doubling as a community center, St. Mark's had a childcare project and a Black Panther breakfast program. Ginsberg, an East Village resident for nearly a half a century (his funeral service was held at St. Mark's in 1997), recounted that the East Village church was his "religious place" in the sense that "that's where my community was, my sangha, my peers."[21]

The growing popularity of St. Mark's poetry program evidenced how, as writer Ronald Sukenick explained, "The audience was getting bigger." Subsequently, through grants and funding, poetry programs became more organized and institutionalized and appeared on the college circuit, offering opportunities for artists to share the stage with poets and their accompanying musicians.[22]

At this same time, jazz musicians accompanied underground film scores, stage productions, and modern dance companies. While in the East Village and other parts of the city, "New Music" composers were booked into the same performance spaces as poetry readings, happenings, and experimental theater. Cage's pervasiveness in underground circles was such that by the mid–1960s he was considered "a classicist of the genre." An instructor at Greenwich Village's New School for Social Research (1956–1960), Cage influenced a vanguard of New Music composers whose music explored a greater sense of duration as they held multimedia concerts showcasing extended compositions based on a single note or drone.

Dedicated to this new musical conception, New Music composer La Monte Young joined with Yoko Ono in holding loft concerts at 112 Chambers Street,

a space rented by Ono. Composer of what he termed "trance music," the Idaho-born Young came to New York with a wealth of experience that crossed the frontiers of avant-garde jazz and New Music composition. Not long after, he was cofounder of a loose avant-garde artist collective, Fluxus, which merged out of a network created by the Chambers Street's performance series. As the founder of the Theatre of Eternal Music in 1964, he claimed to have composed music featuring only one enduring chord, a "hypnotic continuum" with no beginning and no end. Most of New Music composers, like Young, put great demands on listeners. Because the New Music did not pursue rock's onstage energy and eroticism and was devoid of dance rhythms, it was already apparent in the mid–1960s that its composers' esoteric sounds would not become the emerging counterculture's defining music. Yet among rock musicians and their most adventurous listeners, New Music composers, including Edgard Varèse who died in 1965, attained small-cult followings, influencing pop-oriented performers from San Francisco to London.[23]

* * *

Experimental music and art were discussed and advertised in underground magazines— voices of protest and radical politics. One of the most prominent, the *East Village Other*— the district's "answer to the *Village Voice*," founded in October 1965 — eventually attained a circulation of 32,000. The magazine's founders, Walter Bowart and Don and Allan Katzman, decorated psychedelically their second-floor office in the Village Theatre and produced a paper that they considered a work of art and a means of supporting the avant-garde. R. Crumb provided comic strips, Ishmael Reed reported on neighborhood violence, Ginsberg urged every healthy person over fourteen to take LSD, and Burroughs discussed the media's reporting of drug use. One of its many covers satirically depicted Cardinal Spellman, while another showed Maharishi Mahesh Yogi on a box labeled "Instant God." Under police and FBI surveillance (it once printed a poster of J. Edgar Hoover), the *EVO* experienced an office bombing and a forced-entry search by Food and Drug Administration agents.[24]

In 1963 Ed Sanders, a Kansas City–born "erotic provocateur" poet and activist, established a publication of neo-beat consciousness. When Sanders came upon Ginsberg's Howl in a University of Missouri campus bookstore in 1957, it completely altered his conception of life and literature. Later, while attending New York University, he frequented Village poetry readings at Mac-Dougal Street coffeehouses, the Cafe Figaro and the Gaslight. Living in the East Village in 1962, Sanders printed the first issue of his underground magazine at the office of the *Catholic Worker*, horrifying its proprietors with the publication's name: *Fuck You/A Magazine of the Arts*. Between 1962 and 1966 the magazine published poems, stories, plays, essays calling for marijuana's legalization, and writings by Mailer, Burroughs, Ginsberg, and Orlovsky. Sanders

distributed underground material out of his Peace Eye Bookstore. On the façade of this former Jewish butcher shop on East Tenth Street, Sanders painted, around its "Strictly Kosher" sign, two Egyptian eyes of Horus. From this unconventional outlet, Sanders sold beat literature and made such underground films as *Mongolian Group Grope* and *Amphetamine Head*.[25]

In 1964 Sanders, Ken Weaver, and New York–born poet Tuli Kupferberg formed the subversive folk-rock group the Fugs, whose profanely erotic lyrics — their "total assault on culture" — gained them a cult following. As a 1940s Brooklyn College student, Kupferberg had worshipped T. S. Elliot; in Greenwich Village he read beat coffeehouse poetry. For Kupferberg, like Sanders, the reading of "Howl" was revelatory.[26]

Literary-minded, Sanders and Kupferberg had never liked rock and roll music. But in an East Village club they witnessed the mesmerizing effect the new rock had on a dancing Ginsberg (Kupferberg claimed their revelation occurred while watching dancers at the East Village rock club, the Dom). Drawn to this newer sound they formed the Fugs, a term taken from Mailer's *The Naked and the Dead*. With the exception of Weaver, who had been a drummer in high school, the band had no musical training. In their extolling untrained, raw creativity, the Fugs envisioned a "new artform principle," fusing creativity and life in a "future," as Sanders emphasized, "where people, everyone, will do all kinds of creative things" without a "formal education to paint, to sing, to write, to dance."[27]

A "tell it like it is" attitude pervaded the Fugs' music. In the liner notes of the Fugs' 1966 eponymous album, Ginsberg wrote that the group "came to tell the truth that was only dreamy till they opened their mouths for Whitmanic orgy yawp!" A writer for *Avant-Garde* magazine observed: "The charisma of the Fugs is certainly not their sound. Their music is not distinguishable from the dozens of other well-known electric storm troupes"; rather it was their lyrics that set them apart. Among their provocative songs were "Dirty Old Man," "Jack Off Blues," "I Feel Like Homemade Shit," and "Kill for Peace," and they set to music and song the works of Sappho, Blake, Pound, and Ginsberg.[28]

While Fugs lyrics shocked, New York City's electric rock experimenters, the Velvet Underground, took a similar noncommercial stance, selling few records in their short-lived association. Founded by New York–born college students — guitarists Sterling Morrison and Lou Reed, drummer Maureen Tucker, and Welsh-born multi-instrumentalist John Cale — the Velvet Underground performed in the underground film scene and by 1966 played Greenwich Village's Café Bizarre until being fired for playing unconventional material.

After hearing the Velvets at Café Bizarre, Warhol, who described them as "musical sadists," became the band's producer; he bought them equipment, had them rehearse at the Factory, and encouraged the addition of singer Nico, the German model and chanteuse. The Velvets culled their proto-punk fashions, lyrics, and theatrical elements from New York's demimonde. In April 1966

Paul Morrisey brought Warhol to a former East Village recreation center, the Dom, on St. Mark's Place. Warhol rented the Dom (Polish for Home) and launched his Exploding Plastic Inevitable (E.P.I.), a multimedia extravaganza of film, music, dance, and lights. Spotlights, projectors, and strobes were brought from the Factory to the high-ceilinged Dom. Under a revolving mirror-ball's shimmer, dancers, barraged audio-visually, displayed fashions of vinyl, feathers, meshed tights, bellbottoms, and miniskirts. Accompanying the band, Gerard Malanga improvised a whip dance; two films—one by Warhol, another by Paul Morissey—were projected on the wall, making for an act that film impresario Jonas Mekas described as "the most violent, loudest and most dynamic exploration platform for this new art."[29]

Most closely associated with the European musical avant-garde, the Velvet's John Cale had studied with Greek composer Iannis Xenakis under a Bernstein Fellowship. He performed with La Monte Young and took part, as one of the rotating pianists, in John Cage's 1963 concert of Satie's *Vexations*—a short theme piece "to be played eight hundred and forty times"—at the University of California, Davis. Outfitted with guitar strings, Cale's electric viola brought a new instrument into rock music. Modernist literary influences entered the group through Lou Reed, who had earned a B.A. in English literature and philosophy from Syracuse University. An avowed realist, Reed gravitated, as did many of his generation, to existentialism, and his instructor, poet and critic Delmore Schwartz—whom he called "the unhappiest man" and "the smartest man" he ever met, until meeting Warhol—introduced him to Dostoyevsky's *Brothers Karamazov* and Joyce's *Ulysses*.[30]

At Syracuse Reed met literature student and Velvet Underground guitarist Sterling Morrison, with whom he shared an interest in rock music. Reed, an avant-garde jazz fan, named his college radio show after a 1959 Cecil Taylor composition, "Excursion on a Wobbly Rail." He often followed Ornette Coleman around Greenwich Village, and his eclectic tastes extended to R&B, rock, and Bob Dylan, and as an aspiring songwriter and poet, his aim was to be the Kurt Weill of rock and roll. Reed's heroin-tinged lyrics, starkly urban and implying sadistic violence, were a realist's response to the tough city streets; as Reed commented, "Faulkner had the South, Joyce had Dublin, I've got New York."[31]

In the several months of their extended Dom engagement, the Velvets' performances and press write-ups made the East Village a local attraction for the "mink coat people" in search of a hip new scene. Unlike Warhol, the Velvet Underground accrued only a cult following, and in the decades to come, the band's brooding intensity and their black-leather, heroin-chic image helped lay the foundations of another subversive counterculture.

California's Musical Rainbow

Geography, climate, and rebellious temperament differentiated early 1960s

youths of New York's artistic avant-garde circles and California's "Left Coast" that ignited another and more pervasive counterculture. In comparing New York City to northern California, novelist Bob Stone commented that coming west "was like going from black and white to Technicolor." Another Californian set herself apart from the New York beats by stressing, "We weren't sitting around in black turtlenecks, smoking Gauloises and talking about existentialism.... We were partying ... running around the beach or mountains."[32]

Pockets of activity thrived in the Bay area. In Palo Alto, near the Stanford campus, St. Michael's Alley was "a classic" bohemian coffeehouse. Kepler's Bookstore in Menlo Park, novelist Ed McClanahan noted, was "incredibly more hip than any other store," in that it stocked literary quarterlies, political publications, radical magazines, and nudist material. Roy Kepler's patrons spent hours reading Kerouac, Joyce, and Henry Miller, discussing issues, while musicians like Jerry Garcia performed acoustic music. Kepler's regulars rented rooms or lived out back in automobiles, at artist Frank Serratoni's spacious residence "the Château," a way station for those on their way to Big Sur or Berkeley, where jug wine and marijuana enhanced nights of folk or jazz music.[33]

Down the road from Kepler's, a short walk from campus across the Stanford golf course, bohemians gathered at Perry Lane, a block-long string of turn-of-the-century cedar-shake cottages, surrounded by oak and eucalyptus trees and outlying meadows. Known for decades as "Sins Hollow," this "Left Bank of Stanford" with "its lunatic fringe" had by the 1950s evolved into a close-knit student and faculty community who sat on the cottage floors drinking Chianti and smoking the "dread devil's weed."[34]

Perry Lane was soon transformed by the arrival of budding young novelist Ken Kesey. An Oregon University graduate, football player, and wrestling champion, Kesey enrolled in Stanford's creative writing program on a Woodrow Wilson Fellowship. Kesey had acted in the University of Oregon's theater productions in Eugene and had then stayed in Hollywood for a time, hoping to establish an acting career. He found inspiration in Marlon Brando's films and counted himself among the avid readers who had stumbled "out of the mid-century murk of Hemingway's sad suicide and [the death of] Dylan Thomas." At the University of Oregon, Kesey would often air over the Beta Pi house's loudspeaker an album of recited poetry by Rexroth, Ginsberg, and Ferlinghetti. But it was Kerouac's On the Road that freed him from the conception of the solitary writer working at his desk, cut off from the world outside.[35]

Kesey's physicality, witty intelligence, and a logger–Okie manner impressed fellow students, and he lived in one of Perry Lane's larger cottages and wrote in a gardener's backyard cottage shed. He grew a beard, strummed a guitar, and ate his first marijuana brownie. In 1959 Kesey turned Perry Lane's marijuana parties into psychedelic drug gatherings, supplied by substances he obtained through his weekly volunteer experimental sessions at the Veterans

Administration Medical Center in Menlo Park. Kesey later boasted that it was the U.S. Government that first "turned him on" to psychedelics. With confiscated VA Hospital, CIA-funded drugs, he introduced participants to various psychedelics served in venison chili and punch. Though some of the Perry Lane residents had read Aldous Huxley's *Island* and were aware of surrealist painter Joan Miró's experimentation with mescaline, most had little knowledge of psychedelics. As novelist Bob Stone recounted, "We were young and thought we were incredibly sophisticated and bohemian to be doing all this far out stuff."[36]

His participation in the VA experiments having ended, Kesey, while working in the hospital's psychiatric ward and under psilocybin's influence, drew pictures of patients and began his first novel, *One Flew Over the Cuckoo's Nest* (1962). Not long after starting the novel, Kesey befriended the legendary Neal Cassady. Known to locals as the "King of San Francisco" and by the North Beach police as "Johnny Potseed," the handsome blue-eyed Cassady added another dimension to Kesey's circle. Called "Chief" by Cassady, Kesey named his beat companion "Speed Limit" for his spastic dances and rapid weaving of words— with quotes from Proust and Melville, the Bible, street talk, prison jargon, and car and women fetishes, all sounding to Kesey like "*Finnegans Wake* played fast forward."[37]

Cassady's presence linked the beat spirit with a new "dissent minority," among whom literary readings were still common. At these gatherings, Kesey read his Faulkner-influenced writing, while Larry McMurtry and Bob Stone shared their modernist realism, and Vic Lovell read Henry Miller–influenced stories. As Stone recalled, "Hemingway bestrode the world then, inescapable"; Fitzgerald, Dos Passos, Faulkner, and Wolfe were indispensable influences as well. Many had an affinity for Henry Miller. "Kerouac had read Miller, and both had lived at Big Sur," recalled Ed McClanahan. "Henry Miller loomed large."[38]

Perry Lane's artistic comradeship ended with its demolition in 1963. That summer Kesey moved his family to La Honda in San Mateo County. Fifteen miles from Palo Alto and miles from neighboring houses, Kesey's log cabin and six acres of land in La Honda were ideal for louder and bolder experiments. Two large outdoor speakers projected Gregorian chants, the late Beethoven quartets, Ornette Coleman's Free Jazz, Rahsaan Roland Kirk's multi-instrumentalism, and Bob Dylan's ballads reverberated over grounds of Day-Glo painted redwood trees and rocks. For Kesey these activities represented near-religious experiences, and upon looking back on La Honda, he recalled, "I don't think what came out of the sixties could have come out of any other place. It has to have trees; it has to have natural solitude, kind of an Oriental Zen–like" atmosphere.[39]

Though Kesey had vowed never to assume a leadership role, he became a kind of leader/nonleader. "Ken went to the brink of letting a cult form around

him," explained McClanahan. "He backed off being leader, but there was ambiguity in that. He had to have it his way. But when someone showed signs of hero worship he'd drop them like a hot potato." Kesey's later assertion that "either you're on the bus or off the bus" implied that the participants had a choice — either they could participate in his spontaneous experiments or face being cast out of his circle. Kesey's statement implicitly meant, according to Bob Stone, "some who were physically on the bus were not actually on the bus in spirit ... that millions were off the bus, but the bus was coming for them."[40]

Despite his leadership aversion, Kesey attracted a following — the Merry Pranksters, a name given to the La Honda circle by his Perry Lane companion Ken Babbs, a former marine helicopter pilot. Kesey's circle engaged in a lifestyle of sex, drugs, and rock and roll in the years preceding the hippie counterculture. In 1963 he envisioned an artistic flowering, a "Neon Renaissance" that included avant-gardist Ornette Coleman, new wave filmmakers, Lenny Bruce, writers William Burroughs, Joseph Heller, and Gunter Grass, and Rahsaan Roland Kirk, whom Kesey claimed "was up there with Neal Cassady, and Lord Buckley as one of the great teachers of the trip."[41]

His second novel, *Sometimes a Great Notion* completed, Kesey took the money he had earned from his work and purchased movie cameras, recording machines, and musical instruments to make multimedia and film experiments. The Pranksters' LSD-inspired consciousness intensified their dada-like chance encounters, and in this live-in-the-moment aesthetic, Kesey constantly reminded his circle that "art is not eternal." He fused his Nietzschean creative superman persona with his comic-strip heroes, often appearing in superhero garb. The Pranksters' pre-hippie college student look was colorfully enhanced with Day-Glo paint and American flag wear, cut-up, or draped like blankets, or worn as hats.

In 1964 Kesey's Pranksters set out to visit the New York World's Fair and to be present when Viking published *Sometimes a Great Notion*. Purchasing a 1939 International Harvester bus, the Pranksters decorated it; Kesey painted blindfolded, others by brush, broom, hands, and feet. "It all seemed like a natural progression," recounted Kesey. "Right from Kerouac and a car — a small sedan with six people — to a bigger bunch of people. It seemed part of the same drama, and we had been accepted into it by the old gunfighters — the real heavies of our mythologies, Kerouac, Cassady, Ginsberg."[42]

The Pranksters traveled through the Southwest and the Deep South, and then in New York they attended the World's Fair. Through Ginsberg they met a brooding, alcoholic Kerouac, who shared none of his poet friend's enthusiasm for the LSD-animated westerners. The Pranksters then attempted to meet with the East Coast's famed promoters of psychedelic drugs, Timothy Leary and Richard Alpert, at the 4,000 acre Millbrook estate in upstate New York. At Millbrook Leary had founded the League for Spiritual Discovery, insisting that psychedelic drug use be conducted in a controlled environment as in a reli-

gious ceremony.* The League for Spiritual Discovery had never seen anything like the Pranksters as the bus entered Millbrook in a smoke bomb's green haze. But Leary, in the midst of a private session when the Pranksters arrived, was unable to meet them, and the bus traveled westward through the Canadian Rockies and back to La Honda.

Back at La Honda Kesey and the Pranksters held Acid Tests; events begun with a handful of participants that soon drew crowds. At these all-night events, still-legal LSD was distributed in vats of Kool-Aid. Acid Tests were multimedia experiments with light shows—including music often played by Kesey and other Pranksters—and shaman-like voices over loudspeakers. First encountering Kesey at La Honda, the Grateful Dead (formerly the Warlocks), a Bay Area band, became the Pranksters' house band. The Acid Tests, held between 1965 and 1966, soon culminated in the 1966 Trips Festival. Organized by Zack Stewart, Stewart Brand, and Ramon Sender, the festival featured Bay Area rock bands and an evening of the Pranksters' sound experiments. During January 21–23, the Trips Festival, supposedly promoted as a "drug-free event," drew about ten thousand people to San Francisco's Longshoremen's Union Hall on Fisherman's Wharf. The Trips Festival's LSD was covertly supplied by Berkeley chemistry major and underground druggist Augustus Owsley Stanley III, who helped make San Francisco a major capital for the now-illegal psychedelic drug (LSD was outlawed on October 6, 1966). Supplied by Owsley, Kesey sought new rituals for a new generation.

Kesey's vision of a worldwide LSD awakening did not foresee 1967's Summer of Love, when thousands converged on San Francisco, making it a mass-media magnet. Keeping his distance from the hippies, Kesey informed San Francisco's Haight-Ashbury counterculture that it was time "to graduate from acid" and seek new avenues of experience. Believing that his role in the experiment had reached its apex, he announced that "a certain point" had been reached in the drug culture and that people "were not moving any more ... that's why we have to move on to the next step." Facing the California Superior Court on drug charges in the spring of 1967, Kesey confounded most listeners when, as the *East Village Other* reported, he explained that "acid, meaning LSD, is a door that can be used to go into another room. People I saw going through this door ... going through that door, and not into this room." Like a father figure betraying his extended family, Kesey, who received hate mail for his statements, sensed a shift in American life, but he also feared, as thousands of young people flocked to California, the possible failure of what he had envisioned as a psychedelic revolution.[43]

* * *

**Leary's Harvard experiments included participation and assistance from Ginsberg, who helped dispense psilocybin pills to leading creative individuals, including Willem de Kooning, Franz Klein, Thelonious Monk, Kerouac, and Burroughs.*

Before the media covered Kesey's escapades, young artist-types came west under the beats' influence. In *The Dharma Bums* (1958) Kerouac's Japhy Ryder (beat poet Gary Snyder) was not a bohemian, but a sage in the "rucksack revolution," living in nature, reading Whitman, studying and translating Chinese and Japanese literature, engaging in meditation, and championing the Native American. Unashamed of nudity, Japhy practiced free love and lived ascetically in a small cabin near the University of California's Berkley campus. Japhy tells Ray Smith (Kerouac) that Dharma Bums refuse to work away their lives just to buy "all that crap they didn't really want anyway ... general junk you finally always see a week later in the garbage anyway."[44]

Japhy's message had equivalents in the strident voices of literary elders Kenneth Rexroth and his friend Henry Miller. In *The Air-Conditioned Nightmare* (1945), Miller attacked nearly every aspect of American life, its dystopian industrial society guided by a failed Christian faith. Miller's move to Big Sur profoundly changed him, and seemingly having made amends with his native country, turned into a "transcendental optimist, a Whitman not among the corpses," wrote Richard Rurald and Malcolm Bradbury, "but among the flower people."[45]

In San Francisco young people influenced by writers critical of postwar America attempted to establish a utopian urbanism that writer and playwright Paul Goodman, author of the cult classic of youth alienation *Growing Up Absurd* (1960), had long been advocating. Anticonsumer, and anticapitalist, those who came to be called Hippies, fused a back-to-the-earth sensibility with psychedelic drug use; they wore long hair, articles of Native American dress, and non–Western–influenced, brightly colored fashions and prints. Spurning alcohol, their parents' substance of choice, youths turned to the beat staple of marijuana, then various psychedelic drugs and music that in both its volume and lyric content offered the possibility of alternative psychic experiences. Hippies, embracing art and life, looked to avant-garde elements as they took part in free-form happenings and light shows and danced to rock music featuring extended improvised solos influenced by the jazz avant-garde.

Surveying the San Francisco scene, music critic Robert Christgau wrote "Pot is one of the two adhesives that bind the truly disaffiliated to the teenie-boppers with ironed hair and the aging twenty-seven-year old rebels. The other is music." "The new pop," emphasized Christgau, "has an avocational fascination for them all, from the graduate Beatlemaniacs to the mourners of John Hurt and John Coltrane."[46]

The San Francisco scene, as it had nearly a decade before, birthed a counterculture that was imitated nationwide. In 1965 *San Francisco Examiner* journalist Michael Fallon coined the word "hippie"—an African-American jazz term once used to describe would-be white hipsters—for members of the Haight-Ashbury scene. A forty-four block area, once known during the late nineteenth century as "Politicians Row" for its fine Victorian homes built by

some of its leading political and business families, the Haight district became home to beats like Ferlinghetti, McClure, and Snyder. In a pattern of traditional bohemia, inexpensive rents and its proximity to Golden Gate Park brought creative people, making the district's hardware, paint, and grocery stores and its once-genteel wood-framed houses, the heart of a new counterculture.

Jazz musicians, folk musicians, and artists living in the Bay area prompted the establishment of coffeehouses and small clubs. Over time the Haight became a refuge for those escaping police harassment in North Beach, and in 1960 the Blue Unicorn became the district's first North Beach–style coffee shop. By 1965 UC Berkeley dropouts and former North Beach residents made up nearly half of the refugees who came to the Haight, or what the hippies called the "Hashbury," a bohemian community that boasted thirty "hip shops" and scores of new folk-based electric rock bands.

Not long after the 1966 Trips Festival, Bill Graham, a New York promoter, former actor, and business manager of the San Francisco Mime Troupe, held concerts at the Fillmore, a second-story, seatless ballroom in the African-American Fillmore District. When Graham had first held fund-raising concerts in November 1965 for the San Francisco Mime Troupe (featuring the Fugs, Jefferson Airplane, Ferlinghetti, and modern jazz saxophonist John Handy), he saw the potential of music concerts to attract the local counterculture. At the benefit concerts, light-show artists worked with 8mm cameras and pigment oils, using bed sheets for screens—sound and light performances that Graham envisioned as a form of "Living Theatre" where "space was magic."[47]

Initially, Graham's musical tastes leaned toward jazz and Latin music, and his concerts—eclectic mixes of acid rock, blues, modern jazz, and theater— also booked Ginsberg and brought to the stage McClure's controversial play *The Beard*. To broaden the musical horizons of the young rock crowd, he featured modern jazzmen like drummer Elvin Jones and New York saxophonist Charles Lloyd, the practitioner of "psychedelic jazz." Vibraphonist Gary Burton was billed with Electric Flag and Cream. Lenny Bruce performed with Frank Zappa and the Mothers of Invention. In 1967 Rahsaan Roland Kirk and the Afro-Haitian Ballet troupe were billed with Jefferson Airplane, and Jimi Hendrix headlined on a show with Hungarian gypsy guitarist Gabor Szabo.

In the Fillmore's "total environment," dancers lost themselves in moving meditation. A Berkeley student-writer recounted that dancing at the Fillmore changed his life—"not a big thing, but part of the change that is upon us all." Inside the Fillmore's Victorian rococo-style interior (where, according to singer Grace Slick, one felt that "seven centuries" of fashions and designs had been "all thrown together into one room"), lights made bright spots on the floor. Dancers freely expressed themselves in "Fox-trot, Polka, schottische, Cha/cha Cha, Ballet whirls, and gymnastic exercises. Bunny-hop and waltz, fragments of all those dances with-a-name like Gulley and Camel and Twist, and lots of touches or trips from modern dance."[48]

Freeform dance, rock music, and light shows intensified psychoactive drug use, making the Fillmore and other San Francisco venues—like Winterland (an ice arena) and the Avalon—atmospherically different from New York venues. In *Rock of Ages*, Geoffrey Stokes emphasized that "New York had had 'happenings' long before San Francisco had its first 'be-in,' but even when audiences became part of the action, happenings were still performances.... There was still an organizing intelligence, an avant-pop theatricalism.... By contrast, the be-ins and acid tests were events that reflected the tolerant, open let's see what happens San Francisco formula." Forty-nine In 1968 Graham opened the Fillmore East in New York, and by booking bands between his two venues he linked the spirit of the Haight with his new East Village venue on Second Avenue (formerly the Village Theater).

Products of its dancehalls, San Francisco's leading rock bands epitomized the LSD experience and provided a geographic location identifying what became known as "acid rock." San Francisco bands like the Jefferson Airplane, The Grateful Dead, and Big Brother and the Holding Company set the tone of the Bay Area's counterculture. Rock album covers and magazine articles spread the vogue for wearing Native-American headbands, beads, fringed-leather coats, and long hair.

Psychoactive drug use intensified freeform dance and thus encouraged rock musicians to lengthen songs into trance-like numbers with longer solos and drone-like electric sounds. Its immediacy and volume drew large crowds, making music the new counterculture's predominate art. Folk, country, and electric blues were catalysts for much of "the San Francisco Sound." Extended solos and group improvisation also looked to traditional Middle Eastern and Asian Indian music, as exemplified by the Grateful Dead's drummer, Mickey Hart, who eventually studied at the San Francisco's Ali Akbar College of Music with tabla master Shakar Gosh. This opening up or "loosening" of rock music forms also took inspiration from New Music composers. The Grateful Dead's bassist Phil Lesh, a former trumpeter, worshipped Charles Ives, immersed himself in the music of Schoenberg and Stockhausen, and at Mills College (Oakland) mixed tapes for Italian composer Luciano Berio. The Jefferson Airplane listened to Varèse's recorded compositions, and they met, as did members of the Grateful Dead, composer Karlheinz Stockhausen when he taught for six months during 1966–1967 at the University of California, Davis, and the San Francisco Tape Center.

Though less conspicuous an influence on acid rock than folk and blues, modern jazz inspired the increasing use of improvisation. Throughout the sixties, despite jazz music's nadir in popularity, California remained, like New York City, a place open to its experimenters. During the late 1950s, the Los Angeles jazz scene nurtured musicians like Ornette Coleman and Eric Dolphy. In the following decade, Miles Davis played at San Francisco's Blackhawk and Shelly's Manne-Hole in Los Angeles, a club regularly advertised in the under-

ground paper *The Los Angeles Free Press*. Davis and Coltrane appeared at the Monterey Jazz Festival, where a young Jerry Garcia and his beat-attired Palo Alto crowd attended the saxophonist's performance in 1961. At this time, Jefferson Airplane's drummer Spencer Dryden heard the Coltrane quintet perform with drummer Elvin Jones "My Favorite Things" at a night-club and was so moved that he left the establishment in tears. Big Brother's guitarist, James Gurley, attempted to "play guitar like John Coltrane played sax.... That's what I was trying to do— of course nobody understood it, especially me."[50]

The Grateful Dead exemplified the blended folk and electric blues with modern jazz elements as they emphasized extended improvisation. Phil Lesh had studied music formally, and under the influence of modern jazz he wrote compositions for the San Mateo College jazz band. Though one listening to the Dead's mid–1960s music "would be hard pressed," as Garcia's biographer noted, to find direct elements of Davis or Coltrane, "the group was definitely inspired by the questing spirit of jazz contemporaries: the great jazz willingness to abandon form and structure in search of wondrous new avenues of self-expression." And it would not be long until the Dead broke from rock's standard four-four time signature by performing numbers like "The Eleven," played in eleven-four time.[51]

To give voice to the musical avant-garde, the emerging rock sound (before bands landed recording contracts), and local issues, San Francisco's FM radio station, KMPX, became a vital alternative media source, a model for "underground" stations nationwide. Before KMPX's founding in 1967, most San Francisco music aficionados, like those generations before them, listened primarily to records discovered by a word-of-mouth network. Tired of "yammering" radio commercials and dull formats, adventurous young listeners gathered at parties and in bedrooms to listen to non–Top Forty recordings. KMPX — "Radio Free Ashbury" housed in a building near the waterfront — brought in listeners through the efforts of its hulking 350-pound program director and deejay, Tom Donahue, by presenting a wide variety of music and broadcasting lengthy album selections, unreleased music tapes and test pressings. It featured live broadcasts of the Dead from Winterland, interviews, and analytical antiwar discussions. Though it eventually incorporated more standardized commercials, KMPX was devoid of mainstream deejay "cute remarks," and it mixed rock cuts with the playing of Ravi Shankar, Bach, jazz, and music concrete.

By way of the Haight's talented designers of neo-art noveau and Beardsleyan-style poster art, the West Coast psychedelic aesthetic had its imitators across the country. To bring a voice to the new counterculture and its various groups and events, San Francisco produced an underground paper, the *San Francisco Oracle*. Founded by writers and artists as a black-and-white publication in October 1966, the *Oracle*, a year later, converted its pages into "dazzling four-color swirls and mind-blowing visions of mandalas, Indians, women, sex, and

art noveau underbrush" that had a circulation of 50,0000. Responsible for spreading the cult of Native American ecological values, the *Oracle* was described by one journalist "as a mind-flash mag to end mind-flash mags, voice of Haight-Ashbury, and one of the loveliest things ever done on newsprint." Sold to residents and tourists, the paper's content included an eighteen-page conversation (transcribed from tape) between Ginsberg, Leary, Snyder, and Alan Watts.[52]

The Haight was a community experiment stemming from a beat anticapitalist ethos—one that advocated art and culture as the major forces behind radical social change. Eventually members of the San Francisco Mime Troupe joined the Diggers, an anarchistic organization named after the seventeenth-century radicals who emerged during the English Civil War. Well aware that fashion and lifestyle were easily imitated and co-opted by the market, the Diggers' activities avoided this trap by basing their activities entirely upon a nonprofit basis. Echoing Pierre-Joseph Proudhon's nineteenth-century anarchist belief that "property is theft," the Diggers "were saying," related actor-member Peter Coyote, "that anybody who used money was a fucking fascist pig." Fusing anarchist politics with communitarianism, the Diggers advocated the free sharing of food, shelter, education, medical and legal services, and music concerts. Like nineteenth-century Fourierist Phalanxes, the Diggers' Free Cities, guided by Paul Goodman's urban utopianism, were to be made up of diverse groups, including the Black Panthers, and would interlock with free farms that would supply the rural and urban populations. Propagandists of the benevolent deed, the San Francisco Diggers made meals daily from donated food in their communal kitchens, which were served in Panhandle Park. In their free stores (both white and black outlets), no participant was allowed to take credit for any of the activities; there was to be no media publicity of any kind. "From our point of view," explained Coyote: "freedom involved first liberating the imagination from the economic assumption of profit and private property, that demanded existence at the expense of personal truthfulness and honor, then living according to personal authenticity and fidelity to inner directives and impulses. If enough people began to behave this way, we believed, the culture would invariably change to accommodate them and become more compassionate and more human in the process."[53]

Through the efforts of Brooklyn-born Eugene "Emmett" Grogan, a lithe, red-haired, and blue-eyed "life actor par excellence," the Diggers held numerous spontaneous events that aimed, like the 1930s agit-prop theater of the left, at transforming mass consciousness. The Diggers held the 1967 Haight parade "Death of Money"—that saw participants carrying coffins decorated with dollar signs—and the Fillmore-sponsored "Roll Your Own, Stone Your Neighbor," in which, despite Graham's protests, bricks of marijuana were placed over coals and the smoke blown through cardboard tubes.

L.A. Freak-out

The Diggers' legacy would be short-lived, and their goals subverted by the very commercialization they abhorred. In the more commercial and ever-expanding Los Angeles—captured in the L.A. pop art of David Hockney and Ed Ruscha — a sense of performance art had been in the air. Following Claes Oldenberg's first outdoor happening, *Autobodys* in 1963, set in a local park-inglot, were those orchestrated by Alan Kaprow — *Fluids* (1967) — and Judy Chicago—*Multi-Colored Atmosphere* (1970). At a time when L.A. was vying to become America's "second city of art," elements of experimental theater shaped its local rock bands' stage sets and performance styles as did beat poetry and the musical avant-garde.[54]

In the capital of cinematic dreams, home to major record companies, Los Angeles' alternative youth communities also contrasted with those of San Francisco in that they were spread out across its environs and defined by the wearing of glam fashions. By 1964 Los Angles was host to new coffeehouses and nightclubs on the Sunset Strip — such as the Trip and the Brave New World — catering to people wearing long hair, paisley shirts, and Nehru jackets, as well as the Whiskey A Go Go (modeled after a Parisian nightspot).

On the Sunset Strip were numerous commercial psychedelic shops that the older beat-influenced set despised as "efforts to commercialize the movement." Eventually hippies flocked to West Hollywood's Jewish neighborhood centered on Fairfax Avenue, a place of psychedelic shops, bookstores, and coffeehouses with candle-lit tables. Los Angeles was also home to the decade's first underground weekly newspaper, the *Los Angeles Free Press* (known as "the Freep"), dedicated to free, left-wing political debate. Founded by socialist and former die-maker Art Kunkin in 1964, the magazine, modeled on the *Village Voice*, varied in content with each edition and eventually expanded to 40–64 pages. It balanced news about ecology and local civil-rights or civil-liberties issues with informative discussions of composers from Varèse to Harry Partch to Coltrane to underground filmmakers and the literary avant-garde.

Home to a number of influential rock musicians, the L.A. scene produced many creative individuals who came of age reading beat literature. L.A.'s the Doors amalgamated various musical and literary influences and cultivated a dark sound contrasting with the hippies' beatific pacifism. Kerouac's *On the Road* inflamed the imaginations of Doors singer Jim Morrison and keyboardist Ray Manzarek, prompting the latter to leave his native Chicago for California. "I suppose if Jack Kerouac had not written *On the Road*," recalled Manzarek, "the Doors would never had existed. It opened the floodgates and we read everything [by the beat writers] we could get our hands on." As a high-school student Morrison read Joyce's *Ulysses* and *On the Road* remained one of his favorite books. Identifying with Kerouac's fictionalized Cassady-inspired rebel, Morrison often quoted the novel's closing lines: "I think of Dean Moriarty, I even

think of Old Dean Moriarty the father we never found, I think of Dean Moriarty."[55]

Enamored with Kerouac's work, Morrison found revelation in reading "Howl." "Allen Ginsberg made me realize that I needed to be a poet," opined Morrison, and the beats "not only made writers of us, they saved our lives" and "gave us permission to find our own voices." Coming of age in the pre-hippie era, Morrison, like Dylan, found, in college off-campus hangouts beats and folk-music followers. At St. Petersburg Junior College in 1961, he discovered the beat-influenced Contemporary Arts Coffeehouse, where, in the midst "of beat poet/bongo combos," he improvised words while playing a ukulele. There he watched foreign new wave films, and Robert Frank's beat classic *Pull My Daisy*. Affecting an odd artist look, Morrison later attended Florida State University wearing long hair and lens-less steel-rimmed glasses.

In 1964 Morrison entered the University of California at Los Angeles' theater-arts program. At the time, he considered Ginsberg, Kerouac, and Joyce his inspirational trinity in a pantheon of heroes that also included Nietzsche and French symbolist poet Arthur Rimbaud. As literary scholar Wallace Fowlie explained, Rimbaud "was a rebel whom Morrison admired, whom Morrison studied and on whom to some extent he modeled himself." The poet's call for the "derangement of the senses" by imbibing absinthe and hashish no doubt captivated Morrison, who saw himself as embarking on his own alcoholic season in hell. "A legendary figure re-creates himself," explained Fowlie. "This was the accomplishment of Jim Morrison, who had only a film student's knowledge of Rimbaud [and] Nietzsche.... Singing for Jim was the creation of poetry and music and the creation of characters on stage."[56]

Yet as a student Morrison considered film "as the closest approximation in art that we have to the actual flow of consciousness, in both dream life and everyday perception of the world." Fusing elements of modern film, poetry, living theater, and music, Morrison conceived a sexually alluring performance style backed by a band of diverse musical influences. One of Morrison's poet heroes, Ginsberg, expressed that "the way beyond the page is music!" Through rock music, Morrison, like Dylan, took up Ginsberg's clarion call. The Doors took their name from Aldous Huxley's *Doors of Perception*, a title the author took in turn from Blake's poem that asserted, "If the Doors of perception were cleansed, everything then would appear to man as it truly is, infinite." Morrison's reading of modern poets included Hart Crane, and a line from the poet's "Praise for an Urn" (from *White Buildings*, 1926) provided the title of the Doors' classic "Riders on the Storm." Céline's 1934 novel, *Journey to the End of the Night*, inspired the song "End of Night." Morrison's interest in Bertolt Brecht led him to include a Doors' version of the German playwright's 1928 work, *The Rise and Fall of the City of Mahogany*, inspiring an *East Village Other* reporter to write, "the Doors reiterated the German expressionist message of the 20's for the hippies of the 60's."[57]

As a college student Morrison also read the English translation of Antonin

Artaud's *Theater and Its Double*, emphasizing that each performance should be a form of risk. Morrison broadened his Artuad-influenced vision through his contact with the Living Theatre (he participated in Beck and Malina's 1969 San Francisco performances of *Paradise Now*). His self-published book of poetry, *The Lords* (1969), hinted at performances as alchemic events: "The happening is introduced into a roomful of people.... Its agent, or injector, is the artist-showman who creates a performance to witness himself. The people consider themselves the audience, which they perform for each other, and the gas acts out poems of its own through the medium of the human body." For Morrison the most immediate effect of his performance art was to help free his audience from America's chief social evil, sexual repression.[58]

Upon the Doors' formation in 1965, Morrison fulfilled his role as singer-performer; his lyrical influences were rooted in bluesmen like Howlin' Wolf, and he modeled his phrasing on Frank Sinatra. Avid modern-jazz fans, Manzarek and the band's drummer, John Densmore, revered Davis and Coltrane. Like the L.A.-based rock group the Byrds, which scored a 1966 hit with "Eight Miles High," dedicated to John Coltrane, the Doors too displayed the tenor saxophonist's influence. Their 1967 hit "Light My Fire" has a two-chord solo-section that Manzarek attributed to Coltrane's eighteen-minute-long title track from the saxophonist's 1961 album *Ole*. Drummer John Densmore credited his playing on "Light My Fire" as echoing Miles Davis' three/four composition "All Blues" from the 1959 album *Kind of Blue*. Devout in his youthful allegiance to modern jazz, Densmore frequented Los Angeles jazz clubs to hear Cannonball Adderly, Bill Evans, and Art Blakey. "Some kids went to the movies for release," commented Densmore, a devotee of Coltrane's drummer Elvin Jones. "We found jazz. Coltrane and Miles Davis seemed to us the culmination of twenty years of jazz. This was where we got religion."[59]

* * *

Whereas the Doors benefited from Morrison's charisma and sexual persona, Frank Zappa led a Los Angeles–based band of unattractive rock iconoclasts, the Mothers of Invention. A composer whose instrumental works were conducted by Pierre Boulez and Zubin Mehta, Zappa's music was indebted to the New Music composers and the European avant-garde. Aware of dada and the work of John Cage, Zappa's ultimate goal was "to do things that would shake people out of their complacency, or that ignorance that makes them question things." As a teenager Zappa acquired Varèse's recording of *Ionization* (1931), and when he turned fifteen his parents agreed to his birthday request to make a long-distance phone call to the composer's Greenwich Village home. Eventually, he also came to admire Stravinsky, Webern, and Boulez. In 1963 he appeared, clean-cut in suit and tie, on the Steve Allen Show demonstrating the art of "cycophony" by playing drumsticks on the spokes of a spinning bicycle wheel while accompanied by the studio's orchestra.[60]

During his southern California teenage years, Zappa identified with greaser toughs, Italian immigrants, Mexican Americans, and blacks, with whom he played in high school bands. He favored rough urban blues over the "slick playing" of B. B. King and favored early doo-wop over the surf-band harmonies and guitar-twang instrumentals. In his music Zappa interspersed the electric blues of Howlin' Wolf and guitarists Johnny Guitar Watson and Eddie Jones, aka Guitar Slim — "the smuttiest" blues player he ever heard — with modernist composers like Varèse and themes gleaned from comic books and horror movies. Zappa's musical ideas were a collision of highbrow and lowbrow sources, and his music engulfed listeners in an electric wall of sound. Within compositions of varied rhythmic meters and complex erratic melodies were pastiches of fifties doo-wop, spoken word segments — dada vocal noise and soft-pornographic talk — and Zappa's social-political commentary delivered in television announcer-like parody.[61]

Working simultaneously as a composer and lyricist, Zappa abhorred love songs and "overwritten rock poetry"; he once admitted that "he hated poetry quite a bit" and seldom read. In his rejection of love lyrics and romanticism's emotive aesthetic, Zappa looked to his hero Igor Stravinsky, who believed music "was not the correct vehicle for emotional expression"; he paid tribute to the composer with his group the Mothers of Invention's 1969 instrumental pieces "Igor's Boogie — Phase One and Phase Two." Zappa, like Duchamp, believed writing to be "almost obsolete" and that the meanings of words were so easily corrupted that writing could never fully convey one's true meaning. Zappa looked upon himself as a nonsinger and a writer of what he referred to satirically as deliberately "stupid" lyrics — "Lizard King Poetry" (obviously a derogatory stab at Jim Morrison), vocalizations he considered necessary in attracting an audience for his unique brand of progressive rock music.[62]

Behind its pop-oriented aspects, Zappa's music, premised upon a sound-for-sound's sake principle, had avant-garde sources derived from Stravinsky, Varèse, and Cage. Believing his music devoid of emotional value, Zappa proclaimed himself a "psycho-acoustical" practitioner, constructing his art by way of lineal and harmonic relationships. For Zappa, art existed inside a frame in the sense that an artist decides the boundary — the physical parameters of a sculpture, painting, or the measured space on a recording tape. Written music and its recorded sounds were uses of space that he described as "air shapes," with molecular structures occupying greater "air space." These musical "air shapes," contended Zappa, were frames for sounds and do not become music until someone wills them to be music. He emphasized that "If John Cage, for instance, says 'I'm putting a contact microphone on my throat, and I'm going to drink carrot juice, and that's my composition; then his gurgling qualifies as his composition because he put a frame of reference around it and said so."[63]

Beyond his work as composer, instrumentalist, and performance artist, Zappa took on the role of satirist, lambasting the Great Society and its

middle-class "plastic people." Zappa also ridiculed rock heroes, and singer Grace Slick (another listener of Varèse) fondly recalled how the Mothers of Invention's leader "made fun of the very counterculture he was helping to sustain." When first encountering a Mothers' concert poster that showed Zappa, "pants around his ankles," sitting on a toilet, she was shocked because it appeared at a time when, as she explained "San Francisco artists were creating posters with pictures of flowers, fair maidens, and placid Indian gurus." Zappa often joked that he led the ugliest band in the business, and he detested teen idol groups and mocked the Beatles for creating the vogue for moptop haircuts and band uniforms (during the early sixties he resented having to play their music as a requirement for finding nightclub work). The Summer of Love in 1967 and its concurrent music festivals seemed to him a commercialized carnival affair. His 1967 LP *We're Only in It for the Money* satirized the Beatle's *Sgt. Pepper's Lonely Hearts Club Band*, and its cover depicted the Mothers in drag along with figures like Beethoven, Lee Harvey Oswald, Lyndon Johnson, and J. Edgar Hoover.[64]

In a decade when youth decried conformity, Zappa, leading the Mothers of Invention from 1965 to 1969, struggled to attain a large audience; his albums sold well but never attained the sales volume of more commercial rock groups. Yet Zappa remained ambivalent about the music marketplace and ironically sought to attract a large audience by making what he labeled "anti-commercial" music. He embraced "weirdness for weirdness' sake," and without attractive band members the band symbolized the essence of a 1960s "freak scene." Through his music, Zappa hoped to tap into a stratum of non-hippie youths who resembled, in dress and behavior, the band's odd assortment of L.A. groupies, or "freaks." But as he asserted, "We couldn't reach the people who needed to hear us. Radio stations wouldn't play us—even 'underground' stations."[65]

The Mothers of Invention further separated themselves from a mass audience by breaking from the standard blues/R&B/rock instrumental format: guitar, rhythm guitar, bass, piano, and drums, fronted by a singer (horns optional for larger ensembles). Instead, Zappa incorporated compositions that featured non-four/four rhythms and employed instruments unknown to the rock idiom, such as vibes and electric violin. By way of band members like multi-instrumentalist Ian Underwood, elements of modern jazz made their way into the band, as exemplified by Zappa's composition "Eric Dolphy Memorial Barbecue." Critics at the time often linked Zappa's improvisational approach to avant-garde jazzmen like Archie Shepp. Though he had listened with interest to the recordings of Ornette Coleman, Cecil Taylor, and Eric Dolphy, Zappa rejected his supposed link to jazz: "It's foolish, every time you hear someone improvise, to assume that it's jazz.... I mean, is John Cage's music jazz?—much of it is improvised."[66]

The band's performances—immersed in cross-gender images, S&M, and

sexual fetish themes—in many ways resembled happenings and paralleled the Living Theatre's experiments. In dadaist tradition Zappa insulted his audience and ridiculed their drug use that he despised as needless escapism. But to his frustration, the underlying social-cultural messages of his parodies and cynical skits, intended to inspire young people to question their society, were largely ignored, as was the complex music behind the satire and insults.

Never having embraced the counterculture's optimism, Zappa believed early in the decade that it would most likely give rise to a new conformist mentality, "a whole new set of fads." The two-fingered peace sign was, for him, nothing more than a fashionable symbol displayed by youths who, not long before, had been "sticking up one finger." Not long after the Woodstock Festival in 1969, he conceded that "revolutionary things were happening in rock, but most of what passes as revolutionary is an ad man's notion of revolution — tawdry stuff." With regard to social change he admitted that "some real basic changes" had occurred but asserted that "no matter what they wear, the bulk of the kids in the U.S. continue to think as their parents do," and will "drink beer and watch baseball games on TV."[67]

Epilogue

Routinely outrunning the police on his motorcycle in Haight-Ashbury, Hunter S. Thompson realized by 1966 that the free and easy life of the district was about "to come to a bad end at any moment." That same year, a neighborhood police crackdown attracted press publicity. Blacks, sometimes called "spades" by the Haight's hippies, had never been completely welcome in the neighborhood, and in 1967 a black drug dealer in San Francisco, "Super Spade," was found murdered.

By the summer's end, the Haight had been transformed and became a tour-bus attraction — a drive through "Hippyland" — billed as "the only foreign tour within the continental limits of the United States." Opposed to thrill seekers and invading "plastic hippies," original Haight residents mourned their district's transformation, and that October about one hundred of them gathered at daybreak in Panhandle Park for a mock funeral, as pallbearers carried an open casket bearing the words "Hippie, Son of the Media." That same year, Haight residents experienced an increase in amphetamine and heroin use.[1]

Along with drug overdoses, rapes were frequent, and venereal disease and hepatitis became rampant. Poor housing and the overflow of invaders turned a low-rent district into a slum. A 1968 *Newsweek* article, "Where Are They Now?," examined the exodus of thousands that left storefronts either boarded up or empty. The famous Psychedelic Shop had closed, the *Oracle* failed, and the Grateful Dead had long since left the neighborhood. A few thousand hippies remained, along with throngs of junkies, local hoods, bikers, uprooted poor blacks, and teenyboppers.[2]

In New York, drugs were also prevalent in the East Village; by the summer of 1967 teenage bicycle-runners were delivering illegal substances door to door. That year, another *Newsweek* article, "Trouble in Hippieland," described violence in the East Village. In 1968 discontented Puerto Rican youths clashed with hippies and police in what became known as the Tompkins Square Riot. By trying to establish a utopia in poor ethnic neighborhoods, the hippie invaders did not recognize the plight of their fellow urban neighbors, and they did not mix well with the ethnic poor and the working-class Hispanics who considered

the hippies' "squatter's rites" as an unwanted invasion their neighborhoods. Assessing the East Village scene, social commentator and jazz critic Nat Hentoff commented, "You have to be either insensitive or terribly naive to expect to move to a slum and stay free of the effects of that slum. And you can't expect not to exacerbate the feelings of the people who already live there." Addressing the youth invasions and increasing violence in Greenwich Village and Haight-Ashbury, Hunter S. Thompson believed it came down to "the basic futility of seizing turf you can't control." The East Village and the Haight's meteoric decline exemplified the age-old bohemian problem of how the media's exposure had helped ruin urban "utopias" and, in the case of the sixties counterculture, converted millions of suburban youths into pseudo hippies.[3]

* * *

As the counterculture changed perceptions of youth lifestyles, it also impacted upon the popular conception of art. In the *East Village Other* Don Katzman announced commercialism's triumph over the avant-garde. "There is no doubt," he wrote in 1967, "that Art has become a business and that the mystique that once was the 'avant-garde' is no longer valid."[4] If would seem that the avant-garde's war with convention went Warhol's way — that the making of money had become synonymous with creating art.

Just as the 1960s popularized a way of life once known only among a marginal population, the decade also experienced a realignment and reinterpretation of the avant-garde. During the last half of the twentieth century, scholars and critics diversely viewed the avant-garde and bohemia as either having passed into history* or as experiencing at various points of time lull and rebirth. To those who have pronounced the death of the artistic avant-garde, its demise came after World War II when private collections and corporate sponsorship made it into a commodity, when it was co-opted by museums and universities. This corporate and institutional acceptance of modern art, according to many scholars, resulted in its demise as a force for radical social change. Art critic Donald Kuspit has asserted that in pop art's wake a pseudo avant-garde emerged motivated by fame and money, stripped of its therapeutic catharsis linking the viewer and creator via the latter's connection to a revelatory primal impulse. According to Kuspit, the attempt to make the avant-garde into a commodity and its creators into celebrities destroyed its cathartic power once thought to be crucial by the early moderns and their successors.

But, as embraced by the hippies, Warhol's dictum that "anybody can do

*In the 1980s, Ronald Sukenick, resident of the postwar World War II West and East Village, considered bohemia as an ongoing tradition under different guises and titles. For Herbert Gold, who experienced firsthand various 1960s American and European bohemias, this alternative way of life is a living legacy. In Bohemia: Where Art, Angst, Love, and Strong Coffee Meet (New York: Simon & Schuster, 1993) Gold wrote: "What came blowing in the wind is still eddying about us. Americans may not have been greened but they have been boheemed."

anything" spread the democratization of art. This process, emboldened by the emphasis on poststructuralist studies in the universities, attempted to remove hierarchies and the notion of high art, and thus in effect sought to invalidate Van Wyck Brooks' distinctions between highbrow and lowbrow art, with one cultural study being entitled *No Brow*. This ahistorical anti-intellectualism has even alarmed social critic Camille Paglia, who, warning of the overindulgence in rapidly moving imagery as eclipsing interest in more stationary symbols and objects, wrote: "Thanks to postmodernism, strict chronology and historical sweep and synthesis are no longer universally appreciated or considered fundamental." In recent decades, rock, techno, and rap have become American youth's dominant art forms, and despite, some innovations among these pop forms, their domination has resulted in a disconnection from the artistic avant-garde. Proudly spurning the value of books, Ann Powers, a pop culture writer discussing bohemia's so-called resurrection described her eighties generation as seeing "the roughneck paperback poets of the Beat Generation as playing to an elite. But rock and roll," she argued, was "invented by entertainers as interested in money as in art," sold their music to "teenagers who would rather dance than read."[5]

The trend in comparing rebellious-looking popular entertainers with experimental artists glosses over what constitutes a true artistic underground. In a similar trend, efforts to link bohemia's simple way of life dedicated to art (often linked to criminality) with upper-class fashion blurs the distinctions between the avant-garde and popular culture. These well-to-do wearers of "hip" fashions, who David Brooks christened "Bobos," and live in "Latte Towns," upscale liberal communities often located near universities or in former bohemian areas. These "Bobo" enclaves, wrote Brooks, "have become crucial gestation centers for America's new upscale culture." But Brooks' wealthy middle-age hipsters have nothing in common with bohemians or the wealthy art connoisseurs whose salons played vital roles in the promotion and creation of avant-garde art. It would be more accurate to see this new set as fashionable mimics of rebellious rock and film stars, tattooed sports heroes—millionaire "anti-types" exemplifying Warhol's superstars, the combination of wealth and celebrity. In an era when "hip" elderly couples wear matching black leather outfits in trendy shopping malls, rebellious fashion seems a shallow way of making a serious "statement."

Similarly, much of what passes for bohemia on college campuses today is no more than posturing in relaxed, tolerant environments where, as at the local mall, black leather and dyed hair are the norm. Yet college campuses have been important meeting spots—and its dropouts rife for bohemia. Some writers have largely assumed that the sixties subverted the traditional avant-garde, or at least played a significant role in its co-optation or transformation. This process, according to historian Russell Jacoby, scattered the counterculture and the older avant-gardists and public intellectuals, who left bohemia for the comforts of

university life as urban gentrification raised the rents of older bohemian quarters, which caused the last counterculture holdouts to flee.

While Jacoby's assessment certainly pertains to late-twentieth-century urban bohemias like Greenwich Village, it does not take into account places where new countercultures may arise. For bohemia can flourish in any urban area where rents are low and its residents revere art and the freedom of lifestyles. Bohemia arises organically in a coming together of disaffected artists, not from the attempts of developers and urban planners to replicate, theme-park-like, what once was the creation of artists, a process that makes for what serious artists would only consider repulsive and unaffordable.

What Jacoby also does not take into account is that in the past, bohemians and young artists benefited from their proximity to college campuses, like the 1910s 57th Street Colony located near the University of Chicago. At the University of Pennsylvania, William Carlos Williams met Ezra Pound and H.D. (née Hilda Doolittle); Harvard produced a vanguard of 1930s moderns; Columbia University's campus provided the meeting ground for the beat circle; and in general universities brought together sixties radicals and cultural rebels.

Yet, without viable artistic presence, urban countercultural areas may resemble slums more than places of creative activity. Bohemia's founders were like pilot fish who set the initial tone for alternative communities, and their unique gatherings drew outsiders and potential patrons. For unknown serious artists serving apprenticeship periods outside the market and without grants or monetary backing, there were times when living frugally in less desirable neighborhoods was a necessity in creating their work. Once a way station for artists on the way to notoriety or success, bohemia has subsequently come to define a state of mind rather than a way of life. Thus, one must differentiate bohemia by choice and bohemia by circumstance. Never meant as a lifelong pursuit, bohemia has been made into a stance or fashion, a hip posturing that sometimes makes its way into the corporate meeting room.

This study has looked into how artistic avant-gardists and their supporters formed or influenced countercultures and ultimately mainstream culture, which copies its values, as well as its aesthetic surroundings, symbols, and even myths. It is neither the role of the historian to predict, nor is it the aim of this book to declare the end of artistic countercultures or the avant-garde. Rather, it is to delineate and assess the past. New cyber worlds, home-recording studios, and other technologies offer new opportunities in a new century. If it appears that the battle for art went Warhol's way, we may best take Duchamp's advice: "the avant-garde artist of tomorrow will have to go underground."

Chapter Notes

Preface

1. William Burroughs, *Junkie*, 1953. 3rd printing. (New York: Ace Books, 1973), 19.

2. Renato Poggioli, *The Theory of the Avant-Garde*. Translated by Gerald Fitzgerald (New York: Icon Editions, 1968), 27–40.

3. Adelle Heller and Lois Rudnick, *1915, The Cultural Moment: The New Politics, the New Woman, the New Psychology, the New Art, the New Theatre in America* (New Brunswick, NJ: University of Rutgers Press, 1991), 8.

4. Roger Shattuck, *The Banquet Years: The Origins of the Avant-Garde, 1885 to World War I*, rev. ed. (New York: Vintage Books, 1968), 25.

Chapter I

1. Jerrold Seigel, *Bohemian Paris: Culture, Politics, and the Boundaries of the Bourgeois Life, 1830–1930* (New York: Penguin, 1987), 23.

2. W. Scott Haine, *The World of the Paris Café: Sociability Among the French Working Class, 1789–1914* (Baltimore: Johns Hopkins University, 1996), 2–3.

3. Honore Balzac, *The Works of Honoré de Balzac, The Member of Arcis, The Seamy Side of History, and Other Stories*. Introduction by George Saintsbury. (Philadelphia: Avil Publishing Co., 1901), 214–215.

4. Henry Murger, *Scènes de la Vie de Bohème*, 1905 2nd ed. (New York: Howard Fertig, 1984), xxxvii, xliii.

5. Thomas Mann, *Death in Venice and Seven Other Stories*. 1930. (New York: Vintage Books, 1963), 14; Murger, *Scènes de la Vie*, xxxvi, xl.

6. Henry David Thoreau, *Walden and Other Writings*, ed. Joseph Wood Krutch, 1854 (New York: Bantam, 1962), 173, 115.

7. Van Wyck Brooks, *The Flowering of New England 1815–1865* (New York: Modern Library, 1936), 203.

8. *Selected Writings of Ralph Waldo Emerson*, ed. William H. Gilman (New York: Signet, 1965), 262, 263.

9. *The Selected Writings of the American Transcendentalists*, ed. George Hochfield (New York: New American Library, 1966), xxvii.

10. Ronald G. Walters, *American Reformers 1815–1860* (New York: Hill & Wang, 1978), 51–53.

11. *The Heart of Emerson's Journals*, ed. Bliss Perry (New York: Dover Press, 1937), 198.

12. Nathaniel Hawthorne, *The Blithedale Romance*, 1852 (New York: W. W. Norton & Co., 1958), 46.

13. Haine, *Parisian Cafe*, 17–28.

14. William Makepeace Thackeray, *Vanity Fair: A Novel Without a Hero*, 1847–1848 (New York: Signet, 1962), 769.

15. Thackeray quoted in *Thackeray in the United States, 1852–3, 1855–6, Vol. 1* (New York: Dodd & Mead & Co., 1904), 258.

16. Enid Starkie, *Baudelaire* (New York: New Directions, 1958), 215, 216; Baudelaire, *Painter of Modern Life and Other Essays* (New York: Da Capo, 1964),72; Kenneth Silverman, *Edgar A. Poe: Mournful and Never-ending Remembrance* (New York: Harper & Collins, 1992), 183; Seigel, *Bohemian Paris*, 113.

17. Henry Clapp Jr., "A New Portrait of Paris: Painted from Life," *The New York Saturday Press* (January 8, 1859), 18; David S. Reynolds, *Whitman's America: A Cultural Biography* (New York: Vintage Books, 1996), 320, 376.

18. George G. Foster, *New York in Slices* (New York: printed and rev. by author, 1849), 9, 76–79.

19. Christine Stansell, "Whitman at Pfaff's: Commercial Culture, Literary Life and New York Bohemia at Mid-Century," *Walt Whitman Quarterly Review* (Winter 1993): 133; William Dean Howells, *Literary Friends and Acquaintances: A Personal Retrospect of American Authorship* (New York: Harper & Brothers, 1900), 72–73.

20. *The New York Saturday Press* (January 8, 1959), 1; quoted in Albert Parry, *Garretts and Pretenders: A History of Bohemianism in America* (New York: Covici, Friede, 1933), 43; William Dean Howells, *Literary Friends*, 70, 74.

21. David S. Reynolds, *Beneath the American Renaissance: The Subversive Imagination in the Age of Emerson and Melville* (New York: Alfred A.

Knopf, 1988), 208; ibid., David S. Reynolds, *Whit-man's America: A Cultural Biography* (New York: Alfred A. Knopf, 1996), 377–378.

22. Stansell, "Whitman at Pfaff's," 112; Clara Barrus, *Whitman and Burroughs as Comrades* (New York: Houghton Mifflin Co., 1931), 2; Justin Kaplan, *Walt Whitman: A Life* (New York: Simon & Schuster, 1980), 243; Edwin G. Burrows and Mike Wallace, *Gotham: A History of New York City to 1898* (New York: Oxford University Press), 710, 796.

23. *Women in American Theater: Careers, Images, Movements, an Illustrated Anthology and Sourcebook*, ed. Helen Krich Chinoy and Linda Walsh Jenkins (New York: Crown, 1981), 81–82.

24. Stansell, "Whitman at Pfaff's," 112; *Gotham*, 796.

25. Stansell, "Whitman at Pfaff's," 109; *Gotham*, 711; Don Carlos Seitz, *Artemus Ward (Charles Farrar Browne): A Biography and Bibliography* (New York: Harper & Brothers, 1919), 98–99; Emily Hahn, *Romantic Rebels: An Informal History of Bohemianism in America* (Boston: Houghton Mifflin, 1967), 10.

26. E. M. Allen quoted in *Whitman and Burroughs*, 1; Reynolds, *Whitman's America*, 375; Gay Wilson Allen, *The Solitary Singer: A Critical Biography of Walt Whitman* (New York: New York University, 1955), 230, 269–270; Jerome Loving, *Walt Whitman: The Song of Himself* (Berkeley: University of California Press, 2000), 233.

27. Quoted in Paul Zweig, *Walt Whitman: The Making of a Poet* (New York: Basic Books, 1984), 264–265.

28. *Thackeray in the United States*, 48; Foster, *New York in Slices*, 43–46.

29. Reynolds, *Beneath the American Renaissance*, 465; Walt Whitman, *Leaves of Grass*, 1855, Rpt. ed. Malcolm Cowley (New York: Penguin Books, 1959), vii.

30. Horace Traubel, *With Walt Whitman in Camden: July 16–October 31, 1888; January 21–April 7, 1889*, ed. Sculley Bradley (Carbon-dale: Southern Illinois University Press, 1959), 375.

Chapter II

1. Patrick Morrow, *Bret Harte* (Boise, ID: Boise State College, 1972), 9.

2. Quoted in Ken Burns, *Mark Twain*, film documentary, Florentine Films, 2001.

3. Nigey Lennon, *The Sagebrush Bohemian: Mark Twain in California* (New York: Marlowe & Co., 1993), 65.

4. Andrew Hoffman, *Inventing Mark Twain: The Lives of Samuel Langhorne Clemens* (New York: William & Morrow, 1997), 96; Mark Twain, *Mark Twain: Roughing It*, 1872, rev. ed. Leonard Kriegel (New York: Signet, 1962), 310.

5. *Critical Essays on Ambrose Bierce*, James Nagel, general ed., (Boston: G. K. Hall & Co., 1982), 63.

6. Bierce quoted in Kevin Starr, *America's California Dream, 1850–1915* (New York: Oxford University Press, 1973), 273.

7. Scott A. Shields, *Artists at Continent's End: The Monterey Peninsula Art Colony, 1875–1907* (Berkeley: University of California Press, 2006), 4.

8. *Thackeray in the United States*, 300–301.

9. Ronald G. Pisano, *The Tile Club and the Aesthetic Movement in America* with essays by Mary Ann Apicella and Linda Henefield (New York: Harry S, Abrams Inc. Pub: 1999), 88–90; quoted in Lloyd Goodrich, *Winslow Homer* (New York: Whitney Museum of Art with Macmillan Co., 1944), 60–61. Quoted in Pisano, *The Tile Club*, 54.

10. Quoted in Pisano, *The Tile Club*, 54.

11. G. William Domhoff, *The Bohemian Grove and Other Retreats: A Study in Ruling-Class Cohesiveness* (New York: Harper and Row, 1975), 53.

12. Ruskin quoted in James Abbott McNeill Whistler, *The Gentle Art of Making Enemies*, rpt. of the 1892 2nd ed. (New York: Dover Publications, 1967), 1.

13. Reynolds, *Walt Whitman's America*, 539; Richard Ellmann, *Oscar Wilde* (New York: Vintage Books, 1988), 167–172.

14. Ambrose Bierce: *A Sole Survivor, Bits of Autobiography*, ed. S. T. Joshi and David E. Schultz (Knoxville: University of Tennessee Press, 1998), 192–194; Mary Warner Blanchard, *Oscar Wilde's America: Counterculture in the Gilded Age* (New Haven: Yale University Press, 1998), 14–19.

15. Theodore Child, "Proletarian Paris," *Harper's New Monthly* (January 1893), 188,191; Ernest Hemingway, *A Moveable Feast* (New York: Bantam Books, 1965), 3.

16. George du Maurier, *Trilby* (New York: Harper & Bros., 1894), 121.

17. Du Maurier, *Trilby*, 76.

18. Parry, *Garrets and Pretenders*, 106; quoted in Betsy Israel, *Bachelor Girls: The Secret History of Single Women in the Twentieth Century* (New York: William Morrow, 2002), 110–12.

19. Howells, *Literary Friends*, 216–217.

20. James Huneker, *Steeplejack* (New York: Charles Scribner's Sons, 1925), 11; Arnold T. Schwab, *James Huneker: Critic of the Seven Arts* (Stanford: Stanford University Press, 1963), 49.

21. Christine Stansell, *American Moderns: Bohemian New York and the Creation of a New Century* (New York: Metropolitan Books), 22.

22. Quoted in "My Button," *Jewish Chronicle*, June 1892, essay reprinted in *Master of Hope: Selected Writings of Naphtali Herz Imber*, ed. Jacob Kabakoff (Toronto: Associated University Press, 1985), 209; quoted from "Two Ships and Two Riots A Leaflet of My Life," *The American Hebrew*, September 12, 1902, in *Master of Hope*, 74.

23. Jacob Riis, *How the Other Half Lives*, 1890 (New York: Hill and Wang, 1957), 60. Quoted in Gary Schmidgall, *Walt Whitman: A Gay Life* (New York: Plume, 1998), 105.

24. Quoted in *Stephen Crane's Career: Perspectives and Evaluations*, ed. Thomas A. Gullason (New York: New York University Press, 1972), 161;

Stephen Crane, *Maggie* in *Stephen Crane Prose and Poetry* (New York: The Library of America, 1984), 21.
26. Quoted in Linda H. Davis, *Badge of Courage: The Life of Stephen Crane* (New York: Houghton Mifflin, 1998), 56.
27. Arthur Symons, *The Symbolist Movement in Literature*, 1899 (New York: E. P. Dutton, 1958), 2.
28. Robert M. Crunden, *American Salons: Encounters with European Modernism, 1885–1917* (New York: Oxford University Press, 2001), 22.
29. "The Ten O'Clock" in *The Gentle Art of Making Enemies*, 142.
30. Shattuck, *The Banquet Years*, 18–19.
31. Fenollosa quoted in Lawrence W. Chisholm, *Ernest Fenollosa: The Far East and American Culture* (New Haven: Yale University Press, 1963), 173.
32. Estelle Jussim, *Slave to Beauty: The Eccentric Life and Controversial Career of F. Holland Day, Photographer, Publisher, Aesthete* (Boston: David R. Godine, Pub., 1981), 46, 48; *The Photographic Work of F. Holland Day*, ed. Ellen Fritz Clattenburg (Wellesley, MA: Wellesley College Museum, 1975), 10–11.
33. Holbrook Jackson, *The Eighteen Nineties: A Review of Art and Ideas at the Close of the Century*, 1923. (New York: Alfred A. Knopf, 1927), 46.
34. Quoted in Sidney Kramer, *A History of Stone & Kimball and Herbert S. Stone & Company with a Bibliography of Their Publications, 1893–1905* (Chicago: Norman W. Forgue, 1940), 42.
35. Seigel, *Bohemian Paris*, 26; Burgess quoted in Clarence A. Andrews, *Chicago in Story: A Literary History* (Iowa City: Midwest Pub. Co., 1982), 83; Stephen Schwartz, *From West to East: California and the Making of the American Mind* (New York: Free Press, 1998), 127–129.
36. Menken quoted in Joseph Horowitz, *Wagnerian Nights: An American History* (Berkeley: University of California Press, 1994), p. 288; Huneker, *Steeplejack*, 189.
37. Quoted in Schwab, *James Huneker*, 95.

Chapter III

1. Henry James, *The Ambassadors*. 1903. New York: Penguin, 1986, 215.
2. Henry F. May, The End of American Innocence: A Study of the First Years of Our Own Time, 1912–1917 (New York: Columbia University Press, 1992), 249.
3. Tom Quirk, Bergson and America: The Worlds of Willa Cather and Wallace Stevens (Chapel Hill: University of North Carolina Press, 1990),44.
4. May, *End of American Innocence*, 219–220, 328.
5. Schwab, *James Huneker*, 107–108; Horowitz, *Wagner Nights*, 292.
6. Quoted in Schwab, *James Huneker*, 234–
235; quoted in H. L. Mencken's *Smart Set Criticism*, ed. William H. Nolte (Ithaca: Cornell University Press, 1968), 203–204
7. Richard O'Connor, *Jack London: A Biography* (Boston: Little, Brown & Co., 1964), 122; Alex Kershaw, *Jack London, A Life* (New York: St. Martin's Press, 1997), 131.
8. Esther Lanigan Stineman, *Mary Austin: Song of a Maverick* (New Haven: Yale University Press, 1989), 86; Oscar Lewis, *Bay Window Bohemia: An Account of the Brilliant Artistic World of Gaslit San Francisco* (New York: Doubleday, 1956), 103–104.
9. Lewis, *Bay Window Bohemia*, 180; Jack London *Valley of the Moon*, 1913, Paperback edition, (Berkeley: University of California Press, 1990), 258, 270, 278.
10. Shields, *Artists at Continent's End*, 193, 316; Mark Schorer, *Sinclair Lewis: An American Life* (New York: McGraw-Hill, 1961), 147.
11. Emily Hahn, *Romantic Rebels: An Informal History of Bohemianism in America* (Boston: Houghton Mifflin, 1967), 117.
12. May, *End of American Innocence*, 88.
13. Quoted in Joseph Machlis, *The Enjoyment of Music*, 4th ed. (New York: W. W. Norton, 1977), 339; Crunden, *American Salons*, 402; Allan Antliff, *Anarchist Modernism: Art, Politics, and the First Avant-Garde* (Chicago: University of Chicago Press, 2001), 33
14. William Innes Homer, *Robert Henri and His Circle* (Ithaca, NY: Cornell University Press, 1969), 66.
15. Robert Henri, *The Art Spirit* 1923, rpt (New York: Harper & Row, 1951), 84.
16. Barbara Rose, *American Art Since 1900* (New York: Praeger, 1975), 27; Stuart Davis, *Stuart Davis*, Monograph No. 6 (New York: American Artists Group, 1945), 2.
17. Eva Weber, *Alfred Stieglitz* (New York: Crescent Books, 1994), 27.
18. Edward Abrahams, *The Lyrical Left and the Origins of Cultural Radicalism*, first paperback ed., (Charlottesville, University Press of Virginia, 1988), 128.
19. Djuna Barnes, *Djuna Barnes Interviews*, ed. Alyce Barry, foreword by Douglas Messerli (Washington, D.C.: Sun & Moon Press, 1985), 221–222; O'Keeffe quoted in Laurie Lisle, *Portrait of an Artist: A Biography of Georgia O'Keeffe* (New York: Seaview Books, 1980), 41.
20. Walter Kuhn quoted in Neil Harris's chapter "The Chicago Setting," ed. Sue Anne Prince, *The Old Guard and the Avant-Garde: Modernism in Chicago, 1910–1940* (Chicago: Chicago University Press, 1990),16–17.
21. Lincoln Steffens, *Shame of the Cities*, 1904 (New York: Sagamore Press, 1957), 163; Hugh Duncan Dalziel, *The Rise of Chicago as a Literary Center from 1885 to 1920* (Totawa, NJ: Bedminster Press, 1964), 69.
22. Quoted in Sue Ann Price's chapter in *The Old Guard*, 101.
23. Floyd Dell, *Homecoming: An Autobiogra-*

phy (New York: Farrar & Rinehart, 1933), 147–148.

24. Ibid., *Homecoming*, 238.

25. Margaret Anderson, *My Thirty Years War: The Autobiography, Beginnings and Battles to 1930* (New York: Horizon, 1969), 39; Dell quoted in Douglas Clayton, *Floyd Dell: The Life of an American Rebel* (Chicago: Ivan R. Dee, 1994), 95.

26. *Sherwood Anderson's Memoirs: A Critical Edition*, ed. from the original manuscripts, ed. Ray Lewis White, 1942 (Chapel Hill: University of North Carolina Press, 1969), 335–336; Crunden, *American Salons*, 118.

27. Irving Howe, *Sherwood Anderson* (Stanford: Stanford University Press, 1968), 63.

28. Anderson quoted in *The Old Guard*, 148–149.

29. Emma Goldman, *Living My Life: Emma Goldman in Two Volumes, Vol. II*, 1931 (New York: Dover Pub., 1970), 530; Susan Noyes Platt, in *The Old Guard and the Avant-Garde*, 150–151; Anderson quoted in May, *The End of American Innocence*, 306.

30. William MacAdams, *Ben Hecht: The Man Behind the Legend* (New York: Charles Scribner and Sons, 1990), 42.

31. Anderson, *Sherwood Anderson's Memoirs*, 357; Kenneth Rexroth, *An Autobiographical Novel* (The Oil Mills, England: Whittet Books, 1977), 135–137.

32. Anderson, *Sherwood Anderson's Memoirs*, 357.

33. Samuel Putnam, "Chicago: An Obituary," *American Mercury* (August 1926), 417.

Chapter IV

1. Francis M. Naumann, *New York Dada, 1915–23* (New York: Harry N. Abrams, 1994), 36.

2. Max Eastman, *Enjoyment of Living* (New York: Harper & Brothers, 1948), 548–549; Fishbein, 62–63; Cowley, *Exile's Return: A Literary Odyssey of the 1920s* 1934. (New York: Penguin Books, 1976), 66.

3. Sloan's cartoon was reproduced in *Echoes of Revolt: The Masses, 1911–1917*, 1966, ed. William O'Neill, intro. Irving Howe, foreword by Max Eastman (Chicago: Elephant Paperbacks, rpt. 1989), 115.

4. Bourne quoted in Bruce Clayton, *Forgotten Prophet: The Life of Randolph Bourne* ((Columbia, MO: University of Missouri Press, 1984), 93.

5. Dos Passos quoted in Randolph S. Bourne, *War and the Intellectuals: Collected Essays, 1915–1919*, ed. Carl Resek (New York: Harper Torchbooks, 1964), vii; Clayton, *Forgotten Prophet*, 182.

6. Gorham Munson, *The Awakening Twenties: A Memoir-History of a Literary Period* (Baton Rouge: Louisiana State University Press, 1985), 23–26.

7. Dijkstra, *Cubism, Stieglitz, and the Early*

Poetry of William Carlos Williams, 40; Richard Whelan, *Alfred Stieglitz: A Biography* (Boston: Little Brown & Co., 1995), 260, 419; Waldo Frank, *Our America* (New York: Boni and Liveright, 1919), 184–186.

8. Quoted in Randolph Bourne's essay "Traps for the Unwary," *War and the Intellectuals*, 181.

9. Frank, *Our America*, 232.

10. Eastman, *Enjoyment of Living*, 525.

11. Mabel Dodge Luhan, *Movers and Shakers* (New York: Harcourt Brace, 1936), 25, 36; James R. Mellow, *Charmed Circle: Gertrude Stein and Company* (New York: Praeger Publishers, 1974), 170.

12. Crunden, *American Salons*, 409.

13. William Carlos Williams, *The Autobiography of William Carlos Williams* (New York: Random House, 1951), 136; Naumann, *New York Dada*, 27.

14. Arturo Schwarz, *New York Dada: Duchamp, Man Ray, Picabia, exh. cat. (Germany: Prestel-Verlag, 1973)*, 17.

15. Quoted in Calvin Tompkins, *Duchamp: A Biography* (New York: Henry Holt and Company), 152; Arensberg quoted in William A. Cramfield, *Francis Picabia* (New York: Solomon R. Guggenheim Foundation, 1970), 23.

16. Beatrice Wood essay in *Marcel Duchamp: Artist of the Century*, ed. Rudolph Kuenzil and Francis Naumann (Cambridge: MIT Press, 1989), 12.

17. Naumann, *New York Dada*, 36.

18. Ibid, *New York Dada*, 36.

19. Whelan, *Stieglitz*, 347.

20. Hans Richter, *Dada: Art and Anti-art*, 1964 (New York: Thames and Hudson, 1985), 86.

21. Irene Gammel, *Baroness Elsa: Gender, Dada, and Everyday Modernity, A Cultural Biography* (Cambridge: MIT Press, 2002), 134; Robert Hughes, *American Visions: The Epic History of American Art*, (New York: Alfred A. Knopf, 1997), 362.

22. Joseph Freeman, *An American Testament: A Narrative of Rebels and Romantics* (New York: Farrar & Rinehart, 1936), 277.

23. Heap quoted in Gammel, *Baroness Elsa*, 276.

24. Freeman, *Testament*, 266.

25. Carol J. Oja, *Making Music Modern: New York in the 1920s* (New York: Oxford University Press, 2000), 11.

26. Louise Norton, *Varèse: A Looking Glass Diary* (New York: W. W. Norton Co., 1972), 49, 123.

27. Ibid, 139–142.

28. Aaron Copland, *Our New Music: Leading Composers in Europe and America* (New York: McGraw-Hill Book Co., 1941), 140.

29. William Carlos Williams, *The Autobiography*, 135–136.

30. Lincoln Steffens, *The Autobiography of Lincoln Steffens* (New York: Harcourt, Brace & Co., 1931), 635; Tompkins, *Duchamp*, 146; Stansell, *Americans Moderns*, 218.

31. Kreymborg, *Troubadour: An Autobiography* (New York: Boni & Liveright, 1925), 201; Dell, *Homecoming*, 249.

32. Antliff, *Anarchist Modernism*, 95–101; Hippolyte Havel, "After Twenty-five Years," *Mother Earth* (November 1912), 293; ibid, "Syndicalism," *Mother Earth* (October 1912), 255–257; ibid, "Kropotkin the Revolutionist," *Mother Earth* (December 1912), 320–322.

33. Robert Karoly Sarlos, *Jig Cook and the Provincetown Players: Theatre in Ferment* (Amherst: University of Massachusetts Press, 1982), 36; Cook quoted in Leslie Fishbein, *Rebels in Bohemia: The Radicals of the Masses 1911–1917* (Chapel Hill: University of North Carolina Press, 1982), 71, 49.

34. Ross Wetzsteon, *Republic of Dreams: Greenwich Village, The American Bohemia, 1910–1960* (New York: Simon & Schuster, 2002), 572; Freeman, *Testament*, 284.

Chapter V

1. Marc Dolan, *Modern Lives: A Cultural Rereading of "The Lost Generation"* (West Lafayette, IN: Purdue University Press, 1996), 16, 27; Cowley, *Exile's Return*, 41.

2. Roderick Nash, *The Nervous Generation: American Thought, 1917–1930* (Chicago: Rand McNally & Co., 1970), 90; quoted in Anthony Tommasini, *Virgil Thomson: Composer on the Aisle* (W. W. Norton & Co., 1997), 121; A. E. Hotchner, *Papa Hemingway: A Personal Memoir* (New York: Random House, 1965), 49–50.

3. Samuel Putnam, *Paris Was Our Mistress: Memoirs of a Lost and Found Generation* (New York: Viking, 1947), 22.

4. Dos Passos 1936 essay in Dos Passos, *Occasions and Protests* (Chicago: Henry Regnery Co., 1964), 5; Malcolm Cowley, *A Second Flowering: Work and Days of the Lost Generation* (New York: Viking Press, 1973), 54.

5. *The Selected Correspondences of Kenneth Burke and Malcolm Cowley, 1915–1981* (New York: Viking, 1988), 96; advertisement in *McCall's* (September 1925), 58; *The American Mercury*, March 1927, xlv; ibid, May 1926, xxix.

6. Steven Watson, *Prepare for Saints: Gertrude Stein, Virgil Tompson, and the Mainstreaming of Modernism* (New York: Random House, 1998), 55.

7. Tomkins, *Duchamp*, 238; Josephson, *Life Among the Surrealists*, 81; Harold Stearns, *Confessions of a Harvard Man: A Journey Through Literary Bohemia* (Santa Barbara, CA: Paget Press, 1984), 310, 306; Arlen J. Hansen, *Expatriate Paris: A Cultural and Literary Guide to Paris of the 1920s* (New York: Arcade Pub., 1990), 122.

8. Sinclair Lewis, "Self-Conscious America," *The American Mercury*, Oct. 1925, 130; *The Left Bank Revisited: Selections from the Paris Tribune, 1917–1934*, ed. and intro. Hugh Ford, foreword Matthew Josephson (University Park: Pennsylvania State University Press, 1972); Samuel Putnam,

Paris Was Our Mistress, 70; Sisley Huddleston, *Paris Salons, Cafes, and Studios* (Philadelphia: J. B. Lippincott, 1928), 129; Scott Donaldson, *Archibald MacLeish: An American Life* (Boston: Houghton Mifflin, 1992), 127.

9. Josephson, *Life Among the Surrealists*, 83; Hughes quoted in Michel Fabre, *From Harlem to Paris: Black American Writers in France, 1840–1980* (Chicago: University of Illinois Press, 1991), 65.

10. Ernest Hemingway, *The Sun Also Rises*, 20.

11. Ibid., *The Wild Years*, new ed. (New York: Dell, 1967), 150–151.

12. Philippe Julian, *Montmartre* (Oxford: Phaidon Press, 1977), 193.

13. Hansen, *Expatriate Paris*, 268; Hemingway, *The Sun Also Rises*, 64, 65.

14. Craig Lloyd, *Eugene Bullard: Black Expatriate in Jazz-Age Paris* (Athens, GA: University of Georgia Press, 2000), passim; Hemingway, *The Sun Also Rises*, 65.

15. Hemingway, *The Wild Years*, 152; Robert McAlmon and Kay Boyle, *Being Geniuses Together, 1920–1930*, rev. ed. (Baltimore: Johns Hopkins Press, 1984), 281; Shack, 32; Bricktop, with James Haskins, *Bricktop* (New York: Athenaeum, 1983), 85–86.

16. *The Short Stories of F. Scott Fitzgerald*, ed. and preface Matthew J. Bruccoli (New York: Scribner Paperback Fiction, 1995), 620.

17. Garvin Bushell, *Jazz from the Beginning* as told to Mark Tucker (Ann Arbor: University of Michigan Press), 68; Tyler Stovall, 46.

18. Gertrude Stein, *The Autobiography of Alice B. Toklas*, 1933 (New York: Modern Library, 1993), 272; Pound quoted in Noel Riley Fitch, *Sylvia Beach and the Lost Generation: A History of Literary Paris in the Twenties and Thirties* (New York: W.W. Norton & Co., 1983), 128 ; Putnam, *Paris Was Our Mistress*, 130.

19. Harold Loeb, *The Way It Was* (New York: Criterion Books, 1959), 61; Michael Reynolds, *Hemingway: The Paris Years* (New York: W. W. Norton & Co., 1989), 22.

20. Peter Conrad, *Modern Times, Modern Places* (New York: Alfred A. Knopf, 1999), 15; Fitch, *Sylvia Beach*, 105.

21. Cowley, *Second Flowering*, 16: Janet Flanner, *Paris Was Yesterday, 1925–1939*, ed. Irving Drutman (New York: Viking Press, 1972), x–xi.

22. Bennett Cerf, *At Random: The Reminiscences of Bennett Cerf* (New York: Random House, 1977), 90; *The Letters of Hart Crane 1916–1932*, ed. Brom Weber, first paperback ed. (Berkeley: University of California Press, 1965), 94; John Huston, *An Open Book* (New York: Da Capo, 1994), 48.

23. *Being Geniuses Together*, 91.

24. Bernard J. Poli, *Ford Maddox Ford and the Transatlantic Review* (Syracuse, NY: Syracuse University Press, 1967), 23.

25. *The Left Bank Revisited*, 96.

26. Mark Polizzotti, *Revolution of the Mind: The Life of André Breton* (New York: Da Capo, 1997), 105.

27. Huddleston, *Paris Salons*, 227; Polizzotti, *Revolution of the Mind*, 137.

28. Virgil Thomson, *Virgil Thomson by Virgil Thomson* (New York: Alfred A. Knopf, 1966), 58.

29. Tashjian, *Boatload of Madman (full?)*, 123, Josephson, *Life Among the Surrealists*, 116.

30. Josephson, *Life Among the Surrealists*, 123.

31. *The Selected Correspondences of Kenneth Burke and Malcolm Cowley*, 136; Cowley, *Exile's Return*, 137, 164–170; Loeb, *The Way It Was*, 161.

32. Stearns, *Confessions of a Harvard Man*, 298.

33. *The Letters of Hart Crane 1916–1932*, ed. Brom Weber (Berkeley: University of California Press, 1965), 52;, Polizzotti, *Revolution of the Mind*, 137; Virgil Thomson, *Virgil Tompson*, 58; Dickran Tashjian, *Skyscraper Primitives: Dada and the American Avant-Garde, 1910–1925* (Middletown, CT: Wesleyan University Press, 1975), 122.

34. Reynolds, *Hemingway*, 183.

35. Polizzotti, 121, 228.

36. McAlmon, *Being Geniuses Together*, 253.

37. Kyle Gann, *American Music in the Twentieth Century* (New York: Schirmer Books, 1997), 21.

38. Thomson, *Virgil Tompson*, 75.

39. Hugh Ford, *Four Lives in Paris* (San Francisco: North Point Press, 1987), 17; Crunden, *From Self to Society*, 58; Huddleston, *Parisian Salons*, 85; Humphrey Carpenter, *A Serious Character: The Life of Ezra Pound*. Boston: Houghton Mifflin, 1988; 391, 431.

40. Gann, *American Music*, 46; Glenn Watkins, *Pyramids at the Louvre: Music, Culture, and Collage from Stravinsky to the Postmodernists* (Cambridge: Belknap Press of Harvard University Press, 1994), 173.

41. Carol J. Oja, *Making Music Modern: New York in the 1920s* (New York: Oxford University Press, 2000), 82–83.

42. *The Left Bank Revisited*, 220.

43. William Carlos Williams, essay "George Antheil and the Cantilène Critics," in *William Carlos Williams: Selected Essays*, (New York: New Directions, 1969), 57–61.

44. Quoted in J.J. Wilhelm, *Ezra Pound in London and Paris, 1918–1925* (University Park: Pennsylvania State University Press, 1990), p. 269; quoted in Tommasini, *Virgil Thomson*, 133; Thomson, 75; Oja, 94.

45. Kendall Taylor, *Sometimes Madness Is Wisdom: Zelda and Scott Fitzgerald, a Marriage* (New York: Ballantine Books, 2001), 135; Amanda Vaill, *Everybody Was So Young: Gerald and Sara Murphy, A Lost Generation Love Story* (New York: Schirmer Books, 1992), 149.

46. Calvin Tomkins, *Living Well Is the Best Revenge* (New York: Modern Library, 1962), 25.

47. F. Scott Fitzgerald, *Tender Is the Night*, 1934. New York: Charles Scribner's & Sons, 1962, 3, 15, 21, 25.

48. Quoted in Nancy Milford, *Zelda: A Biography* (New York: Harper & Row, 1970), 107.

49. Carlos Baker, *Ernest Hemingway: A Life Story* (New York: Avon Books, 1968), 208, 214; *Letters of the Lost Generation*, 19.

50. Reynolds, *Hemingway*, 340; Hemingway, *A Moveable Feast* (New York: Bantam Books, 1965), 180; *Letters of the Lost Generation*, 29–30.

51. Josephson, *Life Among the Surrealists*, 314; Dickran Tashjian, *Boatload of Madmen: Surrealism and the American Avant-Garde 1920–1950* (London: Thames & Hudson, 1995), 28.

Chapter VI

1. William Carlos Williams, *A Recognizable Image: William Carlos Williams on Art and Artists* (New York: New Directions, 1978), 68; *Civilization in the United States: An Inquiry by Thirty Americans*, ed. Harold E. Stearns (New York: Harcourt, Brace Co., 1922), vii, 231.

2. Conrad, *Modern Times, Modern Places*, 15.

3. Blake, *Beloved Community*, 253.

4. Dodge Luhan, *Edge of Taos Desert*, 1937 (Albuquerque: University of New Mexico Press, 1987), 63; Frank, *Our America*, 112.

5. Ansel Adams, *Ansel Adams, An Autobiography* (New York: Little, Brown & Co., 1996), 75.

6. F. Scott Fitzgerald, *The Last Tycoon*, 1941 (New York: Colliers Books, 1986), 11; Jill Jonnes, *Hep-Cats, Narcs, and Pipe Dreams: A History of America's Romance with Illegal Drugs* (Baltimore: Johns Hopkins University Press, 1996), 61.

7. Harry Carr, *Los Angeles, City of Dreams* (New York: Appleton-Century, 1935), 275,276.

8. Carr, *Los Angeles*, 267; Robert Sklar, *Movie-Made America: A Cultural History of American Movies*. New York: Vintage Books, 1994), 76–77.

9. Gavin Lambert, *Nazimova: A Biography* (New York: Alfred A. Knopf, 1997), 126, 210.

10. Crane, *Letters*, 326; *The Fourteenth Chronicle: Letters and Diaries of John Dos Passos*, ed. with bio. by Townsend Ludington (Boston: Gambit, 1973), 356–357.

11. Oliver La Farge quoted in *The World from Jackson Square: A New Orleans Reader*, ed. Etolia S. Basso (New York: Farrar, Straus and Co., 1948), 376.

12. Quoted in *New Orleans City Guide, Written and Compiled by the Federal Works Projects Administration for the City of New Orleans*. 1938. (Boston: Houghton Mifflin, 1974), 116.

13. Joseph Blotner, *Faulkner: A Biography, Vol. I* (New York: Random House), 367.

14. Ibid., *Faulkner*, 536.

15. William Faulkner, *Mosquitoes*, 1927. Rpt., (New York: Liveright, 1955), 250; Stephen B. Oates, *William Faulkner: The Man and the Artist* (New York: Harper & Row, 1987), 59.

16. Hamilton Basso, quoted in *Literary New Orleans in the Modern World*, edited by Richard S. Kennedy (Baton Rouge: Louisiana State Press, 1998), 50.

17. Oja, *Making Music Modern*, 314; Frank quoted in Blake, *Beloved Community*, 272; Nathan Irvin Huggins, *Harlem Renaissance* (New York: Oxford University Press, 1971), 77.

18. William Holland Kenney, *Chicago Jazz: A*

Cultural History 1904–1930 (New York: Oxford University Press, 1993), 19, 23.

19. Freeman quoted in Burt Korall, *Drummin' Men: The Heartbeat of Jazz, The Swing Years* (New York: Schirmer Books, 1990), 211.

20. Rexroth in *Golden Gate: Interviews with 5 San Francisco Poets*, ed. David Meltzer, rev. ed. (Berkeley, CA: Wingbow Press, 1976), 33; Eddie Condon, *We Called It Music: A Generation in Jazz* (New York: Henry Holt and Co., 1947), 109.

21. Milton Mezzrow and Bernard Wolfe, *Really the Blues* (New York: Random House, 1946), 114.

22. Bud Freeman as told to Robert Wolf, *Crazeology: The Autobiography of a Chicago Jazzman* (Chicago: University of Illinois Press, 1989), 17; Mezzrow, *Really the Blues*, 105, 114.

23. Thurman quoted in Arnold Rampersad, *The Life of Langston Hughes, Vol. I: 1902–1941, I Too Sing America* (New York: Oxford University Press, 1986), 119.

24. *Gay Rebel of the Harlem Renaissance: Selections from the Work of Richard Bruce Nugent*, ed. Thomas H. Worth (Durham: Duke University Press, 2002, 1.

25. Robert E. Hemenway, *Zora Neale Hurston: A Literary Biography* (Urbana: University of Illinois Press, 1977), 44, 47; Rampersad, *The Life of Langston Hughes*, 137; David Levering Lewis, *When Harlem Was in Vogue*, (New York: Penguin Books, 1997),196.

26. S. P. Fullinwider, in Therman B. O'Daniel, *Jean Toomer: A Critical Evaluation* (Washington, D.C.: Howard University Press, 1988), 17.

27. Huggins, *Harlem Renaissance*, 238.

28. Fullinwider, in O'Daniel, *Jean Toomer*, 23.

29. Carolyn Ware, *Greenwich Village, 1920–1930* (Boston: Houghton Mifflin, 1935), 54; Parry, *Garrets and Pretenders*, 307.

Chapter VII

1. "Cubism to Cynicism," *Time* (August 31, 1936), 22; Review of Mabel Dodge Luhan's memoir, *Movers and Shakers*, *Time* (November 23, 1936), 91; "Colorful Shorthand," *Time* (January 6, 1936), 44; "Books" section review of Pound's *XXX Cantos* (March 20, 1933), 51; "Art" section, *Time* (March 22, 1933), 25.

2. Allen Ginsberg, *Deliberate Prose: Selected Writings and Essays 1952–1995* (New York: Perennial, 2000), 497; John Houseman, *Entertainers and the Entertained: Essays on Theater, Film, and Television* (New York: Simon & Schuster, 1986), 31–32; Alfred Kazin, *Starting Out in the Thirties* (New York: Vintage Books, 1980), 136.

3. Diggins, *Lyrical Left*, 116.

4. Kalaidjian, *American Culture Between the Wars: Revolutionary Modernism and Postmodern Technique* (New York: Columbia University Press, 1993), passim.

5. Hughes, *The Shock of the New*. Rev. ed. (New York: Alfred A. Knopf, 1998, 87.

6. Kalaidjian, *American Culture*, 39–43.

7. Freeman, *Testament*, 599–600; Cowley, *Dream of Golden Mountains*, 146.

8. Quoted in *Communism in America: A History in Documents*, ed. Albert Fried (New York: Columbia University Press, 1997), 176–177; Kalaidjian, *American Culture*, 49.

9. Cowley, *Dream of Golden Mountains: Remembering the 1930s* (New York: Penguin, 1981; 140; Phillips quoted in *The Little Magazine in America: A Modern Documentary History*, ed. William Phillips, Elliott Anderson, and Mary Kinzie (Yonkers, NY: Pushcart Press, 1978), 133.

10. Kalaidjian, *American Culture*, 48; *Little Magazines in America*, 134.

11. Daniel Aaron, *Writers on the Left: Episodes in American Literary Communism*, 1961. (New York: Columbia University Press, 1992), 230.

12. Kalaidjian, *American Culture*, 59, 61.

13. Charles Wolfe and Kip Lornell, *The Life and Legend of Leadbelly* (New York: Harper & Collins, 1992), 191.

14. Parry, *Garrets and Pretenders*, 355; Alan Churchill, *The Improper Bohemians* (New York: Ace Books), 236; Alfred Kazin, *Starting Out*, 66–67.

15. Arthur Miller, quoted in *Kesey's Garage Sale* (New York: Viking, 1973), xv; Lawrence Lipton, *Holy Barbarians* (New York: Julian Messner Inc., 1959), 288, 290.

16. *New York Panorama. A Comprehensive View of the Metropolis Presented in a Series of Articles Prepared by the Federal Writers' Project of the Works Progress Administration*, 1938. (New York: Random House, 1976), 140; Harold Clurman, *The Fervent Years: The Story of the Group Theatre and the Thirties* (New York: Hill & Wang), 108; Max Gordon, *Live at the Village Vanguard* (New York: Da Capo, 1980), 11.

17. Chauncey, *Gay New York: Gender, Urban Culture and the Making of Gay Male World, 1890–1940* (New York: Basic Books, 1994), 336–337; Churchill, *Improper Bohemians*, 237.

18. Cowley, *Dream of Golden Mountains*, 261.

19. Max Gordon, *Live at the Village Vanguard*, introduction by Nat Hentoff, Rpt., (New York: Da Capo, 1980), 31.

20. Freeman, *Testament*, 287.

21. Thomas Bender, *New York Intellect: A History of Intellectual Life in New York City, From 1750 to the Beginnings of Our Own Time* (Baltimore: Johns Hopkins University Press, 1987), 321–322.

22. William Phillips, essay "What Happened in the Thirties," in *The Commentary Reader: Two Decades of Articles and Stories*, ed. Norman Podhoretz (New York: Athenaeum, 1966), 756.

23. Crunden, *From Self to Society*, 109.

24. Kazin, *Starting Out*, 82.

25. Richard Schickel, *Elia Kazin: A Biography* (New York: Harper Collins, 2005), 8–9.

26. Clurman, *The Fervent Years*, 5; Crunden, *From Self to Society*, 110; Jeff Young, *Kazan, The Master Director of Films: Interviews with Elia Kazan* (New York: Newmarket Press, 1999), 118.

27. Clurman, *The Fervent Years*, 270; Morgan

Y. Himelstein, *Drama as Weapon: The Left-wing Theater in New York, 1929–1941* (New Brunswick, NJ: Rutgers University Press, 1963), 180.

28. Nick Worrall, *The Moscow Art Theatre* (New York: Routledge, 1996), 11.

29. Clurman, *The Fervent Years*, 40; Cheryl Crawford, *One Naked Individual: My Fifty Years in the Theatre* (New York: Bobbs-Merrill Co. Inc., 1977), 79.

30. Orson Welles and Peter Bogdanovitch, *This Is Orson Welles* (New York: Da Capo, 1988), 13; Flannagan quoted in Jane DeHart Matthews, *The Federal Theatre, 1935–1939: Plays, Relief, and Politics* (Princeton, NJ: Princeton University Press, 1967), 42–43.

31. John Houseman, *Run Through, A Memoir* (New York: Simon & Schuster, 1972), 231; Hallie Flanagan, *Arena: The History of the Federal Theatre* (New York: Benjamin Bloom, 1965), 59.

32. Flanagan, *Arena*, 74.

33. Kazin, *Starting Out*, 119.

34. Frank Brady, *Citizen Welles: A Biography of Orson Welles* (New York: Scribner & Sons, 93; Matthews, *The Federal Theatre*, 102, 122.

35. "Colorful Shorthand," *Time* (January 6, 1936), 44; Adams, *Ansel Adams*, 100.

36. *America and Alfred Stieglitz: A Collective Portrait* (New York: Literary Guild, 1934), 280.

37. Aaron Copland, *What to Listen For in Music*, rev. ed. (New York: Mentor Book, 1957), 145; Steven Watson, *Prepare for Saints: Gertrude Stein, Virgil Thomson, and the Mainstreaming of Modernism* (New York: Random House, 1998), 80.

38. Thomson, *Virgil Tompson*, 75.

39. Houseman, *Run Through*, 103; Watson, *Prepare for Saints*, 45.

40. Eugene R. Gaddis, *Magician of the Modern: Chick Austin and the Transformation of the Arts in America* (New York: Alfred A. Knopf, 2000), 5; Watson, *Prepare for Saints*, 6, 107, 161.

41. Houseman, *Run Through*, 97, 99.

42. Carl Van Vechten, *Letters of Carl Van Vechten*, ed. Bruce Kellner (New Haven: Yale University Press, 1987), 134.

43. Bennett Cerf, *At Random: The Reminiscences of Bennett Cerf* (New York: Random, 1977), 102; "Stein's Way," *Time* (September 11, 1933), 57, 60.

44. Watson, *Prepare for Saints*, 7.

45. Robert Hughes, "What Alfred Barr Saw," *Esquire* (December 1983), 402, 413; Tashjian, *Boatload of Madmen*, 52.

47. Franklin Rosemont in *André Breton, What Is Surrealism? Selected Writings*, ed. Franklin Rosemont (New York: Pathfinder, 1978; Dickran Tashjian, *A Boatload of Madman: Surrealism and the Avant-Garde, 1920–1950* (New York: Thames and Hudson, 1995), 330.

48. Henry Miller, *The Air-Conditioned Nightmare* (New York: New Directions, 1945), 165.

49. Martica Sawin, *Surrealism in Exile and the Beginning of the New York School* (Cambridge: MIT Press, 1995), 79; Hughes, *American Visions*, 468.

Chapter VIII

1. Ted Gioia, *The History of Jazz* (New York: Oxford University Press, 1997), 203–204.

2. Bret Primack, "Max Roach, There's No Stoppin' the Professor from Boppin'," *Down Beat* (November 1978), 22.

3. Gary Giddins, *Celebrating Bird: The Triumph of Charlie Parker* (New York: Beechtree Books, 1987), 68; Ralph Ellison, *Shadow and Act*, 1953 (New York: Quality Paperback Book Club, 1993), 199.

4. Arnold Shaw, Foreword by Abel Green, *The Street That Never Slept: New York's Fabled 52nd Street* (New York: Coward, McCann & Geoghegan, Inc., 1971), 173; *New York Confidential*, 45; Miles Davis with Quincy Troupe, *Miles: The Autobiography* (New York: Touchstone Books, 1990), 67; Dizzy Gillespie and Al Fraser, *Dizzy: To Be or Not to Bop* (New York: Doubleday, 1979), 202; Ira Gitler, *Jazz Masters of the Forties* (New York: Collier Books, 1966), 208.

5. Dexter Gordon quoted in Miles Davis with Quincy Troupe, *Miles: The Autobiography* (New York: Simon & Schuster, 1990), 110–111.

6. Scott DeVaux, *The Birth of Bebop: A Social and Musical History* (Berkeley: University of California Press, 1997), 441; *Bird: The Legend of Charlie Parker*, ed. Robert Reisner, 6th ed. (New York: Da Capo, 1989), 21.

7. Laurent De Wilde, *Monk* (New York: Marlow & Company, 1997), 145.

8. Ralph Ellison, *Shadow and Act*, 1953 (New York: Quality Paperback Book Club, 1994), 222, 228.

9. Malcolm X and Alex Hailey, *The Autobiography of Malcolm X* (New York: Ballantine Books, 1973), 94; Ellison, *Shadow and Act*, 228.

10. Joans, in Reisner *Bird*, 116; McLean quoted in A. B. Spellman, *Four Lives in the Bebop Business* (New York: Pantheon Books, 1966), 224; Gary Giddins quoted in Ken Burns, *Jazz*, episode 8, "Risk," PBS Home Video, Florentine Films, 2000.

11. Quoted in Carl Woideck, *Charlie Parker: His Music and Life* (Ann Arbor: University of Michigan Press), 1996; 45.

12. Reisner, *Bird*, 229.

13. Bernard Gendron, "A Short Stay Under the Sun," in *The Bebop Revolution* (Austin: University of Texas, 1994), 151; Thomas Pynchon, *V*, 1961 (New York: Harper Perennial Modern Classics, 2005), 56.

14. Kerouac, *On the Road*, 1957 (New York: Penguin Books, 1976), 14.

15. Ginsberg, *Spontaneous Mind: Selected Interviews, 1958–1996* ed. David Carter (New York: Perennial, HarperCollins, 2001), 350; Kerouac, *Selected Letters, 1940–1956*, ed. Ann Charters (New York: Penguin, 1995), 274; Erika Ostrovsky, *Céline and His Vision* (New York: New York University Press, 1967), 18; Barry Miles, *William Burroughs* (New York: Hyperion, 1993), 103.

16. Jack Kerouac, *The Town and the City* (New York: Harcourt Brace, 1950), 361; Barry Miles'

essay "The Beat Generation in the Village," *Greenwich Village Culture and Counterculture*, ed. Rick Beard and Leslie Cohen (New Brunswick, NJ: Rutgers University Press, 1993), 169; Kerouac, "Manhattan Sketches" in *The Moderns: An Anthology of New Writing in America*, ed. LeRoi Jones (New York: Corinth Books, 1963), 266–269.

17. Jack Kerouac, *The Dharma Bums*, 1958 (New York: Penguin, 1976), 39.

18. Hajo Holborn, *A History of Modern Germany 1840–1945* (Princeton: Princeton University Press, 1969), 657–658.

19. Kerouac, from "Lamb, No Lion," originally published in *Pageant* (1958), quoted in *Good Blonde & Others*, ed. David Allen (San Francisco: Grey Fox Press, 1993), 50; Ken Kesey, "The Art of Fiction CXXVI, *The Paris Review* (Spring 1991), 70.

20. Kerouac, *On the Road*, 284; Amiri Baraka, *The Autobiography of LeRoi Jones* (Chicago: Lawrence Hill Books, 1997, 190; James Campbell, *Talking at the Gates: The Life of James Baldwin* (Berkeley: University of California Press), 1991.

21. Quoted from Ginsberg's poem "Howl"; Amram, *Offbeat*, 41.

22. *Jack Kerouac: Selected Letters*, 71; Jack Kerouac, *Lonesome Traveler* (New York: Grove Press, 1960), 113; Edie Parker quoted in *Jack Kerouac, King of the Beats*, DVD Goldhill Home Media International, 2003.

23. *Kerouac: Selected Letters*, 226; Kerouac, *Visions of Cody*, 1960 (New York: Penguin Books, 1993), 323.

24. Kerouac, *The Town and the City*, 13; David Amram, *Offbeat: Collaborating with Jack Kerouac* (New York: Thunder's Mouth Press, 2002), 107.

25. Kerouac *On the Road*, 78; from Kerouac's poem "San Francisco Blues," 1954; *Jack Kerouac, Selected Letters*, 115.

26. Rexroth in *Kerouac and Friends*, 44–45.

27. *San Francisco: The Bay and Its Cities*. Compiled by the Writers Program of the Works Progress Administration, 1940, rev. 2nd ed. (New York: Hasting House Pub., 1947), 241; Herb Caen, *Don't Call It Frisco* (New York: Doubleday & Co., 1953), 19.

28. Herb Caen, rev. ed., *Herb Caen's New Guide to San Francisco* (New York: Doubleday & Co., 1958), 58; Rexroth, *An Autobiographical Novel*, 365; *The Jazz Poetry Anthology*, ed. Sascha Feinstein and Yusef Komunyaaka (Bloomington: Indiana University Press, 1991), 109.

29. *Beat Culture and the New America*, ed. Lisa Phillips et al. (New York: Whitney Museum/Flammarion, 1995), 163; Gene Santoro, *Myself When I Am Real: The Life and Music of Charles Mingus* (New York: Oxford University Press, 2000), 130; Watson, *Birth of the Beat Generation*, 229; Brenda Knight, Foreword by Anne Waldman and Afterword by Ann Charters, *Women of the Beat Generation: The Writers, Artists and Muses at the Heart of a Revolution* (New York: MJF Books), 113, 107.

30. Neeli Cherkovski, *Ferlinghetti: A Biography* (New York: Doubleday & Co., 1979), 66, 120.

31. Ginsberg, *Spontaneous Mind*, 149; Charters, *Kerouac*, 233; Ginsberg, *Deliberate Prose*, 239–240.

32. Ginsberg, *Spontaneous Mind*, 118.

33. Ginsberg, *Spontaneous Mind*, 174; *The Gary Snyder Reader: Prose, Poetry, and Translations, 1952–1998*, (Washington, D.C.: Counterpart, 1980), 151.

34. Davis, *Miles*, 203–204.

35. Amram, *Offbeat*, 17.

36. Ferlinghetti, in *Golden Gate*, 151.

37. Dan Wakefield, *New York in the 50s* (Boston: Houghton & Mifflin, 1992), 165–167.

38. Rhino Records, 1990; Ann Charters, *Beat Down to Your Soul: What Was the Beat Generation?* (New York: Penguin Books, 2001); Bruce Cook, *The Beat Generation* (New York: Charles Scribner & Sons, 1971), 3; Bob Dylan, *Chronicles, Volume One* (New York: Simon & Schuster, 2004), 235.

39. Arthur Gelb, *City Room* (New York: Berkley Books, 2003), 73.

40. Mark Stevens and Annalyn Swan, *de Kooning: An American Master* (New York: Alfred A. Knopf, 2004), 400; Quoted in Knight, *Women of the Beat Generation*, 3, 177; Hettie Jones, *Hettie Jones*, 46.

41. *The Village Voice Reader: A Mixed Bag from the Greenwich Village Newspaper* (New York City: Grove Press, Black Cat ed., 1963), 13–22.

42. James Baldwin, *Another Country* (New York: Dell, 1962), 30,251.

43. Diane Di Prima, *Recollections as My Life as a Woman: The New York Years* (New York: Viking, 2001), 85; Bill Morgan, *The Beat Generation in New York: A Walking Tour of Jack Kerouac's City* (San Francisco, City Lights Books, 1997), 87–88.

44. *Life* article quoted in Graham Caveney, *Screaming with Joy: The Life of Allen Ginsberg* (New York: Broadway Books, 1999), 94–95; Aram, *Offbeat*, 41.

45. Caen, *Only in San Francisco*, 130; Francis J. Rigney and L. Douglas Smith, *The Real Bohemia: A Sociological and Psychological Study of the Beats* (New York: Basic Books, 1961), 52, 77, 86; Miles, *Ginsberg: A Biography*, 244–245; Watson, *Birth of the Beat Generation*, 228; Caen, *Don't Call It Frisco*, 229; Lipton, *Holy Barbarians*, 126.

46. Lipton, *Holy Barbarians*, 124.

47. Miller, *The Air-Conditioned Nightmare*, 126; Oliver Evans, *New Orleans* (New York: Macmillan, 1959), 86.

48. *Time* quoted in *The Beats: A Literary Reference*, Edited by Matt Theado (New York: Carroll & Graf Publishers, 2003), 113.

49. Quoted in Cook, *The Beat Generation*, 146.

50. Seymour Krim, *You and Me* (New York: Holt, Rinehart and Winston, 1974), 106–107.

Chapter IX

1. Joni Mitchell quoted in Jack Chambers, *Milestones 2*, 160.

2. Joan Peyser, *The New Music: The Sense Behind the Sound* (New York: Delacorte Press, 1971), 185.

3. Herbert Russcol, *The Liberation of Sound: An Introduction to Electronic Music* (Englewood Cliffs, NJ: Prentice-Hall, 1972), xx, 92–103, xx, xvi.

4. Richard Kostelanetz, *Conversing with John Cage*, (Limelight Editions, 1994), 207, 106; Calvin Tomkins, *The Bride and the Bachelors: Five Masters of the Avant-Garde*, enlarged ed. (New York: Penguin Books, 1976), 110.

5. Kostelanetz, *Conversing with John Cage* 60; Cage quoted in David Revill, *The Roaring Silence: John Cage, a Life* (New York: Arcade Publishing, 1993), 64; Tomkins, *The Bride and the Bachelors*, 135–136.

6. Kostelanetz, *John Cage (ex)plain(ed)* (New York: Schirmer Books, 1996), 91, 22.

7. John F. Szwed, *Space Is the Place: The Lives and Times of Sun Ra* (New York: Pantheon Books, 1997), 230–233.

8. Eric Nisenson, *Ascension: John Coltrane and His Quest*, 150.

9. Taylor quoted in Eric Porter, *What Is This Thing Called Jazz: African-American Musicians as Artists, Critics, and Activists* (Berkeley: University of California Press, 200), 200, 202, 206.

10. Whitney Baillett, *American Musicians II: Seventy-one Portraits in Jazz* (New York: Oxford University Press, 1996), 406; Charles Mingus, *Beneath the Underdog*, ed. Nel King (New York: Penguin Books, 1971), 252; "Crow Jim," *Time* (October 19, 1962), 58.

11. Scott Saul, *Freedom Is, Freedom Ain't: Jazz and the Making of the Sixties* (Cambridge: Harvard University Press, 2003), 117.

12. John Gennari in *Uptown Conversation: The New Jazz Studies*, ed. Robert G. O'Meally, Brent Hayes Edwards, and Farah Jasmine Griffin (New York: Columbia University Press, 2004), 146.

13. Ralph J. Gleason, liner notes to *John Coltrane's Sound*, Atlantic Records, 1964.

14. Quoted in Lewis Porter, *John Coltrane: His Life and Music* (Ann Arbor: University of Michigan Press, 1998), 296.

15. J. C. Thomas, *Chasin' the Trane: The Music and Mystique of John Coltrane* (New York: Da Capo, 1976), 195–196; Marc Shapiro, *Back on Top: Carlos Santana* (New York: St. Martin's Press, 2000), 51.

16. *The Jazz Poetry Anthology*, ed. Sascha Feinstein and Yusef Komunyakaa (Bloomington: Indiana University Press, 1991), xix; Victor Bockris and Roberta Bayley, *Patti Smith: An Authorized Biography* (New York: Simon & Schuster, 1999), 87; John Sinclair, *Guitar Army: Street Writings and Prison Writings* (New York: Douglas Book Corp., 1972), 68.

17. LeRoi Jones, *Black Music* (New York: William Morrow & Co., 1968), 92–98; Bill Flanagan, *Written in My Soul: Rock's Great Songwriters Talk About Their Music* (New York: Contemporary Books, 1986), 107; Dylan quoted in Scott Cohen "Don't Ask Me Nothin' I Might Just Tell the Truth," *Spin*, December 1985, 39; Bob Dylan, *Chronicles Vol. One* (New York: Simon & Schuster, 2004), 48, 94–95.

18. Randy Poe, foreword by Billy F. Gibbons, *Skydog: The Duane Allman Story* (San Francisco: Backbeat Books, 2006), 101; Carlos Santana quoted from *Miles Electric: A Different Kind of Blue*, DVD Eagle Rock Entertainment Ltd., 2004.

19. Harry Shapiro and Caesar Glebbeek, *Electric Gypsy* (New York: St. Martin's Press, 1990), 178.

20. Davis, *Miles*, 292.

21. Stuart Nicholson, *Jazz-Rock: A History* (New York: Schirmer Books, 1999), 86; Ashley Kahn, *Kind of Blue* (New York: Da Capo, 2000), 187.

22. Jack Chambers, *Milestones, 2*, 215; Bert Stratton, "Miles Ahead in Rock Country," *Down Beat* (May 14, 1970), 19.

23. Morgan Ames, in the liner notes to *Miles Davis at the Fillmore*, Columbia, 1970; Levon Helm with Stephen Davis, *This Wheel's On Fire: Levon Helm and the Story of the Band* (New York: William Morrow & Co., 1993), 218; *Electric Miles*, DVD.

Chapter X

1. Bob Dylan, *Chronicles*, 2004, 90.

2. Richter, *Dada*, 96; Tomkins, *Duchamp*, 445.

3. Cage quoted in Revill, *The Roaring Silence*, 214.

4. Tomkins, *Duchamp*, 415.

5. Donald Kuspit, *The Cult of the Avant-Garde Artist* (Cambridge: Cambridge University Press, 1993), 35; Duchamp quoted in *Village Voice Reader*, 302.

6. Wayne Koestenbaum, *Andy Warhol* (New York: Penguin, 2001), 133–134; Andy Warhol and Pat Hackett, *Popism: The Warhol Sixties* (New York: Harcourt & Brace, 1980), 42.

7. Ginsberg quoted in Miles, *Ginsberg*, 335; Koestenbaum, *Andy Warhol*, 50–51; Warhol, *Popism*, 62.

8. Warhol, *Popism*, 133, 169.

9. *The New American Arts*, ed. Richard Kostelanetz (New York: Collier Books, 1965), 84.

10. John Gruen, *The Party's Over Now: Reminiscences of the Fifties — New York's Artists, Writers, Musicians, and Their Friends* (New York: Viking Press, 1972), 92, 103.

11. Bill Morgan, *The Beat Generation*, 62; Tytell, *The Living Theatre*, 35, 80.

12. Anna Balakian, *Surrealism: The Road to the Absolute* (Chicago: University of Chicago Press, 1986), 243; Naomi Greene, *Antonin Artaud: Poet Without Words* (New York: Simon & Schuster, 1970), 36; *Conversing with Cage*, 104.

13. Tytell, *The Living Theatre, Art, Exile and Outrage* (New York: Grove Press, 1995), 148, 154; Naomi Greene, *Antonin Artaud: Poet Without Words* (New York: Simon & Schuster, 1970), 149;

Jack Gelber, *The Connection* (New York: Grove Press, 1960), 9; Spellman, *Four Lives*, 227.

14. Robert Brustein, *Seasons of Discontent: Dramatic Opinions 1959–1965* (New York: Simon & Schuster, 1967), 23–26; Ira Gitler, liner notes to the Freddie Redd Quartet, *The Music from the Connection*, Blue Note (1960), CD reissue, 2005.

15. Henry Geldzahler, *Making It New: Essays, Interviews, and Talks* (New York: Turtle Point Press, 1994), 26; Pierre Cabanne, *Dialogues With Marcel Duchamp*, with an appreciation by Jasper Johns, Rpt. of 1979 ed. (New York: Da Capo, 1987), 9.

16. Warhol, *Popism*, 51.

17. Hughes, *American Visions*, 529.

18. Yuri Kapralov, *Once There Was a Village* (New York: Akashic Books, 1998), 27; Hahn, *Romantic Rebels*, 288–289; Joyce Johnson, *Minor Characters*, 207–208; John F. Szwed, *Space Is the Place: The Lives and Times of Sun Ra* (New York: Pantheon Books, 1997), 194–195; Hettie Jones, *Hettie Jones*, 172.

19. Warhol, *Popism*, 52; Hettie Jones, *Hettie Jones*, 187–188.

20. Brooks McNamara essay, "Something Glorious," in *Greenwich Village: Culture and Counterculture*, 318; Hettie Jones, 172; Miles, *Ginsberg*, 335.

21. Ginsberg, *Deliberate Prose*, 496–497; Gruen, *The New Bohemia*, 69.

22. Ronald Sukenick, *Down and In: Life in the Underground* (New York: William Morrow, 1980), 153–155.

23. Kenneth Terry, La Monte Young, Explorer of the Long Tone," *Down Beat* (April 19, 1979), 17–18; Gruen, 126; Tomkins, *Bride and the Bachelors*, 138.

24. Niomi Feigelson, *The Underground Revolution: Hippies, Yippies, and Others* (New York: Funk & Wagnalls, 1970), 126–127; Sukenick, *Down and In*, 153; Michael Lydon "The Word" *Esquire* (September 1967), 167; Jean Strouse, "Guide to the Underground Press, *The Eye* (February 11, 1969), 51, 52, 61.

25. Sanders in *The Portable Beat Reader*, 516; "The Fugs: Nextness is Godlier than Cleanliness (January 1968), "The Fugs," *Avant-Garde*, 52–53.

26. "The Fugs," *Avant-Grade*, 53.

27. "The Fugs," *Avant-Garde*, 54; Kupferberg in *Notes from Underground: An Anthology*, Edited Jesse Kornbluth (New York: Viking Press, 1968), 206.

28. "The Fugs," *Avant-Garde*, 52, 54; Ginsberg, liner notes for *The Fugs*, ESP-DISK, 1966.

29. Warhol, *Popism*, 144; Mekas quoted in LP liner notes, *Velvet Underground & Nico*. Verve, 1967.

30. *The Velvet Underground Companion: Four Decades of Commentary*, ed. Alban Zak III (New York: Schirmer Books, 1997), 109; Revill, *The Roaring Silence*, 99; Peter Doggett, *Lou Reed: Growing Up in Public* (New York: Omnibus Press, 1992), 20–21.

31. Bill Flanagan, *Written in My Soul: Rock's Greatest Songwriters Talk About Their Music* (New York: Contemporary Books, 1986), 191; *Velvet Underground Companion*, 116.

32. Blair Jackson, *Garcia: An American Life* (New York: Viking, 1999), 36; Carol Brightman, *Sweet Chaos: The Grateful Dead's American Adventure* (New York: Pocket Books, 1999).

33. Cohassey interview with novelist Ed McClanahan, Lexington Kentucky, August 18, 2005; Lesch, 17–18.

34. *One Lord, One Faith, One Cornbread*, ed. Fred Nelson and Ed McClanahan (New York: Anchor Books, 1973), 172–173; McClanahan interview; Ed McClanahan, *Famous People I Have Known* (Louisville: University of Kentucky Press, 2003), 31.

35. John Babbs, *Prankster Memoirs* (Eugene, OR: Angle Productions, 2003), 58; Ken Kesey, "Is There Any End to the Kerouac Highway?" *Esquire* (December 1983), 60; Digital Interviews: Ken Kesey, (Internet source), (April 22, 2004), 1.

36. *On the Bus: The Complete Guide to the Legendary Trip of Ken Kesey and the Merry Pranksters and the Birth of the Counterculture* (New York: Thunder's Mouth Press, 1990), 25.

37. Ed McClanahan, *My Vita, If You Will* (Washington, D.C., Counterpoint, 1998), 104; *The Merry Pranksters* (video) Key-Z Productions, 755 Polk Street, Eugene, Oregon; Kesey interview, *The Paris Review*, 64; Watson, *The Beat*, 287–288.

38. Vic Lovell in *One Lord, One Faith, One Cornbread*, 171, 173; Bob Stone, *Prime Green: Remembering the Sixties* (New York: CCC, 2007), 83; McClanahan interview.

39. Bob Stone, *Prime Green*, 91; Kesey quoted in *The Merry Pranksters* (video).

40. McClanahan interview; Stone, *Prime Green*, 96.

41. John Kruth, *Bright Moments: The Life and Legacy of Rahsaan Roland Kirk* (New York: Welcome Rain Publishers, 2000), 212.

42. *The Life and Times of Allen Ginsberg* (video), New York: First Run Features, 1993.

43. Tom Wolfe, *Electric Kool-Aid Acid Test* (New York: Farrar, Straus & Giroux, 1968), 7, 339; "Kesey Postgrad Trial," *The East Village Other* (May 1–15, 1967), 1.

44. Kerouac, *The Dharma Bums*, 10, 97.

45. Richard Rurland and Malcolm Bradbury, *From Puritanism to Postmodernism: A History of American Literature* (New York: Penguin, 1992), 342.

46. Tom Wolfe, *Electric Kool-Aid Acid Test*, 324, 339; Robert Christgau, "Anatomy of a Love Festival," *Esquire* (January 1968), 64.

47. Ralph J. Gleason, *The Jefferson Airplane and the San Francisco Sound* (New York: Ballantine Books, 1969), 27; Hunter S. Thompson, "The 'Hashbury' Is the Capital of the Hippies," *New York Times Magazine* (May 14, 1967), 29; Bill Graham and Robert Greenfield, *Bill Graham Presents: My Life Inside Rock and Out* (New York: Doubleday, 1992), 142.

48. Michael Rossman, *Wedding Within the War*

(Garden City, NY: Doubleday, 1971), 329; Grace Slick with Andrea Cagan, *Somebody to Love: A Rock and Roll Memoir* (New York: Warner Books, 1998), 97.

49. *The Rock of Ages: The Rolling Stone History of Rock & Roll*, ed. Ed Ward, Geoffrey Stokes, Ken Tucker (New York: Rolling Stone Press, 1986), 329.

50. "Shelly's Manne-Hole," advt. in *San Francisco Free Press* (March 15, 1965), 4; Gleason, *Jefferson Airplane*, 249; Hicks, *Sixties Rock: Garage, Psychedelic, and Other Satisfactions* (Chicago: University of Illinois Press, 1999), 62.

51. Sandy Troy, *Captain Trips: A Biography of Jerry Garcia* (New York: Thunder's Mouth Press), 22; Jackson, *Garcia*, 108.

52. Lydon, "The Word," *Esquire*, (September 1967), 165.

53. Graham and Greenfield, 184–185; Peter Coyote, *Sleeping Where I Fall: A Chronicle* (Washington, D.C.: Counterpoint, 1998), 69.

54. Cecile Whiting, *POP L.A.: Art and the City in the 1960s* (Berkeley: University of California Press, 2006).

55. Ray Manzarek, *Light My Fire: My Life with the Doors* (New York: Berkley Boulevard Books, 1998), 68.

56. Wallace Fowlie. *Rimbaud and Jim Morrison: The Rebel as Poet* (Durham: Duke University Press, 1993), 3, 97; Kerouac, *On the Road*, 310.

57. Jim Riordan and Jerry Prochnicky, *Break on Through: The Life and Death of Jim Morrison* (New York: William Morrow & Co., 1991), 53; Chuck Cristafelli and ed. Dave Dimartino, *The Doors When the Music's Over: The Stories Behind Every Song* (New York: Thunder's Mouth Press, 2000), 25, 32, 135; "Opening the Doors," *East Village Other* (July 1–15, 1967), 11.

58. John Densmore, *Riders on the Storm: My Life with Jim Morrison and the Doors* (New York: Delta Trade Paperback, 2000), 16, 18; Manzarek, *Light My Fire*; Jim Morrison, *The Lords and the New Creatures: Poems*, 1969 (New York: Fireside, 1987), 74; Tytell, *The Living Theatre*, 256–257.

59. Manzarek, *Light My Fire*, 77; Densmore, *When the Music's Over*, 20, 22, 64.

60. Quoted in Ben Watson, *Frank Zappa: The Negative Dialectics of Poodle Play* (New York: St. Martin's Press, 1995), 35.

61. Bill Milkowski "Frank Zappa, Guitar Player" *Down Beat* (February 1983), 14; Frank Zappa, "The Oracle Has It All Psyched Out," *Life* (June 28, 1968), 85.

62. Barry Miles, *Zappa: A Biography* (New York: Grove Press, 2004), 286–287; Bruce Pollock, *Working Musicians: Defining Moments from the Road, the Studio, and the Stage* (Harper Entertainment, 2002), 302–303.

63. Miles, *Zappa*, 287; Tim Schneckloth, "Frank Zappa: Garni Du Jour, Lizard King Poetry, and Slime," *Down Beat* (May 18, 1978), 45; Frank Zappa with Peter Occhiogrosso, *The Real Frank Zappa Book* (New York: Poseidon Press, 1989), 140.

64. Grace Slick, *Somebody to Love? A Rock and Roll Memoir* (New York: Warner Books, 1998), 152.

65. Chris Hodenfield, *Rock '70* (New York: Pyramid Books, 1970), 72.

66. Neil Slaven, *Electric Don Quixote: The Definitive Story of Frank Zappa* (New York: Omnibus Press, 1996), 138; Miles, *Zappa*, 41–42.

67. *Rock '70*, 73.

Epilogue

1. Thompson, *New York Times Magazine*, 123; Coyote, *Sleeping Where I Fall*, 135; Earl Shorris, "Love Is Dead" *New York Times Magazine* (October 29, 1967), 115; Nicholas Von Hoffman, *We Are the People Our Parents Warned Against* (Greenwich, CT: Fawcett Crest Book, 1968), 18.

2. "Where Are They Now? The Haight-Ashbury Scene," *Newsweek* (December 2, 1968).

3. Hentoff quoted in "Trouble in Hippieland," *Newsweek* (October 30, 1967), 88; Hunter S. Thompson, *Fear and Loathing in America: The Brutal Odyssey of an Outlaw Journalist* (New York: Simon & Schuster, 2000), 234, 235.

4. Allan Katzman, "Poor Man's Almanac," *East Village Other* (May 1–15, 1967), 9.

5. Camille Paglia, "The Magic of Images: Word and Picture Images in a Media Age," *Arion* (Winter 2000), 8; Ann Powers, *Weird Like Us: My Bohemian America* (New York: Simon & Schuster, 2000), 28, 30.

Selected Bibliography

Manuscript Collections

Alfred Stieglitz Archive. Yale University Library.

Dr. John Weichsel Papers. Archives of American Art. Detroit.

Edward Steichen Papers. Museum of Modern Art.

Georgia O'Keeffe Papers. Yale University Library.

Gertrude Stein Archive. Yale University Library.

Henry McBride Papers. Archives of American Art. Detroit.

Mabel Dodge Papers. Yale University Library.

Marsden Hartley Papers. Yale University Library.

Sherwood Anderson Papers. Newberry Library. Chicago. Art Institute of Chicago Archives.

Stieglitz Collection. International Museum of Photography. George Eastman House, Rochester, New York.

Books and Articles

Aaron, Daniel. *Writers on the Left*. 1961. New York: Columbia University Press, 1992.

Abrahams, Edward. *The Lyrical Left: Bourne and Alfred Stieglitz and the Origins of Cultural Radicalism in America*. Charlottesville, VA: University Press of Virginia, 1986.

Aldridge, John. *After the Lost Generation*. New York: Noonday Press, 1951.

Allen, Frederick Lewis. *Only Yesterday: An Informal History of the 1920s*. 1931. New York: John Wiley & Sons Inc., 1997.

Allen, Gay Wilson. *The Solitary Singer: A Critical Biography of Walt Whitman*. New York: New York University Press, 1967.

_____. *Waldo Emerson: A Biography*. New York: Viking Press, 1981.

Ambrose Bierce: A Sole Survivor, Bits of Autobiography. Edited by S.T. Joshi and David E.

Schultz. Knoxville: University of Tennessee Press, 1998.

American Poster Art of the 1890s. Ed. Phillip Dennis Cate, Nancy Finlay et al. New York: Harry N. Abrams, 1987.

Ames, Morgan. Liner notes to *Miles Davis at the Fillmore*. Columbia, 1970.

Amram, David. *Offbeat: Collaborating with Jack Kerouac*. New York: Thunder's Mouth Press, 2002.

Anderson, Elliott, and Mary Kinzie, eds. *The Little Magazine in America: A Modern Documentary History*. Yonkers, New York: Pushcart Press, 1978.

Anderson, Margaret. *My Thirty Years War: The Autobiography Beginnings and Battles to 1930*. New York: Horizon Press, 1969.

Anderson, Sherwood. *Letters of Sherwood Anderson*. Edited by Howard Mumford Jones and Walter B. Rideout. Boston: Little, Brown, & Co., 1953.

_____. *Sherwood Anderson's Memoirs: A Critical Edition*. 1942. Chapel Hill: University of North Carolina Press, 1969.

Andrews, Clarence A. *Chicago in Story: A Literary History*. Iowa City, IA: Midwest Heritage Pub., 1982.

Antliff, Allan. *Anarchist Modernism: Art, Politics, and the First Avant-Garde*. Chicago: University of Chicago Press, 2001.

Ashcroft, Linda. *Wild Child: My Life with Jim Morrison*. New York: Thunder Mouth's Press, 1997.

Babbs, John. *Prankster Memoirs*. Eugene, OR: Angle Productions, 2003.

Babbs, Ken, and Paul Perry. *On the Bus: The Complete Guide to the Legendary Trip of Ken Kesey and the Merry Pranksters and the Birth of a Counterculture*. Edited by Michael Schwartz and Neil Ortenberg. New York: Thunder's Mouth Press, 1990.

Baker, Carlos. *Ernest Hemingway: A Life Story*. New York: Avon Books, 1968.

233

Baker, Paul R. *Stanny: The Gilded Life of Stanford White.* New York: Free Press, 1989.

Balakian, Ann. *Surrealism, Road to the Absolute.* Chicago: University of Chicago Press, 1986.

Baldwin, James. *Another Country.* New York: Dell, 1962.

_____. *Nobody Knows My Name.* New York: Dell, 1963.

Baldwin, Neil. *Man Ray, an American Artist.* 2d. ed. New York: Da Capo, 2000.

Balliett, Whitney. *American Musicians II: Seventy-one Portraits in Jazz.* New York: Oxford University Press, 1996.

_____. "Love Match: Miles Davis and Gil Evans Made Magic Out of Melancholy." *New Yorker,* 26 August 1996.

Balzac, Honoré de. George Saintsbury ed. *The Works of Honoré de Balzac, The Member of Arcis, The Seamy Side of History, and Other Stories.* Introduction by George Saintsbury. Philadelphia: Avil Publishing Co., 1901.

Baraka, Amiri. *The Autobiography of LeRoi Jones.* Chicago: Lawrence Hill Books, 1997.

Barnes, Djuna. *Interviews.* Edited by Alyce Barry, foreword by Douglas Messerli. Washington, D.C.: Sun & Moon Press, 1985.

Barrett, William. "The Atlantic Bookshelf." *The Atlantic,* August 1964, 118–119.

Barrus, Clara. *Whitman and Burroughs: Comrades.* New York: Houghton Mifflin, 1931.

Barzun, Jacques. *Classic Romantic and Modern.* New York: Anchor Books, 1961.

_____. *From Dawn to Decadence: 500 Years of Western Cultural Life, 1500 to the Present.* New York: Harper Collins, 2000.

Basso, Etolia S., ed. *The World from Jackson Square: A New Orleans Reader.* Introduction by Hamilton Basso. New York: Farrar, Straus and Co., 1948.

Baudelaire, Charles. *The Painter of Modern Life and Other Essays.* Trans. and ed. Jonathan Mayne. New York: Da Capo, 1964.

Beard, Rick, and Leslie Cohen Berlowitz, eds. *Greenwich Village: Culture and Counterculture.* New Brunswick, NJ: Rutgers University Press, 1993.

The Beat Generation: An American Dream. Video dir. by Jane Forman. Renaissance Motion Pictures, 1987.

Beer, Thomas. *The Mauve Decade: American Life at the End of the Nineteenth Century.* 1926. New York: Vintage Books, 1961.

Belgrad, Daniel. *The Culture of Spontaneity: Improvisation and the Arts in Postwar America.* Chicago: University of Chicago, 1998.

Bender, Thomas. *New York Intellect: A History of Intellectual Life in New York City, From 1750 to the Beginnings of Our Own Time.* Baltimore: Johns Hopkins University Press, 1987.

Benfry, Christopher. *Degas in New Orleans: Encounters with the Creole World of Kate Chopin and George Washington Cable.* New York: Alfred A. Knopf, 1997.

Bingham, Sue. "The Intelligent Square's Guide to Hippieland." *The New York Times Magazine,* 24 September 1967.

Blake, Casey Nelson. *Beloved Community: The Cultural Criticism of Randolph Bourne, Van Wyck Brooks, Waldo Frank, and Lewis Mumford.* Chapel Hill: University of North Carolina Press, 1990.

Blanchard, Mary Warner. *Oscar Wilde's America: Counterculture in the Gilded Age.* New Haven: Yale University Press: 1998.

Bloom, Alan. *The Closing of the American Mind.* New York: Simon & Schuster, 1987.

Blotner, Joseph. *Faulkner, A Biography,* Vol. I. New York: Random House, 1974.

Bogdanovich, Peter. *This Is Orson Welles.* New York: Da Capo, 1988.

Bontemps, Arna, ed. *The Harlem Renaissance Remembered.* New York: Dodd, Meade & Co., 1972.

"Books" section of *Time.* Review of Ezra Pound's XXX Cantos, 20 March 1933.

Bourne, Randolph. *War and the Intellectuals: Collected Essays, 1915–1919.* Edited by Carl Resek. New York: Harper & Row, 1964.

Bowart, Walter. "The Birth of the Sufi." *East Village Other,* 15–22 October 1967, 3.

Brady, Frank. *Citizen Welles: A Biography of Orson Welles.* New York: Scribner & Sons, 1989.

Breton, André. *What Is Surrealism? Selected Writings.* Edited by Frank Rosemont. New York: Pathfinder, 1978.

Bricktop, *Bricktop,* with James Haskins. New York: Athenaeum, 1983.

Brightman, Carol. *Sweet Chaos: The Grateful Dead's American Adventure* New York: Pocket Books, 1999.

Brinkley, Douglas, ed. *Windblown World: The Journals of Jack Kerouac, 1947–1954.* New York: Viking, 2004.

Brooks, David. *Bobos in Paradise: The New Upper Class and How They Got There.* New York: Simon & Schuster, 2000.

Brooks, Van Wyck. *America's Coming-of-Age.* New York: Doubleday, 1958.

_____. *The Confident Years, 1885–1915.* New York: E. P. Dutton Press, 1952.

_____. *The Flowering of New England, 1815–1865.* New York: Modern Library, 1936.

_____. *The Times of Melville and Whitman.* New York: E. P. Dutton & Co., 1947.

Brustein, Robert. *Seasons of Discontent: Dramatic Opinions, 1959–1965.* New York: Simon & Schuster, 1967.

Burns, Ken. *Jazz.* "Risk." Episode Eight. PBS Home Video, 2000.

_____. *Mark Twain.* Film documentary, Florentine Films, 2001.

Burns, Sarah. *Inventing the Modern Artist: Art and Culture in Gilded Age America.* New Haven: Yale University Press, 1996.

Burroughs, William. *Junkie.* 1953. 3rd printing. New York: Ace Books, 1973.

Burrows, Edwin G., and Mike Wallace. *Gotham: A History of New York City to 1898.* New York: Oxford University Press, 1999.

Bushell, Garvin. *Jazz from the Beginning.* As Told to Mark Tucker. First paperback ed., Ann Arbor: University of Michigan Press, 1980.

Butler, Christopher. *Early Modernism: Literature, Music, Painting, in Europe, 1900–1916.* New York: Oxford University Press, 1994.

Cabanne, Pierre. *Dialogues with Marcel Duchamp.* New York: Da Capo, 1979.

Caen, Herb. *Don't Call It Frisco.* Garden City, NY: Doubleday & Co., 1953.

_____. *Herb Caen's New Guide to San Francisco and the Bay Area.* Rev. ed. New York: Doubleday & Co., 1958.

_____. *Only in Frisco.* Garden City, NY: Doubleday & Co., 1960.

Calloway, Stephen. *Aubrey Beardsley.* New York: Harry N. Abrams, 1998.

Camfield, William A. *Francis Picabia.* New York: Solomon R. Guggenheim Foundation, 1970.

Campbell, James. *Talking at the Gates: The Life of James Baldwin.* Berkeley: University of California Press, 1991.

_____. *This Is the Beat Generation, New York — San Francisco — Paris.* Berkeley: University of California Press, 2001.

Carpenter, Humphrey. *A Serious Character: The Life of Ezra Pound.* Boston: Houghton Mifflin, 1988.

Carr, Harry. *Los Angeles, City of Dreams.* New York: D. Appleton-Century, 1935.

Carr, Ian. *Miles Davis: A Definitive Biography.* New York: Thunder's Mouth Press, 1998.

Cerf, Bennett. *At Random: The Reminiscences of Bennett Cerf.* New York: Random House, 1977.

Chain, Steve. "Telegraph Avenue in Berkeley: After the Barricades, Let the People Decide." *Ramparts,* 24 August 1968, 23–26.

Chamberlin, Stafford. "Charles Mingus, 'If They Don't Like My Music, They Don't Like Me.'" *Los Angeles Free Press,* 8 October 1965, 5.

_____. "Impressions at Mother's Neptune." *Los Angeles Free Press,* 13 August 1965, 5–6.

Chambers, Jack. *Milestones 2: The Music and Times of Miles Davis Since 1960.* New York: William Morrow, 1985.

Chapin, Anna Alice. *Greenwich Village.* New York: Dodd, Mead, & Co., 1917.

Charters, Ann, ed. *Beat Down to Your Soul: What Was the Beat Generation?* New York: Penguin, 2001.

_____. *Kerouac, A Biography.* San Francisco: Straight Arrow Books, 1973.

_____. *The Portable Beat Reader.* New York: Viking, 1992.

_____. *The Portable Sixties Reader.* New York: Penguin Books, 2003.

Chase, Gilbert. *America's Music: From the Pilgrims to the Present.* New York: McGraw-Hill Book Co., 1955.

Chauncey, George. *Gay New York: Gender, Urban Culture, and the Making of a Gay Male World, 1890–1940.* New York: Basic Books, 1994.

Cherkovski, Neeli. *Ferlinghetti: A Biography.* New York: Doubleday, 1979.

Child, Theodore. "Proletarian Paris." *New Harper's Monthly,* January 1893, 185–198.

Chinoy, Helen Krich, and Linda Walsh Jenkins, eds. *Women in American Theatre: Careers, Images, Movements: An Illustrated Anthology and Sourcebook.* New York: Crown Pub., 1981.

Chisholm, Lawrence W. *Ernest Fenollosa: The Far East and American Culture.* New Haven: Yale University Press, 1963.

Christgau, Robert. "Anatomy of a Festival." *Esquire,* January 1968, 61–67, 147–153.

Churchill, Allen. *The Improper Bohemians.* New York: Ace Books, 1959.

Clapp, Henry. "A New Portrait of Paris: Painted From Life." *The New York Saturday Press,* January 8, 1859.

Clayton, Bruce. *Forgotten Prophet: The Life of Randolph Bourne.* Columbia, MO.: University of Missouri Press, 1984.

Clayton, Douglas. *Floyd Dell: The Life of an American Rebel.* Chicago: Ivan R. Dee, 1994.

Clurman, Harold. *The Fervent Years: The Story of the Group Theatre.* New York: Hill & Wang, 1957.

Cohen, Marty. "The Fugs: Nextness Is Godlier Than Cleanliness." *Avant-Garde,* January 1968, 52–56.

Cohen, Scott. "Don't Ask Me Nothin' I Might Just Tell the Truth." *Spin,* December 1985, 39.

Colacello, Bob. *Holy Terror: Andy Warhol Close Up.* New York: Harper Perennial, 1991.

"Colorful Shorthand." *Time,* 6 January 1936, 44.

Commager, Henry Steele. *The American Mind: An Interpretation of the American Mind Since the 1880s.* New Haven: Yale University Press, 1950.

The Commentary Reader: Two Decades of Articles and Stories. Edited by Norman Podhoretz. Introduction by Alfred Kazin. New York: Atheneum, 1966.

Communism in America: A History in Documentaries. Edited by Albert Fried. New York: Columbia University Press, 1997.

"Composers Chronicle." Time, 2 November 1936, 38, 40.

Condon, Eddie. We Called It Music: A Generation of Jazz. New York: Holt & Co. 1947.

Conover, Ann. Olga Rudge and Ezra Pound. New Haven: Yale University Press, 2001.

Conrad, Peter. Modern Times, Modern Places. New York: Alfred A. Knopf, 1999.

Cook, Bruce. The Beat Generation. New York: Charles Scribner's Sons, 1971.

Cooney, Terry A. The Rise of the New York Intellectuals: Partisan Review and Its Circle. Madison: University of Wisconsin Press, 1986.

Copland, Aaron. Our New Music. New York: McGraw-Hill & Co. 1941.

_____. What to Listen for in Music, rev. ed. New York: Mentor Book, 1957.

_____, with Vivian Perlis. Copland, 1900 through 1942. New York: St. Martin's Press, 1984.

Cortissoz, Royal. American Artists. New York: Charles Scribner's & Sons, 1923.

Cowley, Malcolm. The Dream of Golden Mountains: Remembering the 1930s. New York: Penguin Books, 1964.

_____. Exile's Return: A Literary Odyssey of the 1920s. 1934. New York: Penguin Books, 1976.

_____. The Flower and the Leaf: A Contemporary Record of American Writing Since 1941. New York: Viking Press, 1985.

_____. A Second Flowering: Works and Days of the Lost Generation. New York: Viking Press, 1973.

Coyote, Peter. Sleeping Where I Fall: A Chronicle. Washington, D.C.: Counterpoint, 1998.

"Craft Interview with Allen Ginsberg." New York Quarterly, Spring 1972, 12–40.

Crane, Diana. The Transformation of the Avant-Garde: The New York Art World, 1940–1985. Chicago: University of Chicago Press, 1987.

Crane, Hart. The Letters of Hart Crane. Edited by Brom Weber. Berkeley: University of California Press, 1962.

Crane, Stephen. Stephen Crane Prose and Poetry. New York: The Library of America, 1984.

Crawford, Cheryl. One Naked Individual: My Fifty Years in the Theatre. New York: Bobbs & Merrill Co. Inc., 1977.

Crisafulli, Chuck. The Doors: When the Music's Over, The Stories Behind Every Song. Edited by Dave DiMartino. New York: Thunder's Mouth Press, 2000.

"Crow Jim." Time, 19 October 1962, 58.

Crow, Thomas. The Rise of the Sixties: American and European Art in the Era of Dissent. New York: Harry N. Abrams, 1996.

Croyden, Margaret. Lunatics, Lovers, and Poets: The Experimental Theatre. New York: Delta, 1974.

Crunden, Robert M. American Salons: Encounters with European Modernism, 1885–1917. New York: Oxford University Press, 1993.

_____. From Self to Society, 1919–1941. Englewood Cliffs, NJ: Prentice-Hall, 1972.

"Cubism to Cynicism." Time, 31 August 1936, 22.

Dalziel, Hugh Duncan. The Rise of Chicago as Literary Center: A Sociological Essay in American Culture. Totowa, NJ: The Bedminster Press, 1964.

Davidson, Abraham A. Early American Modernist Painting, 1910–1935. New York: Harper & Row, 1981.

Davidson, Michael. The San Francisco Renaissance: Poetics and Community at Mid-Century. Cambridge: Cambridge University Press, 1989.

Davis, John H. The Guggenheims: An American Epic. New York: William Morrow & Co., 1978.

Davis, Linda H. Badge of Courage: The Life of Stephen Crane. New York: Houghton Mifflin, 1998.

Davis, Miles, with Quincy Troupe. Miles: The Autobiography. Simon & Schuster, 1990.

Davis, Stephen. Jim Morrison, Life, Death, Legend. New York: Gotham Books, 2004.

Dell, Floyd. Homecoming: An Autobiography. New York: Farrar & Rinehart, 1933.

Densmore, John. Riders on the Storm: My Life with Jim Morrison and the Doors. New York: Delta: 2000.

DeVeaux, Scott. Bebop: A Social and Musical History. Los Angeles: University of California Press, 1997.

De Wilde, Laurent. Monk. New York: Marlowe & Co., 1997.

A Dial Miscellany. ed. William Wasserstrom. Syracuse, NY: Syracuse University Press, 1963.

Dickason, David Howard. The Daring Young Men: The Story of the American Pre-Raphaelites. 1953. New York: Benjamin Bloom, 1970.

Dickstein, Morris. Gates of Eden: American Culture in the Sixties. New York: Penguin Books, 1989.

Dictionary of Literary Biography — Vol. 54, American Poets, 1880–1945. Third Series, Part I: A-M. Detroit: Gale Research, 1987.

Diggins, John P. The American Left in the Twentieth Century. New York: Harcourt Brace Jovanovich, 1973.

Dijkstra, Bram. Cubism, Stieglitz, and the Early Poetry of William Carlos Williams. 1969. Princeton: Princeton University Press, 1998.

Di Prima, Diane. *Recollections as My Life as a Woman: The New York Years.* New York: Viking, 2001.

Doggett, Peter. *Lou Reed: Growing Up in Public.* New York: Omnibus Press, 1992.

Dolan, Marc. *Modern Lives: A Cultural Rereading of "The Lost Generation."* West Lafayette, IN: Purdue University, 1996.

Domhoff, G. William. *The Bohemian Grove and Other Retreats: A Study in Ruling-Class Cohesiveness.* New York: Harper & Row, 1975.

Donahue, Don. "Avant-Garde Faces Metafiscal Loss." *Berkeley Barb,* 24 September 1965, 2.

Donaldson, Scott. *Archibald MacLeish: An American Life.* Boston: Houghton Mifflin, 1992.

Dos Passos, John. *The Fourteenth Chronicle: Letters and Diaries of John Dos Passos.* Edited by Townsend Ludington. Boston: Gambit, 1973.

_____. *Occasions and Protests.* Chicago: Henry Regency Co., 1964.

Douglas, Ann. *Terrible Honesty: Mongrel Manhattan in the 1920s.* New York: Farrar, Straus & Giroux, 1995.

du Maurier, George. *Trilby: A Novel.* New York: Harper & Brothers, 1894.

Dumoff, William G. *The Bohemian Grove and Other Retreats: A Study in Ruling Class Cohesiveness.* New York: Harper & Row, 1975.

Dylan, Bob. *Chronicles, Volume One.* New York: Simon & Schuster, 2004.

Earisman, Delbert L. *Hippies in Our Midst.* Philadelphia: Fortress Press, 1968.

Eastman, Max. *Enjoyment of Living.* New York: Harper & Brothers, 1948.

Edwards, Christine. *The Stanislavsky Heritage: Its Contributions to the Russian and American Theatre.* New York: New York University Press, 1965.

Eksteins, Modris. *Rites of Spring: The Great War and the Birth of the Modern Age.* New York: Anchor Books, 1990.

Ellison, Ralph. *Shadow and Act.* New York: Quality Paperback Book Club, 1953.

Ellman, Richard. *James Joyce.* First rev. ed. 1959. Rpt., New York: Oxford University Press, 1983.

_____. *Oscar Wilde.* New York: Vintage Books, 1988.

Emerson, Ralph Waldo. *The Heart of Emerson's Journals.* Edited by Bliss Perry. New York: Doubleday, 1937.

_____. *Selected Writings of Ralph Waldo Emerson.* Ed. William H. Gilman. New York: Signet, 263.

Ennis, Philip H. *The Seventh Stream: The Emergence of RocknRoll in American Music.* Hanover, NH: Wesleyan Press, 1992.

Evans, Oliver. *New Orleans.* New York: Macmillan, 1959.

Evergreen Review Reader, 1967–1973. Edited by Barney Rosset. New York: Four Walls Eight Windows, 1998.

Fabre, Michel. *From Harlem to Paris: Black American Writers in France, 1840–1980.* Chicago: University of Illinois Press, 1991.

Faulkner, William. *Mosquitoes.* 1927. Rpt., New York: Liveright, 1955.

Feather, Leonard. *Encyclopedia of Jazz.* New York: Bonanza Books, 1966.

_____. *Inside Jazz.* 1949. New York: Da Capo, 1977.

Feigelson, Naomi. *The Underground Revolution: Hippies, Yippies, and Others.* New York: Funk & Wagnall's, 1970.

Feinstein, Sascha, and Yusef Komunyakaa, eds. *The Jazz Poetry Anthology.* Bloomington: Indiana University Press, 1991.

Fiofori, Tam. "Sun Ra's Space Odyssey." *Down Beat,* 14 May 1970, 14–15.

Fishbein, Leslie. *Rebels in Bohemia: The Radicals of the Masses, 1911–1917.* Chapel Hill: University of North Carolina Press, 1982.

Fitch, Noel Riley. *Sylvia Beach and the Lost Generation: A History of Literary Paris in the Twenties and Thirties.* New York: W. W. Norton, 1983.

Fitzgerald, F. Scott. *The Beautiful and Damned.* 1922. New York: Modern Library, 2002.

_____. *The Last Tycoon.* 1941. New York: Collier Books: 1986.

_____. *The Short Stories of F. Scott Fitzgerald.* Edited with a preface by Matthew J. Bruccoli. New York: Scribner Paperback Fiction, 1989.

_____. *Tender Is the Night.* 1934. New York: Charles Scribner's Sons, 1962.

_____. *This Side of Paradise.* New York: Charles Scribner's Sons, 1920.

Flanagan, Bill. *Written in My Soul: Rock's Greatest Songwriters Talk About Their Music.* New York: Contemporary Books, 1986.

Flanagan, Hallie. *Arena: A History of the Federal Theatre.* 1940 reissue. New York: Benjamin Bloom, 1965.

Flanner, Janet. *Paris Was Yesterday, 1925–1939.* New ed. New York: Viking, 1972.

Fleming, Gordon. *The Young Whistler, 1834–66.* Boston: George Allen & Unwin, 1978.

Ford, Hugh. *Four Lives in Paris.* San Francisco: North Point Press, 1987.

Foster, George G. *New York in Slices.* New York: W. F. Burgess, 1849.

Fowlie, Wallace. *Mallarmé.* Chicago: University of Chicago Press, 1953.

_____. *Poem and Symbol: A Brief History of Symbolism.* University Park: Pennsylvania State University Press, 1990.

_____. *Rimbaud and Jim Morrison: The Rebel as Poet.* Durham: Duke University Press, 1993.

Frank, Waldo. *Our America*. 1919. New York: AMS Press, 1972.

_____, et al., eds. *America and Alfred Stieglitz: A Collective Portrait*. New York: Literary Guild, 1934.

Freeman, Bud, as told to Robert Wolf. *Crazeology: The Autobiography of a Chicago Jazzman*. Chicago: University of Illinois Press, 1989.

Freeman, Joseph. *An American Testament: A Narrative of Rebels and Romantics*. New York: Farrar & Rinehart, 1936.

Fried, Albert, ed. *Communism in America: A History in Documents*. New York: Columbia University Press, 1997.

Frothingham, Octavius Brooks. *Transcendentalism in New England: A History*. Philadelphia: University of Pennsylvania Press, 1876.

Fullinwider, S. P. *The Mind and Mood of Black America*. Homewood, IL: The Dorsey Press, 1969.

Gaddis, Eugene R. *Magician of the Modern: Chick Austin and the Transformation of the Arts in America*. New York: Alfred A. Knopf, 2000.

Gallanti, Barbara Dayer. *William Merritt Chase*. New York: Harry N. Abrams Inc. Pub., 1995.

Gammel, Irene. *Baroness Elsa: Gender, Dada, and Everyday Modernity, A Cultural Biography*. Cambridge: MIT Press, 2002.

Gann, Kyle. *American Music in the Twentieth Century*. New York: Schirmer Books, 1997.

Gans, David. *Conversations with the Dead: The Grateful Dead Interview Book*. Updated ed. New York: Da Capo, 2002.

Garrison, William Lloyd. *The Letters of William Lloyd Garrison, Vol. III, No Union with Slave Holders, 1841–1849*. Edited by Walter M. Merrill. Cambridge: Belknap Press of Harvard University Press, 1973, 473.

Gaunt, William. *The Aesthetic Adventure*. New York: Schocken Books, 1967.

Gelb, Arthur. *City Room*. Paperback ed., New York: Berkley Books, 2003.

_____, and Barbara. *O'Neill: Life with Monte Cristo*. New York: Applause, 2000.

Gelber, Jack. *The Connection*. Introduction by Kenneth Tynan. New York: Grove Press, 1960.

Geldzahler, Henry. *Making It New: Essays, Interviews, and Talks*. New York: Turtle Point Press, 1994.

Giddins, Gary. *Celebrating Bird: The Triumph of Charlie Parker*. New York: Beechtree Books, 1987.

Gilbert, James B. *Writers and Partisans: A History of Literary Radicalism in America*. New York: John Wiley & Sons, 1968.

Gillespie, Dizzy, with Al Fraser. *Dizzy: To Be or Not to Bop*. New York: Doubleday & Co., 1979.

Gillman, Richard. *Decadence: The Strange Life of an Epithet*. New York: Farrar Strauss & Giroux, 1979.

Ginsberg, Allen. *Deliberate Prose: Selected Essays, 1952–1995*. Edited by Bill Morgan. Foreword by Edward Sanders. New York: Perennial, 2000.

_____. Liner notes to *The Fugs*. ESP Disk, 1966.

_____. *Spontaneous Mind: Selected Interviews, 1958–1996*. Edited by David Carter, introduction by Edmund White. New York: Perennial, 2001.

Gioia, Ted. *The History of Jazz*. New York: Oxford University Press, 1997.

_____. *West Coast Jazz: Modern Jazz in California, 1945–1960*. New York: Oxford University Press, 1992.

Gitler, Ira. *Swing to Bop: An Oral History of the Transition of Jazz in the 1940s*. New York: Oxford University Press, 1985.

_____. *Jazz Masters of the Forties*. New York: Collier Books, 1966.

_____. Liner notes to *The Music from the Connection*, Freddie Redd, Blue Note CD, 2005.

Gitlin, Todd. *The Sixties: Years of Hope, Days of Rage*. New York: Bantam Books, 1987.

Gleason, Ralph J. *The Jefferson Airplane and the San Francisco Sound*. New York: Ballantine Books, 1969.

_____. Liner notes to *John Coltrane's Sound*. Atlantic Records, 1964.

Gold, Herbert. *Bohemia: Where Art, Angst, Love, and Strong Coffee Meet*. New York: Simon & Schuster, 1993.

Goldberg, Joe. Liner notes to *Kenny Burrell On View at the Five Spot*. Recorded in 1959. Blue Note, 1987.

Golden Gate: Interviews with 5 San Francisco Poets. Rev. ed. Edited by David Meltzer. Berkeley, CA: Wingbow Press, 1976.

Goldman, Emma. *Living My Life. in Two Volumes, Vol. II*. 1937. New York: Dover Pub., 1970.

Goldman, Eric. *Rendezvous with Destiny: A History of Modern American Reform*. Rev. ed. New York: Vintage Books, 1977.

Good Times: An Oral History of America in the Nineteen Sixties. Edited by Peter Joseph. New York: William Morrow, 1973.

Goodrich, Lloyd. *Winslow Homer*. New York: Whitney Museum of Art with Macmillan Co., 1944.

Gordon, Max. *Live at the Village Vanguard*. Introduction by Nat Hentoff. New York: Da Capo, 1980.

Gottlieb, Robert, ed. *Reading Jazz: A Gathering of Autobiography, Reportage, and Criticism*

from 1919 to Now. New York: Pantheon Books, 1996.

Gourse, Leslie. *Straight, No Chaser: The Life and Genius of Thelonious Monk*. New York: Simon & Schuster, 1997.

Graham, Bill, and Robert Greenfield. *Bill Graham Presents: My Life Inside Rock and Out*. New York: Doubleday, 1992.

Gray, Michael. *Mother: The Frank Zappa Story*. London: Plexus, 1994.

Green, Benny. *The Reluctant Art: Five Studies in the Growth of Jazz*, Enlarged ed., New York: Da Capo, 1991.

Green, Jonathan, ed. *Camera Work: A Critical Anthology*. Millerton, NY: Aperture,, 1973.

Green, Martin. *New York 1913: The Armory Show and the Patterson Strike Pageant*. New York: Collier Books, 1988.

Greene, Naomi. *Antonin Artaud: Poet Without Words*. New York: Simon & Schuster, 1970.

Grenander, M. E. *Ambrose Bierce*. New York: Twayne Pub, 1971.

Griffin, C. S. *The Ferment of Reform, 1830–1860*. New York: Thomas Y. Crowell Co., 1967.

Grosser, Maurice. Liner notes to *Virgil Thomson, Four Saints in Three Acts*. CD, Nonesuch Records, 1982.

Gruen, John. *The New Bohemia: The Combine Generation*. New York: Shorecrest, 1966.

_____. *The Party's Over Now: Reminiscences of the Fifties — New York's Artists, Writers, and Musicians, and Their Friends*. New York: Viking Press, 1972.

Guggenheim, Peggy. *Out of This Century: Confessions of an Art Addict*. New York: Universe Books, 1979.

Gullason, Thomas A., ed. *Stephen Crane's Career: Perspectives and Evaluations*. New York: New York University Press, 1972.

Hadlock, Richard. *Jazz Masters of the '20s*. 1972. Rpt., New York: Da Capo, 1988.

Hahn, Emily. *Romantic Rebels: An Informal History of Bohemianism in America*. Boston: Houghton Mifflin, 1967.

Haine, W. Scott. *The World of the Paris Café: Sociability Among the French Working Class, 1789–1914*. Baltimore: Johns Hopkins University Press, 1996.

Hamalian, Linda. *A Life of Kenneth Rexroth*. New York: W. W. Norton, 1991.

Hansen, Arlen J. *Expatriate Paris: A Cultural and Literary Guide to Paris of the 1920s*. New York: Arcade Pub., 1990.

Hapgood, Hutchins. *A Victorian in the Modern World*. New York: Harcourt Brace, 1939.

Harris, Neil. *The Artist in American Society: The Formative Years, 1790–1860*. New York: George Braziller, 1966.

Hart, James D. *The Popular Book: A History of*

America's Taste. Berkeley: University of California Press, 1961.

Haskell, Barbara. *Joseph Stella*. New York: Whitney Museum of Art, 1994.

Havel, Hippolyte. "After Twenty-Five Years," *Mother Earth*, November 1912, 293..

_____. "Kropotkin the Revolutionist." *Mother Earth*, December 1912, 320–327.

_____. "Syndicalism," *Mother Earth*, October 1912, 255–257

Hawthorne, Nathaniel. 1852. *The Blithedale Romance*. New York: W. W. Norton, 1958.

Hecht, Ben. *A Child of the Century*. New York: Simon & Schuster, 1954.

Heller, Adelle, and Lois Rudnick, eds. *1915: The Cultural Moment: The New Politics, the New Woman, the New Psychology, the New Art, and the New Theatre in America*. New Brunswick, NJ: Rutgers University Press, 1991.

Hemenway, Robert. Foreword by Alice Walker. *Zora Neale Hurston: A Literary Biography*. Champaign: University of Illinois Press, 1980.

Hemingway, Ernest. *A Moveable Feast*. New York: Charles Scribner's Sons, 1964.

_____. *The Sun Also Rises*. New York: Charles Scribner's Sons, 1926.

Henri, Robert. *The Art Spirit*. 1923. Rpt., New York: Harper & Row, 1951.

Hentoff, Nat. Liner notes to *Newport Rebels: Jazz Artists Guild*. Candid, CD release 1991.

Hess, Thomas B., and John Ashbery, eds. *Avant-Garde Art*. New York: Collier, 1967.

Hewitt, Nicholas. *The Life of Celine: A Critical Biography*. Malden, MA: Blackwell Publishers, 1999.

Hicks, Michael. *Sixties Rock: Garage, Psychedelic, and Other Satisfactions*. Chicago: University of Chicago, 1999.

Himelstein, Morgan Y. *Drama as a Weapon: The Left-Wing Theatre in New York, 1929–1941*. New Brunswick, NJ: Rutgers University Press, 1963.

Hinton, Brian. *Joni Mitchell: Both Sides Now, The Biography*. London: Sanctuary Pub. Ltd., 1996.

The Hippies. Joe David Brown, ed. New York: Time, 1967.

Hobbs, Stuart D. *The End of the American Avant-Garde*. New York: New York University Press, 1997.

Hobson, Fred. *Mencken: A Life*. Baltimore: Johns Hopkins University Press, 1994.

Hochfield, George, ed. *Selected Writings of the American Transcendentalists*. New York: New American Library, 1966.

Hoffman, Andrew. *Inventing Mark Twain: The Lives of Samuel Langhorne Clemens*. New York: William Morrow, 1997.

Hofstadter, Richard, ed. and intro. *The Pro-*

gressive Movement, 1900–1915. 1963. New York: Touchstone, 1966.

Holborn, Hajo. A History of Modern Germany, 1840–1945. Princeton: Princeton University Press, 1969.

Holdenfield, Chris. Rock '70. New York: Pyramid Books, 1970.

Holliday, J. S. The World Rushed In: The California Gold Rush Experience, An Eyewitness Account of a Nation Heading West. New York: Touchstone, 1983.

Hollier, Dennis, ed. A New History of French Literature. 2nd ed. Cambridge: Cambridge University Press, 1994.

Homer, William Innes, with the assistance of Violet Organ. Alfred Stieglitz and the American Avant-Garde. Boston: New York Graphic Society, 1977.

_____. Robert Henri and His Circle. Ithaca, NY: Cornell University Press, 1969.

Honour, Hugh. Romanticism. New York: Harper & Row, 1979.

Hoppes, James. Van Wyck Brooks: In Search of American Culture. Amherst: University of Massachusetts Press, 1977.

Horowitz, Joseph. Wagner Nights: An American History. Berkeley: University of California Press, 1994.

Hotchner, A. E. Papa Hemingway: A Personal Memoir. New York: Random House, 1966.

Houseman, John. Entertainers and the Entertained: Essays on Theater, Film, and Television. New York: Perennial, 2000.

_____. Run-Through; A Memoir. New York: Simon & Schuster, 1972.

Howe, Irving. A Margin of Hope: An Intellectual Autobiography. New York: Harcourt Brace Jovanovich, 1982.

_____. Sherwood Anderson. 1951. Stanford, CA: Stanford University Press, 1961.

Howells, William Dean. The Coast of Bohemia. New York: Harper & Brothers, 1893.

_____. Literary Friends and Acquaintances: A Personal Retrospect of American Authorship. New York: Harper & Brothers, 1900.

Huddleston, Sisley. Paris, Salons, Cafes, Studios, Being Social, Artistic, and Literary Memories. Philadelphia: J. B. Lippincott Co. 1928.

Huggins, Nathan. Harlem Renaissance. New York: Oxford University Press, 1971.

Hughes, Langston. The Big Sea, An Autobiography. 1940. New York: Hill & Wang, 1963.

Hughes, Robert. American Visions: The Epic History of American Art. New York: Alfred A. Knopf, 1997.

_____. The Shock of the New: The Hundred-Year History of Modern Art — Its Rise, Its Dazzling Achievement, Its Fall. 2nd ed. New York: Alfred A. Knopf, 1980.

_____. "What Alfred Barr Saw." Esquire, December 1983, 402–413.

Huneker, James. Steeplejack. New York: Charles Scribner's Sons, 1925.

Huston, John. Open Book. New York: Da Capo, 1994.

Hyde, Lewis, ed. The Essays of Henry David Thoreau. New York: North Point Press, 2002.

Imber, Naphtali Herz. Master of Hope: Selected Writings; Edited by Jacob Kabakoff. Toronto: Associated University Press, 1985.

Israel, Betsy. Bachelor Girls: The Secret History of Single Women in the Twentieth Century. New York: William Morrow, 2002.

Jack Kerouac Collection. Liner notes to CD Rhino Records, 1990.

Jack Kerouac, King of the Beats. Goldhill DVD, 2003.

Jackson, Blair. Garcia: An American Life. New York: Viking, 1999.

Jackson, Holbrook. The Eighteen Nineties: A Review of Art and Ideas at the Close of the Nineteenth Century. 1923. New York: Alfred A. Knopf, 1927.

Jackson, Jeffrey H. Making Jazz French: Music and Modern Life in Interwar Paris. Durham, NC: Duke University Press, 2003.

Jacoby, Russell. The Last Intellectuals: American Culture in the Age of Academe. New York: Basic Books, 1987.

Jaffe, Irma B. Joseph Stella. Rev. ed. New York: Fordham University, 1988.

James, William. The Ambassadors. 1903. New York: Penguin Books, 1986.

Jay, Paul, ed. The Selected Correspondence of Kenneth Burke and Malcolm Cowley, 1915–1981. New York: Viking, 1988.

Jenkins, Nicholas, ed. By With To & From: A Lincoln Kirstein Reader. New York: Farrar, Straus & Giroux, 1991.

John Cage's Diary III. Advertisement. East Village Other, 1–15 September 1967, 20.

Johnson, Joyce. Door Wide Open: A Beat Love Affair in Letters. New York: Viking, 2000.

_____. Minor Characters: A Young Woman's Coming-of-Age in the Beat Orbit of Jack Kerouac. New York: Anchor Books, 1994.

Johnson, S. T., and David E. Schultz, eds. Ambrose Bierce: A Sole Survivor, Bits of Autobiography. Knoxville: University of Tennessee Press, 1998.

Jones, Hettie. How I Became Hettie Jones. New York: Grove Press, 1990.

Jones, Idwal. Ark of Empire: San Francisco's Montgomery Block. New York: Ballantine Books, 1972.

Jones, LeRoi. Black Music. New York: William Morrow, 1968.

Jonnes, Jill. Hep-Cats, Narcs, and Pipe Dreams:

A History of America's Romance with Illegal Drugs. Baltimore: Johns Hopkins University Press, 1996.

Josephson, Matthew. *Life Among the Surrealists: A Memoir of a Literary Period.* New York: Holt, Rinehart & Winston, 1962.

Judd, Alan. *Ford Maddox Ford.* Cambridge: Harvard University Press, 1991.

Julian, Philippe. *Dreamers of Decadence: Symbolists of the 1890s.* 1969. 3rd rpt., New York: Praeger, 1971.

_____. *Montmartre.* Trans. Anne Carter. Oxford: Phaidon Press, 1977.

Jussim, Estelle. *Slave to Beauty: The Eccentric Life and Controversial Career of F. Holland Day, Photographer, Publisher, Aesthete.* Boston: David R. Godine, Publisher, 1981.

Kahn, Ashley. *Kind of Blue.* New York: Da Capo, 2000.

Kalaidjian, Walter. *American Culture Between the Wars: Revisionary Modernism and Postmodern Critique.* New York: Columbia University Press, 1993.

Kandinsky, Wassily. *Concerning the Spiritual in Art.* 1914. New York: Dover Publications, 1977.

Kaplan, Justin. *Walt Whitman: A Life.* New York: Simon & Schuster, 1980.

Kapralov, Yuri. *Once There Was a Village.* New York: Akashic Books, 1998.

Karchur, Lewis. *Displaying the Marvelous: Marcel Duchamp, Salvador Dalí, and the Surrealist Exhibition Installations.* Cambridge: MIT Press, 2001.

Karl, Frederick R. *Modern and Modernism: The Sovereignty of the Artist, 1885–1925.* New York: Athenaeum, 1985.

Katzman, Allan. "Poor Man's Almanac." *East Village Other,* 1–15 May 1967, 9.

Kazin, Alfred. *Starting Out in the Thirties.* 1962. Rpt. New York: Vintage Books, 1980.

Kennedy, Richard S., ed. *Literary New Orleans: Essays and Meditations.* Baton Rouge: Louisiana University Press, 1992.

Kenner, Hugh. *The Pound Era.* Berkeley: University of California Press, 1971.

Kenney, William Holland. *Chicago Jazz: A Cultural History 1904–1930.* New York: Oxford University Press, 1993.

Kerouac, Jack. *Atop an Underwood: Early Stories and Other Writings.* Edited by Paul Marion. New York: Viking, 1999.

_____. *The Dharma Bums.* New York: Viking, 1958.

_____. *On the Road.* New York: Viking Press, 1957.

_____. *The Subterraneans.* New York: Grove Press, 1958.

_____. *The Town and the City.* New York: Harcourt Brace & Co. 1950.

_____. *Visions of Cody.* 1960. New York: Penguin Books, 1993.

_____. *Good Blonde and Others.* Edited by David Allen. San Francisco: Grey Fox Press, 1993.

_____, and Joyce Johnson. *Door Wide Open: A Beat Love Affair in Letters, 1957–1958.* New York: Viking, 2000.

Kershaw, Alex. *Jack London, A Life.* New York: St. Martin's Press, 1997.

Kesey, Ken. "Is There Any End to Kerouac Highway?" *Esquire,* December 1983, 60–62.

_____. "Ken Kesey, The Art of Fiction," interview with Robert Faggen. *The Paris Review,* Spring 1994, 59–94.

_____. *Kesey's Garage Sale.* New York: Viking, 1973.

_____. *One Flew Over the Cuckoo's Nest.* New York: Viking, 1962.

_____. *Sometimes a Great Notion.* New York: Viking, 1964.

"Kesey Postgrad Trial." *The East Village Other,* 1–15 May 1967, 1.

"King of the YADS." *Time,* 30 November 1962, 96–97.

Kirby, Michael. *Happenings: An Illustrated Anthology.* New York: E. P. Dutton & Co., 1966.

Klonsky, Milton. *A Discourse on Hip: Selected Writings on Hip.* Edited by Ted Solotaroff, introduction by Mark Shechner. Detroit, MI: Wayne State University Press, 1991.

Knight, Brenda. *Women of the Beat Generation: The Writers, Artists, and Muses at the Heart of a Revolution.* New York: MJF Books, 2000.

Koch, Lawrence O. *Yardbird Suite: A Compendium of the Music and Life of Charlie Parker.* Bowling Green, KY: Bowling Green University Popular Press, 1988.

Koestenbaum, Wayne. *Andy Warhol.* New York: Penguin, 2001.

Korral, Burt. *Drummin' Men: The Heartbeat of Jazz, The Swing Years.* New York: Schirmer Books, 1990.

Kostelanetz, Richard, ed. *Conversing with Cage.* New York: Limelight Editions, 1994.

_____. *John Cage (ex)plain(ed).* New York: Schirmer Books, 1996.

_____. *The New American Arts.* New York: Collier Books, 1965.

Kotynek, Roy Anthony. "291: Alfred Stieglitz and the Introduction of Modern Art to America." Dissertation. Evanston, IL.: Northwestern University, June 1970.

Kraft, James. *Who Is Witter Bynner?: A Biography.* Albuquerque: University of New Mexico Press, 1995.

Kramer, Jane. *Allen Ginsberg in America.* 1969. New intro. New York: International Publishing Corp., 1997.

_____. *Off Washington Square: A Reporter*

Looks at Greenwich Village, N.Y. New York: Duell, Sloan and Pearse, 1963.

Kramer, Sidney. *A History of Stone & Kimball and Herbert S. Stone & Co., with a Bibliography of Their Publications, 1893–1905.* Chicago: Norman W. Forgue, 1940.

Kreymborg, Alfred. *Troubadour: An Autobiography.* New York: Boni and Liveright, 1925.

Krim, Seymour. *You and Me.* New York: Holt, Rinehart & Winston, 1974.

Kruth, John. *Bright Moments: The Life and Legacy of Rahsaan Roland Kirk.* New York: Welcome Rain Pub., 2000.

Kuenzil, Rudolph, and Francis M. Naumann, eds. *Marcel Duchamp: Artist of the Century.* Cambridge: MIT Press, 1989.

Kuspit, Donald. *The Cult of the Avant-Garde Artist.* Cambridge: Cambridge University Press, 1993.

Lait, Mort, and Lee Mortimer. *New York Confidential: The Lowdown on Its Bright Life.* New York: Dell, 1950.

Lake, Inez Hollander. *The Road from Pompey's Head: The Life and Work of Hamilton Basso.* Baton Rouge: Louisiana State University Press, 1999.

Lambert, Gavin. *Nazimova: A Biography.* New York: Alfred A. Knopf, 1997.

Lardas, John. *The Bop Apocalypse: The Religious Visions of Kerouac, Ginsberg, and Burroughs.* Chicago: University of Illinois Press, 2001.

Lasch, Christopher. *The New Radicalism in America, 1889–1963: The Intellectual as a Social Type.* New York: W. W. Norton, 1965.

Leach, William. *Land of Desire: Merchants, Power, and the New American Culture.* New York: Vintage Press, 1993.

Leamer, Laurence. *The Paper Revolutionaries: The Rise of the Underground Press.* New York: Simon & Schuster, 1972.

The Left Bank Revisited: Selections from the Paris Tribune, 1917–1934. Edited with an introduction by Hugh Ford, foreword by Matthew Josephson. University Park: Pennsylvania University Press, 1972.

Lennon, Nigey. *The Sagebrush Bohemian: Mark Twain in California.* New York: Paragon House, 1993.

Levy, Julian. *Memoir of an Art Gallery.* New York: G. P. Putnam's Sons, 1977.

Lewis, Levering. *When Harlem Was in Vogue.* New York: Oxford University Press, 1989.

Lewis, Oscar. *Bay Window Bohemia: An Account of the Brilliant Artistic World of Gaslit San Francisco.* New York: Doubleday & Co., 1956.

Lewis, Sinclair. "Self-Conscious America." *The American Mercury,* October 1925, 129–139.

The Life and Times of Allen Ginsberg. Video,

dir. Jerry Aronson. New York: First Run Features, 1993.

"Life in a Loony Bin." *Time,* 16 February 1962, 90.

Linson, Corwin K. *My Stephen Crane.* Edited by Edwin H. Cady. Syracuse, NY: Syracuse University Press, 1958.

Lipton, Lawrence. *The Holy Barbarians.* New York: Grove Press, 1962.

Lisle, Laurie. *Portrait of an Artist: A Biography of Georgia O'Keeffe.* New York: Seaview Books, 1980.

Litweiler, John. *The Freedom Principle: Jazz After 1958.* New York: William Morrow & Co., 1984.

Lloyd, Craig. *Eugene Bullard: Black Expatriate in Jazz Age Paris.* Athens: University of Georgia Press, 2000.

Loeb, Harold. *The Way It Was.* New York: Criterion Books, 1959.

London, Jack. *Valley of the Moon.* 1913. Paperback ed. Berkeley: University of California Press, 1999.

Loughey, John. *John Sloan: Painter and Rebel.* New York: Henry Holt, 1995.

Loving, Jerome. *Walt Whitman: The Song of Himself.* Los Angeles: University of California Press, 1999.

Luhan, Mabel Dodge. *Movers and Shakers.* New York: Harcourt Brace, 1936.

Lydon, Michael. "The Word," *Esquire,* September 1967, 106,107, 156–167.

Lyons, Len. *The Great Jazz Pianists: Speaking of Their Lives and Music.* New York: Da Capo, 1983.

MacAdams, William. *Hecht: The Man Behind the Legend.* New York: Charles Scribners & Sons, 1990.

Machlis, Joseph. *The Enjoyment of Music,* 4th ed. New York: W. W. Norton, 1977.

Maher, Paul, Jr. *Kerouac: The Definitive Biography.* New York: Taylor Trade Publishing, 2004.

Mailer, Norman. *The Armies of the Night: History as a Novel, the Novel as History.* New York: New American Library, 1968.

Mann, Thomas. *Death in Venice and Seven Other Stories.* 1930. New York: Vintage Books, 1963.

Mann, William J. *Wisecracker: The Life and Times of William Haines, Hollywood's First Openly Gay Star.* New York: Viking, 1998.

Manning, Peter. *Electronic and Computer Music.* New York: Oxford University Press, 1994.

Manzarek, Ray. *Light My Fire: My Life with the Doors.* New York: Berkeley Boulevard Books, 1998.

"Marvelous and Fantastic." *Time,* 14 December 1936, 62.

Masters, Edgar Lee. *Across Spoon River: An Autobiography.* New York: Farrar & Rinehart, 1936.

Matthews, Jane DeHart. *The Federal Theatre, 1935–1939: Plays, Relief, and Politics.* Princeton, NJ: Princeton University Press, 1967.

Matthiessen, F. O. *American Renaissance: Art and Expression in the Age of Emerson and Whitman.* New York: Oxford University Press, 1941.

May, Henry F. *The End of American Innocence: A Study of the First Years of Our Own Time.* New York: Columbia University Press, 1992.

McAlmon, Robert and Kay Boyle. *Being Geniuses Together,* rev. supp. chapters. Baltimore: Johns Hopkins University Press, 1968.

McBrien, William. *Cole Porter: A Biography.* New York: Alfred A. Knopf, 1999.

McClanahan, Ed. *Famous People I Have Known.* Lexington, KY: University of Kentucky Press, 1997.

_____. *My Vita If You Will.* Washington, D.C: Counterpoint, 1998.

_____. Private phone interview, Lexington, KY, 18 August 2005.

McDarrah, Fred W., and Timothy S. McDarrah, eds. *Kerouac and Friends: A Beat Generation Album.* New York: Thunder's Mouth Press, 2002.

McLellan, Diana. *The Girls: Sappho Goes to Hollywood.* New York: L.A. Weekly Books, 2000.

McMillan, Doug. *Transition: The History of a Literary Era, 1927–1993.* New York: George Braziller, 1976.

Mekas, Jonas. Liner notes to *The Velvet Underground and Nico.* Verve, 1966.

Mellow, James R. *Charmed Circle: Gertrude Stein and Company.* New York: Praeger Publishers, 1974.

Mencken, H. L. *The Smart Set Criticism.* Edited by William H. Nolte. Ithaca: Cornell University, 1968.

The Merry Pranksters. Video. Key-Z Productions.

Mezzrow, "Milton" Mezz. *Really the Blues.* New York: Random House, 1964.

Miles, Barry. *Ginsberg: An Autobiography.* 1959. New York: Simon & Schuster, 1989.

_____. *William Burroughs.* New York: Hyperion, 1993.

_____. *Zappa: A Biography.* New York: Grove Press, 1993.

Miles Electric: A Different Kind of Blue. DVD Eagle Rock Entertainment Ltd., 2004.

Milford, Nancy. *Zelda: A Biography.* New York: Harper & Row, 1970.

Milkowski, Bill. "Frank Zappa: Guitar Player." *Down Beat,* February 1983, 14–17, 46.

Miller, Henry. *The Air-Conditioned Nightmare.* New York: New Directions, 1945.

Miller, Linda Patterson, ed. *Letters of the Lost Generation: Gerald and Sara Murphy and Friends.* Expanded ed. Gainesville: University of Florida Press, 2002.

Miller, Michael V., and Susan Gilmore, eds. *Revolution at Berkeley: The Crisis in American Education.* Introduction by Irving Howe. New York: Dell, 1965.

Mingus, Charles. *Beneath the Underdog.* Edited by Nel King. New York: Penguin Books, 1971.

Mirrors of the Year: A National Review of the Outstanding Figures, Trends and Events of 1926–27. Edited by Hal Overton. New York: Frederick A. Stokes Co., 1927.

The Moderns: An Anthology of New Writing in America. Edited and introduction by LeRoi Jones. New York: Corinth Books, 1963.

Morgan, Bill. *The Beat Generation in New York: A Walking Tour of Jack Kerouac's City.* San Francisco: City Lights Books, 1997.

Morgan, H. Wayne. *New Muses: Art in American Culture, 1865–1920.* Norman, OK: Oklahoma University Press, 1978.

_____. *Unity and Culture: The United States, 1877–1900.* Baltimore: Penguin Books, 1971.

Morgan, Ted. *Literary Outlaw: The Life and Times of William Burroughs.* New York: Avon Books, 1988.

Morrison, Jim. *The Lords and the New Creatures.* 1969. New York: Fireside, 1987.

Morrow, Patrick. *Bret Harte.* Boise, ID: Boise State College, 1972.

Moss, Arthur, and Evalyn Marvel. *The Legend of the Latin Quarter: Henry Murger and the Birth of Bohemia.* New York: Beechhurst Press, 1946.

Munson, Gorham. *The Awakening Twenties: A Memoir — History of a Literary Period.* Baton Rouge: Louisiana State University Press, 1985.

Murger, Henri. *Bohemians of the Latin Quarter (Scènes de le Vie de Bohème).* 1905. 2nd ed. New York: Fertig, 1984.

Murray, Paul. *A Fantastic Journey: The Life and Literature of Lafcadio Hearn.* Ann Arbor: University of Michigan Press, 1993.

Nagel, James, general ed. *Critical Essays on Ambrose Bierce.* Boston: G. K. Hall & Co., 1982.

Nash, Roderick. *The Nervous Generation: American Thought, 1917–1930.* Chicago: Rand McNally & Company, 1970.

Naumann, Francis M. *New York Dada, 1915–23.* New York: Harry N. Abrams, 1994.

Nelson, George. *The Death of Rhythm and Blues.* New York: E. P. Dutton, 1989.

Nevin, Penelope. *Carl Sandburg: A Biography.* New York: Charles Scribner & Sons, 1991.

New Orleans Guide. Written and Compiled by the Federal Writers Project of the Works

Progress Administration For the City of New Orleans. 1938. Boston: Houghton & Mifflin, 1974.

New York City Panorama. A Comprehensive Guide to the Metropolis — Presented in a Series of Articles Prepared by the Federal Works Project of WP in New York City. 1938. New York: Random House, 1976.

The New York City Sketches of Stephen Crane, and Related Pieces, Edited by R. W. Stallman and E. R. Hagemann. New York: New York University Press, 1966.

The New York Saturday Press, 8 January 1859, 1.

Newton, Eric. *The Romantic Rebellion*. New York: Schocken Books, 1962.

Nicholson, Stuart. *Jazz-Rock: A History*. New York: Schirmer Books, 1998.

Nicosia, Gerald. *Memory Babe: A Critical Biography of Jack Kerouac*. Berkeley: University of California Press, 1983.

Nisenson, Eric. *Ascension: John Coltrane and His Quest*. 1993. New York: Da Capo, 1995.

Norton, Louise. *Varèse: A Looking-Glass Diary*. New York: W. W. Norton Co., 1972.

Notes from the New Underground: An Anthology Edited by Jesse Kornbluth. New York: Viking Press, 1968.

Oates, Stephen. *William Faulkner: The Man and the Artist*. New York: Harper & Row, 1987.

O'Connor, Richard. *Jack London: A Biography*. Boston: Little, Brown & Co., 1964.

O'Daniel, Therman B., ed. *Jean Toomer: A Critical Evaluation*. Washington, D.C.: Howard University Press, 1988.

Oja, Carol J. *Making Music Modern: New York in the 1920s*. New York: Oxford University Press, 2000.

Okrent, Daniel. *Great Fortune: The Epic of Rockefeller Center*. New York: Viking, 2003.

O'Meally, Robert G., Brent Hayes Edwards, and Farah Jasmine Griffin, eds. *Uptown Conversation: The New Jazz Studies*. New York: Columbia University Press, 2004.

One Lord, One Faith, One Cornbread. Edited by Fred Nelson and Ed McClanahan. New York: Anchor Books, 1973.

Ostrovsky, Erika. *Celine and His Vision*. New York: New York University Press, 1967.

Owens, Thomas. *Bebop: The Music and Its Players*. New York: Oxford University Press, 1995.

Paglia, Camille. "The Magic of Images: Word and Picture Images in a Media Age." *Arion*, Winter 2000, 8.

Parry, Albert. *Garretts and Pretenders: A History of Bohemianism in America*. New York: Covici, Friede, 1933.

Peck, Abe. *Uncovering the Sixties: The Life and Times of the Underground Press*. New York: Pantheon Books, 1985.

Pelles, Geraldine. *Art, Artists, and Society: Painting in England and France, 1750–1850*. Englewood Cliffs, NJ: Prentice-Hall, 1963.

Pells, Richard H. *Radical Visions and American Dreams*. Middletown, CT: Wesleyan University Press, 1984.

Peretti, Burton W. *The Creation of Jazz: Music, Race, and Culture in Urban America*. Chicago: University of Illinois Press, 1992.

Perlmann, Bernard B. *The Immortal Eight: American Painting from Eakins to the Armory Show (1870–1913)*. New York: Exposition Press, 1962.

Perry, Lewis. *Radical Abolitionism: Anarchy and the Government of God in Anti-Slavery Thought*. Ithaca, NY: Cornell University Press, 1973.

Peyser, Joan. *The New Music: The Sense Behind the Sound*. New York: Delacorte Press, 1971.

"Pfaff's." *The New York Saturday Press*, 3 December 1859, 2.

Phillips, Lisa, et al. *Beat Culture and the New America, 1950–1965*. New York: Whitney Museum/Flammarion, 1995.

The Photographic Work of F. Holland Day. Edited with Introduction by Ellen Fritz Clattenburg. Wellesley, MA: Wellesley College Museum, 1975.

Pisano, Ronald G. With essays by Mary Ann Apicella and Linda Henefield Skalet. *The Tile Club and the Aesthetic Movement in America*. New York: Harry N. Abrams, 1999.

Poe, Edgar Allan. *The Works of Edgar Allan Poe, Vol. Nine, Essays-Philosophy*. New York: Funk & Wagnall's, 1904.

Poe, Randy. Foreword by Billy F. Gibbons. *Skydog: The Daune Allman Story*. San Francisco: Backbeat Books, 2006.

Poggioli, Renato. *The Theory of the Avant-Garde*. Translated by Gerald Fitzgerald. New York: Harper and Rowe, 1971.

Polizzotti, Mark. *Revolution of the Mind: The Life of André Breton*. New York: Farrar, Straus, & Giroux, 1995.

Poli, Bernard J. *Ford Maddox Ford and the Transatlantic Review*. Syracuse, N Y: Syracuse University: 1967.

Pollock, Bruce. *When the Music Mattered: Rock in the 1960s*. New York: Holt, Rinehart, & Winston, 1984.

_____. *Working Musicians: Defining Moments from the Road, the Studio, and the Stage*. New York: HarperCollins, 2002.

Porter, Eric. *What Is This Thing Called Jazz: African American Musicians as Artists, Critics, and Activists*. Berkeley: University of California Press.

Porter, Lewis. *John Coltrane: His Life and*

Music. Ann Arbor: University of Michigan Press, 1998.

Pound, Ezra. *Ezra Pound: Selected Prose, 1909–1915.* New York: New Directions, 1950.

Powers, Ann. *Weird Like Us: My Bohemian America.* New York: Simon & Schuster, 2000.

Price, Sue Ann, ed. *The Old Guard and the Avant-Garde: Modernism in Chicago, 1910–1940.* Chicago: University of Chicago Press, 1990.

Priestly, Brian. *Mingus: A Critical Biography.* New York: Da Capo, 1982.

Primack, Bret. "Max Roach, There's No Stoppin' the Professor from Boppin'." *Down Beat,* November 1978, 72.

The Progressive Movement, 1900 to 1915. 1963. Edited with introduction by Richard Hofstadter. New York: Touchstone, 1986.

Pullen, John J. *Comic Relief: The Life and Laughter of Artemus Ward, 1834–1867.* Hamden, CT: Anchor Books, 1983.

Putnam, Samuel. "Chicago: An Obituary." *American Mercury.* August 1926, 417.

_____. *Paris Was Our Mistress: Memoirs of a Lost and Found Generation.* New York: Viking, 1947.

Pynchon, Thomas. *V.* 1961. Rpt., New York: Harper Perennial, 2005.

Quirk, Tom. *Bergson and American Culture: The Worlds of Willa Cather and Wallace Stevens.* Chapel Hill: University of North Carolina Press, 1990.

Rampersad, Arnold. *The Life of Langston Hughes: Volume I 1902–1941, I Too Sing America.* New York: Oxford University Press, 1986.

Ray, Man. *Self-Portrait.* Boston: Little & Brown, 1963.

Read, Herbert. *A Concise History of Modern Painting.* Enlarged 3rd ed. New York: Praeger Pub., 1974.

Readings by Jack Kerouac on the Beat Generation. Rhino Records, 1990.

Reisner, Robert. *Bird: The Legend of Charlie Parker.* New York: Da Capo, 1962.

Revill, David. *The Roaring Silence: John Cage: A Life.* New York: Arcade, 1992.

Rexroth, Kenneth. *An Autobiographical Novel.* 1964. The Oil Mills, England: Whittet Books, 1977.

Reynolds, David S. *Beneath the American Renaissance: The Subversive Imagination in the Age of Emerson and Melville.* New York: Knopf, 1988.

_____. *Whitman's America: A Cultural Biography.* New York; Alfred A. Knopf, 1996.

Reynolds, Michael. *Hemingway: The Paris Years.* New York: W. W. Norton, 1999.

Richter, Hans. *Dada: Art and Anti-Art.* 1964. New York: Thames & Hudson, 1983.

Rideout, Walter B. *The Radical Novel in the United States 1900–1954: Some Interrelations of Literature and Society.* New York: Hill & Wang, 1956.

Rigney, Francis J., and L. Douglas Smith. *The Real Bohemia: A Sociological and Psychological Study of the Beats.* New York: Basic Books, 1961.

Riis, Jacob A. *How the Other Half Lives.* 1890. New York: Hill and Wang, 1957.

Riordan, James, and Jerry Prochnicky. *Break on Through: The Life and Death of Jim Morrison.* New York: William Morrow, 1991.

Rose, Barbara. *American Art Since 1900.* Rev. ed. New York: Holt, Rinehart & Winston, 1975.

Rosenfeld, Paul. *Port of New York: Essays on Fourteen American Moderns.* 1924. Urbana: University of Illinois, 1966.

Rosenthal, David H. *Hard Bop: Jazz and Black Music, 1955–1965.* New York: Oxford University Press, 1992.

Roske, Ralph J. *Everyman's Eden: A History of California.* New York: Macmillan & Co., 1968.

Rossman, Michael. *The Wedding Within the War.* New York: Paris Review of Books, 1971.

Roszak, Theodore. *The Making of a Counterculture.* 1969. Berkeley: University of California Press, 1995.

Rubin, Joseph Jay. *The Historic Whitman.* University Park: Pennsylvania State University Press, 1973.

Rudnick, Lois Palken. *Mabel Dodge Luhan: New Woman, New Worlds.* Albuquerque: University of New Mexico Press, 1984.

_____. *Utopian Vistas: The Mabel Dodge Luhan House and the American Counterculture.* 1996. Albuquerque: University of New Mexico Press, 1998.

Rurland, Richard and Malcolm Bradbury. *From Pruitanism to Postmodernism: A History of American Literature.* New York: Penguin, 1992.

Russcol, Herbert. *The Liberation of Sound: An Introduction to Electronic Music.* Englewood Cliffs, NJ: Prentice-Hall, 1972.

Sale, Kirkpatrick. *SDS.* New York: Vintage Books, 1973.

Sandy, Troy. *Captain Trips: The Life and Fast Times of Jerry Garcia.* London: Virgin Books, 1995.

San Francisco: The Bay and Its Cities. Comp. by Works the Writer's Program of the Works Progress Admin. In Northern California. Rev. 2nd ed. New York: Hasting House Pub., 1947.

Santoro, Gene. *Myself When I'm Real: The Life and Music of Charles Mingus.* New York: Oxford University Press, 2000.

Sarlos, Robert Karoly. *Jig Cook and the Province-town Players: Theatre in Ferment.* Amherst: University of Massachusetts Press, 1982.

Saul, Scott. *Freedom Is, Freedom Ain't: Jazz and the Making of the Sixties.* Cambridge: Harvard University Press, 2003.

Sawin, Martica. *Surrealism in Exile and the Beginning of the New York School.* Cambridge: MIT Press, 1995.

Sawyer-Laucanno, Christopher. *E. E. Cummings: A Biography.* Naperville, IL: Sourcebooks, 2004.

Schickel, Richard. *Elia Kazan: A Biography.* New York: HarperCollins, 2005.

Schmidgall, Gary. *Walt Whitman: A Gay Life.* New York: Plume, 1998.

Schneckloth, Tim. "Frank Zappa: Garni Du Jour, Lizard King, and Slime." *Down Beat,* 18 May 1978, 15–17, 44–45.

Schorer, Mark. *Sinclair Lewis: An American Life.* New York: McGraw-Hill, 1961.

Schumacher, Michael. *Dharma Lion: A Critical Biography of Allen Ginsberg.* New York: St. Martin's Press, 1992.

Schwab, Arnold T. *James Gibbons Huneker: Critic of the Seven Arts.* Stanford: Stanford University Press, 1963.

Schwartz, Elliott, and Barney Childs, eds. *Contemporary Composers on Contemporary Music,* enlarged ed. New York: Da Capo, 1998.

Schwartz, Stephen. *From West to East: California and the Making of the American Mind.* New York: Free Press, 1968.

Schwarz, Arturo. *New York Dada: Duchamp, Man Ray, Picabia.* exh. cat. Germany: Prestel-Verlag, 1973.

Seigel, Jerrold. *Bohemian Paris: Culture, Politics, and the Boundaries of Bourgeois Life, 1830–1930.* New York: Penguin Books, 1987.

Seitz, Don Carlos. *Artemus Ward (Charles Farrar Browne): A Biography and Bibliography.* New York: Harper & Brothers, 1919.

Seldes, Gilbert. *The Seven Lively Arts.* 1924. New ed. New York: Sagamore Press, 1957.

Shack, William A. *Harlem in Montmartre: A Paris Jazz Story Between the Great Wars.* Berkeley: University of California Press, 2001.

Shand-Tucci, Douglass. *Boston Bohemia 1881–1900, Volume One of Ralph Adams Cram: Life and Architecture.* Amherst: University of Massachusetts, 1995.

Shapiro, Harry, and Caesar Glebbeck. *Jimi Hendrix: Electric Gypsy.* New York: St. Martin's Press, 1992.

Shapiro, Marc. *Back on Top: Carlos Santana.* New York: St. Martin's Press, 2000.

Shattuck, Roger. *The Banquet Years: The Origins of The Avant-Garde in France, 1885 to World War I.* Rev. ed. New York: Vintage Books, 1968.

Shaw, Arnold. *The Street That Never Slept: New York's Fabled 52nd Street.* New York: Coward, McCann & Geoghegan, 1971.

"Shelly's Manne-Hole." Advertisement. *Los Angeles Free Press,* 15 March 1965, 4.

Shelton, Barry. *No Direction Home: The Life and Music of Bob Dylan.* New York: Da Capo, 1986.

Shields, Scott A. *Artists at Continent's End: The Monterey Peninsula Art Colony, 1875–1907.* Berkeley: University of California Press, 2006.

Shorris, Earl. "Love Is Dead." *New York Times Magazine,* 29 October 1967, 27, 113–114.

Silverman, Kenneth. *Edgar A. Poe: Mournful and Never-Ending Remembrance.* New York: Harper & Collins, 1991.

Sims, Henry W., ed. *Autobiography of Brook Farm.* Englewood Cliffs, NJ: Prentice-Hall, 1958.

Sinclair, Andrew. *Jack: A Biography of Jack London.* New York: Harper & Row, 1977.

Sinclair, John. *Guitar Army: Street Writings/ Prison Writings.* New York: Douglas Printing Corp., 1972.

Sklar, Robert. *Movie-Made America: A Cultural History of American Movies.* Rev. ed. New York: Vintage Books, 1994.

Slaven, Neil. *Electric Don Quixote: The Definitive Story of Frank Zappa.* New York: Omnibus Press, 1996.

Slick, Grace. *Somebody to Love? A Rock and Roll Memoir.* New York: Warner Books, 1998.

"Slug's in the Far East." Advertisement. *East Village Other,* 1–15 May 1967, 17.

Smith, Edward Lucie. *Symbolist Art.* New York: Oxford University Press, 1972.

Smith, Owen F. *Fluxus: History of an Attitude.* San Diego: San Diego State University Press, 1998.

Smith, Richard Candida. *Utopia and Dissent: Art, Poetry, and Politics in California.* Berkeley: University of California Press, 1995.

Snodgrass, Chris. *Aubrey Beardsley: Dandy of the Grotesques.* New York: Oxford University Press, 1995.

Snyder, Gary. *The Gary Snyder Reader, Prose, Poetry, and Translations, 1952–1998.* Washington, D.C.: Counterpoint, 1999.

_____. *The Real Work, Interviews & Talks 1964–1979, Gary Snyder.* Edited with introduction by Scott McLean. New York: New Directions, 1980.

Sochen, June. *The New Woman: Feminism in Greenwich Village, 1910–1920.* New York: Quadrangle Books, 1972.

Sounes, Howard. *Down the Highway: The Life of Bob Dylan.* New York: Grove Press, 2001.

Spann, Edward K. *Brotherly Tomorrows: Movements for a Cooperative Society in America,*

1820–1920. New York: Columbia University Press, 1989.

Spellman, A. B. *Four Lives in the Bebop Business.* New York: Pantheon Books, 1966.

Spencer, Robin. *The Aesthetic Movement: Theory and Practice.* New York: Studio Vista/ Dutton Picturebacks, 1972.

Stallman, R. W. *Stephen Crane: A Biography.* New York: George Braziller, 1968.

Stansell, Christine. *American Moderns: Bohemian New York and the New Century.* New York: Metropolitan Books, 2000.

_____. "Whitman at Pfaff's: Commercial Culture, Literary Life, and New York Bohemia at Mid-Century." *Walt Whitman Quarterly Review.* Winter 1993, 107–123.

Starkie, Enid. *Baudelaire.* New York: New Directions Books, 1958.

Starr, Frederick S. *Red and Hot: The Fate of Jazz in the Soviet Union, 1917–1980.* New York: Oxford University Press, 1983.

Starr, Kevin. *Americans and the California Dream, 1850–1915.* New York: Oxford University Press, 1973.

Stearns, Harold, ed. *Civilization in the United States: An Inquiry by Thirty Americans.* New York: Harcourt Brace, 1922.

_____. *Confessions of a Harvard Man: A Journey Through Literary Bohemia in the 20s and 30s.* 1935. Santa Barbara, CA: Paget Press, 1984.

Steffens, Lincoln. *The Autobiography of Lincoln Steffens.* New York: Harcourt, Brace & Co., 1931.

_____. *The Shame of the Cities.* 1904. New York: Sagamore Press Inc., 1957.

Stein, Roger B. *John Ruskin and Aesthetic Thought in America 1840–1900.* Cambridge: Harvard University Press, 1967.

"Stein's Way." *Time,* 11 September 1933, 57–60.

Sterrit, David. *Mad to Be Saved: The Beats, the '50s, and Film.* Carbondale, IL: Southern Illinois University Press, 1998.

Stevens, Mark and Annalyn Swan. *de Kooning an American Master.* New York: Alfred A. Knopf, 2004.

Stewart, George R., Jr. *Bret Harte: Argonaut in Exile.* Port Washington, NY: Kennikat Press, 1935.

Stineman, Esther Lanigan. *Mary Austin: Song of a Maverick.* New Haven, CT: Yale University Press, 1989.

Stoddard, Charles Warren. *In the Footprints of the Padres.* San Francisco: A. M. Robertson, 1902.

Stone, Bob. *Prime Green: Remembering the Sixties.* New York: CCC, 2007.

Stovall, Tyler. *Paris Noir: African Americans in the City of Light.* New York: Houghton Mifflin Co., 1996.

Stratton, Bert. "Miles Ahead in Rock Country." *Down Beat,* 14 May 1970, 19.

Strouse, Jean. "Guide to the Underground Press." *Eye,* 11 February 1969, 51, 61, 78.

Such, David S. *Avant-Garde Jazz Musicians, "Performing Out There."* Iowa City: University of Iowa Press, 1993.

Sukenick, Ronald. *Down and In: Life in the Underground.* New York: William Morrow, 1987.

Swain, Martica. *Surrealism in Exile: The Beginning of the New York School.* Cambridge: MIT Press, 1995.

Symons, Arthur. *The Symbolist Movement in Literature.* 1899. New York: E.P. Dutton, 1958.

Szwed, John F. *Space Is the Place: The Lives and Times of Sun Ra.* New York: Pantheon Books, 1997.

Tashjian, Dickran. *Skyscraper Primitives: Dada and the American Avant-Garde.* Middletown, CT.: Wesleyan University Press, 1975.

_____. *A Boatload of Madmen: Surrealism and the American Avant-Garde 1920–1950.* New York: Thames & Hudson, 1995.

Taylor, Kendall. *Sometimes Madness Is Wisdom: Zelda and Scott Fitzgerald, a Marriage.* New York: Ballantine Books, 2001.

Taylor, William R., ed. *Inventing Times Square: Commerce and Culture at the Crossroads of the World.* New York: Russell Sage Foundation, 1991.

Terry, Kenneth. "La Monte Young, Explorer of the Long Note." *Down Beat,* 19 April 1979, 17–18.

Thackeray, William Makepeace. *Vanity Fair: A Novel Without a Hero.* 1852. New York: Signet, 1962.

Thackeray in the United States, 1852–3, 1855–6, Vol. I. Including a Record of a Variety of Thackerayana by James Grant Wilson. New York: Dodd & Mead Co., 1904.

Theado, Matt, ed. *The Beats, A Literary Reference.* New York: Carroll & Graff Pub., 2000.

Thomas, J. C. *Chasin' the Trane: The Music and Mystique of John Coltrane.* New York: Da Capo, 1976.

Thomson, David. *Rosebud: The Story of Orson Welles.* New York: Vintage Books, 1996.

Thompson, Hunter S. *Fear and Loathing in America: The Brutal Odyssey of an Outlaw Journalist, 1968–1976.* New York: Simon & Schuster, 2000.

_____. "The Hashbury Is the Capital of the Hippies." *New York Times Magazine,* 14 May 1967, 28–29, 120–124.

_____. *Hell's Angels: A Strange and Terrible Saga.* New York: Ballantine Books, 1967.

Thomson, Virgil. *Virgil Thomson by Virgil Thomson.* New York: Alfred A. Knopf, 1966.

Thoreau, David Henry. *Walden and Other Writ-*

ings. 1854. Edited with foreword by Joseph Wood Krutch. New York: Bantam, 1962.

Thurman, Wallace. *Blacker the Berry.* 1929. Scribner paperback ed., New York: Simon & Schuster, 1996.

_____. *Infants of the Spring.* 1932. New York: Modern Library, 1999.

Time, review of Mabel Dodge Luhan's *Movers and Shakers,* 23 November 1936, 91. [order items better?]

Time, 24 September, 1967, 25–27, 68–84. [needs specific subject reference]

Tingen, Paul. *Miles Beyond: The Electric Explorations o Miles Davis, 1967–1991.* New York: Billboard Books, 2001.

Tocqueville, Alexis de. *Democracy in America.* 1835–1840, abr. intro. Thomas Bender. New York: Modern Library, 1981.

Tomkins, Calvin. *The Bride and the Bachelors: Five Masters of the Avant-Garde,* enlarged ed. New York: Penguin Books, 1976.

_____. *Duchamp: A Biography.* New York: Owl Books, 1996.

_____. *Living Well Is the Best Revenge.* New York: Modern Library, 1962.Tommasini, Anthony. *Virgil Thomson: Composer on the Aisle.* New York: W. W. Norton, 1997.

Traubel, Horace. *With Walt Whitman in Camden, July 16-October 31, 1888; January 21-April 7, 1889.* Ed. Sculley Bradley. Carbondale: Southern Illinois University Press, 1959.

"Trouble in Hippieland." *Newsweek,* 30 October 1967, 84–90.

Troy, Sandy. *Captain Trips: A Biography of Jerry Garcia.* New York: Thunder's Mouth Press, 1995.

Twain, Mark. *Roughing It.* 1872. Rev. updated bib. and fwd. Leonard Kriegel. New York: Signet, 1962.

_____. *Life on the Mississippi.* 1883. New York: Airmont Pub Co., 1965.

_____. *Mark Twain's Own Biography: The Chapters from the North American Review.* Introduction and notes by Michael J. Kiskis. Madison: University of Wisconsin, 1990.

Tyler, Alice Felt. *Freedom's Ferment: Phases of American Social History from the Colonial Period to the Outbreak of the Civil War.* 1944. New York: Harper Torch Books, 1962.

Tytell, John. *The Living Theatre: Art, Exile, Outrage.* New York: Grove Press, 1995.

_____. *Naked Angels: The Lives & Literature of the Beat Generation.* New York: Dodd, Mead & Company, 1974.

_____. *Paradise Outlaws: Remembering the Beats.* New York: William Morrow, 1999.

Unger, Irwin. *The Movement: A History of the American New Left, 1959–1972.* New York: Dodd, Mead & Company, 1974.

Vaill, Amanda. *Everybody Was So Young: Gerald and Sara Murphy, A Lost Generation Love Story.* New York: Houghton Mifflin, 1998.

Van Vechten, Carl. *The Letters of Carl van Vechten.* Edited by Bruce Keller. New Haven, CT: Yale University Press, 1987.

_____. *Nigger Heaven.* 1926. Chicago: University of Illinois Press, 2000.

Varèse, Louise. *Varèse: A Looking-Glass Diary.* New York: W. W. Norton Inc., 1972.

The Village Voice Reader: A Mixed Bag from the Greenwich Village Newspaper. New York: Grove Press, Black Cat ed., 1963.

Von Hoffman, Nicholas. *We Are the People Our Parents Warned Against.* Greenwich, CT: Fawcett Crest Book, 1968.

Wakefield, Dan. *New York in the Fifties.* Boston: Houghton & Mifflin, 1992.

Walker, Franklin. *Frank Norris: A Biography.* New York: Russell & Russell, 1963.

Walters, Ronald G. *American Reformers, 1815–1860.* New York: Hill & Wang, 1978.

Ware, Carolyn. *Greenwich Village, 1920–1930.* Boston: Houghton Mifflin, 1935.

Warhol, Andy and Pat Hackett. *Popism: The Warhol Sixties.* New York: Harcourt & Brace, 1980.

Watkins, Glenn. *Pyramids at the Louvre: Music, Culture, and Collage, from Stravinsky to the Postmodernists.* Cambridge: Belknap Press of Harvard University Press, 1994.

Watson, Ben. *Frank Zappa: The Negative Dialectics of Poodle Play.* New York: St. Martin's Press, 1995.

Watson, Steven. *Birth of the Beat Generation: Visionaries, Rebels, and Hipsters, 1944–1960.* New York: Pantheon Books, 1995.

_____. *The Harlem Renaissance: Hub of African-American Culture, 1920–1930.* New York: Pantheon Books, 1995.

_____. *Prepare for Saints: Gertrude Stein, Virgil Thomson, and the Mainstreaming of American Modernism.* New York: Random House, 1998.

_____. *Strange Bedfellows: The First American Avant-Garde.* New York: Abbeville Press, 1991.

Weber, Eva. *Alfred Stieglitz.* New York: Crescent Books, 1994.

Weigle, Marta, and Kyle Fiore. *Santa Fe & Taos: The Writer's Era, 1916–1941.* Santa Fe, NM: Ancient City Press, 1994.

Weintraub, Stanley. *Whistler: A Biography.* New York: Weybright and Talley, 1974.

Wetzsteon, Ross. *Republic of Dreams: The American Bohemia, 1910–1960.* New York: Simon & Schuster, 2002.

Whaley, Preston. *Blows Like a Horn: Beat Writing, Jazz, Style, and Markets in the Transformation of U.S. Culture.* Cambridge: Harvard University Press, 2004.

Whelan, Richard. *Alfred Stieglitz: A Biography.* New York: Little, Brown and Co., 1995.

"Where Are They Now? The Haight-Ashbury Scene." *Newsweek,* 2 December 1968.

Whistler, James Abbott McNeill. *The Gentle Art of Making Enemies.* 1892. Reprint 2nd edition. New York: Dover Publications, 1967.

Whitman, Walt. *Leaves of Grass.* Edited with introduction by Malcolm Cowley. 1855. New York: Penguin Books, 1959.

Wickes, George. *The Amazon of Letters: The Life and Loves of Natalie Barney.* New York: G.P. Putnam's & Sons, 1976.

_____. *Americans in Paris.* Foreword by Virgil Thomson. Rpt., New York: Da Capo, 1980.

Wiggins, Robert A. *Ambrose Bierce.* Minneapolis: University of Minnesota Press, 1964.

Wilhelm, J. J. *Ezra Pound in London and Paris, 1908–1925.* University Park: Pennsylvania State University Press, 1990.

Williams, William Carlos. *The Autobiography of William Carlos Williams.* New York: Random House, 1951.

_____. *A Recognizable Image: William Carlos Williams on Art and Artists.* Edited with introduction by Bram Dijkstra. New York: New Directions, 1978.

_____. *The Selected Essays of William Carlos Williams.* 1954. New York: New Directions, 1969.

Wilson, Edmund. *The American Earthquake: A Documentary of the Twenties and Thirties.* New York: Anchor Books, 1964.

_____. *Axel's Castle: A Study of the Imaginative Literature of 1870–1930.* New York: Modern Library, 1931.

_____. *The Thirties, From Notebooks and Diaries of the Period.* New York: Farrar, Straus, & Giroux, 1980.

_____. *The Twenties, From Notebooks and Diaries of the Period.* New York: Farrar, Straus, & Giroux, 1975.

Wilson, Elizabeth. *Bohemians: The Glamorous Outcasts.* New Brunswick, NJ: Rutgers University Press, 2000.

Wilson, James Grant. *Thackeray in the United States, 1852–3, 1855–6, Vol. I.* New York: Dodd, Mead & Co., 1904.

Woideck, Carl. *Charlie Parker: His Music and Life.* Ann Arbor: University of Michigan Press, 1996.

Wolfe, Burton H. *The Hippies.* New York: Signet, 1968.

Wolfe, Charles, and Kip Lornell. *The Life and Legend of Leadbelly.* New York: HarperCollins, 1992.

Wolfe, Tom. *The Electric Kool-Aid Acid Test.* New York: Farrar, Straus & Giroux, 1968.

Wolff, Geoffrey. *Black Sun: The Brief Transit and Violent Eclipse of Harry Crosby.* New York: Vintage Books, 1976.

Women in American Theater: Careers, Images, Movements, an Illustrated Anthology and Sourcebook. Ed. Helen Krich Cinoy and Linda Walsh Jenkins. New York: Crown, 1981.

Women in Dada: Essays on Sex, Gender, and Identity, edited by Naomi Sawelson Gorse. Cambridge: MIT Press, 1998.

Wood, Paul, ed. *The Challenge of the Avant-Garde.* New Haven: Yale University Press, 1999.

Worrall, Nick. *The Moscow Art Theatre.* New York: Routledge, 1996.

X, Malcolm, with Alex Haley. *The Autobiography of Malcolm X.* New York: New York: Ballantine Books, 1991.

Yablonsky, Lewis. *The Hippie Trip.* New York: Pegasus, 1968.

Young, Jeff. *Kazan, the Master Director of Films: Interviews with Elia Kazan.* New York: Newmarket Press, 1999.

Zak, Albin, III, ed. *The Velvet Underground Companion: Four Decades of Commentary.* New York: Schirmer Books, 1997.

Zappa, Frank. "The Oracle Has It All." *Life,* 28 June 1968, 82–89.

_____, with Peter Occhiogrosso. *The Real Frank Zappa Book.* New York: Poseidon Press, 1989.

Zender, Karl F. *Crossing of the Ways: William Faulkner, the South, and the Modern World.* New Brunswick, NJ: Rutgers University Press, 1989.

Zweig, Paul. *Walt Whitman: The Making of a Poet.* New York: Basic Books, 1984.

Index

251